The complete
typographer

The complete
typo

A manual
for designing
with type

Written by
Christopher Perfect

grapher

Design by
Jeremy Austen

LITTLE, BROWN AND COMPANY

A LITTLE, BROWN BOOK
First published in Great Britain in 1992 by Little, Brown
and Company

Copyright © 1992 Quarto Publishing

A CIP catalogue record for this book is available from the
British Library.

ISBN 0 316 90326 4

This book was designed and produced by
Quarto Publishing plc, 6 Blundell Street,
London B7 9BH

Senior Editor Cathy Meeus
Copy Editor Emma Callery
Editorial Assistant Katie Preston
Designer and Picture Researcher Jeremy Austen
Photographers Jon Wyand, John Rutter
Picture Managers Sarah Risley, Rebecca Horsewood
Art Director Moira Clinch
Publishing Director Janet Slingsby

Text typeset in Great Britain by 212 Design,
Bournemouth.
Manufactured in Hong Kong by Regent Publishing
Services Ltd.
Printed in Hong Kong by Leefung Asco Printers Ltd.

Little, Brown and Company (UK) Ltd
165 Great Dover Street, London SE1 4YA

The author would like to extend his special thanks to all the
staff of The Perfect Design Company and, in particular,
Allison Smith for typing the manuscript; also to James
Moseley, Joanne Hawkins and other staff at the St Bride's
Printing Library, London, for their help and advice; Joe
Alderfer of The University of Chicago Press for co-ordinating
the submissions of work from the USA; Mike Daines and John
Clements at Signus, London for assisting with the desktop
typography illustrations.

With thanks to *Bookworm*, Manchester, who supplied the
majority of typefaces in this book with the following
exceptions:

The Berthold faces published in this book were provided and
are available from: *Ado Typesetting Ltd*, 11-13 Pollen Street,
London W1R 9PH.

Alphabet Typesetting, London EC2: American Uncial, Auriga,
Avenir, Bernhard Gothic, Calypso, Cancelleresca Bastarda,
Caslon 471 (italic and swashes only), Clarion, Comenius,
Deepdene, Erasmus, Fortune, Franklin Gothic (ATF), ITC
Franklin Gothic, Garamont, Gill Cameo, Grotesque 215 &
216, Hollandse Mediaeval, Jenson Old Style, Jersey,
Lavenham, Linotype Typewriter, Minister, Neon, Poppl
Pontifex, Poster Bodoni Black, Prisma, Seneca, Stempel
Schadow, Stempel Schneidler, Stratford, Trajanus.

APT Photoset Group Ltd, London SE17: Lutetia, Verona.

Berthold Typographic Communications Ltd, London SW14:
Imago.

Castle Printers London Ltd, London W1: Abadi, Albertina, Arial,
Baskerville 169 (Monotype), Bell (Monotype), Bitstream
Charter, Blado Italics, Calisto, Century Schoolbook, French
Round Face, Goudy (Monotype), Klang, Monotype Modern
No.7, Neo Didot, New Clarendon, Octavian, Poliphilus,
Scotch Roman, Times New Roman (Monotype), 20th Century
Monotype, Walbaum.

Graphic Unit, London EC1: Mole Foliate.

Linotype-Hell Ltd, Gloucester: Caslon No. 3 (Linotype).

Panache Graphics Ltd, London EC1: Foundry Old Style,
Foundry Sans.

PTPS Typesetters, Norwich: Centaur.

The Artstop Partnership, London EC1: Cremona.

The Brightside Partnership, London WC2: Arrighi Italics,
Goudy Text, Metrolite.

Trinity, London EC1: FF Meta, ITC Officina Sans, ITC
Officina Serif.

Typestyles London Ltd, Essex: Bodoni (Monotype), Bookman
(Linotype), Cheltenham, Garamond 156.

West End Studios, Eastbourne: Cheltenham, ITC Golden Type,
ITC Quay Sans, Palatino (Linotype).

Preface

Typography as a profession is in its infancy. Until the first quarter of the 20th century, typographic specification and design was often the domain of the type compositor (setter) or the printer. Perhaps the first all-round specialist typographer or typographic designer was Jan Tschichold, who emerged as a leading figure in the 1920s.

Today, all forms of communication and design involve the use of type to some degree, and a sound knowledge of typography and its relationship to other disciplines is therefore essential. For the purposes of this book, the term "typographer" means everyone who works with type – student, graphic designer, packaging designer, typesetter, copywriter, editorial staff, printer and so on.

To produce effective typography is not just a question of learning instant formulas or mimicking fashions in design. It is more concerned with attention to the finer detail and the development of a discerning typographic eye. Indeed, the margin of error between a successful or unsuccessful piece of typography can often be measured in points – such is the nature and delicate balance of typographic elements.

Such awareness is not only gained through a knowledge of type and how to use it, but also by an understanding of the rich typographic past. The combination of these three aspects provides the typographer with a stimulus of ideas, which can be synthesized to develop an individual and creative approach to typographic problem-solving. This book provides an introduction "course" to all these aspects.

The book is divided into three main sections – The story of typography, Directory of typefaces, and Working with type. The first section charts the development of writing, the alphabet and movable printing types right up to the present day, with reference to the key typographic watersheds (such as the invention of the first mechanical typesetting machines in the 1880s).

The following section, Directory of typefaces, is divided into seven type categories or groups – Humanist, Old Style, Transitional, Modern, slab serif and Display. Each category has an introduction that focuses on the main stylistic features of the type group, followed by some of the key typefaces, including alphabet specimens and sample text settings. The section ends with listings of other typefaces in the category and "inspirational" examples showing many of the types in action. This makes it much more than just a "typefinder".

Although the principal typeface group nomenclature has been adopted, the categorization of typefaces is not solely on a historical basis because each type group contains 20th–century designs which may have only some of the main characteristics or, in some cases, the "feel" of that particular historical type category. The selection of types in the display category is by necessity only a limited one.

The final section, Working with type, gives an introduction to measuring, structuring and choosing type, enlivening text, display typography, type and colour. A brief overview of desktop typography concludes the section.

Since the early 1950s, the pace of technological change in type manufacture and typesetting has been considerable, but the single most influential development has been the arrival of the computer, which has changed the typographic industry beyond all recognition. In turn, this has not only brought about a radical change in the skills and working procedures of the practising typographer today, but, through the widespread use of DTP systems, type is now accessible and usable by a new group of inexperienced typographers with little or no formal training in design. This book is intended to serve as a working manual for both these audiences because the maintenance of the highest standards of typography is critical, so that the many complex communication problems of today's fast-moving world can be solved creatively and with clarity.

However, although there have been such dramatic changes in technology and in the commercial marketplaces in which typographers work today, the basic platform from which good typographical design is built – namely an attention to detail and the development of a sensitive, highly trained typographical eye – remains the same as ever.

Christopher Perfect

Contents

* Roman (or equivalent), italic and bold setting have been illustrated for most typefaces. The omission of any of these styles indicates that the particular style or weight is not available in the version of the typeface shown.

Sumerian cuneiform 3000BC

Egyptian hieroglyph 2500BC

Phoenician 1500BC

Greek 500BC

Black letter 14th C

First printed type 1455

First printed roman 1470

Bembo 1495

The of

First italic 1501

Garamond 1530

Romain du Roi 1692

Caslon 1734

Baskerville 1750

Bodoni 1787

Franklin Gothic 1905

Goudy Old Style 1915

Futura 1927

Gill Sans 1928

Times New Roman 1932

Rockwell 1934

 Etruscan 400BC

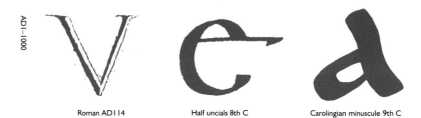 Roman AD114 Half uncials 8th C Carolingian minuscule 9th C

story

typography

 First sans serif 1816 Clarendon 1845 Display type 19th C Revival type 1890s Century 1895

Since 1951

Univers 1957 Helvetica 1958 Optima 1958 Frutiger 1976 Bitmap type 1980s Emigré 1990s

The story of typography

THE PROLOGUE TO the story of typography is the story of the development of the alphabet and handwriting. The first known written language was cuneiform. This and the later Egyptian scripts, and the Phoenician, Greek and Etruscan alphabets, were the inspiration for the Roman alphabet which we use today. Several different forms of handwriting were then developed such as the Roman square capitals, uncials and the Carolingian minuscule from which came the Gothic minuscule and humanistic writing, the models for the early movable types of the 15th century.

Written language was invented by the Sumerians who established the first advanced civilization in Southern Mesopotamia in 3500BC. They are credited with making the first "written" marks around 3150BC which were signs impressed upon clay tokens used for record keeping. These simple marks soon became more sophisticated and by 3000BC, the Sumerians had devised the earliest known writing system. This consisted of small, wedge-shaped marks which were impressed in soft wet clay tablets using a piece of reed. The tablets were then baked in furnaces or under the sun. This system of writing was later called cuneiform from the Latin "cuneus" meaning "wedge". Like other early writing systems, cuneiform was syllabic (non-alphabetic) and not phonetic (alphabetic). By their arrangement, the marks made pictograms (simple pictures or symbols) which could represent a syllable, a word or an idea.

The Sumerian culture had a great influence on other early civilizations, in particular those of the Babylonians and the Egyptians. The Egyptians probably borrowed the idea of pictograms from the Sumerians and developed their own writing system using hieroglyphics. Initially, the hieroglyphic script had some similarities to cuneiform but the Egyptians recognized the shortcomings of simple pictograms because they could not adequately convey more complex and sophisticated ideas. As a result, they created ideograms. These were made up of a number of signs or abstract drawings which, by an association of ideas, could represent the message being expressed. They also developed an enhanced written language involving the use of 24 signs, each of which represented a particular sound. This clearly indicates that they had made the connection between the written and spoken word. The seed for a fully-fledged phonetic alphabet had been sown.

In 2500BC, the Egyptians made an even greater contribution to the development of handwriting – the invention of the reed pen and papyrus (which came from the papyrus plant) as a writing surface. These new writing tools were to be a dynamic force because they made the art of writing more accessible to a much wider audience. Throughout the history of handwriting and typography, the development of new image-making tools and surfaces have been responsible for corresponding changes in letterforms. The reed pen and papyrus enabled people to write faster and, consequently, a new, simpler Egyptian script based on hieroglyphics developed, called hieratic.

The first alphabets

There are many theories as to the origins of the alphabet but, whichever one is true, its invention was a landmark of great magnitude in the development of civilization. An alphabet is a writing system with one unique visual sign (letter) for each consonant and vowel sound (although there were no vowels in the earliest alphabets) which can be combined to form visual units (words) to represent a spoken language. From about 1500BC, the alphabet has outperformed all other systems of writing and has survived intact through many tumultuous chapters in the history of the Western world.

If the origins of the alphabet are unknown, what is clear is that in 1500BC, a Semitic people, the Phoenicians developed a new phonetic written language – the first alphabetic system. It consisted of a sign for each of 22 consonant sounds and showed some visual similarity to the Egyptian hieratic script. Significantly, though, the Phoenician writing system did not use any pictograms which made the new language much more economical.

The Phoenicians used their location on the eastern Mediterranean coast to exploit sea travel as a means of exporting their goods to other countries in the region. Through the cultivation of these business relationships, their trading partners were gradually exposed to their alphabetic system of writing and, by 800BC, its influence had permeated westwards to Greece.

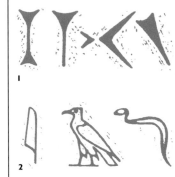

1 The first "writing" system, cuneiform (3150 BC), consisted of a series of wedge-shaped marks which were made by the cut tip of a reed impressed into clay tablets.

2 The ancestor of the graphic symbols and signs that we use today is early picture writing (3rd century BC), of which Egyptian hieroglyphs (shown here) are the best known.

3 These four signs from the Phoenician alphabet (1500 BC), which is regarded as the first phonetic alphabet, are identifiable as the origins of the letters 'k', 'l', 'm' and 'n'.

4 The influence of the Phoenician alphabet on the early Greek alphabet is evident when the same four Greek letters are compared with those above.

In Greece at this time there were many local dialects and alphabets in use. But eventually, two principal alphabets emerged – the Ionian, in the east of the country, and the Chalcidian, in the west. There were many similarities between the Phoenician and early Greek alphabets – the order and names of the letters were the same as was the direction of the writing which was from right to left (or sometimes alternating). From about 500BC, the direction of writing was reversed so that it read from left to right. In 403BC, the Ionian alphabet was officially adopted in Athens as the Classical Greek alphabet. However, it was the Chalcidian, which had been most influenced by the Phoenicians, that was to play a more significant role in the development of the Roman alphabet. It was to become the model for all the succeeding alphabets of Western Europe.

Around 675BC, trade developed between the Greeks and the Etruscans, a people who had settled on the west coast of Italy after migrating from their homeland in Asia Minor. It was through this trading relationship that the influence of the western Greek Chalcidian alphabet spread to Italy and it is believed that it was from the Chalcidian that the Etruscan alphabet derived.

The Etruscans remained dominant in Italy for about 250 years, reaching the height of their power about 500BC. Some one hundred years later their conquests were lost to the rising power of Rome. The legacy that the Etruscans left to the Romans was considerable. It is to them that the Romans owed their architecture, law, roads and other trappings of a civilized society. The Etruscan alphabet was the basis for the Roman alphabet which we use today. After modification – the Romans changed some letters, added new ones and deleted others – they were left with an alphabet of 23 letters which is the same as the Roman alphabet used today (but excluding J, U and W which were added in the Middle Ages).

The development of the Roman alphabet

From about 500BC, the Romans began to expand their Empire through invasion and colonization and imposed their written alphabet on the conquered nations in the process. The effect was that the letters of the Roman alphabet became an established set of signs which were understood in many parts of Europe and Asia Minor – an "international" written language.

In the Roman Empire, two main kinds of letterforms were widely used – square capital letters (called majuscules) for formal inscriptions and, later, a cursive style (which sloped like italics) for informal purposes such as letter writing. This cursive style is the origin of our lower case letters (called minuscules). The finest example of formal Roman inscriptional square capitals, also called quadrata, is Trajan's Column in Rome, completed in AD114. These authoritative and beautifully proportioned letterforms were constructed from geometric shapes such as the square, circle or triangle and were the mould for the capital letters of our alphabet today. At first, the stone-carved strokes of the letters were of even thickness, but later the width of strokes varied in imitation of the natural effect of a square-tipped brush which the stone masons used to draw out the letters on the stone prior to cutting. The difficulty of cutting curves with a chisel meant that many of the letters were simply constructed of straight lines. The varying width of the letters is believed to relate to their gradual evolvement over the centuries from pictograms and phonetic signs of a corresponding width. Serifs developed naturally as finishing strokes to visually strengthen the terminals of the letters.

By the first century AD, a simpler and more condensed written style of inscriptional square capitals, called rustic, had developed – an example of which is the graffiti found on the walls at Pompeii. This was a direct response to the needs of an increasingly literate Roman population to write with a pen or brush more quickly and economically (to save on vellum which was their writing surface). Rustic writing required fewer lifts of the pen and the vertical strokes of the letters were thinner than the earlier square capitals as the pen was held at a sharper angle. Likewise, the pen-formed serifs were heavier than the stone-carved ones which they imitated. There were no spaces between the words and often little between the lines, producing a heavy effect on the page.

In the fourth century AD, a further variation of the inscriptional square capitals called uncials was developed which was mainly used as book scripts. Uncials were distinctively round and simpler, and had more contrasting widths of letter strokes which were the natural result of an even faster writing speed made possible by the invention of a flat quill pen on a smooth paper-like surface. By the sixth century AD, half uncials were in widespread use. This handwriting is characterized by ligatures (letters joined together with a linking stroke) and the extension of the vertical strokes of letters such as 'b', 'd' and 'p' so creating the first ascenders and descenders. This was an important development because it gave these letters more distinctive shapes which helped in the recognition of words. The ascenders and descenders automatically increased the space between the lines which helped readability and created a lighter colour on the page. These letterforms can

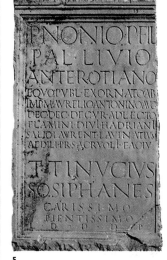

5

6

5 The earliest form of the Roman alphabet was the inscriptional square capitals (1st century AD) shown here. The letters comprise mainly straight lines, because curves were difficult to render with a chisel. The finishing strokes to the terminals are what we now call serifs.

6 Half uncials, a book script written with a flat quill pen, are used in this 8th-century *Book of Kells*. The beginnings of lower case letters can be seen in the extension of the vertical strokes of letters such as 'b', 'd' and 'p', to make the first ascenders and descenders.

be regarded as the beginnings of a lower case alphabet. One of the finest examples of this style is the *Book of Kells*, a Celtic manuscript with decorations and initial letters, produced by Irish monks in the eighth century AD.

As a consequence of the decline of the Roman Empire, many national scripts had emerged in Europe by AD700. But, in 800, a new style of writing called the Carolingian minuscule was commissioned by Emperor Charlemagne (742–814) for his official documents which were produced at his scriptorium at Tours under the supervision of Alcuin of York. It was introduced at a time when the Emperor and the Christian Church had instigated an extensive programme of education and culture – the Carolingian Renaissance. The Carolingian minuscule was an open, rounded and upright style with more contrast in the width of the letter strokes and a strong oblique (diagonal), calligraphic stress created by the angle at which the quill pen was held. It had been influenced by the Anglo-Irish half uncials and the Frankish script known as Merovingian, and it was highly legible as each letter had a distinctive shape and there was now even more space between the words and the lines. The Carolingian minuscule remained the dominant style of handwriting in Europe until the emergence of a second wave of national scripts in Europe during the 12th century of which the German Gothic minuscule, or black letter, was to be the most significant in the development of movable types.

The early movable types

The first movable types, invented in Germany by Johann Gutenberg (c1397–1468) in 1455, and the roman types in Italy that followed, imitated the styles of handwriting that were popular in those countries at the time. These were the black letter in Germany and humanistic writing (a revival of the Carolingian minuscule) in Italy.

The black letter emerged as a national script in Germany in the 12th century after the decline in popularity of the Carolingian minuscule. The early forms were austere, heavy and condensed with a strong vertical emphasis. By the 13th century, they had become even more condensed with the vertical strokes ending in points. Slowly, the ascenders and descenders became shorter and the style became less and less legible. It was one of the later styles, Textura – a formal black letter used for religious and legal purposes – that was the model for Gutenberg's first movable types.

Although it is now known that the Chinese were experimenting with movable ceramic types as early as the 11th century, Johann Gutenberg is the acknowledged father of

1

1 The rich effect created by the lavishly decorated border, initial letters and illustration is overpowering in this early 16th-century Italian humanistic manuscript. However, the letterforms are open and legible, in stark contrast to the black letter shown in the example on the right.

2

movable type. He lived at Mainz in Germany and by trade he was a goldsmith, but he had acquired technical knowledge of the art of printing (prints had been made from hand-cut wood blocks many years earlier). In 1440, he began a series of experiments which, ten years later, resulted in the invention of printing from movable type. He used his knowledge of existing technology and materials – the screw press, oil-based inks and paper (which was a Chinese invention) – but it was the manufacture of type that consumed his energy.

As a goldsmith he had considerable skill and knowledge of the patterning, mixing and casting of metal and, with great ingenuity and tenacity, he eventually developed a method of manufacturing type. It involved the engraving of every character in relief and reverse on a steel punch which was then struck with a mallet into the strike (a bar of copper). The strike was set into the matrix (a master mould for casting each letter) by a process called justification. Then the matrix was put into an adjustable hand mould into which a hot alloy metal of lead and antimony was poured thereby casting each sort (the term for a single piece of type).

The process of hot metal casting gave rise to the term

3

2 & 3 The condensed, angular and austere qualities of the black letter can be seen in the first movable types, used for the 42-line Bible printed by Gutenberg in 1455. While the type has a great impact on the page, it is virtually illegible. The hand coloured initial letters and borders, which were added later, provide some visual relief.

"hot metal typesetting" when referring to setting from metal types. It was a significant technological feat which was the catalyst for a revolution in printing in Europe. The basic principles which Gutenberg employed for type manufacturing and letterpress printing were still used until well into the 20th century. Letterpress printing is a process whereby the impression on the paper is taken from the raised surface of the type.

The visible fruits of his labours finally emerged in the printing and publishing of his 42-line Bible in 1455, the earliest extant printed book from movable types in the Western world. He had, however, printed the *Mainz Indulgencies* during the previous year for which he used a more cursive style of black letter type called Schwabacher or Bastarda. Gutenberg's use of the Textura black letter type produced a magnificent and authoritative effect on the page, quite equalling the manuscripts that it was imitating. But it was condensed, monotonous and heavy-looking and, therefore, difficult to read. For his *Cathlicon*, in 1460, he used a different black letter type, Rotunda, which was more open and legible but lacked the style and authority of his Textura.

There was a human cost to pay for Gutenberg's invention – the job losses of the scribes and copyists who had been the "printers" of manuscripts until this time.

The Humanist (or Venetian) types

The early roman types which appeared in Italy in the 1460s and 1470s were based on humanistic handwriting, a revival of the Carolingian minuscule, and as a group are known as the Humanist or Venetian typefaces. The renewed interest in the Carolingian minuscule had brought about a refinement of its design – the additions of serifs to the lower case letters created better harmony with the serifed capitals and produced a stronger horizontal flow to aid readability. The end result was the final blueprint for the first roman types.

After 1460, the leadership in the development of movable type moved from Germany to Italy, the artistic centre of the Rennaissance. In 1465, at Subiaco near Rome, Conrad Sweynheym (*d*1477) and Arnold Pannartz (*d*1476), two Germans who had moved to Italy and who had been influenced by Gutenberg's work, produced a curious hybrid type which possessed a mixture of black letter and roman features. In 1467, they moved to Rome and, by 1470, Sweynheym and Pannartz had produced a new set of types which were much lighter and more open and entirely based on humanistic handwriting. It is from these types that the term "roman" was derived.

Meanwhile, in 1469 in Venice, two German brothers, John and Wendelin da Spira, cut a roman type which was rounder and more even, the letter spacing was better and was generally superior to that of Sweynheym and Pannartz. But in 1470, Nicholas Jenson (1420–80), a French typecutter and printer who lived in Venice, produced a type that surpassed all the earlier roman types cut in Italy. Jenson went on to produce a second type six years later (the same year as William Caxton printed the first book in English from movable type), known as the white letter roman, and used for the printing of *Nonius Peripatetica*. This type had a slight contrast between thick and thin strokes, the serifs were heavy and steeply sloped, the lower case 'e' had a sloping horizontal bar, the letters had an oblique stress and the ascenders had oblique serifs. The first line of a paragraph was indicated by its extension into the left-hand margin, large initial letters were used at the beginning of sections and the type was justified (the lines were set to the same length). The fine proportions of Jenson's types have been an inspiration for type designers ever since.

Although the predominant typographic style in Italy was roman, it was not exclusively so. Even Jenson still continued to produce books using the black letter, as did others. In 1483, a Venetian printer called Erhard Ratdolt who, like the da Spira brothers, had migrated from Germany, printed *Eusebius*, in which, unusually, he used

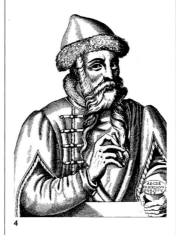

The true Effigies of Iohn Guttenberg *Delineated from the Original Painting at Mentz in Germanie.*

4

4 Johann Gutenberg (1397–1468), the father of movable type. By trade a gold-smith, he was knowledgeable in the casting of metal – essential training for typefounding.

5 This extract from Sweynheym and Pannartz's 1470 type is a poor cutting with bad letter fit and alignment, but it firmly established the Humanist type style.

non uidit illud fatiuf effe illum in infamia relinqui: ac fordibuf: q̃ infirmo iudicio cómitti. fed ductuf odio properauit rem deducere in iudicium. cum illum plumbeo gladio iugulatú iri tamé diceret. fed iudicium fi querif quale fuerit: incredibili exitu: ficuti nunc ex euentu ab aliif a me tamen ex ipfo initio confilium Hortenfii re/ prebendatur. Nam ut reiectio facta eft clamoribuf maximif: cú accufator tanq̃ cenfor bonuf hominef neqffimof reiiceret: reuf tã q̃ demenf lanifta frugaliffimú qnq; fecerneret. ut primú cófederút: ualde diffidere boni ceperunt. non enim unq̃m turpior in ludo talario conceffuf fuit. maculofi fenatoref. nudi equitef. tribuni nó tam erati: q̃ ut appellantur: erari. pauci tamé boni inerant. quof reiectione ille effugare non poterat: qui mefti inter fui diffimilef & merentef fedebant. et contagione turpitudinif ueheméter pmo/ uebant. hic ut queq; ref ad cófiliú primif poftulatóibuf referebat: incredibilif erat feueritaf: nulla uarietate fentétiaq̃. nihil ípetrarat reuf. pluf accufatori dabatur: q̃ poftulabat. triumphabat. Quid querif? Hortenfiuf: fe uidiffe tantum. Nemo erat qui illum reú ac non milief condemnatum arbitraretur. me uero tefte producto

5

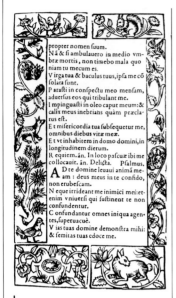

1 This page from a 16th-century French psalm is set in Garamond, the jewel in the Old Style crown.

2 & 3 The developing skill of the early punchcutters can be seen in the difference between the crude cutting of the Aldine italic (1501) and the more controlled italic of Antonio Blado (1539) which also has italicized capital letters.

the black letter and the roman types side by side. The two styles were in such a stark cultural and visual contrast that it was an unhappy marriage.

Old Style – Italy

In 1490, Aldus Manutius (1450–1515), a Greek and Latin scholar, moved to Venice to set up a publishing business, the Aldine Press. Five years later he produced a book in which he used a new style of roman type with capitals that were shorter than the ascenders of the lower case letters. In the same year he published *De Aetna* by Cardinal Pietro Bembo, in which he unveiled a new lower case, cut by Francesco Griffo (*d*1519), which harmonized with the new style of capitals.

Griffo, like Guttenberg a former goldsmith, was a highly skilled punchcutter who created all the types for the Aldine Press. His *De Aetna* types were characterized by an oblique stress, a greater contrast between the thick and thin strokes, lighter, bracketed serifs and a horizontal crossbar on the lower case 'e'. The end result was a finely cut, more open and highly legible type, which showed Griffo's understanding of the affect on type of the printing process (the letters tended to thicken up because of ink squash). It was also a deliberate movement away from the previous slavish mimicry of humanistic handwriting. It was the beginning of a new style, called, somewhat confusingly, Old Style.

Aldus Manutius produced books of the highest quality

such as *Hypnerotomachia Poliphili*, published in 1499, which is regarded as one of the most accomplished book productions of the Italian Renaissance. He was innovative both with his typographical layouts (setting blocks of text to irregular shapes) and in his combination of text with woodcut illustrations. Through the distribution of his books to all parts of Europe, his roman types enjoyed a wide exposure and this was the reason why they were so influential: they were the model for all the Old Style types produced in the 16th and 17th centuries in France, the Netherlands and England.

In 1501, Aldus Manutius published a series of pocket-size editions of the classics and, in order to compress the text into the small format, Griffo cut a condensed, sloping type, but the capital letters remained upright with the lines unjustified (where the right hand margin is not aligned) which imitated humanistic cursive handwriting. This was the first italic type (a term derived from "Italy", its birthplace). Although his type had many ligatures and was difficult to read with comfort, it became popular throughout Europe in the first half of the 16th century, a period which is known as the age of italic types.

However, it was another italic which has been the inspiration for many of the italic fonts in use today. In 1523, Ludovico Arrighi (*d*1527), a calligrapher and writer, designed an italic type, superior to that of Griffo, for *Coryciana*, a collection of poems by Blodius Paladius. Arrighi's type had fewer ligatures, long ascenders and descenders and larger capital letters.

Old Style – France

From about 1530 until 1585, the new ideas in typographic design and typefounding came from France. This was the era known as the Golden Age of French typography, a period when magnificent hand-decorated printed books were produced. The leading French printers, such as Robert Estienne, Simon de Colines (*d*1546) and Geofroy Tory (1480–1533), had all been influenced by the books and the development of the roman types in Italy. So had the French punchcutters, including a young punchcutter by the name of Claude Garamond (1480–1561) who had been apprenticed to Antoine Augereau.

In 1530, Garamond cut a series of new roman and italic types for Robert Estienne, a printer in Paris. The design for his roman typeface had been based on the *De Aetna* types of Aldus Manutius and that of his italic on Arrighi's type. However, Garamond's types were lighter in colour and had a new vitality, elegance and more even letter fit. They were a huge success – so much so that his work

came to the attention of the King who commissioned him to design a Greek font, the Grec du Roi. Garamond continued to refine his type designs during the 1540s and they were to set the standard for the next century.

Until the mid-16th century, a printer had to employ both a punchcutter and a typecaster (although they could be the same person), buy-in the metal and manufacture all his type on the premises. The punchcutters were highly skilled craftsmen who were in short supply and, consequently, many printers had difficulty in producing sufficient quantities of type. In the late 16th century, though, typefounding (the manufacturing of type) became a separate trade from printing. "Type shops" were established which had stocks of punches, matrices and typecasting equipment and from whom printers could buy their type.

The punchcutters were independent spirits who remained in great demand and who usually worked for a number of different clients as did Garamond himself and Robert Granjon (1513–89). Granjon cut his first type in 1545 and although he produced roman types, it was italic designs on which his reputation was built – such as Civilité (1557) and his cutting of Garamond italics (which has been the model for many 20th-century revivals of Garamond). In about 1565, he cut types for Christopher Plantin (1514–89), a scholar-printer, based in Antwerp, for whom he continued to work until 1578 when he moved to the Vatican Press in Rome.

Old Style – Netherlands

Towards the end of the 16th century, the Golden Age of French typography was at an end and the Netherlands became the focal point for new developments in typographic design. The decline of book production in France had been caused through the censorship of the press by the French government and Church. This brought about an exodus of French printers to the Netherlands, including Christopher Plantin who ran one of the largest and influential printing houses in Europe. Plantin and other Dutch printing houses, such as Elzevir, flourished during the 17th century.

At first, many printers in the Netherlands imported the punches and matrices of Garamond and Granjon from France. But by the mid-17th century, a number of highly skilled "freelance" Dutch punchcutters had emerged such as Dirk Voskens (d1669) and Cristoffel van Dijck (1601–72) – who was the best punchcutter of the period and cut some very fine types. A Dutch Old Style gradually developed which was characterized by sharply cut letters, greater contrast between the thick and thin strokes, a larger 'x'-height (height of lower case letters) and a narrower set (width) to the lower case.

Old Style – England

Typefounding in England was strictly controlled by the government until 1637 (through the restrictions on printing by the Star Chamber who wanted to limit competition in the trade) and, therefore, printers had to import their types from abroad, mostly from the Netherlands. The influence of Dutch Old Style types in England is typified by the story of Dr John Fell (1625–86), the Bishop of Oxford and Vice Chancellor of Oxford University. He brought back a collection of types, punches and matrices from the Netherlands around 1670 for use at the Oxford University Press, which he managed. In 1676, he set up a

4 An extract from the first specimen sheet showing the English Old Style types of William Caslon (1734). At this time, type sizes were still referred to by names such as "Double Pica" as here.

5 A sample of the Fell types of Dr John Fell, the Bishop of Oxford, which were greatly influenced by Dutch Old Style designs. Notice the curled foot of the lower case 'h' and the extended leg of the 'k'. "1689" is also an example of non-aligning or Old Style figures.

4

5

typefoundry at the Press and employed a Dutch punch-cutter named Peter Walpergen, to cut the types now known as the Fell Types (1693).

The Old Style in England only really established itself in the early years of the 18th century, when a group of printers commissioned a young English engraver, William Caslon (1692–1766), to cut a new type. The type, which had a strong Dutch influence but more vertical emphasis and contrast, was issued in 1734. It was an immediate success with English printers, both on its merits as a type design and because it meant that they would no longer have to import their types from abroad.

Caslon's types remained popular in England until the early 19th century despite some later competition from the new designs of John Baskerville. Through the expansion of the British Empire, Caslon's types were soon in widespread use in the British colonies, including America. First introduced by Aldus Manutius in Italy in 1495, Caslon's type was the final expression of Old Style.

Transitional typefaces

In the last decade of the 17th century, after over 200 years in which the Old Style design had prevailed in Europe, a wind of change began to blow in France. In 1692, Philippe Grandjean (1666–1714), a French typecutter, was commissioned to produce a new Royal roman type, the Romain du Roi, for the Imprimerie Royale in France. For the first time, the design of each letter had been based precisely on a square and its outline mathematically plotted on a grid in order to achieve a precise cutting.

The type, completed in 1702, was sharply cut and had a combination of new features – flat unbracketed serifs, a narrower set, good contrast in the width of the thick and thin strokes of the letters, and the stress more vertically inclined. The impact of its design, the first in a new style called Transitional, would soon be felt in typefoundries throughout Europe. The term Transitional was adopted because it was between Old Style and Modern in design.

Some years later, two French punchcutters, Pierre Fournier (1712–68) and J F Fleischman (1730–68), both cut roman types which were very similar to the Romain du Roi, despite the fact that the design of the Royal roman was supposed to be exclusive to the Imprimerie Royale. In 1737, Fournier made a further and more significant contribution to typography with the invention of the European point system as a means of measuring type. Although revised at a later date, his system is still in use in Continental Europe today.

Shortly after this development, John Baskerville

(1707–75) made England's first original contribution to the design of roman types. In 1750, Baskerville, a letter-cutter and japanner, set up a press in Birmingham for the production of fine books. In 1757, he published his first book, *The Georgics of Virgil*, and the following year, his second – a two-volume edition of Milton. The design of these books represented a new typographic manifesto. The types, which were cut by John Handy, were rounded, well-proportioned, light in colour, had good contrast between the thick and thin letter strokes and the stress was almost vertical. Baskerville's radical approach to typographic design – generous letterspacing, leading and margins – brought a new simplicity and openness to the printed page. For the first time, type was centre-stage and not playing a supporting role to illustration and lavish ornament in book design.

In his obsession to achieve perfection in book production, Baskerville was responsible for the upgrading of printing inks, a new process of wove papermaking and the invention of the smoothing press (which made the paper smoother and whiter). Despite these innovations and the merits of his type designs, Baskerville's business was not a commercial success. Printers, who were already well-stocked with Caslon's types, did not feel inclined to buy his types and the book trade regarded his publications as too expensive. But, perhaps the main reason for his failure was simply that his ideas were new and ahead of their time in England. Ironically, his type designs greatly influenced typefoundries in Europe. Indeed, Baskerville's types were not fully appreciated until the early 20th century when Bruce Rogers (1870–1957), the American book and type designer, rediscovered them.

Late transitional style in England

In 1790, William Bulmer (1757–1830), a printer who did much to raise the standards of printing in England, was commissioned to produce an edition of Shakespeare. For this work he ordered a new roman type to be cut by William Martin (d1815) whose brother had been an apprentice to Baskerville. It was a Transitional-Modern hybrid design called Bulmer and was greatly influenced

1 The above illustration shows the first Transitional type, the Romain du Roi, commissioned in 1692 for the Imprimerie Royale in France. It represents a watershed in type design since it is the first type to be mathematically constructed on a square grid in order to achieve a finer and more precise cutting. The serifs are evenly cut, as are the curves. The whole design is a product of the development and perfecting of the art of type founding and the availability of smoother, better quality paper on which to print.

by both Baskerville's types and the new Modern-style types of Firmin Didot (1730–1804) and Giambattista Bodoni (1740–1813) which were emerging in Europe. Martin's type was characterized by its sharpness and almost pointed serifs, and was more condensed than Baskerville's types had been.

At about the same time, John Bell (1746–1831), an English publisher, employed an engraver called Richard Austin, to cut a new roman type. It was based on Old Style models but had more contrast between the thick and thin letter strokes, a vertical emphasis and finer serifs – features which give it the colour and texture of a Modern-style typeface.

Unfortunately for Bell, his typeface appeared on the scene at the same time as the arrival of the typefaces of Didot and Bodoni and was completely overshadowed by them. However, in the early 20th century, Bell's type found new admirers in Bruce Rogers and American master-printer Daniel Updike in the United States and Stanley Morison (1889–1967) in England. It was Morison who was instrumental in the revival of Bell's type by the Monotype Corporation in 1931. In 1809, Austin also cut a type for William Miller, an Edinburgh typefounder, that would be the model for a well-known Modern-style typeface, Scotch Roman, issued by Monotype in 1920.

The Modern typefaces

Although Baskerville's radical new designs had fallen on stony ground in England, they had an inspirational effect on European typefounders. For the first time, England was dictating the pace in type design to mainland Europe. Firmin Didot, a Frenchman, was a printer to the King, Louis XVI, and the King's brother. His first type, cut in 1784, was based on Fournier's type of 1750 (which was very similar to the Romain du Roi cut by Grandjean) but, undoubtedly, he was also influenced by Baskerville's types. Didot's type was characterized by an abrupt contrast between the strokes of thick and thin letters, vertical stress and hairline, straight unbracketed serifs. It can be regarded as the first in a new style called Modern. Technology and new materials played their part in the creation of Modern types. The invention of the engraving tool enabled delicate letterforms to be cut and the manufacture of smoother paper made it possible to reproduce them successfully.

In 1768, in Italy, Giambattista Bodoni, who had learned the art of printing from his father, became Director of the Duke of Parma's Printing Office, the Stamperia Reale. Bodoni, who had also been impressed with Baskerville's

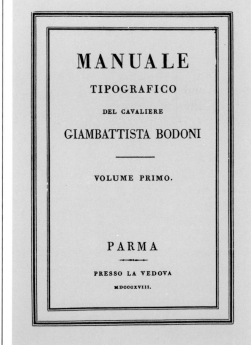

2 Pierre Fournier's table of type sizes (1742). Fournier was responsible for the invention of the first standardized form of typographic measurement in 1737 – the point system – which although amended in 1785, is still in use in mainland Europe today.

3 The title page of the *Manuale Tipografico* (1818), the type specimen book of Giambattista Bodoni. The abrupt contrast in the width of the letterstrokes is mirrored by the contrasting weights of the bolder rules.

4 A page from John Baskerville's *Virgil* (1754) which is set in his own types. The roundness of the letters and the long ascenders and descenders demand generous letterspacing and leading. Variety and interest is achieved by changes in the type size and case as well as the use of italics for emphasis.

types, was working on the same typographic canvas as Didot. Like those of Didot, his first types were closely based on Fournier's types, but he later cut an original design characterized by a very abrupt contrast between the thick and thin strokes, a strong vertical emphasis and fine bracketed serifs. It was a grand and striking design that can be seen as the ultimate expression of the Modern style.

The design criteria for Bodoni's types was that first and foremost they should be beautiful and impressive images in their own right – products in the grand style of the neo-classical age. Fine as they were, his types nevertheless had poor legibility for continuous reading because they looked weak on the page and their strong vertical emphasis interrupted the natural horizontal movements of the eye. The even, mechanically-formed modern types lacked the legibility of the more distinct, calligraphically-based letterforms of Old Style types. To compensate for this poor legibility, Bodoni was later often set with loose letter and narrow spacing but this trend only led to even uglier typographical effects.

However, Bodoni's types soon became very popular throughout Europe and the United States, both as text and display faces, and were revived by many typefounders in the 20th century. Bodoni's own *Manuale Tipografico* is regarded as one of the best type specimen books ever printed. Other influential types of the time include those by Justus Walbaum (1768–1839) and Joaquin Ibarra. In 1800, Walbaum cut a notable copy of Bodoni's types which has been the subject of many revivals by typefounders in the 20th century. The Spaniard Ibarra, a fine printer of Bodoni's time, was famous for books such as *Sallust* (1772) and *Don Quixote* (1780) in which he successfully combined finely engraved illustrations with elegant typography.

The Industrial Revolution

Until the start of the 19th century, the work of typefounders and printers in Britain had been orientated towards the production of books. The Industrial Revolution, however, turned their craft-based activities into a dogfight for commercial survival. No longer were typefounders judged by the excellence of their roman types or printers by the quality of their paper and printing; the demands of their new entrepreneurial clientele was for novelty, impact and speed. Typography became a powerful weapon in the battle for commercial success.

In addition, the 19th century saw a host of major technological advances – the invention of steam and oil power,

electricity, the telephone, the phonograph and photography – which brought about the mechanization of many industrial processes and manufacturing. In the printing and typesetting industries, the new technologies and the demands of the marketplace led to the automation of printing processes, papermaking and, later, typesetting. This mechnization improved speed at the expense of quality. As the 19th century progressed, the typographic and printing skills which had been developed over 400 years were soon forgotten.

Manufacturers, needing to promote their products to a wider and more affluent market, triggered a wave of new kinds of promotional printed matter such as posters, periodicals, brochures, leaflets and advertisements, all referred to as jobbing work. At the same time, the need to spread news and information led to the expansion of the newspaper industry through the establishment of the popular press. As a result, typefounders entered into a competitive race to satisfy the unquenchable thirst of their commercial customers for new types that could shout their advertising slogans from the rooftops. A new genre of typefaces emerged, called display.

At first, printers tried to meet the demands of their new customers by using existing stocks of text types. But they were too limited in terms of size and impact and so printers turned to typefounders to produce bigger, bolder and more flamboyant typefaces. Inspiration was sought from vernacular letterforms rather than the traditional calligraphic models, and typefounders responded with a flood of new styles such as fat face, square serif (Egyptian or slab serif), decorative and sans serif. In some cases, these were available in a variety of different forms: three dimensional, shaded, outline, inline, condensed, expanded and many more. From this moment onwards type became a follower of fashion.

In this climate, interest in the design of text faces was put firmly on the back burner. There were, of course, a

1

1 Although the 19th century was the great age of decorated types, they had attracted the attention of several well-known mid 18th century typecutters. J. F. Rosart's Dutch Enschedé Foundry produced this inline serif type specimen in 1757.

2 This fat face type shows poor legibility and a high level of crudity. Additional weight has been added to the thick letterstrokes, and the weight of the thin strokes and serifs has been reduced. The effect is to create small, ugly counter shapes (such as the bowls of the lower case 'h' and 'd') which visually "fill in".

EIGHT LINES PICA ROMAN.

BRIDGE
ashford.

2

few exceptions, such as the work of the English printers Charles Pickering and Charles Whittingham who revived 16th- and 17th-century book types for use in their high quality editions. Furthermore, when typefounders had come to terms with the new demands of their customers, they realized that the manufacture of display types was more lucrative than text types had been. The ensuing clamour for business led to fierce rivalry and plagiarism of typeface designs between typefounders, even to the extent of putting some of them out of business. The standards in type design were sacrificed in the stampede to bring a never-ending flow of new display types on to the market.

Fat faces

In the early years of the 19th century, the most popular and widely accepted type forms were Moderns such as Bodoni and these were the models for the first display types. By fattening the thick letter strokes, reducing the weight of the serifs and cutting them in larger sizes, typefounders in England such as Thomas Cottrell, pressed them into service as display types. For obvious reasons, these became known as fat faces. The first fat face was designed in about 1800, by Robert Thorne (1754–1820), an apprentice of Thomas Cottrell. Outline, three-dimensional and italic variations appeared shortly afterwards. For most forms of jobbing work, it became common practice to use numerous different faces, sizes, weights and widths of type all jumbled up together in a symmetrical (centred) layout. Typographic overkill was the trademark of 19th-century printed matter. The popularity of fat faces waned after about 1850 but interest in them returned in the early part of the 20th century. These types were clumsy and difficult to read but noticeability was the criterion by which they were judged.

Square serif types

Shortly after the advent of fat faces, a second and more significant new type design emerged – square serif, or Egyptian, or – as they are known today – slab serif. This style first appeared in 1817 in a specimen book of the typefounder, Vincent Figgins. To confuse matters, they were referred to as Antiques. Robert Thorne also designed several square serif types, which he called Egyptians, probably because of the popular interest in the archaeological studies in Egypt at this time. In the same year, they appeared in the specimen book of his successor at the Fann Street Foundry, William Thorowgood (d1877).

Unusually, these types had unbracketed serifs which were of the same thickness as the stem of the letter giving them a monotone and mechanical look that exemplified the spirit of the new industrial age. Although initially only available in capitals, they had more impact than fat faces and soon became popular in England, Europe and the United States. In 1825, the first square serif type with a lower case was issued by the Caslon Foundry, but the result was visually poor.

In 1845, a new square serif, called Clarendon, designed by Robert Besley, was issued by William Thorowgood as a bold text type for use with roman type. It had bracketed serifs, some contrast in the letter strokes and a narrower set. Clarendon has proved its durability as both a text and display typeface for printing on poor quality papers (such as newsprint). Square serif faces remained popular until the last quarter of the 19th century, and enjoyed revivals in the 1930s and 1950s.

Sans serif

An important landmark in the history of type design occurred in 1816 when the Caslon factory issued a monoline (all of the strokes are of the same thickness) design without serifs – the first sans serif type, or gothic, as they are known in the United States. This type, which was a crude cutting, received a muted response from the trade but this was probably because it appeared at a time when fat faces and square serif types were taking the type market by storm.

3 An Egyptian or square serif, often used as an effective display type in advertisement and other forms of jobbing work thrown up by the Industrial Revolution. The heavy, mechanical-looking and monoline design works well for the capital letters, but the lower case is uneven, with poor legibility. In particular, the lower case 'g' and 'a' do not match the weight of the other letters.

4 The Industrial Revolution brought about the birth of a new type style – sans serif (a type without serifs). This early 19th-century example is a poor cutting, especially the 'S', 'N' and 'G'. The coarseness of this design can be attributed to the general decline in type quality caused by pressure on the design departments of foundries to produce an endless supply of new display types.

EIGHT LINE EGYPTIAN CONDENSED.

CELEBRATED
Birmingham

TWO-LINE GREAT PRIMER SANS-SERIF.

TO BE SOLD BY AUCTION, WITHOUT RESERVE; HOUSEHOLD FURNITURE, PLATE, GLASS, AND OTHER EFFECTS. VINCENT FIGGINS.

However, by the 1830s, many English typefoundries were showing sans serif types in their specimen books and William Thorowgood was the first to produce a sans serif type with a lower case – a type which he referred to as Grotesque, a term still used to describe the style of the sans serif types designed in the 19th century.

By 1850, the flexible design concept of sans serif types was exploited to produce many different weights and variations. These were in widespread use as display types in both Europe and the United States but, it was not until the 1870s that they became popular in England. The simplicity and flexibility of the sans serif design led to the development of families of sans serif types, which doubled up as both text and display faces, but this idea did not take off until the 20th century.

Decorative

The handwritten manuscripts that pre-date the invention of movable type are the original source of many decorative typefaces. The Union Pearl, an italic face cut in 1690, is the earliest-known decorative type. However, it was not until the mid-18th century that they started to become popular when Fournier, the French typecutter, produced some ornamental types. His lead was soon followed by other foundries, including those in England who produced inline and outline versions of many classic roman types.

In the first half of the 19th century, the English typefoundries were the pacesetters in decorative types and an abundance of imaginative designs flowed from the drawing boards of their design departments – inline, outline, three-dimensional, Tuscans, reversed, condensed, expanded, distorted, shaded, floriated, ornamental, rounded – and more! Typefounders also used pen script forms as a source of inspiration for their display types and even black letter types were emboldened and issued as makeshift fat faces. In the second half of the 19th century, the leadership in design passed to the United States but, due to the increasing pressure to maintain a constant flow of new fanciful faces, the quality of decorative types gradually deteriorated.

The 19th century was a great era for the production of decorative types. In the 20th century, this was furthered by the revival of fat faces in the 1920s, the Art Deco-style of the 1930s, the revival of scripts in the 1950s, the emergence of dry transfer lettering in the 1960s (which provided a huge outlet for new fancy and outrageous types) and the advent of headline (display) typesetting machines. Together, these developments helped to maintain interest and constant supply of new decorative types.

William Morris and the Private Press Movement

As the 19th century drew to a close, the production of new display types continued relentlessly although the manufacture of new text type designs had come to a halt and the standards of the type produced, as well as the quality of printing, had gone into reverse. For over three centuries, the book had been a showcase for the highest standards and latest ideas in typographical design and printing. But by the end of the 19th century it was reduced to playing a subsidiary role to jobbing work of all shapes and sizes. The state of the art in text types were the Modern faces which had been designed over 100 years earlier. Furthermore, for reasons of expediency, their poor legibility for continuous reading was now compounded – by bad setting, bad spacing and bad printing, often using poor quality litho printing. Never had readers of printed roman types had to suffer so much.

In 1890, however, the English designer and social theorist, William Morris (1834–96), embarked on a personal crusade to revive the highest standards in type design and printing. This was part of the wider Arts and Crafts movement, advocating a return to old craft values and often drawing on "medieval" sources of inspiration, which was a major influence in art and design at this time.

In 1891, Morris formed his own private press, the

1 During the 19th century, ornamented letterforms flourished as a typographical product of the Industrial Revolution. As the century progressed, their quality in terms of design and manufacture deteriorated and the result were types that were often nothing more than an over-elaborate orgy of ornamentation. This example from an English foundry is typical of decorative types from this period.

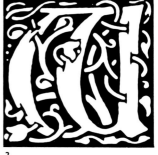

2 An initial letter from a page from the "Chaucer" published by William Morris's private press, the Kelmscott Press. The swirling mass of floral embellishments and the letter 'W' is a clear statement of Morris's backward-looking design philosophy which harks back to the medieval era. A further example of Morris's work is shown on the opposite page.

Kelmscott, at Hammersmith in London. In the same year, Morris designed a new roman type, called Golden, cut by Edward Prince (1846–1923), for his book *The Golden Legend*, published the following year. The type was based on Nicholas Jenson's Humanist roman of 1476 but Morris added extra weight to the type which gave it the feel of a handwritten script from the medieval era. The production of such a heavy, solid-looking type was also Morris's visual protest against the anaemic Modern-style text types which had been used throughout the 19th century.

The Golden Type attracted considerable interest in typographic circles. Indeed, one American typefoundry in Boston asked Morris if they could issue the type on a commercial basis, but Morris refused. A string of Golden-inspired types followed, such as Village by Frederic Goudy (1865–1947), which helped to revive a great interest in the 15th-century Humanist types. Later, this interest resulted in the design of Kennerley by Frederic Goudy, Cloister Old Style by Morris Benton (1872–1948) and Centaur by Bruce Rogers – all popular commercial types in the Humanist style.

Four years later, in 1896, Morris designed two related typefaces called Troy and Chaucer for his book *The Works of Geoffrey Chaucer*. These were black letters based on the 1462 type of Peter Schoeffer. For his type designs, Morris was accused of turning the typographic clock back by 400 years. But, in the early part of the 20th century, his harmonious treatment of type and illustrations, and the quality of the printing and binding of his book productions, played a significant role in raising the standards of commercial printing the world over. Despite this, for many people, his lavish and highly ornate use of decoration in his page designs was totally hideous.

Morris's crusade attracted many disciples who formed their own private presses to spread a similar gospel. In 1900, T J Cobden-Sanderson (1840–1922) and Emery Walker (1851–1933), two business acquaintances of Morris, formed their own press, the Doves Press, also at Hammersmith. In the same year, they designed a new Humanist-style roman type, the Doves type. It was much more faithful to Jenson's original design than Morris's Golden Type had been for they did not support Morris's backward-looking interpretation of Jenson's types. The type was used for their *Doves Bible*, completed in 1905. In 1916, however, after serious disagreements between Cobden–Sanderson and Walker about how the Press was being run, Cobden–Sanderson threw the Doves types into the River Thames in London.

During the next 10 years, Morris's private press move-ment gathered pace and many other presses were started – for example, The Vale and The Ashendene in England, and the Roycroft Press in the United States. In 1913, Count Harry Kessler formed the Cranach Press at Weimar in Germany. Kessler employed Emery Walker and punchcutter Edward Prince to design and produce a roman and an italic type. They enlisted the help of calligrapher, Edward Johnston (1872–1944), for the design of the italic font and two years later he designed the sans serif type for use on the London Underground. Johnston designed a further notable type at that time, an italic called the Cranach Italic, but, due to the intervention of the First World War, it was not used until 1931.

In the early part of the 20th century, the private presses played a further significant role in the development of type design for they were responsible for commissioning many of the contemporary roman typefaces which are in popular use today.

3

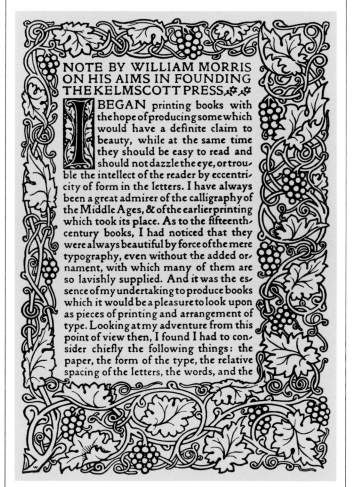

4

3 & 4 In the 1890s, William Morris (1834–96) was influential in re-awakening interest in 15th-century Italian Humanist types, after the typographic industry had been preoccupied with the production of fanciful display types for most of the 19th century. His Golden type, which is shown in the example below left, inspired leading American typographers Bruce Rogers and Frederic Goudy to design commercial Humanist typefaces based on 15th-century models. Morris's type, which was based on Nicholas Jenson's type of 1476, was fattened up to recreate the feeling of a medieval manuscript and to match the weight of the border illustration and initial letter. Notice also the high number of word breaks at the end of a line in order to avoid ugly word breaks or rivers in the justified setting.

Frederic Goudy

In 1896 when Frederic Goudy (1865–1947) from Bloomington, Illinois submitted his first typeface to the Dickinson Foundry in Boston, part of the newly-formed American Typefounders Company, he was already in his thirties and had received very little training or experience in type design. To Goudy's surprise the design was accepted and subsequently produced as a foundry type under the name of Camelot and Goudy went on to become one of the 20th century's most energetic and influential type designers.

Much influenced by William Morris and the English private press movement, Goudy designed Village (1903), which became the house typeface for his private press, The Village Press.

In 1911 Mitchell Kennerley, a New York publisher, commissioned him to design a book. However, Goudy persuaded Kennerley to go one better and also allow him to design a new typeface for the book. The type, Kennerley Old Style (1911), established Goudy's reputation as a type designer. In 1915, he then produced the popular Goudy Old Style which was issued by American Typefounders and, in 1920, he became a typographical consultant to Lanston Monotype. During his association with the company he designed a revival of Garamond (called Garamont), Italian Old Style (1924), Deepdene (1927), Goudy Text (1928) and many others. Goudy spent much of his later working life at his Village Press and Foundry where he designed and produced his own types.

Goudy Old Style was a bestseller for American Typefounders. Its very short and distinctive descenders were popular with typesetters and advertisers because it saved vertical space.

Goudy Old Style

Technological advances

During the course of the 19th century, many manufacturing processes were mechanized but it was not until the 1880s that a series of major technological advances occurred which revolutionized methods of typesetting and type manufacture. After 400 years, the working procedures of Gutenberg were no longer the state of the art.

In 1886, in Baltimore, Ottmar Mergenthaler invented the Linotype machine. It involved the input of text by means of a keyboard and the text was then mechanically set and cast line by line from matrices located on the machine. In the following year, Tolbert Lanston invented the Monotype machine which followed the same principles but set and cast each letter as a single piece of type, or sort. These two events were important not only because they were technological watersheds but they also brought about the formation of two companies who would mount the most substantial type development programmes of

the 20th century.

Of even more significance to the creative development of type design was the patenting of a punchcutting machine, in 1884, by Linn Boyd Benton (1844–1932), a typefounder from Milwaukee. The machine worked by means of a pantographic matrix-engraving machine – a device which synchronized the movement of a needle around the contours of a brass pattern of each letter with a fine engraving drill that cut the letter in relief on the end of a steel punch. It was an immediate success since every foundry went out and bought one. Benton's machine made punchcutting a relatively easy process and, consequently, punchcutters fell from the powerful position which they had held for the past four centuries. The most beneficial effect of his invention was that it opened up the field of type design to designers who did not have any experience or technical knowledge about the manufacture of type. From then on, the creative inspiration for a type design would only rarely originate from the foundry's drawing office.

The new design opportunities were soon seized upon. In 1896, the American Typefounders Company (which in

1 The Linotype machine, the first mechanical typesetting machine, was invented in 1886. The machine cast lines of type rather than individual characters (as the Monotype machine did) and the name Linotype stems from its use for setting and casting a "line of type" (or slug as it is sometimes referred to.) The machine revolutionized typesetting in the newspaper industry because it could set type quickly, and the cost of corrections were low compared to setting which had to be hand-corrected.

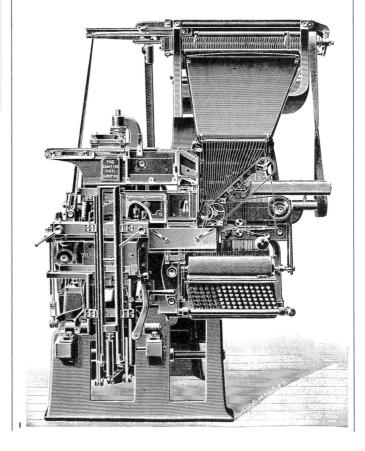

1

1894 had been formed from the amalgamation of 29 independent American Foundries) received a type design from an architect, Bertram Goodhue. Morris Benton (1872–1948), son of inventor Linn Boyd Benton, was the house designer at American Typefounders at this time and using the new pantographic punchcutting machine he developed a range of 20 or more variants from Goodhue's design (bold, italic, condensed, etc.) over seven years. The type, Cheltenham, was the first commercially produced type family and was completed in 1911.

Morris Benton was an industrious and highly skilled type designer in his own right and during his long career at American Typefounders he produced many other successful faces such as Franklin Gothic (1902), Bookman (1903), Cloister (1913), and revivals of both Garamond and Bodoni. Another notable achievement was the development of Century, a Modern face commissioned by the American printer and publisher Theodore De Vinne (1828–1914) in 1895 for *The Century* magazine. Over 30 years, Benton designed numerous variants of the Century family, including the popular Century Schoolbook (1924).

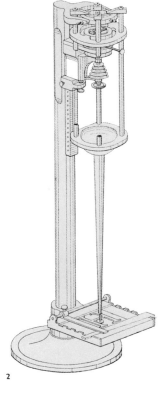

2

2 The punchcutting machine, invented by Linn Boyd Benton in 1884.

3 & 4 The Monotype Caster and Keyboard, introduced in 1887.

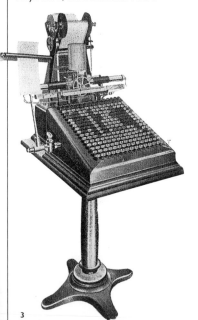

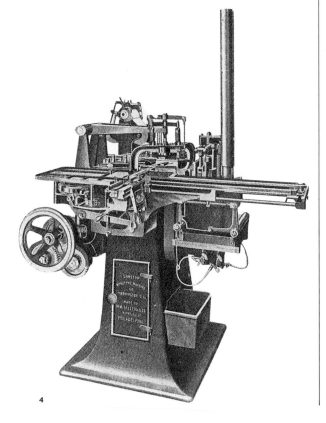

3

4

Bruce Rogers

Bruce Rogers (1870–1957) was a key figure in the American design community during the early part of the 20th century. A book and type designer, Rogers' first major job was as a designer at the Riverside Press in Cambridge, Massachusetts, where he produced many fine book designs. Like Goudy, he had been stimulated by William Morris' work at the Kelmscott Press, in particular, Morris' Golden type of 1891. Rogers designed his first type, Montaigne, in 1902. It was a Jenson-inspired production but he was not pleased with the result and refined his design which, was later issued as Centaur in 1914. Centaur was to become one of the most admired revivals of this century. In 1929, it was also released by Monotype for mechanical composition. Rogers' first love was always books and one of his most elegant designs was the *Oxford Lectern Bible* – set in Centaur, of course.

Centaur
abcdefghijklmnopqrstuvwxyz
ABCDEFGHIJKLMNOPQR
STUVWXYZ 1234567890
.,'':;-()!?£$& fi fl ffi ffl ff ß

Centaur Italic
abcdefghijklmnopqrstuvwxyz
ABCDEFGHIJKLMNOPQRST
UVWXYZ 1234567890
.,'':;-()!?£$& fi fl ffi ffl ff ß

The specimens of Centaur and Centaur Italic above are the Monotype version issued for mechanical composition in 1929. The type is an elegant revival of Nicholas Jenson's type of 1470, while the italic is based on Frederic Warde's Arrighi Italic of 1923. Its compressed design, small x-height and long descenders make it an impractical face to use for modern commercial applications.

1

1 & 2 Two examples that clearly demonstrate the typographic style of the Art Nouveau movement at the turn of the 20th century. The hand drawn, flowing floral letterforms are in stark contrast to the functional sans serif types which were the trademark of the typography of the modern art movement emerging in Europe during the 1900s – an example of which is shown below.

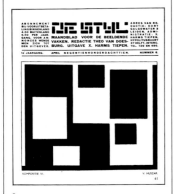

3

3 The De Stijl movement was founded in the Netherlands in 1917. Its minimal design compositions solely featured sans serif type forms, horizontal or vertical straight lines, and the use of black, grey, white or primary colours.

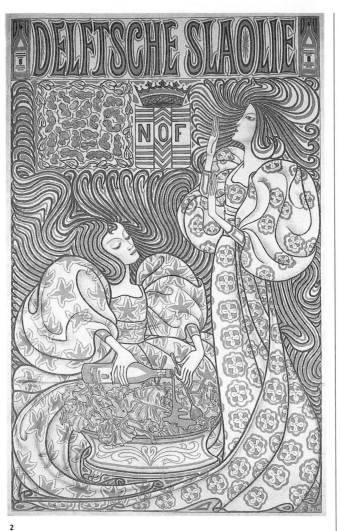

2

With the invention of mechanical text typesetting systems in the 1880s and the renewed interest in classic roman types instigated by William Morris, attention once again focused on more serious letterforms and their application in typographic design. With the Art Nouveau movement of the late 1890s and the emergence of commercial artists, who produced one-off, hand-drawn novelty types for the advertising market, there was a general preoccupation with display types in all forms of typographic design. In particular, the development of poster art for commercial advertising purposes produced a new and larger-scale typographic canvas on which designers could work. Art Nouveau, with its trademarks of floral borders and swirling decorative letterforms (often hand-drawn), utilized the new poster medium to great effect through the marriage of floral, free-flowing illustrations and letterforms.

The influence of the modern art movements

The Industrial Revolution was a time of manufacturing growth, industrial innovation, commercial development and great technological achievements. But in its wake it left a population explosion, social injustice, human exploitation and huge environmental catastrophes. Early on in the 20th century, the elaborate ornamentation and stale conventions of Victorian society came to be regarded by many people as incompatible with the new industrialized world in which they lived. They were impatient for change and the experiences of the First World War made the need for change even more urgent.

While the machine had earlier forced William Morris and his followers to retreat into a creative time warp, many young people now saw it as the symbol of a new modern world and a lifeboat in which to escape from the problems of the past. Their hopes lay in what was new. None more so than the groups of European artists, designers, writers and architects who formed "modern art movements" such as Futurism, Dadaism, Constructivism, Suprematism and De Stijl. In different ways, they challenged the creative status quo, rejected any ideas that did not belong to the modern machine age and replaced them with ideas that did.

The members of these movements were neither typographers nor particularly knowledgeable about printing but they recognized that typography was a dynamic and powerful tool for expressing their new ideas and that printing was the medium by which their theories could be disseminated to the masses. In the process, they shook the foundations of the printing and typographic industries in Europe – which they regarded as static, superficial and living in the past. Certainly, the typographic trend at this time was for hideous display typefaces such as fat faces and ornamental types which were usually inappropriate for their particular purpose and the mood of the new industrial age in general. Also, the craft and skills of the art of printing had been lost. The demands for expediency and volume had made the standard of the run-of-the-mill printing appalling.

The modern typography which these movements employed broke out of the strait-jacket imposed by the linear rules of movable metal type. They bulldozed away traditional typographic conventions and practices, and created a new visual language in which words became abstract shapes in a typographic painting and not just a set of written signs representing a phonetic language. The new typography was dynamic and aggressive and the only types permitted were sans serif, regarded as being pure

letterforms and in visual harmony with the machine age. Symmetry was branded as illogical and purely decorative, and was replaced by functional asymmetric concepts creating new visual tensions and contrasts – the trademarks of the modern typography.

Futurism was the first of the "isms". Its manifesto, published in 1909 by Italian Filippo Marinetti, stated the movement's determination to find new visual expressions in art and design that would better reflect the modern machine age. In typographic terms, it led to a violent juxtaposition of bold, freeform typographic images which reflected the aggressive propaganda of the Futurists such as Marinetti, Severini and Govoni.

By 1913, the Suprematist movement had been formed in Russia and the simple geometric style of design which was used in its propaganda became a catalyst for the outbreak of abstract painting which followed in Europe. Laszlo Moholy-Nagy and El Lissitzky were two prominent members of the Suprematist movement. In 1916, the Dadaists also arrived on the scene. This literary and artistic movement came about through opposition to the futility of the First World War and their propaganda was characterized by the use of the graphic technique of collage (of which the MERZ pictures of Kurt Schwitters are a good example).

The following year, the De Stijl movement, of which Theo Van Doesburg and Piet Mondrian were two of its most influential disciples, started in the Netherlands. It soon gained popular support in other parts of Europe and its manifesto proclaimed that simple geometric shapes

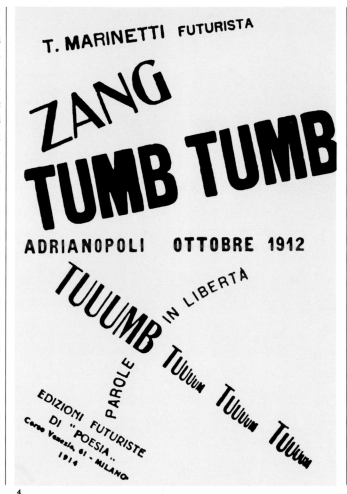

4

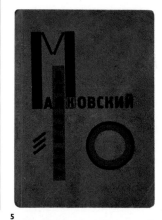

5

4 & 5 The stale conventions of Victorian society and the over-elaborate floral designs of William Morris and the Arts and Crafts movement were responsible for the rebellious and dynamic typographic designs of the modern art movements. The work of Italian Futurist Marinetti's (left) and El Lissitsky's cover for *The Voice* (1923) illustrate the style of the modern typography.

Jan Tschichold

The most influential figure in the typographic world involved in the modern art movements was the German Jan Tschichold (1902–74). At the age of 21 he had visited the Bauhaus Exhibition at Weimar in 1923 and had returned home to spread the new ideology.

Unlike the other prominent individuals of these movements, he had received the benefit of formal training in lettering and calligraphy and was already a practising typographic designer. These factors alone made his work stand out from the rest. In 1925, he wrote an article, *Elementaire Typographie*, in which he stated with great clarity his new typographic manifesto expounding the merits of sans serif types and asymmetric typography. In 1928, Tschichold's first book, *Die Neue Typographie*, was published which was the first attempt to clearly set out the principles of typography in terms that could be understood by the printing trade.

After being arrested by the Nazis in 1933 because of his association with the modern art movements, Tschichold fled with his family to Switzerland. Two years later his second book was published, *Typographische Gestaltung*, in which he gave another detailed appraisal of the principles of typographic design. In the same year, he also admitted that he believed there was a time and a place for both asymmetric and symmetric typography. Some of his ardent supporters found his U-turn hard to stomach.

In 1946, Tschichold began work at Penguin books in England where he stayed for three years and designed over 500 books before returning to Switzerland. His only major commercially-produced typeface, Sabon, appeared in 1967.

Tschichold can be regarded as the first of a new breed of all-round practising typographers who not only worked in the traditional area of book design but also on a wide range of jobbing work. His dynamic use of space and sensitive typography work is some of the most influential in the 20th century.

JAN TSCHICHOLD

DIE NEUE TYPOGRAPHIE

EIN HANDBUCH FÜR ZEITGEMÄSS SCHAFFENDE

BERLIN **1928**

VERLAG DES BILDUNGSVERBANDES DER DEUTSCHEN BUCHDRUCKER

Title page of Tschichold's first book *Die Neue Typographie* (1928).

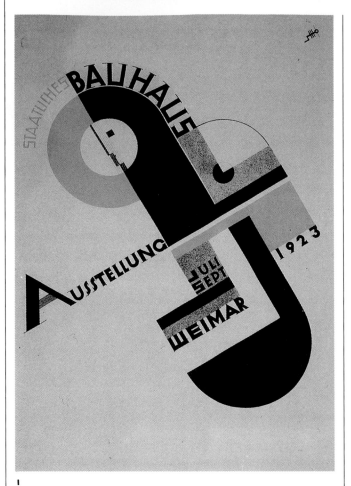

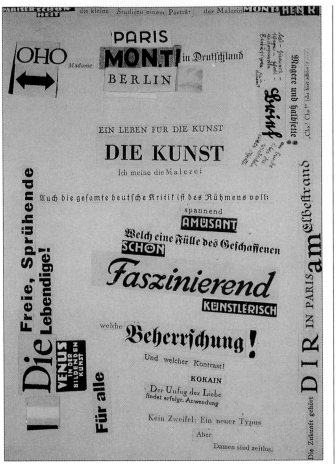

abc def

1 A poster design by Joost Schmidt for the Bauhaus Exhibition at Weimar in 1923 which features Geometric sans serif type and a dynamic diagonal arrangement. Jan Tschichold's visit to the Exhibition converted him to the modern typography movement.

2 The typographic compositions of the Bauhaus regularly featured the use of collage as in this design by Lou Scheper (1927). The resulting dynamic and revolutionary designs broke free from the linear restrictions of metal type.

3 At the Bauhaus during the 1920s, Herbert Bayer and Jan Tschichold both attempted to create an all lower case "universal alphabet". Bayer's design was received with little enthusiasm because it has poor legibility, and an all lower case alphabet cannot communicate adequately the variety and subtleties of modern written language.

and primary colours were the only appropriate visual expressions of the new machine age.

In 1919, the Bauhaus, a new school of visual arts, opened at Weimar in Germany. The architect Walter Gropius was its first principal and he defined the broad objective of the school as the bringing together of the visual arts and industry. Many of the leading lights from the new art movements, such as Wassily Kandinsky, Laszlo Moholy-Nagy and Paul Klee, became tutors, and their influences could be seen in the students' work.

After disagreements with the government of Thuringia about how the school was run, it moved to Dessau in 1925. There a distinctive Bauhaus design style evolved, reflecting the school's modern approach to typography. Many of the teaching methods and course structures developed at that time have become the framework of our art and design education today. Following a move to Berlin, the school was closed down by the Nazis in 1933 but its influence has lived on.

Typographic design (1910–1929)

During the First World War, the poster became an important vehicle for recruitment campaigns by the governments of Britain, Germany and the United States. The use of bold sans serif types dominated war poster design in England, as did the black letter in Germany.

Until the 1920s, then, sans serif types had been grotesques with the notable exception of Edward Johnston's alphabet for the London Underground in 1916 which was based more closely on classical letterforms and was more geometric in design. It was Johnston's type which had possibly influenced the designers of the early Geometric sans serif types (types constructed from simple shapes such as the circle or rectangle) – a style which had developed from the modern typography movement.

The father of these types was Jakob Erbar (1878–1935), a German who had experimented with sans serif letterforms before the First World War. But it was not until 1926 and with a geometrical design which he called Erbar

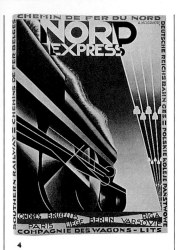

4

4 Despite the popularity of the functional Geometric sans serif types during the 1920s and 1930s, hand drawn typefaces still flourished in many mainstream forms of graphic design. In the above example by A. M. Cassandre, the hand drawn letterforms are designed to suggest movement and create impact.

5 The hotel luggage label below right is a typical example of the typographical style of jobbing work during the 1930s.

that he produced a type commercially. Unfortunately, a similar but superior design called Futura which was designed by another German, Paul Renner (1878–1956), appeared only a year later and it overshadowed Erbar's type. Futura became the popular flagship of the Geometric sans serif style. In the same year, Rudolf Koch (1876–1934) designed Kabel which was issued by Klingspor. The capital letters of this type closely resembled Futura, but the lower case did not. Unusually, it also had oblique endings to some of the letter strokes.

In order to jump onto the Futura bandwagon which had soon begun to pick up speed in Europe, the typefoundries in the United States hurriedly produced a string of Futura look-alikes. By 1930, Linotype had issued Metro, by William Dwiggins (1880–1956), followed by Spartan produced in conjunction with American Typefounders. Intertype weighed in with Vogue (originally designed for *Vogue* magazine), Ludlow with Tempo by Hunter Middleton (1898–1985), American Typefounders produced Bernhard Gothic, and Monotype issued 20th Century.

Geometric sans serifs have remained popular throughout the 20th century although they have met with considerable competititon from later Grotesque designs such as Univers (1957) and Helvetica (1958), as well as from the Humanist sans serifs (types based on the proportions of inscriptional Roman capital letters and the lower case forms of humanistic handwriting) such as Gill Sans (1929) and Optima (1958).

Also during the 1920s and 1930s, the functional typography of the new modern art movements and the Bauhaus was influential in many parts of Europe. However, there was still a demand for eye-catching novelty typefaces for use in advertisements and on packaging and during the 1920s and 1930s, the Art Deco style (or Art Moderne)

5

flourished in typographical design. Many new quirky, thin and condensed type styles combined with matching illustrative styles were produced during this period.

Elsewhere, typographic styles were developing apace. In Britain, the growth of the national newspaper industry attracted new legible typeface designs and typographic stylings. In Switzerland, the beginnings of the functional Swiss approach to typographic design was emerging using type and photographic images with great success.

The development of text types (1885–1945)

The invention of mechanical typesetting in the 1880s in the United States was the beginning of the end for many typefoundries on both sides of the Atlantic. For others it was the end. Large chunks of the everyday business of the foundries were soon swallowed up by the new Linotype and Monotype machines, especially the supply of text type to newspapers. In a bid to survive, some foundries merged while others formed business partnerships with rival foundries, something which previously would have been unthinkable. In the United States, 29 foundries amalgamated to form the American Typefounders Company in 1892, and similar reconciliations and collaborations occurred in Europe.

To some extent, the initial blow to the foundries was softened both by a reluctance in some quarters of the trade to accept immediately the new machinery, and by the limitations of the early typesetting systems. Linotype and Monotype initially supplied only a very limited range of types for their machinery in the form of the most popular Old Style and Modern text types of the day. So display types still had to be manufactured separately and set by hand and the printing trade continued to require display types of all descriptions for use in advertising and other forms of jobbing work. Such types, of course, could only be provided by foundries.

However, it was not long before Linotype and Monotype realised the limitations of their systems. The demands of their customers for a particular type or range of types quickly made them reconsider their policies for the selection of typefaces for their systems. When threatened with an ultimatum of "no typeface, no system", Monotype were known to quickly add the appropriate new type to their range. The invention of the pantographic punchcutting machine had made it increasingly easy to produce new types.

In order to widen the market for their typesetting systems to Europe at the turn of the century, Linotype and Monotype had formed autonomous sister companies in

ABCD
EFGHI

1 & 2 Eric Gill (right), the English writer and sculptor, made a major contribution to typography during the 1920s and 1930s. His popular sans serif design, Gill Sans, is based on the sympathetic style and proportions of classical letterforms and is in complete contrast to the austerity of the Geometric sans serifs which were so popular at this time. On the left is a series of sign letters in Gill Sans Light. Gill's other major typefaces were Perpetua (1932) and Joanna (cut in 1938 but not issued until 1958).

2

1

3

3 A poster promoting trips to Kew Gardens on the London Underground featuring the use of Johnston, a typeface designed specifically for London Transport by calligrapher Edward Johnston in 1916. This type was later to be the inspiration for Eric Gill's type, Gill Sans.

England. On both sides of the Atlantic they developed separate typeface programmes, in competition with the larger remaining foundries such as American Typefounders in the United States and Stempel, Baeur and Berthold in Europe. While they all made substantial contributions to the development of type and typographic design in the early part of the 20th century, the extensive programme instigated by Monotype in England under the direction of Stanley Morison (1889–1967) was the most significant and influential.

Monotype UK and Stanley Morison

The Monotype Corporation in the States (originally called the Lanston Monotype Corporation) was bought out by a British syndicate in 1897. In the same year it established an operating company in London, England and two years later it opened a new works at Salfords in Surrey. Harold Duncan, an American who was a friend of Tolbert Lanston, was the Managing Director, Frank Pierpoint the Works Manager and Fritz Stelzer Head of Type Drawing Office.

In the first two decades of the 20th century, there were few significant developments, partly because of the interruption of the First World War. However, Monotype manufactured a new type in 1912 called Imprint modelled on Caslon and commissioned for *Imprint*, a new journal for the printing industry launched in 1913. The type was a success and was the first to be specifically cut for mechanical composition. Somewhat ironically, the journal, which was produced to raise the profile of type design in the printing trade, was a failure as the trade was not yet ready for it. The following year, Monotype issued Plantin. The design was based on a 16th-century French Old Style roman of Robert Granjon and it thickened up to compensate for the weakening effect of the type when printed on coated papers. Plantin was given a built-in ink squash. In 1921, a revival of Bodoni was also added to the range.

In 1922, Monotype issued their revival of Garamond following the success of the American Typefounders' version in 1917. For the research of a suitable historical model for their type, Monotype enlisted the help of Stanley Morison, an English typographical historian and practising typographer. Morison's involvement in the Garamond project was instrumental in his subsequent appointment as Monotype's typographic adviser in 1922 (several years after the American end of Monotype had appointed Goudy).

Prior to joining Monotype, Morison had worked for both the Pelican Press and then the Cloister Press as a typographer. He was co-editor with Oliver Simon of *The Fleuron*, an influential typographical journal. In 1922, he also became typographical adviser to the Cambridge University Press just prior to his appointment at Monotype. Morison devised a programme of type development within Monotype. At first, he concentrated on the revival of a number of classic roman types and his justification for this was that "certain lessons had to be

learnt and much necessary knowledge discovered or recovered. The way to go forward was to make a step backward".

Following William Morris's revival of 15th-century Humanist types, a great many typographic faces were reproduced during the 1920s. Other private presses also contributed to the trend of resuscitating classical roman letterforms. After a barren period in the development of text types during the 19th century, there was now a desperate need to find legible types to efficiently disseminate the mass of information produced by an increasingly sophisticated industrialized society. Few organizations could have more motivation to develop such types than the manufacturers of text typesetting systems. Morison and others believed that one rich source for these typefaces was the past.

During the period that Morison was typographical adviser to Monotype, many revivals of classic roman types were produced. Some of these were Baskerville (1923), Poliphilus with Blado Italic (1923), Fournier (1924), Bembo (1929) which was based on the *De Aetna* types of Aldus Manutius in 1495, Centaur with Arrighi Italic (1929), Bell (1931), Walbaum (1933), Ehrhardt (1937) and Van Dijck (1937).

In addition to the revival programme, many typefaces which had originally been commissioned by the private presses were adapted for Monotype mechanical composition under the supervision of Morison. Among the types cut were Lutetia (1930), Romulus (1936) and Spectrum (1955), all by Dutch type designer Jan van Krimpen (1892–1958), Emerson (1953) by American Joseph Blumenthal (*b*1897), and three types by the English letter-cutter, writer and sculptor, Eric Gill (1882–1940).

Gill was a man of many talents but surprisingly he did not regard type design as one of them. He is reported to have told Morison that typography was "not his country". Undeterred, Morison approached Gill to produce a set of drawings for a contemporary roman alphabet based on inscriptional lettering. After a long gestation period of seven years, it was finally issued by Monotype in 1932 as Perpetua. In the meantime, Gill had produced his major contribution to typography in the form of Gill Sans (1928). Influenced by Edward Johnston's earlier type for the London Underground, it is an elegant and popular sans serif type produced exclusively for Monotype. Joanna, another of Gill's types, originally designed for his private press (Hague and Gill), was released by Monotype in 1937. This was followed by Pilgrim in 1953 which was first used by the Limited Editions Club of New York under the name of Bunyan.

4

In the mid-1920s, Morison began to take an interest in the design of newspaper types which were already the subject of a number of legibility studies by Linotype, the major typesetting system used by newspapers. Linotype had developed their Legibility Group of typefaces (two of these being Ionic and Excelsior) which were all specifically designed to withstand the rigours of letterpress printing on coarse newsprint.

In 1929, Morison vehemently rubbished the typography of *The Times* to a shocked member of the newspaper's staff. Morison's hysterical outburst later paid dividends by providing him with an opportunity to submit a full report and historical survey of the typography of the paper to its proprietor, John Astor. Morison recommended that trial settings should be carried out using Plantin, Baskerville and Perpetua – all, of course, Monotype faces. None of the three was accepted but a suggestion from Morison that a new typeface should be commissioned using Plantin as its basic model (the preferred design of the three) was approved by the newspaper. The new type, Times New Roman, first appeared in 1932. It is the most

4 *The Fleuron*, which appeared between 1923 and 1930, was an influential typographical journal which set out to promote the highest standards of typography.

THE TIMES

5

5 & 6 In 1932, the first issue of *The Times* newspaper to be set in a specially commissioned typeface, Times New Roman, was published. The type, a modernized version of Plantin, was designed by Stanley Morison (below) and it was used exclusively for setting the newspaper until it was replaced in 1972 by Times Europa.

6

commercially successful text face ever produced. Other notable types manufactured by Monotype around this time were Albertus (1932) by Berthold Wolpe (1905–89), and Rockwell (1934), a slab (or square) serif type which reflected the popularity of these styles in the mid-1930s.

Morrison's contribution to the development of typography is substantial. His work is one of the most influential from the first half of the 20th century. Morison's association with *The Times* continued, for he was made editor of their *Literary Supplement* in 1945.

Developments in typography (1930–1944)

During the 1930s, the importance of clarity and legibility in typographic design was recognized and many forms of popular printed matter received typographic overhauls. The books published by Penguin which extensively feature Gill Sans are a good example of the typographic style of this time. It was generally a period of type consciousness and the revival of many classic typefaces. With the onset of the Second World War, the poster once again became the focus for typographic energy. Recruitment posters and Government propaganda combined dynamic typographic, illustrative and photographic effects.

The new phototypesetting age

At the end of the Second World War, the type manufacturing industry was still in the technological slow lane where it had been for much of the 20th century. By comparison, its sister trade, printing, had seen dramatic changes. In the early 1900s, the invention of flexible metal printing plates had brought about offset lithography – a new printing process in which a flexible plate was wrapped around a cylinder and the image was offset from the plate to the paper by means of a rubber blanket. Offset lithography was a development of lithography which had been invented in 1799 by a German called Alois Senefelder. Lithography involved the drawing of an image with a greasy pencil on a flat limestone slab which was then dampened and inked. The greasy image repelled the water but attracted the sticky ink.

During the first half of the 20th century, offset lithography increasingly replaced letterpress printing mainly because it was faster and the origination of the reprographic film (photographically produced from the original artwork and used to transfer the design to the plate) and printing plates was both cheaper and easier. However, in order to originate type for offset lithography printing, first it had to be set in hot metal from which a reproduc-

tion pull was taken and then photographed. The concept of casting lots of heavy metal type just to produce a piece of artwork that could be photographed on to a printing plate only served to highlight the lack of technological progress in the typesetting industry when compared to printing and the graphic arts in general.

In the early 20th century, experiments were carried out to find ways of producing type through the use of photography (an invention that had already celebrated its 100th birthday). In 1930, Edmund Uher designed a prototype for an early phototypesetting system (also called a photocomposition system) which involved the selection of characters on a rotating master negative by means of a keyboard and the exposure of the characters via a lens on to photographic paper. Jan Tschichold designed about a dozen typefaces for the Uhertype machine in 1933 but no record of these appears to have survived.

By the beginning of the 1950s, the first generation of phototypesetters appeared on the market. Linotype brought out the Linofilm machine which could output on to film, Monotype produced the Monophoto, and other manufacturers launched similar equipment at the same time. In many respects, these machines were no more than converted hot metal equipment with the old metal typecaster replaced by new photographic units.

However, these early phototypesetting machines soon ran into technical problems. The expedient decision to use one master negative for the generation of different sizes of type without making the necessary optical adjustments to compensate for enlargement led to ugly distortions and poor spacing. On top of this, it was difficult and expensive to make corrections as they had to be patched or spliced in which took time, and the exposure of the final setting varied. Understandably, the typographic community remained unconvinced of the benefits of the new machines.

In addition, the speed with which technology was developing and the urgent need for typefaces to work on the phototypesetting machines completely overwhelmed the available resources of the foundries' type drawing offices. Consequently, short cuts were taken in the preparation of new designs and type quality suffered in the process. In typographical terms, the price of progress was too high. But worse lay just around the corner.

A new breed of manufacturers entered the phototypesetting marketplace. They had little or no understanding of the traditional values and ethics of the type industry and the relative ease of producing type fonts for phototypesetting, together with the commercial pressure to quickly build up a range of typefaces for their machines,

1

2

1 Hans Schmoller, a well-known book designer and typographer, succeeded Jan Tschichold at Penguin Books in 1949. He continued to develop the design principles which had been established by Tschichold. The front cover design of *Room at the Top*, which extensively features Gill Sans, is typical of Penguin covers during the late 1950s.

2 A cover of the Society of Typographers' magazine, *The Typographer*, uses a combination of Playbill and Groteque sans serif type in an asymmetric layout featuring dynamic panel shapes.

led them to behave like typographical pirates. They copied existing designs, made minor adjustments and re-issued them under "bastard" names – for example, Helvetica became "Helios" and Optima, "Chelmsford".

The serious implications of these developments for the type manufacturing industry was partly responsible for the formation of the Association Typographique Internationale (ATypI) in 1957, which is an association of the leading type manufacturers, type designers and typographers in the world. In 1973, an agreement for the protection of typeface designs was drafted, but persuading all of the signatory nations to alter their laws to accommodate it is proving to be disappointingly slow.

The second generation of phototypesetters

By the early 1960s, a second generation of phototypesetters had emerged. They were considerably faster, but often at the expense of quality. Some of their operations were electronically controlled and the information inputted via the keyboard was stored in a computer memory unit. While the new phototypesetting machines raised a new set of technical considerations for type designers, they freed them from the linear restrictions of metal type. The possibilities for kerning (the overlapping of one character into the rectangular space of the next) were endless, and there was no longer a need for ligatures (two metal type characters joined together on one body in order to avoid an ugly wide space such as between the lower case 'f' and 'i').

Phototypesetting also removed some of the technical obstacles which had previously confronted type designers when handling flowing and delicate letterforms. Now that kerning was no longer a problem it was possible to design flowing scripts so that when the letters were set they joined up. Swash letters (those with flourishes) and other finely detailed letterforms could also be translated into type more easily.

In the 1960s, the production of display types was also revolutionized. Dedicated display phototypesetting machines were produced which had many advantages over metal display types. They could set type in any size up to a maximum cap height (the distance from the top to the bottom of a capital letter) of about 2in (5cm), they

Adrian Frutiger

The career of Adrian Frutiger (b1928) spans the eras of hot metal, photo and digital typesetting. The Univers family of types, which he designed in the late 1950s for both phototypesetting and hot metal, firmly established him at the leading edge of type development.

At the age of 16, he started a four-year apprenticeship with a printing firm in Interlaken, Switzerland. Simultaneously, he studied at the Zurich School of Arts where, among other things, he worked on a project to design a sans serif typeface. His designs subsequently became the basis for Univers. In 1952, he moved to Paris in France and joined the foundry of Deberny and Peignot where he oversaw the transfer of the classic roman types from hot metal to the new Lumitype phototypesetting machine. Three years later, he designed his first major type, called Meridien.

In 1957, Frutiger designed Univers, a grotesque-style sans serif, which was available in an extensive family of related weights, widths and italics. Frutiger gave each of the 21 variations a unique but inter-related reference number. Univers has been one of the most commercially successful typefaces ever produced.

Frutiger was commissioned by Monotype in 1962 to design a roman type called Apollo exclusively for their Monophoto machine – the first typeface produced solely for phototypesetting. In 1975, he designed a sans serif typeface for the directional signs at the Charles de Gaulle Airport in Paris which was issued by Linotype as Frutiger in 1976. Some of his other major typefaces are Egyptienne (1956), Serifa (1967), OCR-B (1968), Iridium (1975), Glypha (1979), Icone (1980), Breughel (1982) and Versailles (1982).

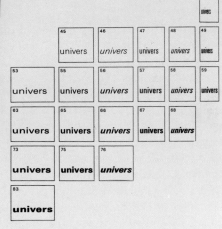

Frutiger's coding system for Univers (1957), which had 21 variations, was an attempt to avoid the varying and confusing typeface names used within the industry, such as light, medium, bold, extra bold, heavy and so on.

gave complete flexibility in letterspacing, and characters could be overlapped, condensed, expanded and slanted backwards or forwards. The phototypesetting machines were so cheap and easy to use that not only was there an outbreak of classic revivals but many new designs of varying degrees of outrageousness were created.

In the 1950s and 1960s, Monotype and Linotype converted many of their metal types for use on their phototypesetting systems and, in addition, commissioned new designs. Some outstanding designs during this period were Vendome (1952), Mistral (1953) and Antique Olive (1962) by Roger Excoffon (1910–83), Trump Medieval (1954) by Georg Trump (1896–1985), Albertina (1964) by Chris Brand (b1921), Sabon (1966) by Jan Tschichold and Syntax (1969) by Hans Meier.

During the 1960s, new designs for display types found another outlet in dry transfer lettering which was introduced by Letraset in 1961. An enormous range of typefaces was developed in sheet form which became popular in design studios during the 1960s and 1970s.

Developments of typography (1945–69)

Following the Second World War, advertising and commercial applications of typographic design gradually regained momentum. Partly because of the ease with which script typefaces could be produced as new photographic type fonts, these types enjoyed a renaissance. Ashley Script was one such face.

Switzerland was the dominant force in typographic design during the 1960s, and its leading exponents were Emile Ruder, Josef Muller-Brockmann (b1914) and Armin Hofmann (b1920). The style was characterized by its clean, constructed and minimal approach to typography and the almost exclusive use of Helvetica (or Neue Haas Grotesk), a Grotesque-style sans serif typeface designed by Max Miedinger (d1980) in 1957 for the Swiss Foundry Haas. Helvetica, which is available in many variations, is one of the most commercially successful and popular designs produced in the second half of the 20th century and during the 1960s and 1970s it was used to the point of saturation in many parts of the world.

In the United States, as a reaction to the austerity of the Swiss style, there was a revival of fancy types and lettering – Milton Glaser (b1929) was a leading exponent of this style with his "psychedelic" posters and album covers.

The very different work of another American, Bradbury Thompson (b1911) is a fine example of the emphasis placed on clarity, legibility and order in typographic design during the 1950s and 60s in projects such

1 2

as the Westvaco *Inspirations for Printers* (1938–62). Every detail is carefully handled so that the typographical hierarchy of the design solution can be immediately and quietly assimilated by the reader.

The computer age (1970 – present day)

The story of typography from 1970 to the present day is the story of the explosion of computer power throughout the type industry. During this period there has been an unprecedented growth in type technology which has profoundly affected everyone who works with type – designers, typographers, typesetters and manufacturers alike. As a chapter in the history of type, it will be remembered for the farewell to hot metal setting; and the arrival of digital typography and desktop publishing. The digital computer was at the heart of these developments.

The growing need of the modern industrialized world to find better and more effective methods of communication has led to an increased demand for typographers and designers. It has also created new outlets for typographic design such as TV and computer graphics, logotypes, corporate identity programmes, signposting schemes, information design and public information systems. The most significant development occurred in the late 1980s – the desktop publishing boom. All over the world, off-the-shelf desktop publishing (DTP) systems, complete with

1 One of the leading exponents of the Swiss typographic style was Josef Muller-Brockmann. His poster design from 1955 features the use of sans serif type and a photographic image taken from an unusual ground level view to increase the dramatic effect of the "mind that child" message.

2 The prosperity of the western world, especially in the United States, led to the development and sophistication of consumer advertising during the 1950s and 1960s. The car, the ultimate status symbol, became the focus of attention for highly creative copywriters and designers. This Volkswagen advertisement by Doyle Dane Bernbach is a part of a well-known series which appropriately featured Futura, a German Geometric sans serif typeface.

3

4

3 Lettering from a poster design by Brownjohn, Chermayeff and Geismar that shows imaginative use of positive and negative type.

4 The widespread use of psychedelic colours in the late 1960s is typified by the design of the cover for the album Disraeli Gears by Cream.

do-it-yourself typography instructions and a range of typefaces, were sold in their hundreds of thousands. Suddenly, type had become big business and typefaces household names.

Digital typography

In the 1970s, the computer started a technological revolution in the type manufacturing and typesetting industries. Digital computers operate electronically (there are no mechanical parts as in the previous generation of photo-typesetters) and process information in the form of binary units or impulses, called bits, which are stored in its memory.

The shape of each character is made-up of a fine grid of tiny squares called pixels and, together with coded instructions for letterspacing, kerning, measure and other typographical specifications, the character shapes are stored in the computer memory as digital information. Foundries use different methods of digitization but fonts are designed in two forms – bitmaps and outlines. A bitmap is the filled-in area of squares or pixels which define the shape of each character and a new bitmap is produced for each type size. Each character is generated as type by means of a cathode ray tube (CRT) or a laser beam which exposes the computer image on to photographic paper or film, or sometimes even directly on to a printing plate.

The sharpness and quality of digital type depends not only on the digitizing system and skills of the designer employed by the foundry which manufacturers it, but also on the resolution (the number of pixels per square inch) of the output device used on which the type is set. A low-resolution machine will produce a coarse type where the jagged edges of the pixel pattern are visible.

The flexibility, speed and accuracy of the digital system has been responsible for its universal application throughout the type industry. During the 1950s and 1960s, each typesetting system had its own dedicated and limited library of typefaces, and it was not possible to use faces designed and produced for other systems. Digital type, however, is device-independent which means it is compatible across a wide range of typesetting and operating systems, screens, printers and other output devices. Never has type been so flexible. In addition, new digital fonts can now be created more quickly and with greater control. In particular, the quality of letterspacing that can be achieved is far superior to that allowed by the previous generations of phototypesetting machines. Type can easily be re-drawn, fattened, squashed and manipulated in

Hermann Zapf

Hermann Zapf (b1918), the German type designer, typographer and calligrapher has made the most influential contribution to typography since the Second World War. He is one of the few type designers whose career has straddled the manufacture of metal, photo-typeset and digital typefaces and who has successfully managed to adapt his work to suit all three systems. Perhaps Zapf's ability to adapt to the new technological developments in photography and computers lay in his interest in electrical engineering, a career he wished to pursue as a teenager. However, the sensitivities of the political climate in Germany in the 1930s were such that he was unable to follow his intended career path and he had to be satisfied with an apprenticeship as a retoucher with a local printing company.

After he has completed his apprenticeship he worked for Paul Koch (the son of Rudolf Koch whose calligraphy and type design he much admired) and then he moved on to the Stempel Foundry in Frankfurt where he designed many of his well-known types. Zapf's first type, a black letter called Gilgengart, was cut in metal in 1941 and in 1949, he designed his first major type, Palatino, based on 15th-century Italian Renaissance types. Melior, a contemporary newspaper type in the mould of the Linotype Legibility Group of typefaces, was produced in 1952 and, in the same year, he designed a contemporary interpretation of Janson for Linotype in Germany.

Zapf left Stempel in 1956 and in 1958, he produced his most outstanding type, Optima, a Humanist sans serif. Originally cut as a foundry type, subsequently it became available for photocomposition.

Since then he has continued to lead the field in type design with a prolific and outstanding string of commercially successful typefaces including Orion (1971), ITC Zapf Chancery (1974), Comenius (1976), ITC Zapf Book (1976) and ITC Zapf International (1977). He has won numerous awards for his work.

Below are Zapf's handwritten corrections to an early sample version of Optima.

any number of ways. Indeed, type has taken on an elastic quality.

The desktop publishing boom

In the mid-1980s, a new piece of computer software called PostScript, manufactured by Adobe Systems in the United States, was the technological breakthrough which gave rise to the DTP boom of the late-1980s. PostScript is a computer language which encodes the descriptive information about the design and layout of a page of text and which is both device-independent and resolution-independent – it can operate irrespective of the resolution of any particular device.

PostScript operates in the output device, such as a laser printer, and enables the software to pass information to the output device about the type font, size, measure, layout and other typographical specifications. In a short time, PostScript has virtually become an industry standard in electronic publishing for outputting made-up pages of text.

An ever increasing number of PostScript fonts are being produced, and their affordability has led to the growth in PostScript type libraries in design studios, publishing houses and publications departments around the world. Such accessibility to type is unprecedented. For many design studios, in particular, their life has been transformed by PostScript fonts and, of course, by the Apple Macintosh, probably the most popular digital computer used for DTP and graphics work. This is the age of the designer-typesetter.

It is also the age of the inexperienced typographer. Most DTP systems are extremely user friendly, and anyone with little knowledge of type can reasonably quickly produce a finished page. Of course, this situation may represent a challenge to the maintenance of good standards in typography because it is often the finer points and the decision of a trained eye that can make or break a piece of communication.

Type manufacturing today

Digital computer technology has dramatically changed the make-up of the typefounding business. No longer does it consist of only the big foundries such as Monotype and Linotype but also of an array of new and smaller independent typefoundries, sometimes called type vendors. Some of the best known digital typefoundries are Adobe Systems and Bitstream in the United States, and Robert Norton Photosetting in England. Following their introduction of PostScript, Adobe Systems has developed an extensive range of digital types. Among their original designs are Utopia, Minion and Tekton. Sumner Stone (b1945) has designed the Stone family of typefaces; ITC Stone Serif, ITC Stone Sans and ITC Stone Informal.

By 1970, type licensing became a necessity due to the ease with which a new photographic font could be produced. Also, some type manufacturers found the cost of producing their own new designs prohibitive and so acquired types from other sources. As a result, a type licensing company called the International Typeface Corporation (ITC) was established by Aaron Burns and Herb Lubalin in New York.

Initially, the company only issued display typefaces, some of which had been developed from commercial design commissions received by Herb Lubalin, a highly creative American typographer. For example, Avant Garde Gothic (1970) was originally conceived as a masthead for *Avant Garde* magazine. Other early ITC designs were Souvenir, Tiffany and Korinna – all of which were designed by Ed Benguiat.

ITC were innovative in the marketing of their typefaces. The creative design and layout of their type specimen book, *U&lc* (Upper and lower case) magazine, which was principally aimed at designers, was in itself a significant contribution to typographic design during the 1970s and 1980s. Later, their list of typefaces was expanded by the addition of types by leading type designers such as ITC Zapf Book (1976) and ITC Zapf International (1977) by Hermann Zapf (b1918) and ITC Novarese (1980) and ITC Fenice (1982) by Aldo Novarese (b1920).

During this period, Monotype, Linotype and Berthold converted existing typefaces for digital typesetting and commissioned new designs. Monotype issued Photina (1972) by Jose Mendoza, Calvert (1980) by Margaret Calvert (b1936), Nimrod (1980) by Robin Nicholas (b1947) and Ellington (1990) by Michael Harvey (b1931). New releases from Linotype included Auriga (1970), Olympian (1970) and Video (1977) by Matthew Carter (b1937), and Iridium (1975), Egyptienne (1976), Frutiger (1976) and Serifa (1977) by Adrian Frutiger (b1928). Berthold's new designs included Comenius (1976) by Hermann Zapf, Imago (1982) by Gunter Gerhard Lange (b1921) and Poppl Laudatio (1983) by Fredrich Poppl (b1923–82).

The rapid growth in the number of small foundries and the emergence of type designers as typefoundries has occurred mainly because of the wide availability of ready-made desktop computer systems and programs such as Ikarus and Fontographer which have been developed

2

1 During the 1970s, Britain was a major centre for new ideas in graphic design and typography. The Punk Rock movement of the late 1970s had a distinctive visual style which is closely identified with sex and drugs. The rebellious and provocative images thrown up by the movement had an influential effect on the work of Neville Brody and other leading typographers during the 1980s.

2 The 1970s saw the formation of the International Typeface Corporation (ITC), a new type licensing organization founded by Aaron Burns and Herb Lubalin. Their type catalogue *U & lc* (Upper and Lower Case) played a significant role in promoting and encouraging new typeface designs and typographic ideas through its highly creative layouts and presentation.

specifically for type design. As a result, some other notable new typefaces manufactured during the 1970s and 1980s were Demos (1978), Praxis (1979) and Flora (1980) by Gerard Unger (*b*1942) and released by Dr Ing Rudolf Hell, Else designed and manufactured by Robert Norton Photosetting, Lucida designed and manufactured by Chuck Bigelow (*b*1945) and Kris Holmes (*b*1950), and Trinite designed by Bram de Does and issued by Bobst Graphic.

Contemporary typographic design

During the 1970s and 1980s, the last stronghold of hot metal typesetting – the newspaper industry – finally fell to the irresistible forces of phototypesetting and digital typography. Recently, many newspapers such as *The Guardian* in England have also carried out major overhauls of their typographic styling in acknowledgement of the higher expectations of an increasingly design and type conscious readership.

The 1970s saw the emergence and mushrooming of design groups throughout the world. One reason for this was the growing awareness by industry of the influence of type and image on their customers. They were also recognized as being creative specialists. As a result, the design groups attracted work that previously would have been consumed by the art departments of advertising agencies. New logos, corporate identity programmes, brochures, packaging, advertisements and other typographic jobbing work rolled off the production lines in ever-increasing numbers. Design became big business complete with new design management teams of account executives, business managers and financial directors.

By the 1980s computer graphics had become a commercial reality. At the touch of a button, type could take off, turn through 360 degrees and somersault its way across the screen. With the arrival of the Apple Macintosh computer, type could be squashed, distorted and overlapped in design studios all over the world. The Apple Macintosh and digital typography inspired a trend towards low-resolution typefaces such as those produced by British graphic designer Neville Brody (*b*1957) for *The Face* magazine and American designer Susanna Licko (*b*1961) for *Emigré* magazine.

Brody is a leading disciple of deconstructivism, a style which prevailed during the 1980s. Its characteristic features are a mix of type styles and sizes, extreme letterspacing and leading, and overlapping blocks of text to create new typographic effects and textures. The letterforms are subjected to computer-generated distortions of all kinds.

By the end of the decade, the high profile of design and the unprecedented exposure to type through DTP produced a new phenomenon known as type hype. After more than 500 years, type had become fashionable and a topic of immense public interest. For example, in the 1980s designer Erik Spickermann (*b* 1947) made a series about type for British television, the British public keenly debated the pros and cons of British Telecom's new logotype and even David Hockney could not resist producing his own book called *Just About Typefaces*. Everybody got in on the act.

As for the future, technological advances in digital typography are sure to continue, especially in the development of low cost, high-resolution output devices. There will be an increasing demand to explore new horizons in type and typographic design in order to satisfy the needs of tomorrow's type-conscious and typographically literate audience. Typographic design, which has long since been entwined with architecture and fashion, will continue to be cross-fertilized by new trends and fashions from other design disciplines. Since the arrival of the digital computer, it has certainly never been easier to produce typography or even a new typeface. As Stanley Morison said "the way to go forward is to make a step backward". For typographers, there is no doubt that one rich source of future inspiration will be the past.

3 During the 1980s, the Netherlands was a focal point for the development of the avant garde style which is characterized by a multiplicity of layered images often utilizing the techniques of collage, photomontage and multi-media effects. The style can be seen as a reaction to the ordered and disciplined minimal design of the Swiss movement during the 1960s and early 1970s.

4 This logotype for Cabaret Voltaire by Neville Brody is a good example of the outbreak of modified and distorted letterforms in the late 1980s.

5 A page from *Emigré*, a typographic journal which first appeared in the United States during 1990. The publication has featured many new typefaces specifically designed to withstand low resolution output on DTP systems. Susanna Licko of *Emigré* has been a leading figure in the development of this new type genre.

3

4

5

Humanist

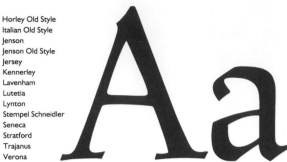

ITC Berkeley Old
 Style
Centaur
Cloister
Deepdene
Erasmus
ITC Golden Type
Guardi
Hollandse
 Mediaeval
Horley Old Style
Italian Old Style
Jenson
Jenson Old Style
Jersey
Kennerley
Lavenham
Lutetia
Lynton
Stempel Schneidler
Seneca
Stratford
Trajanus
Verona

Transitional

Apollo
Auriga
Baskerville No 2
Baskerville
ITC New
 Baskerville
Binny Old Style
Bitstream Charter
Bookman
ITC Bookman
Candida

Century Old Style
Century
 Schoolbook
Cheltenham
ITC Cheltenham
Clarion
ITC Clearface
Cochin
Comenius
Corona
Cremona
Demos
Electra
Else NPL
Excelsior

Fournier
Impressum
Ionic 5
Joanna
Melior
Meridien
Nimrod
Old Style 7
Olympian
Orion
Pilgrim
Poppl Pontifex
Quadriga Antiqua
ITC Slimbach

ITC Stone Serif
Textype
Times Europa
Versailles
ITC Zapf
 International

Di of

Madison
Monotype
 Modern 7
ITC Modern 216
Neo Didot
Photina
Primer
Scotch Roman
Scotch 2
Tiemann
Torino
Walbaum
ITC Zapf Book

Modern

Augustea
Haas Basilia
Bell
Bodoni
Bruce Old Style
Bulmer
Caledonia
Linotype
 Centennial
ITC Century
Century Expanded
Century Nova
Corvinus
De Vinne
Ellington
Fairfield
ITC Fenice
French Round Face
Iridium

Slab Serif

A & S Gallatin
Aachen
ITC American
 Typewriter
Beton
Calvert
City
Clarendon
New Clarendon
Courier
 Typewriter

Egyptian 505
Egyptienne
Glypha
Helserif
Linotype
 Typewriter
ITC Lubalin Graph
Memphis
ITC Officina Serif
Rockwell
Stempel Schadow
Serifa
Stymie
Volta

Directory of typefaces

Old Style

Aa

Albertina
Aster
Bembo
Berling
Breughel
Calisto
Cartier
Caslon
Adobe Caslon
Caslon Buch

Caslon Old Face No 2
ITC Caslon
Caslon 471
Caxton
Concorde
Eldorado
Foundry Old Style
ITC Galliard
Garamond
ITC Garamond
Simoncini Garamond

Stempel Garamond
Garamond No 3
Garamond 156
Garamont
Gazette
Goudy
Goudy Catalogue
Goudy Old Style

Granjon
Imprint
Janson
Lectura
Life
Minister
Palatino
Perpetua
Plantin
Poliphilus
Rotation
Sabon

Spectrum
Times New Roman
Times Roman
Trump Mediaeval
Van Dijck
Vendome
Weiss Roman
Z-Antiqua

Display

Aa

Albertus
Americana
American Uncial
Arrighi Italics
Bank Gothic
Fry's Baskerville
ITC Bauhaus
Belwe
ITC Benguiat
ITC Benguiat Gothic
Bernhard Modern
Blado Italics

Broadway
Brush Script
Cancelleresca Bastarda
Calypso
Caslon Antique
Cloister Black
Compacta Bold
Compacta Bold Outline

Copperplate Gothic
Folio Extra Bold
ITC Friz Quadrata
Futura Black
Gando Ronde
Gill Cameo
Gill Kayo
Goudy Text
Goudy Handtooled

Icone
Karnak Black
Klang
Koch Antiqua
Libra
Mistral
Mole Foliate
Neon
Neuland
ITC Newtext
Nicholas Cochin
ITC Novarese
Octavian
Pabst Extra Bold (or Cooper Black)
Playbill
Poster Bodoni Black

Prisma
Promotor
ITC Ronda
Sapphire
Shelley Allegro Script
Snell Roundhand Script
ITC Souvenir
ITC Souvenir Gothic
Spartan (size 1)
ITC Stymie Hairline
Tempo Heavy Condensed
ITC Tiffany
Wilhelm Klingspor Gotisch
Windsor
ITC Zapf Chancery Medium

Sans Serif

Aa

Abadi
Akzidenz Grotesk
Antique Olive
Arial

ITC Avant Garde Gothic
Avenir
Bell Centennial
Bell Gothic

Bernhard Gothic
Clearface Gothic
ITC Eras
Erbar
Eurostile
Folio
Foundry Sans
Franklin Gothic
ITC Franklin Gothic
Frutiger
Futura
Gill Sans
ITC Goudy Sans
Grotesque
Haas Unica

Heldustry
Helvetica
Neue Helvetica
Imago
Kabel
ITC Kabel
Lucida Sans
FF Meta
Metrolite
ITC Mixage
Neuzeit Grotesk
News Gothic
OCR-A
OCR-B
ITC Officina Sans
Optima

ITC Quay Sans
Spartan
ITC Stone Sans
Syntax
Trade Gothic
20th Century
Univers
Venus
Video

Humanist

Shortly after Gutenberg's invention of movable type in 1455, the first group of roman types, called Humanist, appeared in Italy during the 1460s and 1470s. By 1495, the first Old Style types of Aldus Manutius had appeared and the Humanist faces went into obscurity until they were revived by William Morris and the private press movement in the closing years of the 19th century. The term "Humanist" derives from the 15th-century Italian humanistic handwriting on which these types were closely modelled. The alternative name, "Venetian", refers to Venice, the home of the punchcutters of Humanist types and the printing capital of Europe at this time.

Typefaces included in this section are either revivals of Humanist designs of the 15th century or 20th-century romans which have some of the characteristics of Humanist historical models (some may also have features of other type groups). All faces have an oblique cross bar on the lower case 'e'.

The first Humanist typefaces were slavish copies of the 15th-century Italian humanist manuscript hand. The shapes and strokes formed by the quill pen were re-created in type by the early punchcutters so that the letters feature an oblique stress, oblique ascender and foot serifs on the lower case letters, a heavy weight, a wide set, heavy, steeply sloped serifs, and an oblique crossbar on the lower case 'e'.

The finest types cut in the Humanist style are those of Venetian printer Nicholas Jenson during the 1470s. His much admired white letter roman of 1476 was the model for William Morris' Golden type of 1891, which has recently been revived in a variety of weights by the International Typeface Corporation (ITC). Morris added weight to Jenson's type, giving it the blackness of a medieval manuscript which reduced Golden type to nothing more than a period or precious nostalgia face with few commercial applications.

As a result of the increasing interest in Humanist types created by Morris, many commercial typefounders produced revivals in the early 20th century. Kennerley (1911) designed by Frederic Goudy, Hollandse Mediaeval (1912) by S.H. de Roos, Cloister (1913) by Morris Benton and the foundry version of Centaur (1915) by Bruce Rogers appeared in quick succession. These were followed in the

In this Kelmscott Press edition from the 1890s (above), William Morris has recreated the weight of a medieval manuscript through the combination of his heavy Humanist face, Golden Type, solid setting, justified lines and decorated initial letter. The enlargement (right), shows the crudeness and wide set of the letters.

The main characteristics of Humanist typefaces

- a poor and gradual contrast between the thick and thin letterstrokes
- an oblique stress
- an oblique bar on the lower case 'e'
- the lower case letters have oblique ascender and foot serifs
- the capital letters are of the same height as the ascenders
- the serifs are heavy and steeply sloped
- the set of the letters is generally wide
- a heavy weight and colour in general appearance

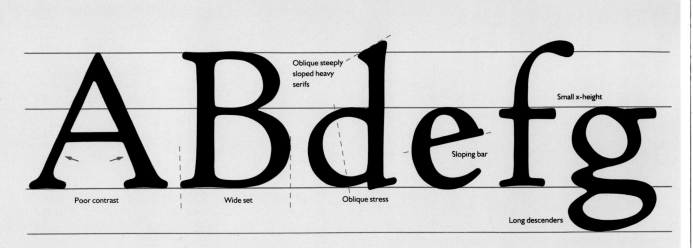

Oblique steeply sloped heavy serifs

Small x-height

Sloping bar

Poor contrast

Wide set

Oblique stress

Long descenders

1920s by Verona (1923), Monotype's Horley Old Style (1925), Frederic Goudy's Deepdene (1927), Italian Old Style (1927) and Monotype's cutting of Bruce Rogers' Centaur (1929) for mechanical composition. In 1938, Goudy also designed Californian Old Style which was revived in 1983 by ITC as Berkeley Old Style.

There are a small number of 20th-century romans that are included in this section, such as Seneca (1977–79) and Stratford (1978), which possess some characteristics of the Humanist style (in particular, the oblique cross bar of the lower case 'e') but they are not pure Humanist revivals.

Selecting Humanist typefaces

Humanist designs are not frequently used today for continuous text setting. Their heavy weight, wide set and obtrusively large capitals considerably impair their legibility. In addition, the strong calligraphic influence makes the letter shapes too irregular for continuous text reading. However, they are used extensively in advertisements and for small amounts of brochure copy.

Although many of these typefaces have a wide set, Jenson has the widest – it also has no italic font. Deepdene and Centaur have very long descenders and therefore require generous leading, making them very uneconomical in the use of space. Centaur, Guardi (1987) and Stempel Schneidler (1983) are the lightest of the Humanist types and, when used for large quantities of text, have less overpowering colour and texture on the page than most of the other Humanist faces. Guardi is a recent design which retains the crispness of pen-formed letters and has a range of weights and italics.

Trajanus (1939) and Hollandse Mediaeval should be used for display applications only; they are too idiosyncratic for text setting. However, while Seneca and Stratford retain the heavy weight and poor contrast of the Humanist design, they have been regularized making them more suitable for text setting. Both have a range of weights and matching italics. Italian Old Style has peculiar slab-like serifs which imitate the pen serifs of humanistic handwriting. This type is rarely used today and is really only suitable as a display face.

ITC Berkeley Old Style is a regularized version of Frederic Goudy's Californian Old Style (1938), but with an additional selection of weights and italics. The general lack of variations in weight and italics among the Humanist faces is a further reason why they are largely ignored for continuous text setting. In recognition of this problem, Monotype have recently added a bold roman and bold italics to Centaur.

The ease with which fonts can be produced for digital and phototypesetting has led many type manufacturers to dip into the past in search of new text and display types. With the development in technology, it is possible that other forgotten Humanist designs could be rediscovered, regularized in order to improve their legibility and make them more acceptable as text typefaces. If extra weights and italic fonts were also added, then perhaps Humanist types would enjoy a renaissance.

Quick selection guide
Availability: Average. Humanist types are not widely used for continuous text setting and their availability can be patchy.

PostScript fonts for the Apple Macintosh include: Centaur, ITC Berkeley Old Style and Stempel Schneidler.

Recent designs: Guardi (1987)

Faces by leading type designers: Centaur by Bruce Rogers; Kennerley, Deepdene and ITC Berkeley Old Style (previously Californian Old Style) by Frederic Goudy.

Display fonts related to faces in this section: Arrighi Italic (for Centaur).

Centaur

Centaur was designed by American book and type designer Bruce Rogers and is regarded as one of the finest revivals of a roman type ever produced. Modelled on Venetian printer Nicholas Jenson's roman of 1470, the type was originally cut as a foundry titling face for the Metropolitan Museum of New York but was subsequently adapted for mechanical composition by Monotype in England in 1929. The capitals retain the noble proportions of Roman inscriptional lettering and the whole font is lighter than Jenson's type but still retains the characteristics of a Humanist face. The italic, a reworked version of Frederic Warde's Arrighi Italic of 1923, has long descenders (which are almost flourishes) and some letters are of uneven width, such as the lower case 'z'. Centaur is both an elegant display and text face but because of its long descenders it requires leading. A bold weight of the roman and italic are now available.

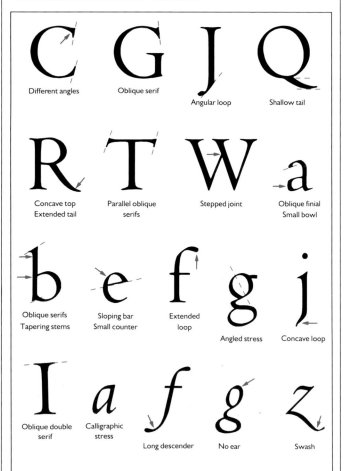

Different angles — Oblique serif — Angular loop — Shallow tail

Concave top / Extended tail — Parallel oblique serifs — Stepped joint — Oblique finial / Small bowl

Oblique serifs / Tapering stems — Sloping bar / Small counter — Extended loop — Angled stress — Concave loop

Oblique double serif — Calligraphic stress — Long descender — No ear — Swash

Centaur roman, 10/11 point, ranged left

Readability is the biggest single necessity for typography. Designers must always keep this as their chief priority. Copy which is meant to be read, but is hard to read no matter how clever or fashionable the layout might appear is badly designed. Readability need not mean dullness. On the contrary, the more attractive, the more exciting, the more creative the feel for tone and space, the more readable that design will become. Although body copy usually occupies the largest area of space, it often requires the least amount of the designer's time. Type is also used to attract attention, often in a headline where the design complements the message. Readability is the biggest

Centaur roman, 10/12 point, ranged left

Readability is the biggest single necessity for typography. Designers must always keep this as their chief priority. Copy which is meant to be read but is hard to read, no matter how clever or fashionable the layout might appear, is badly designed. Readability need not mean dullness. On the contrary, the more attractive, the more exciting, the more creative the feel for tone and space, the more readable that design will become. Although body copy usually occupies the largest area of space, it often requires the least amount of the designer's time. Type is also used to attract attention, often in a headline where the design complements the message. Readability is the biggest

Centaur roman, 10/13 point, ranged left

Readability is the biggest single necessity for typography. Designers must always keep this as their chief priority. Copy which is meant to be read but is hard to read, no matter how clever or fashionable the layout might appear, is badly designed. Readability need not mean dullness. On the contrary, the more attractive, the more exciting, the more creative the feel for tone and space, the more readable that design will become. Although body copy usually occupies the largest area of space, it often requires the least amount of the designer's time. Type is also used to attract attention, often in a headline where the design complements the message. Readability is the biggest

Centaur roman, 10/12 point, justified

Readability is the biggest single necessity for typography. Designers must always keep this as their chief priority. Copy which is meant to be read but is hard to read, no matter how clever or fashionable the layout might appear, is badly designed. Readability need not mean dullness. On the contrary, the more attractive, the more exciting, the more creative the feel for tone and space, the more readable that design will become. Although body copy usually occupies the largest area of space, it often requires the least amount of the designer's time. Type is also used to attract attention, often in a headline where the design complements the message. Readability is the biggest single necessity for typography.

Centaur italic, 10/12point, ranged left

Readability is the biggest single necessity for typography. Designers must always keep this as their chief priority. Copy which is meant to be read but is hard to read no matter how clever or fashionable the layout might appear is badly designed. Readability need not mean dullness. On the contrary, the more attractive, the more exciting, the more creative the feel for tone and space, the more readable that design will become. Although body copy usually occupies the largest area of space it often requires the least amount of the designer's time. Type is also used to attract attention, often in a headline where the design compliments the message. Readability is the biggest single necessity for typography. Designers

Centaur bold, 10/12 point, ranged left

Readability is the biggest single necessity for typography. Designers must always keep this as their chief priority. Copy which is meant to be read but is hard to read, no matter how clever or fashionable the layout might appear, is badly designed. Readability need not mean dullness. On the contrary, the more attractive, the more exciting, the more creative the feel for tone and space, the more readable that design will become. Although body copy usually occupies the largest area of space, it often requires the least amount of the designer's time. Type is also used to attract

Centaur roman

ABCDEFGHIJKLMNOPQRSTUVWXYZ
abcdefghijklmnopqrstuvwxyz
1234567890 1234567890 &!?().,.:;"" "£$¢

Centaur italic

ABCDEFGHIJKLMNOPQRSTUVWXYZ
abcdefghijklmnopqrstuvwxyz
1234567890 1234567890 &!?().,.:;""'£$¢

Centaur bold

ABCDEFGHIJKLMNOPQRSTUVWXYZ
abcdefghijklmnopqrstuvwxyz
1234567890 &!?().,.:;""'£$¢

Centaur bold italic

ABCDEFGHIJKLMNOPQRSTUVWXYZ
abcdefghijklmnopqrstuvwxyz
1234567890 &!?().,.:;" "£$¢

Other versions
Arrighi italic

41

Kennerley

Originally commissioned by New York Publisher Mitchell Kennerley for an edition of H.G. Wells' story *The Door in the Wall*, Kennerley was the American type designer Frederic Goudy's first commercially successful type. In 1920, it was made available for mechanical composition by Lanston Monotype in the USA. It has all the key Humanist characteristics but also some Goudy-like idiosyncracies such as the ear on the lower case 'g', the very short descenders, the hideously deformed figure 5 and the almost upright style of the italics. Kennerley is too ungainly and quirky to be a popular mainstream text face but it is a favourite with many typographers in the advertising world. It is available in both regular and bold weights.

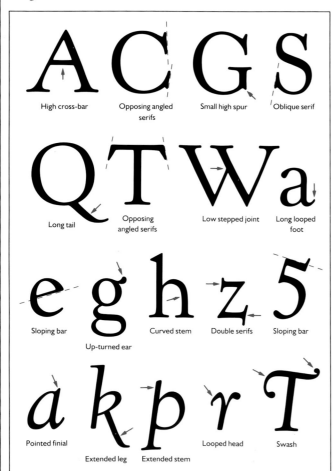

High cross-bar — Opposing angled serifs — Small high spur — Oblique serif

Long tail — Opposing angled serifs — Low stepped joint — Long looped foot

Sloping bar — Up-turned ear — Curved stem — Double serifs — Sloping bar

Pointed finial — Extended leg — Extended stem — Looped head — Swash

Kennerley roman, 10/11 point, ranged left

Readability is the biggest single necessity for typography. Designers must always keep this as their chief priority. Copy which is meant to be read but is hard to read, no matter how clever or fashionable the layout might appear, is badly designed. Readability need not mean dullness. On the contrary, the more attractive, the more exciting, the more creative the feel for tone and space, the more readable that design will become. Although body copy usually occupies the largest area of space, it often requires the least amount of the designer's time. Type is also used to attract attention,

Kennerley roman, 10/12 point, ranged left

Readability is the biggest single necessity for typography. Designers must always keep this as their chief priority. Copy which is meant to be read but is hard to read, no matter how clever or fashionable the layout might appear, is badly designed. Readability need not mean dullness. On the contrary, the more attractive, the more exciting, the more creative the feel for tone and space, the more readable that design will become. Although body copy usually occupies the largest area of space, it often requires the least amount of the designer's time. Type is also used to attract attention,

Kennerley roman, 10/13 point, ranged left

Readability is the biggest single necessity for typography. Designers must always keep this as their chief priority. Copy which is meant to be read but is hard to read, no matter how clever or fashionable the layout might appear, is badly designed. Readability need not mean dullness. On the contrary, the more attractive, the more exciting, the more creative the feel for tone and space, the more readable that design will become. Although body copy usually occupies the largest area of space, it often requires the least amount of the designer's time. Type is also used to attract attention,

Kennerley roman, 10/12 point, justified

Readability is the biggest single necessity for typography. Designers must always keep this as their chief priority. Copy which is meant to be read but is hard to read, no matter how clever or fashionable the layout might appear, is badly designed. Readability need not mean dullness. On the contrary, the more attractive, the more exciting, the more creative the feel for tone and space, the more readable that design will become. Although body copy usually occupies the largest area of space, it often requires the least amount of the designer's time. Type is also used to attract attention,

Kennerley italic, 10/12 point, ranged left

Readability is the biggest single necessity for typography. Designers must always keep this as their chief priority. Copy which is meant to be read but is hard to read, no matter how clever or fashionable the layout might appear, is badly designed. Readability need not mean dullness. On the contrary, the more attractive, the more exciting, the more creative the feel for tone and space, the more readable that design will become. Although body copy usually occupies the largest area of space, it often requires the least

Kennerley bold, 10/12 point, ranged left

Readability is the biggest single necessity for typography. Designers must always keep this as their chief priority. Copy which is meant to be read but is hard to read, no matter how clever or fashionable the layout might appear, is badly designed. Readability need not mean dullness. On the contrary, the more attractive, the more exciting, the more creative the feel for tone and space, the more readable that design will become. Although body copy usually occupies

Kennerley roman

ABCDEFGHIJKLMNOPQRSTUVWXYZ
abcdefghijklmnopqrstuvwxyz
1234567890 &!?().,:;""£$¢ƒ

Kennerley italic

ABCDEFGHIJKLMNOPQRSTUVWXYZ
abcdefghijklmnopqrstuvwxyz
1234567890 &!?().,:;""£$¢ƒ

Kennerley bold

ABCDEFGHIJKLMNOPQRSTUVWXYZ
abcdefghijklmnopqrstuvwxyz
1234567890 &!?().,:;""£$¢ƒ

Kennerley bold italic

ABCDEFGHIJKLMNOPQRSTUVWXYZ
abcdefghijklmnopqrstuvwxyz
1234567890 &!?().,:;""£$¢ƒ

ITC Berkeley Old Style
1983

ABCDEFGHIJKLMNOPQRSTUVWXYZ &!?(),.:;"" "

ABCDEFGHIJKLMNOPQRSTUVWXYZ abcdefghijklmnopqrstuvwxyz 1234567890

Cloister
1913

ABCDEFGHIJKLMNOPQRSTUVWXYZ &!?(),.:;"" "

ABCDEFGHIJKLMNOPQRSTUVWXYZ abcdefghijklmnopqrstuvwxyz 1234567890

Deepdene
1927

ABCDEFGHIJKLMNOPQRSTUVWXYZ &!?(),.:;" "

ABCDEFGHIJKLMNOPQRSTUVWXYZ abcdefghijklmnopqrstuvwxyz 1234567890

Erasmus
1923

ABCDEFGHIJKLMNOPQRSTUVWXY &!?().:;

ABCDEFGHIJKLMNOPQRSTUVWXYZ abcdefghijklmnopqrstuvwxyz 1234567890

ITC Golden Type

ABCDEFGHIJKLMNOPQRSTUVWXYZ &!?(),.:;" "

ABCDEFGHIJKLMNOPQRSTUVWXYZ abcdefghijklmnopqrstuvwxyz 1234567890

Guardi

ABCDEFGHIJKLMNOPQRSTUVWXYZ &!?(),.:;" "

ABCDEFGHIJKLMNOPQRSTUVWXYZ abcdefghijklmnopqrstuvwxyz 1234567890

Hollandse Mediaeval
1912

ABCDEFGHIJKLMNOPQRSTUVWXYZ &!?O,.:;" "

ABCDEFGHIJKLMNOPQRSTUVWXYZ abcdefghijklmnopqrstuvwxyz 1234567890

Horley Old Style
1925

ABCDEFGHIJKLMNOPQRSTUVWXYZ &!?(),.:;""

ABCDEFGHIJKLMNOPQRSTUVWXYZ abcdefghijklmnopqrstuvwxyz 1234567890

Italian Old Style
(Monotype)
1924

ABCDEFGHIJKLMNOPQRSTUVWXYZ &!?(),.:;"" "

ABCDEFGHIJKLMNOPQRSTUVWXYZ abcdefghijklmnopqrstuvwxyz 1234567890

Jenson

ABCDEFGHIJKLMNOPQRSTUVWXYZ &!?(),.:;"" "

abcdefghijklmnopqrstuvwxyz 1234567890 £$¢ƒ

ITC Berkeley Old Style
1983

ABCDEFGHIJKLMNOPQRSTUVWXYZ *abcdefghijklmnopqrstuvwxyz 1234567890*

abcdefghijklmnopqrstuvwxyz 1234567890 £$¢ƒ

Cloister
1913

ABCDEFGHIJKLMNOPQRSTUVWXYZ *abcdefghijklmnopqrstuvwxyz 1234567890*

abcdefghijklmnopqrstuvwxyz 1234567890 £$

Deepdene
1927

ABCCDDEFGGHIJKLMCMNNOPQRRSTTUVWXYZ *abcdefghijklmnopqrstuvwxyz 1234567890*

abcdefghijklmnopqrstuvwxyz 1234567890 £

Erasmus
1923

abcdefghijklmnopqrstuvwxyz 1234567890 £$¢

ITC Golden Type

abcdefghijklmnopqrstuvwxyz 1234567890 £$¢ƒ

Guardi

ABCDEFGHIJKLMNOPQRSTUVWXYZ *abcdefghijklmnopqrstuvwxyz 1234567890*

abcdefghijklmnopqrstuvwxyz 1234567890 £$¢

Hollandse Mediaeval
1912

abcdefghijklmnopqrstuvwxyz 1234567890 £$¢ƒ

Horley Old Style
1925

ABCDEFGHIJKLMNOPQRSTUVWXYZ *abcdefghijklmnopqrstuvwxyz 1234567890*

abcdefghijklmnopqrstuvwxyz 1234567890 £$¢ƒ

Italian Old Style
(Monotype)
1924

abcdefghijklmnopqrstuvwxyz 1234567890 £$¢ƒ

Jenson

45

Jenson Old Style

ABCDEFGHIJKLMNOPQRSTUVWXYZ &!?,:;" "

Jersey

ABCDEFGHIJKLMNOPQRSTUVWXYZ &!?(),:;" "

ABCDEFGHIJKLMNOPQRSTUVWXYZ abcdefghijklmnopqrstuvwxyz 1234567890

Lavenham

ABCDEFGHIJKLMNOPQRSTUVWXYZ &!?,:;" "

ABCDEFGHIJKLMNOPQRSTUVWXYZ abcdefghijklmnoprstuvwxyz1234567890

Lutetia
1925

ABCDEFGHIJKLMNOPQRSTUVWXYZ &!?(),:;" "

Lynton

ABCDEFGHIJKLMNOPQRSTUVWXYZ &!?(),:;" "

ABCDEFGHIJKLMNOPQRSTUVWXYZ abcdefghijklmnopqrstuvwxyz 1234567890

Stempel Schneidler
1983

ABCDEFGHIJKLMNOPQRSTUVWXYZ &!¿(),:;" "

ABCDEFGHIJKLMNOPQRSTUVWXYZ abcdefghijklmnopqrstuvwxyz 1234567890

Seneca
1977-79

ABCDEFGHIJKLMNOPQRSTUVWXYZ &!?,:;" "

ABCDEFGHIJKLMNOPQRSTUVWXYZ abcdefghijklmnopqrstuvwxyz1234567890

Stratford
1978

ABCDEFGHIJKLMNOPQRSTUVWXYZ &!?(),:;" "

ABCDEFGHIJKLMNOPQRSTUVWXYZ abcdefghijklmnopqrstuvwxyz 1234567890

Trajanus
1939

ABCDEFGHIJKLMNOPQRSTUVWXYZ &!?(),:;" "

ABCDEFGHIJKLMNOPQRSTUVWXYZ abcdefghijklmnopqrstuvwxyz 1234567890

Verona
1923

ABCDEFGHIJKLMNOPQRSTUVWXYZ &!?(),:;" "

ABCDEFGHIJKLMNOPQRSTUVWXYZ abcdefghijklmnopqrstuvwxyz 1234567890

Jenson Old Style

abcdefghijklmnopqrstuvwxyz *1234567890* £

Jersey

abcdefghijklmnopqrstuvwxyz 1234567890 £$

ABCDEFGHIJKLMNOPQRSTUVWXYZ abcdefghijklmnopqrstuvwxyz 1234567890

Lavenham

abcdefghijklmnopqrstuvwxyz 1234567890 £$

Lutetia
1925

abcdefghijklmnopqrstuvwxyz 1234567890

ABCDEFGHIJKLMNOPQRSTUVWXYZ abcdefghijklmnopqrstuvwxyz 1234567890

Lynton

abcdefghijklmnopqrstuvwxyz 1234567890 £$*f*

ABCDEFGHIJKLMNOPQRSTUVWXYZ abcdefghijklmnopqrstuvwxyz 1234567890

Stempel Schneidler
1983

abcdefghijklmnopqrstuvwxyz 1234567890 £$¢*f*

ABCDEFGHIJKLMNOPQRSTUVWXYZ abcdefghijklmnopqrstuvwxyz 1234567890

Seneca
1977-79

abcdefghijklmnopqrstuvwxyz 1234567890 £

ABCDEFGHIJKLMNOPQRSTUVWXYZ abcdefghijklmnopqrstuvwxyz

Stratford
1978

abcdefghijklmnopqrstuvwxyz 1234567890 £$¢*f*

ABCDEFGHIJKLMNOPQRSTUVWXYZ abcdefghijklmnopqrstuvwxyz 1234567890

Trajanus
1939

abcdefghijklmnopqrstuvwxyz 1234567890 £$¢*f*

ABCDEFGHIJKLMNOPQRSTUVWXYZ abcdefghijklmnopqrstuvwxyz 1234567890

Verona
1923

abcdefghijklmnopqrstuvwxyz 1234567890 £

ABCDEFGHIJKLMNOPQRSTUVWXYZ abcdefghijklmnopqrstuvwxyz 1234567890

1 A page from the Doves Bible (1903–05) – printed by T. J. Cobden-Sanderson and Emery Walker at the Doves Press. The Humanist-style Doves type shown here is a revival of Jenson's type of 1476. The paragraph marks are functional and introduce a decorative element to provide visual relief.

2 This poster for a typesetting company features Seneca, a 20th-century roman type, which has some Humanist features, such as the sloping crossbar on the lower case 'e', strong serifs, good weight and poor contrast in the width of the letterstrokes.

3 A poster from the Poems on the Underground series which is set in Deepdene (1924), by Frederic Goudy. The long ascenders and descenders make the type uneconomical in the use of vertical space. Although the type measure is long, good legibility is maintained by the generous use of leading.

4 On this title page by Bruce Rogers, the rules help maintain a pleasing shape to the centred type groupings. The decorative embellishments are bombs raining down from the sky.

son, & the people that were present with them, abode in Gibeah of Benjamin: I Samuel 13 but the Philistines encamped in Michmash. And the spoilers came out of the camp of the Philistines in three companies: one company turned unto the way that leadeth to Ophrah, unto the land of Shual: & another company turned the way to Beth-horon: & another company turned to the way of the border that looketh to the valley of Zeboim toward the wilderness. Now there was no smith found throughout all the land of Israel: for the Philistines said, Lest the Hebrews make them swords or spears: but all the Israelites went down to the Philistines, to sharpen every man his share, & his coulter, & his axe, & his mattock. Yet they had a file for the mattocks, and for the coulters, and for the forks, and for the axes, & to sharpen the goads. So it came to pass in the day of battle, that there was neither sword nor spear found in the hand of any of the people that were with Saul and Jonathan: but with Saul and with Jonathan his son was there found. And the garrison of the Philistines went out to the passage of Michmash. ¶ Now it came to pass upon a day, that Jonathan the 14 son of Saul said unto the young man that bare his armour, Come, & let us go over to the Philistines' garrison, that is on the other side. But he told not his father. And Saul tarried in the uttermost part of Gibeah under a pomegranate tree which is in Migron: and the people that were with him were about six hundred men; and Ahiah, the son of Ahitub, I-chabod's brother, the son of Phinehas, the son of Eli, the Lord's priest in Shiloh, wearing an ephod. And the people knew not that Jonathan was gone. And between the passages, by which Jonathan sought to go over unto the Philistines' garrison, there was a sharp rock on the one side, & a sharp rock on the other side: and the name of the one was Bozez, & the name of the other Seneh. The forefront of the one was situate northward over against Michmash, & the other southward over against Gibeah. And Jonathan said to the young man that bare his armour, Come, & let us go over unto the garrison of these uncircumcised: it may be that the Lord will work for us: for there is no restraint to the Lord to save by many or by few. And his armourbearer said unto him, Do all that is in thine heart: turn thee; behold, I am with thee according to thy heart. Then said Jonathan, Behold, we will pass over unto these men, & we will discover ourselves unto them. If they say thus unto us, Tarry until we come to you; then we will stand still in our place, and will not go up unto them. But if they say thus, Come up unto us; then we will go up: for the Lord hath delivered them into our hand: & this shall be a sign unto us. And both of them discovered themselves unto the garrison of the Philistines: & the Philistines said, Behold, the Hebrews come forth out of the holes where they had hid themselves. And the men of the garrison answered Jonathan & his armourbearer, & said, Come up to us, & we will shew you a thing. And Jonathan said unto his armourbearer, Come up after me: for the Lord hath delivered them into the hand of Israel. And Jonathan climbed up upon his hands and upon his feet, and his armourbearer after him:

2 a 369

1

Seneca

2

"Bombed but Unbeaten"

EXCERPTS FROM
THE WAR COMMENTARY OF
BEATRICE L. WARDE

PRINTED FOR FRIENDS OF FREEDOM
BY THE TYPOPHILES : NEW YORK : 1941

4

Love without hope, as when the young bird-catcher
Swept off his tall hat to the Squire's own daughter,
So let the imprisoned larks escape and fly LOVE
Singing about her head, as she rode by. WITH
-OUT
HOPE

Robert Graves (1895–1985)

Poems on the Underground
The Poetry Society 071-373 2551 · The British Council · The British Library (Zweig Programme) · Designed and typeset by APT Photoset 071-701 0477

Reprinted by permission of A.P. Watt Ltd from
Collected Poems (1975) © Robert Graves

3

Printer's Note

THE conversation from Dibdin's Bibliographical Decameron, which I have here reprinted, was chosen partly for its own pleasant quality and partly because of its appropriateness to the purpose of this pamphlet. Later bibliographical research has no doubt superseded Dibdin's in accuracy and completeness, but to many of us the charm of his style is as engaging as ever and his taste in printing as unimpeachable; and this brief account of seven early Venetian printers, with its islands of text and oceans of commentary, supplies just the right material for displaying Mr. Goudy's Italian Old Style under various requirements of composition. The new type itself, though showing the study of several of the best early Italian faces, reminds me most strongly and admirably of Ratdolt's fine Roman. Single letters of the font are quite full and round enough to look well in lines of almost any length, and its close fitting makes it especially suitable for composition in narrow measures, as (I hope) the following pages will show. It was, too, an interesting problem to work out a title-page and initials reminiscent of the simple wood-cut designs of the great Venetians, and I found abundant material for them amongst the ornaments furnished by the Monotype Company, even though a few astronomical signs have been pressed into service. In the text initials only have I departed from conventional practice by making photo-engravings in reverse after the designs were composed, to give the black ground effect of the early Italian wood-cut initials.

The mention of islands, above, suggests to me that when my own time comes to be marooned on a desert island (by a party of no longer indulgent friends, whose books I haven't completed, or whose letters I haven't answered) instead of taking along the favorite volumes that most amateur castaways vote for, I think I shall arrange to be shipwrecked in company with a Monotype caster and a select assortment of ornamental matrices. The fascination and amusement—and the occasional happy result—that can be got out of the almost numberless combinations of a few simple units would enable me to cast away for an indefinite period with great contentment.

BRUCE ROGERS

NEWS FROM NOWHERE OR AN EPOCH OF REST. CHAPTER I. DISCUSSION AND BED.

UP at the League, says a friend, there had been one night a brisk conversational discussion, as to what would happen on the Morrow of the Revolution, finally shading off into a vigorous statement by various friends, of their views on the future of the fully-developed new society.

SAYS our friend: Considering the subject, the discussion was good-tempered; for those present, being used to public meetings & after-lecture debates, if they did not listen to each other's opinions, which could scarcely be expected of them, at all events did not always attempt to speak all together, as is the custom of people in ordinary polite society when conversing

6

5 A page from a book designed in 1924 by Bruce Rogers, set in Italian Old Style roman and italic. The italic has some unusual swash characters, such as the 'T', and ligatures, such as 'st'. The page is decorated with a floriated initial letter and colophons – characteristic features of private press work.

6 A sample page from a Kelmscott Press edition (1892) that features the exclusive use of William Morris's Golden type – a revival of the Humanist type of Nicolas Jenson from 1476. The heaviness of the type matches the weight of the decorative initial letters, while the small counters of some letters, such as the lower case 'e', are filling in, and the excessive contrast of the heavy type against the background reduces legibility. By comparison, the Doves type opposite, which is also based on Jenson, is much lighter and more sharply cut than Morris's interpretation.

1 This page is from a pamphlet designed by Bruce Rogers in 1924, set in Italiana Old Style. The 'v' shape of the text, which is set in hot metal type, was more difficult to achieve in the 1920s than it would be today on the Macintosh computer.

2 Centaur Serials, a modern variation of Bruce Rogers' Centaur design from the 1920s, is used for this direct mail shot for a typesetting company. The letterspaced heading and aligning numerals create a nostalgic feel and the variations in "colour" of the text are produced by changes in case and measure. Notice how the long ascenders and descenders clash in some places in the text.

1

It's a Giorgio mushroom. And that makes all the difference in the world.

Backed by almost 70 years of growing, processing and R&D experience, Giorgio people know

what it takes to develop the right mushrooms for the right applications. A wide range of cuts,

GIORGIO.

sizes and types are available — all examined and graded to the highest standards we know.

Our own. Practically all of our mushrooms are grown, hand-picked and processed within

the confines of our 300-acre complex. This ensures that you'll consistently receive the

most extraordinary mushrooms available.

ORIGINATED
I · 9 · I · 4

BY BRUCE ROGERS AS A TITLING FOUNT ONLY FOR THE METROPOLITAN MUSEUM OF NEW YORK, CENTAUR HAD BEEN MODELLED ON JENSON'S ROMAN.

BY THE MID TWENTIES THE MONOTYPE CORPORATION WERE WORKING ON THEIR VERSION OF CENTAUR STILL ONLY A ROMAN FACE RECOMMENDING ARRIGHI ITALIC AS COMPANION.

After thoughtfully combining the original classical feel with present advertising typographical & media demands, Typeshop of Dusseldorf released Centaur Serials in 1981.

To put it mildly we're pleased to be able to offer all 5 weights on ADS 3000 with matching cuts on headline.

2

THE
DISCOVERY
of
SCOTLAND

MAURICE LINDSAY
(Robert Hale Ltd. London 1964)

Faujas St. Fond, the notable French geologist, visited Staffa in 1874

"Now that he was so near to Staffa, the ultimate objective of his long journey, Faujas was anxious to press on. He learned that the rest of the party had sailed at five o'clock for the island. However, the weather had begun to deteriorate, as it does quickly in these parts, and it soon became obvious that Faujas's friends must either have been storm-stayed somewhere, or be in considerable danger at sea. Four days after they had set out, the weather improved, and the anxious Faujas, walking on the Mull shore, saw them "with the aid of a good glass." When they landed, worn out with fatigue, cold and lack of food, and covered with lice, they certainly had a tale to tell. Their boat had only just been able to set them down on Staffa, though not without soaking them to the skin in the process, and had then been forced to run for shelter to Iona, fifteen miles away. Thus

stranded, the party, headed by the American, William Thornton, had to accept an offer of shelter for the night from the more prosperous of the two families living on Staffa. They found themselves sharing a 'black house' with the man of the house and his wife, six children, a cow, a pig, a dog and some hens. The floor was covered with straw which had been used to litter the cow some days before, and the only heat was the fire in the middle of the floor which was used for cooking, and the smoke from which, as it made its way towards the hole in the centre of the roof, dried their clothes'...[Faujas decided to set out, despite the tale he had heard about the difficulties of reaching the island as "determination and scientific curiosity overcame fear and prudence").

'The oats dipped in time with the singing, and Faujas grew drowsier and drowsier and

16

4

3 A traditional, established look and an Italian flavour is created by use of TF Habitat, a 20th-century roman type based on 15th-century Italian Humanist models. The large concave serifs are a common feature on Humanist typefaces. The squared-up, bleed photographs give the design a dynamic, modern feel.

4 The height of Humanist types is balanced by the generous leading in this spread from a catalogue. Notice how the first line of each paragraph is set to a wider measure to create hanging indents.

3

5 In this double page advertisement for Timberland, the type has been modified through the extensions of the ascenders. The overall feel of the design is of traditional qualities.

6 Stempel Schneidler (1983), a revival of Schneidler Old Style (1939), is used to reinforce a quality, established look in this advertisement for food retailer J. Sainsbury plc. In the heading, the descenders interlock with the ascenders to reduce the space between the lines.

7

7 For this card design, the type (Seneca) is used to create the image of food held in the bird's mouth.

Timberland. Because the earth is two-thirds water.

5

Who knows better than Sainsbury's how dryness can age the skin?

The 'J' skin care range. Exclusive to Sainsbury's.

6

Troubled employees cost money. They increase absenteeism, lateness, accidents, health insurance costs and ultimately, the costs of recruitment and training. An Employee Assistance Program can help troubled employees.

WHAT IS AN EMPLOYEE ASSISTANCE PROGRAM?
An Employee Assistance Program (EAP) is a cost-effective, early intervention system that helps employees with problems that interfere with their on-the-job functioning. Through the program, employees whose work performance is affected by alcohol, substance abuse, eating disorders, emotional, marital, family, gambling or financial problems are identified and aided in seeking treatment.

The EAP guarantees confidentiality for the employee, as dictated by the employer's personnel policy and by federal and state labor laws.

WHAT IS THE METHODIST HOSPITAL EAP CONSORTIUM?
Many local businesses and agencies are unable to assume the expense of an EAP. To help Brooklyn businesses provide EAP services, the New York State Division of Alcoholism and Alcohol Abuse awarded The Methodist Hospital a matching grant to develop an Employee Assistance Program Consortium. Through the consortium, organizations with fewer than 700 employees can enjoy dramatic cost-savings which allow them to offer employees quality assessment, counseling and referral services.

HOW DOES IT WORK?
After your company joins the Consortium, all of your employees will be informed about the program and encouraged to refer themselves confidentially – if they need help. Our off-workplace site helps to reinforce this important facet of the program and to increase employee-willingness to participate. Referral can also be made by an employee's supervisor, co-worker or family member.

Once the referral is made, the employee is assessed by a member of the Methodist EAP staff and treatment recommendations and/or referral to an appropriate outside agency is made. Up to seventy percent of all problems can be resolved through short-term counseling. Your employee's treatment and progress will be monitored by a professional staff member and re-entry into the workplace will also be monitored and evaluated.

We'll also train your management and supervisory staff to detect problems and respond effectively within the workplace environment.

Participation in the Methodist Hospital EAP Consortium assures compliance with the Federal Drug Free Work Place Law of 1988.

FOR MORE INFORMATION
Call (718) 780-3752 or 3753 or write to:
The Methodist Hospital
EAP Consortium
519 Sixth Street
Brooklyn, NY 11215

The staff of the Consortium is available to meet with interested groups to provide information or to answer any questions you may have.

THE METHODIST HOSPITAL

Employee Assistance Program

8

8 In this brochure for the Methodist Hospital, the contemporary Humanist-style type, Jersey, looks friendly but solid. The vertical direction of the large type creates interest, while its colour – blue – has a calming effect.

Old Style

The first Old Style type was cut by Francesco Griffo for *De Aetna*, a book published in Venice by Aldus Manutius in 1495. This type cast the mould for all the roman types which followed during the 16th, 17th and early 18th centuries in Italy, France, the Netherlands and England. Like the Humanist designs, Old Style types were largely forgotten until the revival of classic roman faces in the 1920s.

Old Style is known also as Old Face or Garalde (a name derived from Garamond and Aldine, the types of the Aldine Press of Aldus Manutius). Typefaces included in this section are either revivals of Old Style designs from the late 15th to early 18th centuries, or 20th-century romans that have some of the characteristics of Old Style models, although they may also have features of other type groups.

Old Style types display the same strong calligraphic influences as the earlier Humanist faces but the pen-formed shapes are sharper and more refined owing to the punchcutters' increasing skill with the engraving tool. These qualities can be seen in the first group of Old Style types, those of Aldus Manutius in Italy, which have a greater contrast between the thick and thin letterstrokes, lighter and bracketed serifs and a less heavy appearance than their Humanist predecessors. In addition, the cross-bar of the lower case 'e' is horizontal, the set of the letters is relatively narrow and the capital letters are shorter than the ascenders of the lower case. These changes are a departure from Humanist designs.

Old Style variations

The Aldine roman has been the subject of two revivals – Bembo (1929), a lighter and more regularized rendition than the original, and Poliphilus (1937), a "warts and all" facsimile copy. Other Old Style faces that are in the same mould are Goudy Old Style (1915), designed by Frederic Goudy, Hermann Zapf's Palatino (1949), Spectrum (1955) by Jan Van Krimpen and Chris Brand's Albertina (1964). The 16th-century French Old Style types that followed are lighter than the Italian models, the fit of the letters is better and the general effect has a greater elegance and harmony. Of course, the "jewel" in the Old Style crown is Garamond, first revived by American Typefounders in 1917 and shortly afterwards by just about every other

typefoundry in the world. Modern interpretations of the Garamond design are Sabon (1966) designed by Jan Tschichold and ITC Galliard (1978) by Matthew Carter.

The 17th-century Dutch punchcutters took the French Old Style models and enlarged the x-height, made the set narrower and increased the contrast between the thick and thin strokes. Dutch Old Style types are sharply cut, economical faces that reflect the considerable skill of Cristoffel Van Dijck and the other Dutch punchcutters. Van Dijck (1935), Janson (1937) and Ehrhardt (1937) are all revivals of 17th-century Dutch models.

The types cut by William Caslon in England during the early part of the 18th century have many of the characteristics of the Dutch Old Style but have a greater contrast between the thick and thin letterstrokes and a more vertical stress. Revivals of Caslon have been produced by Monotype, Linotype, ITC, Abode, American Typefounders (ATF) and others. Imprint (1913), issued by Monotype, is another revival based on William Caslon's types.

The first italic, the Aldine Italic (1501) (left), was a compressed and sloping design, originally conceived for reasons of economy in the use of space. When set, the type has a lighter appearance than roman because of its more pronounced calligraphic stress and the generous leading needed to compensate for the long ascenders and descenders. The capitals were roman, ranged below the height of the ascenders.

Quick selection guide
Availability: Excellent for most faces.

PostScript fonts for the Apple Macintosh: Garamond, Times New Roman, Plantin and other popular typefaces.

Recent designs: Calisto (1988), Caxton and Foundry Old Style Book.

Faces by leading type designers: Palatino by Hermann Zapf, Sabon by Jan Tschichold, ITC Galliard by Matthew Carter, Breughel by Adrian Frutiger.

Display fonts related to faces in this section: Goudy Handtooled (Goudy Old Style), Caslon Open Face (Caslon). Caslon Antique has no direct connection with Caslon.

Swash Characters: Stempel Garamond, Haas Caslon.

Special titling fonts: Bembo and Stempel Garamond.

Greek font availability: Times Roman No. 2 (Linotype) (1935).

The first italic types – 1501

Today, virtually all text typefaces have "matching" italic fonts, but this has not always been the case. The first italic type, the Aldine Italic, which was cut by Francesco Griffo in 1501, was designed independently from the roman face, as were Ludovico Arrighi's well-known italic (1523) and those of Robert Granjon (in the Basle style) during the 16th century. Although the italic and roman types were often cut on the same body size and used together, they were not designed as an integrated type family until about 1700. ITC Galliard and Ehrhardt are two of the many Old Style typefaces that have elegant italic fonts.

Selecting Old Style typefaces

While the Old Style type group does not have a monopoly on good text faces, you will find that many of the most legible and popular types for continuous reading are to be found in this section, such as Bembo, Caslon, Ehrhardt (1937), Garamond, Goudy Old Style, Palatino, Plantin (1913) and Times New Roman (1932). The factors contributing to their legibility include a medium weight, a medium contrast both between the thick and thin letter-strokes and against the background, and the openness of the easily recognizable unique shapes of each letterform.

Almost all of these typefaces have both roman and italic fonts in a variety of different weights. Among the exceptions are Aster (1958), which does not have a bold italic, and Cartier (1967) with no bold or bold italic. Some faces have extra bold or ultra weights, but these should be used sparingly as they tend to look clumsy – ITC Garamond Ultra is a case in point. Most Old Style types have a fairly neutral character, but one or two faces such as Poliphilus (1937) and Cartier have strong individual styles that impair legibility.

Dutch Old Style faces, such as Van Dijck and Ehrhardt have a narrower set, and combine legibility with economy in the use of space. For durability, consider using Times New Roman or Plantin which are faces with sufficient weight to withstand the effects of low grade printing or reproduction on coarse papers such as newsprint.

Breughel (1982) by Adrian Frutiger, Plantin, Times New Roman and most ITC designs have large x-heights which make them particularly suitable where good legibility and a small type size is required. Spectrum (1955) and Perpetua (1929) have long ascenders and descenders which require plenty of leading and this can be a problem if you are short of depth. Times New Roman or Goudy Old Style, with their short descenders, are useful alternatives.

The main characteristics of Old Style typefaces

- an oblique stress
- medium contrast between the thick and thin letterstrokes
- oblique ascender and foot serifs of the lower case letters
- medium weight and colour in general appearance
- bracketed serifs that are lighter than those of Humanist types
- horizontal cross bar of the lower case 'e'
- capitals that are usually shorter than the ascenders of the lower case letters

Italic Old Style / French Old Style / Dutch Old Style / English Old Style

53

Bembo

Bembo is Monotype's 1929 revival of Griffo's type for *De Aetna* by Cardinal Bembo (hence the name) which was published by Aldus Manutius in 1495. Unusually, two companion italic faces have been cut for the Bembo roman. The first, designed by calligrapher Alfred Fairbanks and called Narrow Bembo Italic, was regarded as insufficiently compatible with the roman and was issued as a separate face under the name of Bembo Condensed Italic. Subsequently, a second version that was more open was cut and this is the face shown here.

Bembo's credentials as a legible text face are beyond question. The roman is open, slightly narrow and of medium weight and its only irregularities are the unusual bowing strokes of the capital 'K'. The italic is angular and slightly compressed and is recognizable by the horizontal serif on the tail of the 'y'. Bembo is a popular book face that is available in a full range of weights.

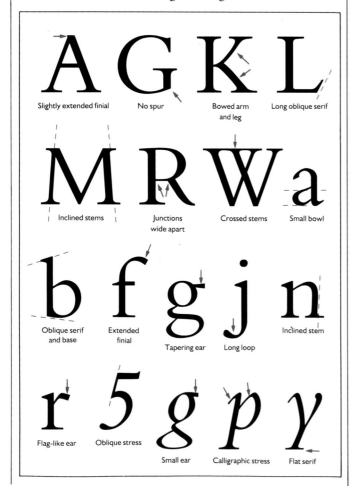

Slightly extended finial · No spur · Bowed arm and leg · Long oblique serif

Inclined stems · Junctions wide apart · Crossed stems · Small bowl

Oblique serif and base · Extended finial · Tapering ear · Long loop · Inclined stem

Flag-like ear · Oblique stress · Small ear · Calligraphic stress · Flat serif

Bembo roman, 10/11 point, ranged left

Readability is the biggest single necessity for typography. Designers must always keep this as their chief priority. Copy which is meant to be read but is hard to read, no matter how clever or fashionable the layout might appear, is badly designed. Readability need not mean dullness. On the contrary, the more attractive, the more exciting, the more creative the feel for tone and space, the more readable that design will become. Although body copy usually occupies the largest area of space, it often requires the least amount of the designer's time. Type is also used to attract attention,

Bembo roman, 10/12 point, ranged left

Readability is the biggest single necessity for typography. Designers must always keep this as their chief priority. Copy which is meant to be read but is hard to read, no matter how clever or fashionable the layout might appear, is badly designed. Readability need not mean dullness. On the contrary, the more attractive, the more exciting, the more creative the feel for tone and space, the more readable that design will become. Although body copy usually occupies the largest area of space it often requires the least amount of the designer's time. Type is also used to attract attention,

Bembo roman, 10/13 point, ranged left

Readability is the biggest single necessity for typography. Designers must always keep this as their chief priority. Copy which is meant to be read but is hard to read, no matter how clever or fashionable the layout might appear, is badly designed. Readability need not mean dullness. On the contrary, the more attractive, the more exciting, the more creative the feel for tone and space, the more readable that design will become. Although body copy usually occupies the largest area of space, it often requires the least amount of the designer's time. Type is also used to attract attention,

Bembo roman, 10/12 point, justified

Readability is the biggest single necessity for typography. Designers must always keep this as their chief priority. Copy which is meant to be read but is hard to read, no matter how clever or fashionable the layout might appear, is badly designed. Readability need not mean dullness. On the contrary, the more attractive, the more exciting, the more creative the feel for tone and space, the more readable that design will become. Although body copy usually occupies the largest area of space, it often requires the least amount of the designer's time. Type is also used to attract attention,

Bembo italic, 10/12 point, ranged left

Readability is the biggest single necessity for typography. Designers must always keep this as their chief priority. Copy which is meant to be read but is hard to read, no matter how clever or fashionable the layout might appear, is badly designed. Readability need not mean dullness. On the contrary, the more attractive, the more exciting, the more creative the feel for tone and space, the more readable that design will become. Although body copy usually occupies the largest area of space, it often requires the least amount of the designer's time.

Bembo bold, 10/12 point, ranged left

Readability is the biggest single necessity for typography. Designers must always keep this as their chief priority. Copy which is meant to be read but is hard to read, no matter how clever or fashionable the layout might appear, is badly designed. Readability need not mean dullness. On the contrary, the more attractive, the more exciting, the more creative the feel for tone and space, the more readable that design will become. Although body copy

Bembo roman

ABCDEFGHIJKLMNOPQRSTUVWXYZ
abcdefghijklmnopqrstuvwxyz
1234567890 1234567890 &!?().,:;""£$¢f

Bembo italic

ABCDEFGHIJKLMNOPQRSTUVWXYZ
abcdefghijklmnopqrstuvwxyz
1234567890 1234567890 &!?().,:;""£$¢f

Bembo bold

ABCDEFGHIJKLMNOPQRSTUVWXYZ
abcdefghijklmnopqrstuvwxyz
1234567890 1234567890 &!?().,:;""£$¢f

Bembo bold italic

ABCDEFGHIJKLMNOPQRSTUVWXYZ abcdefghijklmnopqrstuvwxyz 123456789

Bembo medium

ABCDEFGHIJKLMNOPQRSTUVWXYZ abcdefghijklmnopqrstuvwxyz 1234567890

Bembo medium italic

ABCDEFGHIJKLMNOPQRSTUVWXYZ abcdefghijklmnopqrstuvwxyz 1234567890

Bembo black

ABCDEFGHIJKLMNOPQRSTUVWXYZ abcdefghijklmnopqrstuvwxyz 123456789

Bembo black italic

ABCDEFGHIJKLMNOPQRSTUVWXYZ abcdefghijklmnopqrstuvwxyz 123456789

Other versions
Bembo Display

55

Caslon

In 1720 an English engraver called William Caslon established his own type foundry and in 1725 cut his first roman type which was issued in 1734. Greatly influenced by Dutch Old Style types, the type was cast to the highest standards. It was characterized by a medium to high contrast between the thick and thin letterstrokes (the thin strokes were nearly hairlines), large x-height, a near vertical stress, and fine (hairline) bracketed serifs. It was the final expression of Old Style and could almost be regarded as a Transitional face.

Caslon's types have been revived by many typefounders in the early part of the 20th century, including Linotype, American Typefounders and, more recently, Adobe and ITC. Caslon 540 and Caslon No. 3 (1913) have been chosen here because of their close relationship to the original design and their current availability. The ITC version is available in a wide range of weights and italics.

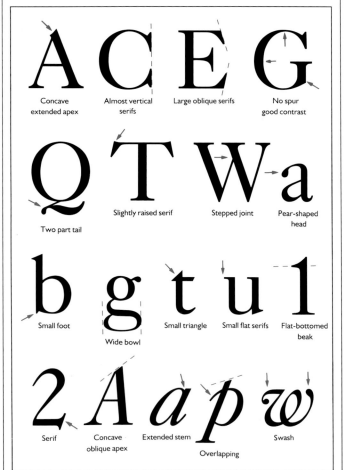

Concave extended apex · Almost vertical serifs · Large oblique serifs · No spur good contrast · Two part tail · Slightly raised serif · Stepped joint · Pear-shaped head · Small foot · Wide bowl · Small triangle · Small flat serifs · Flat-bottomed beak · Serif · Concave oblique apex · Extended stem · Overlapping · Swash

Caslon 540 roman, 10/11 point, ranged left

Readability is the biggest single necessity for typography. Designers must always keep this as their chief priority. Copy which is meant to be read but is hard to read, no matter how clever or fashionable the layout might appear, is badly designed. Readability need not mean dullness. On the contrary, the more attractive, the more exciting, the more creative the feel for tone and space, the more readable that design will become. Although body copy usually occupies the largest area of space, it often requires the least amount of the designer's time. Type is also used to attract attention, often in a headline

Caslon 540 roman, 10/12 point, ranged left

Readability is the biggest single necessity for typography. Designers must always keep this as their chief priority. Copy which is meant to be read but is hard to read, no matter how clever or fashionable the layout might appear, is badly designed. Readability need not mean dullness. On the contrary, the more attractive, the more exciting, the more creative the feel for tone and space, the more readable that design will become. Although body copy usually occupies the largest area of space, it often requires the least amount of the designer's time. Type is also used to attract attention, often in a headline

Caslon 540 roman, 10/13 point, ranged left

Readability is the biggest single necessity for typography. Designers must always keep this as their chief priority. Copy which is meant to be read but is hard to read, no matter how clever or fashionable the layout might appear, is badly designed. Readability need not mean dullness. On the contrary, the more attractive, the more exciting, the more creative the feel for tone and space, the more readable that design will become. Although body copy usually occupies the largest area of space, it often requires the least amount of the designer's time. Type is also used to attract attention, often in a headline

Caslon 540 roman, 10/12 point, justified

Readability is the biggest single necessity for typography. Designers must always keep this as their chief priority. Copy which is meant to be read but is hard to read, no matter how clever or fashionable the layout might appear, is badly designed. Readability need not mean dullness. On the contrary, the more attractive, the more exciting, the more creative the feel for tone and space, the more readable that design will become. Although body copy usually occupies the largest area of space, it often requires the least amount of the designer's time. Type is also used to attract attention, often in a headline

Caslon 540 italic, 10/12 point, ranged left

Readability is the biggest single necessity for typography. Designers must always keep this as their chief priority. Copy which is meant to be read but is hard to read, no matter how clever or fashionable the layout might appear, is badly designed. Readability need not mean dullness. On the contrary, the more attractive, the more exciting, the more creative the feel for tone and space, the more readable that design will become. Although body copy usually occupies the largest area of space, it often requires the least amount of the designer's time. Type is also used to attract

Caslon No 3 roman, 10/12 point, ranged left

Readability is the biggest single necessity for typography. Designers must always keep this as their chief priority. Copy which is meant to be read but is hard to read, no matter how clever or fashionable the layout might appear, is badly designed. Readability need not mean dullness. On the contrary, the more attractive, the more exciting, the more creative the feel for tone and space, the more readable that design will become. Although body copy usually occupies the

Caslon 540 roman

ABCDEFGHIJKLMNOPQRSTUVWXYZ
abcdefghijklmnopqrstuvwxyz
12345678901234567890 &!?().,:;""£$¢ƒ

Caslon 540 italic

ABCDEFGHIJKLMNOPQRSTUVWXYZ
abcdefghijklmnopqrstuvwxyz
1234567890123456789o &!?().,:;""£$¢ƒ

Caslon No 3 roman

ABCDEFGHIJKLMNOPQRSTUVWXYZ
abcdefghijklmnopqrstuvwxyz
1234567890123456789o &!?().,:;""£$¢ƒ

Caslon No 3 italic

ABCDEFGHIJKLMNOPQRSTUVWXYZ
abcdefghijklmnopqrstuvwxyz
1234567890123456789o &!?().,:;""£$¢ƒ

Other versions
Adobe Caslon
ITC Caslon
Caslon Old Face 2
Caslon 471 (ATF)

Ehrhardt

A popular Dutch Old Style face released by Monotype in 1937, Ehrhardt is a regularized version of an early 18th-century · cutting of Janson (originally designed by Hungarian Míklos Kis) from the Ehrhardt Foundry of Leipzig, Germany. It displays all the characteristics of the sharply cut 17th-century Dutch Old Style – a narrow set, medium to high contrast between the thick and thin letter strokes, a large x-height and letters that fit snugly together. It is a highly legible and economical text face. Regular and semi-bold weights of both the roman and italic (which is particularly graceful) are available, which have non-aligning and aligning figures. Ehrhardt and other Dutch Old Style types such as Janson and Van Dijck have become increasingly popular text faces in recent years.

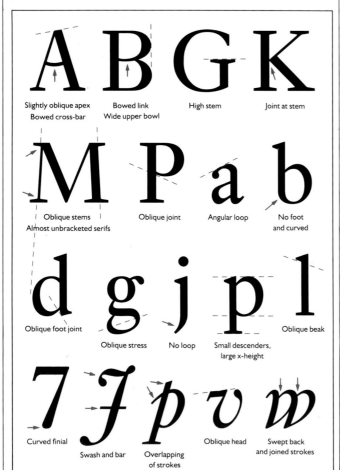

Slightly oblique apex Bowed link High stem Joint at stem
Bowed cross-bar Wide upper bowl

Oblique stems Oblique joint Angular loop No foot and curved
Almost unbracketed serifs

Oblique foot joint Oblique beak
Oblique stress No loop Small descenders, large x-height

Curved finial Oblique head Swept back and joined strokes
Swash and bar Overlapping of strokes

Ehrhardt roman, 10/11 point, ranged left

Readability is the biggest single necessity for typography. Designers must always keep this as their chief priority. Copy which is meant to be read but is hard to read, no matter how clever or fashionable the layout might appear, is badly designed. Readability need not mean dullness. On the contrary, the more attractive, the more exciting, the more creative the feel for tone and space, the more readable that design will become. Although body copy usually occupies the largest area of space, it often requires the least amount of the designer's time. Type is also used to attract attention, often in a headline where the design compliments the

Ehrhardt roman, 10/12 point, ranged left

Readability is the biggest single necessity for typography. Designers must always keep this as their chief priority. Copy which is meant to be read but is hard to read, no matter how clever or fashionable the layout might appear, is badly designed. Readability need not mean dullness. On the contrary, the more attractive, the more exciting, the more creative the feel for tone and space, the more readable that design will become. Although body copy usually occupies the largest area of space, it often requires the least amount of the designer's time. Type is also used to attract attention, often in a headline where the design compliments the

Ehrhardt roman, 10/13 point, ranged left

Readability is the biggest single necessity for typography. Designers must always keep this as their chief priority. Copy which is meant to be read but is hard to read, no matter how clever or fashionable the layout might appear, is badly designed. Readability need not mean dullness. On the contrary, the more attractive, the more exciting, the more creative the feel for tone and space, the more readable that design will become. Although body copy usually occupies the largest area of space, it often requires the least amount of the designer's time. Type is also used to attract attention, often in a headline where the design compliments the

Ehrhardt roman, 10/12 point, justified

Readability is the biggest single necessity for typography. Designers must always keep this as their chief priority. Copy which is meant to be read but is hard to read, no matter how clever or fashionable the layout might appear, is badly designed. Readability need not mean dullness. On the contrary, the more attractive, the more exciting, the more creative the feel for tone and space, the more readable that design will become. Although body copy usually occupies the largest area of space, it often requires the least amount of the designer's time. Type is also used to attract attention, often in a headline where the design compliments the

Ehrhardt italic, 10/12 point, ranged left

Readability is the biggest single necessity for typography. Designers must always keep this as their chief priority. Copy which is meant to be read but is hard to read, no matter how clever or fashionable the layout might appear, is badly designed. Readability need not mean dullness. On the contrary, the more attractive, the more exciting, the more creative the feel for tone and space, the more readable that design will become. Although body copy usually occupies the largest area of space, it often requires the least amount of the designer's time. Type is also used to attract attention, often

Ehrhardt semi bold, 10/12 point, ranged left

Readability is the biggest single necessity for typography. Designers must always keep this as their chief priority. Copy which is meant to be read but is hard to read, no matter how clever or fashionable the layout might appear, is badly designed. Readability need not mean dullness. On the contrary, the more attractive, the more exciting, the more creative the feel for tone and space, the more readable that design will become. Although body copy usually occupies the largest area of

Ehrhardt roman

ABCDEFGHIJKLMNOPQRSTUVWXYZ
abcdefghijklmnopqrstuvwxyz
1234567890&!?().,:;""£$¢f

Non-aligning figures are available.

Ehrhardt italic

ABCDEFGHIJKLMNOPQRSTUVWXYZ
abcdefghijklmnopqrstuvwxyz
1234567890&!?().,:;""£$¢f

Non-aligning figures are available.

Ehrhardt semi-bold

ABCDEFGHIJKLMNOPQRSTUVWXYZ
abcdefghijklmnopqrstuvwxyz
1234567890&!?().,:;""£$¢f

Non-aligning figures are available.

Ehrhardt semi-bold italic

ABCDEFGHIJKLMNOPQRSTUVWXYZ
abcdefghijklmnopqrstuvwxyz
1234567890&!?().,:;""£$¢f

Non-aligning figures are available.

Other versions
Ehrhardt 453 (Monotype)

Garamond

Stempel Garamond shown here is the most popular revival of the 16th-century French Old Style types, originally cut by Claude Garamond in 1530. Although Garamond's type was based on the roman of Venetian printer Aldus Manutius for *De Aetna* in 1495, it is lighter and has more contrast between the thick and thin letterstrokes, it has concave bracketed serifs, the fit of the letters is better, and the whole font appears elegant and harmonious. The italic is based on a mid 16th-century design of French punchcutter Robert Granjon.

During the 20th century, Garamond has been revived by almost every type manufacturer around the world including American Typefounders (the first), Monotype, Linotype (as Granjon), Berthold and ITC. Stempel Garamond (1924) has been selected here because it is based on the original punches of Garamond and is manufactured in an extensive range of weights, widths and italics.

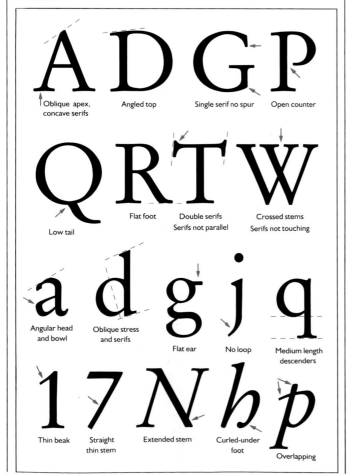

Stempel Garamond roman, 10/11 point, ranged left

Readability is the biggest single necessity for typography. Designers must always keep this as their chief priority. Copy which is meant to be read but is hard to read, no matter how clever or fashionable the layout might appear, is badly designed. Readability need not mean dullness. On the contrary, the more attractive, the more exciting, the more creative the feel for tone and space, the more readable that design will become. Although body copy usually occupies the largest area of space, it often requires the least amount of the designer's time. Type is also used to attract attention, often in a headline where the design

Stempel Garamond roman, 10/12 point, ranged left

Readability is the biggest single necessity for typography. Designers must always keep this as their chief priority. Copy which is meant to be read but is hard to read, no matter how clever or fashionable the layout might appear, is badly designed. Readability need not mean dullness. On the contrary, the more attractive, the more exciting, the more creative the feel for tone and space, the more readable that design will become. Although body copy usually occupies the largest area of space, it often requires the least amount of the designer's time. Type is also used to attract attention, often in a headline where the design

Stempel Garamond roman, 10/13 point, ranged left

Readability is the biggest single necessity for typography. Designers must always keep this as their chief priority. Copy which is meant to be read but is hard to read, no matter how clever or fashionable the layout might appear, is badly designed. Readability need not mean dullness. On the contrary, the more attractive, the more exciting, the more creative the feel for tone and space, the more readable that design will become. Although body copy usually occupies the largest area of space, it often requires the least amount of the designer's time. Type is also used to attract attention, often in a headline where the design

Stempel Garamond roman, 10/12 point, justified

Readability is the biggest single necessity for typography. Designers must always keep this as their chief priority. Copy which is meant to be read but is hard to read, no matter how clever or fashionable the layout might appear, is badly designed. Readability need not mean dullness. On the contrary, the more attractive, the more exciting, the more creative the feel for tone and space, the more readable that design will become. Although body copy usually occupies the largest area of space, it often requires the least amount of the designer's time. Type is also used to attract attention, often in a headline where the design

Stempel Garamond italic, 10/12 point, ranged left

Readability is the biggest single necessity for typography. Designers must always keep this as their chief priority. Copy which is meant to be read but is hard to read, no matter how clever or fashionable the layout might appear, is badly designed. Readability need not mean dullness. On the contrary, the more attractive, the more exciting, the more creative the feel for tone and space, the more readable that design will become. Although body copy usually occupies the largest area of space, it often requires

Stempel Garamond bold, 10/12 point, ranged left

Readability is the biggest single necessity for typography. Designers must always keep this as their chief priority. Copy which is meant to be read but is hard to read, no matter how clever or fashionable the layout might appear, is badly designed. Readability need not mean dullness. On the contrary, the more attractive, the more exciting, the more creative the feel for tone and space, the more readable that design will become. Although body copy usually occupies the largest area of space, it often

Stempel Garamond roman

ABCDEFGHIJKLMNOPQRSTUVWXYZ
abcdefghijklmnopqrstuvwxyz
1234567890 1234567890 &!?().,:;""£$¢f

Stempel Garamond italic

ABCDEFGHIJKLMNOPQRSTUVWXYZ
abcdefghijklmnopqrstuvwxyz
1234567890 1234567890 &!?().,:;""£$¢f

Stempel Garamond bold

ABCDEFGHIJKLMNOPQRSTUVWXYZ
abcdefghijklmnopqrstuvwxyz
1234567890 1234567890 &!?().,:;""£$¢f

Stempel Garamond bold italic
ABCDEFGHIJKLMNOPQRSTUVWXYZ abcdefghijklmnopqrstuvwxyz 1234567890

Stempel Garamond light
ABCDEFGHIJKLMNOPQRSTUVWXYZ abcdefghijklmnopqrstuvwxyz 1234567890

Stempel Garamond light italic
ABCDEFGHIJKLMNOPQRSTUVWXYZ abcdefghijklmnopqrstuvwxyz 1234567890

Stempel Garamond black
ABCDEFGHIJKLMNOPQRSTUVWXYZ abcdefghijklmnopqrstuvwxyz 12345

Stempel Garamond black italic
ABCDEFGHIJKLMNOPQRSTUVWXYZ abcdefghijklmnopqrstuvwxyz 12345

Other versions
Garamond (Berthold)
ITC Galliard
Garamond No 3 (Linotype)
Garamond 156 (Monotype)
ATF Garamond
ITC Garamond
Simoncini Garamond
Garamont
Garaldus
Granjon

Goudy Old Style

Designed by prolific American type designer Frederic Goudy (who produced all the original drawings free-hand), Goudy Old Style (1915) was one of the most commercially successful and popular faces ever produced by American Typefounders (ATF). Goudy used Italian Renaissance lettering as the inspiration for his capital letters which have small concave serifs and a low contrast between the thick and thin letterstrokes. The lower case is easily identifiable by its very short descenders and the peculiar upwardly-projecting ear on the lower case 'g'. The italic is almost upright. The short descenders make it economical in depth and for this reason it is popular in advertising circles. Goudy parted company with ATF and the later Goudy Catalogue and Goudy Handtooled were designed by ATF's in-house designer Morris Benton. Goudy Old Style remains popular as a titling or display face but less so for continuous text setting.

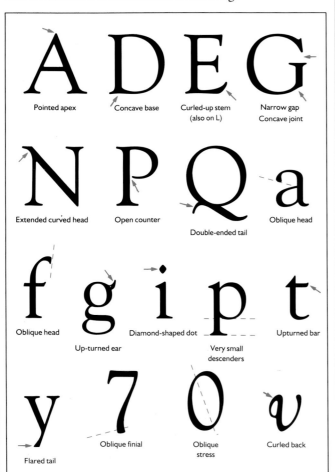

Pointed apex — Concave base — Curled-up stem (also on L) — Narrow gap / Concave joint

Extended curved head — Open counter — Double-ended tail — Oblique head

Oblique head — Up-turned ear — Diamond-shaped dot — Very small descenders — Upturned bar

Flared tail — Oblique finial — Oblique stress — Curled back

Goudy Old Style roman, 10/11 point, ranged left

Readability is the biggest single necessity for typography. Designers must always keep this as their chief priority. Copy which is meant to be read but is hard to read, no matter how clever or fashionable the layout might appear, is badly designed. Readability need not mean dullness. On the contrary, the more attractive, the more exciting, the more creative the feel for tone and space, the more readable that design will become. Although body copy usually occupies the largest area of space, it often requires the least amount of the designer's time. Type is also used to attract attention, often in a headline where the design complements the

Goudy Old Style roman, 10/12 point, ranged left

Readability is the biggest single necessity for typography. Designers must always keep this as their chief priority. Copy which is meant to be read but is hard to read, no matter how clever or fashionable the layout might appear, is badly designed. Readability need not mean dullness. On the contrary, the more attractive, the more exciting, the more creative the feel for tone and space, the more readable that design will become. Although body copy usually occupies the largest area of space, it often requires the least amount of the designer's time. Type is also used to attract attention, often in a headline where the design complements the

Goudy Old Style roman, 10/13 point, ranged left

Readability is the biggest single necessity for typography. Designers must always keep this as their chief priority. Copy which is meant to be read but is hard to read, no matter how clever or fashionable the layout might appear, is badly designed. Readability need not mean dullness. On the contrary, the more attractive, the more exciting, the more creative the feel for tone and space, the more readable that design will become. Although body copy usually occupies the largest area of space, it often requires the least amount of the designer's time. Type is also used to attract attention, often in a headline where the design complements the

Goudy Old Style roman, 10/12 point, justified

Readability is the biggest single necessity for typography. Designers must always keep this as their chief priority. Copy which is meant to be read but is hard to read, no matter how clever or fashionable the layout might appear, is badly designed. Readability need not mean dullness. On the contrary, the more attractive, the more exciting, the more creative the feel for tone and space, the more readable that design will become. Although body copy usually occupies the largest area of space, it often requires the least amount of the designer's time. Type is also used to attract attention, often in a headline where the design complements the

Goudy Old Style italic, 10/12 point, ranged left

Readability is the biggest single necessity for typography. Designers must always keep this as their chief priority. Copy which is meant to be read but is hard to read, no matter how clever or fashionable the layout might appear, is badly designed. Readability need not mean dullness. On the contrary, the more attractive, the more exciting, the more creative the feel for tone and space, the more readable that design will become. Although body copy usually occupies the largest area of space, it often requires the least amount of the designer's time. Type is also used to attract

Goudy bold, 10/12 point, ranged left

Readability is the biggest single necessity for typography. Designers must always keep this as their chief priority. Copy which is meant to be read but is hard to read, no matter how clever or fashionable the layout might appear, is badly designed. Readability need not mean dullness. On the contrary, the more attractive, the more exciting, the more creative the feel for tone and space, the more readable that design will become. Although body copy usually occupies the largest area of space, it often requires the least amount of the designer's

Goudy Old Style roman

ABCDEFGHIJKLMNOPQRSTUVWXYZ
abcdefghijklmnopqrstuvwxyz
1234567890 1234567890 &!?().,:;""£$¢f

Goudy Old Style italic

ABCDEFGHIJKLMNOPQRSTUVWXYZ
abcdefghijklmnopqrstuvwxyz
1234567890 1234567890 &!?().,:;""£$¢f

Goudy bold

ABCDEFGHIJKLMNOPQRSTUVWXYZ
abcdefghijklmnopqrstuvwxyz
1234567890 &!?().,:;""£$¢f

Goudy bold italic

ABCDEFGHIJKLMNOPQRSTUVWXYZ
abcdefghijklmnopqrstuvwxyz
1234567890 &!?().,:;""£$¢f

Other versions

Goudy Old Style (Monotype)
Goudy Modern (Monotype)
Goudy Catalogue (Monotype)
Goudy WTC

Palatino

Palatino was designed in 1929 by the famous German type designer and calligrapher Hermann Zapf for the Stempel Foundry in Frankfurt. Zapf added weight to the letters so that it could withstand and compensate for the reducing effect on type of the lithographic and gravure printing processes. It is an open face which shows a strong calligraphic influence and the capitals 'E', 'F' and 'L' have the narrow proportions of classical Roman letters. Zapf wanted to call the type Medici, but the foundry named it after a 16th-century calligrapher called Giovanbattista Palatino. Later, Zapf designed related titling fonts called Michaelangelo and Sistina. Palatino is offered in a full range of weights and italics and although Palatino was originally conceived as a display face, it is widely used as a text typeface for books. The type has been heavily pirated over the years and versions have appeared under a variety of other names such as Paladium, Andover and Malibu.

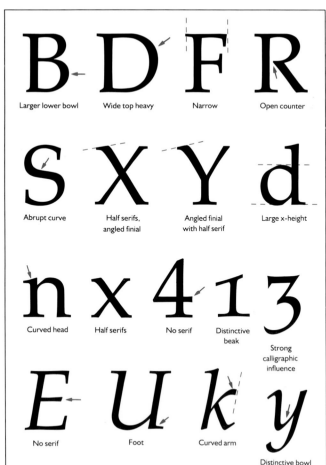

Palatino roman, 10/11 point, ranged left

Readability is the biggest single necessity for typography. Designers must always keep this as their chief priority. Copy which is meant to be read but is hard to read, no matter how clever or fashionable the layout might appear, is badly designed. Readability need not mean dullness. On the contrary, the more attractive, the more exciting, the more creative the feel for tone and space, the more readable that design will become. Although body copy usually occupies the largest area of space, it often requires the least amount of the designer's time. Type is also used to attract attention

Palatino roman, 10/12 point, ranged left

Readability is the biggest single necessity for typography. Designers must always keep this as their chief priority. Copy which is meant to be read but is hard to read, no matter how clever or fashionable the layout might appear, is badly designed. Readability need not mean dullness. On the contrary, the more attractive, the more exciting, the more creative the feel for tone and space, the more readable that design will become. Although body copy usually occupies the largest area of space, it often requires the least amount of the designer's time. Type is also used to attract attention

Palatino roman, 10/13 point, ranged left

Readability is the biggest single necessity for typography. Designers must always keep this as their chief priority. Copy which is meant to be read but is hard to read, no matter how clever or fashionable the layout might appear, is badly designed. Readability need not mean dullness. On the contrary, the more attractive, the more exciting, the more creative the feel for tone and space, the more readable that design will become. Although body copy usually occupies the largest area of space, it often requires the least amount of the designer's time. Type is also used to attract attention

Palatino roman, 10/12 point, justified

Readability is the biggest single necessity for typography. Designers must always keep this as their chief priority. Copy which is meant to be read but is hard to read, no matter how clever or fashionable the layout might appear, is badly designed. Readability need not mean dullness. On the contrary, the more attractive, the more exciting, the more creative the feel for tone and space, the more readable that design will become. Although body copy usually occupies the largest area of space, it often requires the least amount of the designer's time. Type is also used to attract attention

Palatino italic, 10/12 point, ranged left

Readability is the biggest single necessity for typography. Designers must always keep this as their chief priority. Copy which is meant to be read but is hard to read, no matter how clever or fashionable the layout might appear, is badly designed. Readability need not mean dullness. On the contrary, the more attractive, the more exciting, the more creative the feel for tone and space, the more readable that design will become. Although body copy usually occupies the largest area of space, it often requires the least amount of the designer's time.

Palatino bold, 10/12 point, ranged left

Readability is the biggest single necessity for typography. Designers must always keep this as their chief priority. Copy which is meant to be read but is hard to read, no matter how clever or fashionable the layout might appear, is badly designed. Readability need not mean dullness. On the contrary, the more attractive, the more exciting, the more creative the feel for tone and space, the more readable that design will become. Although body copy usually occupies the

Palatino roman

ABCDEFGHIJKLMNOPQRSTUVWXYZ
abcdefghijklmnopqrstuvwxyz
1234567890 1234567890 &!?().,:;""''£$¢ƒ

Palatino italic

ABCDEFGHIJKLMNOPQRSTUVWXYZ
abcdefghijklmnopqrstuvwxyz
1234567890 1234567890 &!?().,:;""''£$¢ƒ

Palatino bold

ABCDEFGHIJKLMNOPQRSTUVWXYZ
abcdefghijklmnopqrstuvwxyz
1234567890 1234567890 &!?().,:;""''£$¢ƒ

Palatino bold italic

ABCDEFGHIJKLMNOPQRSTUVWXYZ abcdefghijklmnopqrstuvwxyz 1234567890

Palatino light

ABCDEFGHIJKLMNOPQRSTUVWXYZ abcdefghijklmnopqrstuvwxyz 1234567890

Palatino medium

ABCDEFGHIJKLMNOPQRSTUVWXYZ abcdefghijklmnopqrstuvwxyz 1234567890

Palatino medium italic

ABCDEFGHIJKLMNOPQRSTUVWXYZ abcdefghijklmnopqrstuvwxyz 1234567890

Palatino black

ABCDEFGHIJKLMNOPQRSTUVWXYZ abcdefghijklmnopqrstuvwxyz 123456

Also available
Light italic
Black italic

Other versions
Palatino 1950

65

Perpetua

Eric Gill, the highly skilled English lettercutter, writer and sculptor, originally designed this type for Stanley Morison at Monotype in 1925. It was Monotype's first original design produced under Morison's direction. The face retains the qualities of stone-cut lettering (which was Morison's intention) as well as the Old Style features of an oblique stress and medium contrast between the thick and thin letterstrokes. The serifs are particularly small, sharply cut and horizontal. The italic, which was issued later and originally called Felicity (but later re-cut by Gill and issued as Perpetua Italic), is more akin to a sloping roman rather than the usual cursive-style letterform. Perpetua's small x-height, which impairs legibility, and long ascenders and descenders, which need plenty of leading, limit its use as a mainstream text face. However, the roman and italic fonts are widely available in both regular and bold weights. An extra bold version of the roman and a tilting font have also been produced.

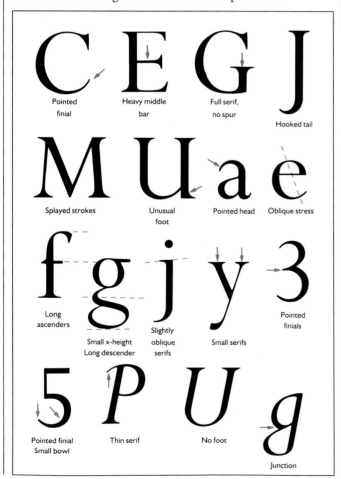

Perpetua roman, 10/11 point, ranged left

Readability is the biggest single necessity for typography. Designers must always keep this as their chief priority. Copy which is meant to be read but is hard to read, no matter how clever or fashionable the layout might appear, is badly designed. Readability need not mean dullness. On the contrary, the more attractive, the more exciting, the more creative the feel for tone and space, the more readable that design will become. Although body copy usually occupies the largest area of space, it often requires the least amount of the designer's time. Type is also used to attract attention, often in a headline where the design complements the message. It may do this by being

Perpetua roman, 10/12 point, ranged left

Readability is the biggest single necessity for typography. Designers must always keep this as their chief priority. Copy which is meant to be read but is hard to read, no matter how clever or fashionable the layout might appear, is badly designed. Readability need not mean dullness. On the contrary, the more attractive, the more exciting, the more creative the feel for tone and space, the more readable that design will become. Although body copy usually occupies the largest area of space, it often requires the least amount of the designer's time. Type is also used to attract attention, often in a headline where the design complements the message. It may do this by being

Perpetua roman, 10/13 point, ranged left

Readability is the biggest single necessity for typography. Designers must always keep this as their chief priority. Copy which is meant to be read but is hard to read, no matter how clever or fashionable the layout might appear, is badly designed. Readability need not mean dullness. On the contrary, the more attractive, the more exciting, the more creative the feel for tone and space, the more readable that design will become. Although body copy usually occupies the largest area of space, it often requires the least amount of the designer's time. Type is also used to attract attention, often in a headline where the design complements the message. It may do this by being

Perpetua roman, 10/12 point, justified

Readability is the biggest single necessity for typography. Designers must always keep this as their chief priority. Copy which is meant to be read but is hard to read, no matter how clever or fashionable the layout might appear, is badly designed. Readability need not mean dullness. On the contrary, the more attractive, the more exciting, the more creative the feel for tone and space, the more readable that design will become. Although body copy usually occupies the largest area of space, it often requires the least amount of the designer's time. Type is also used to attract attention, often in a headline where the design complements the message. It may do this by being

Perpetua italic, 10/12 point, ranged left

Readability is the biggest single necessity for typography. Designers must always keep this as their chief priority. Copy which is meant to be read but is hard to read, no matter how clever or fashionable the layout might appear, is badly designed. Readability need not mean dullness. On the contrary, the more attractive, the more exciting, the more creative the feel for tone and space, the more readable that design will become. Although body copy usually occupies the largest area of space, it often requires the least amount of the designer's time. Type is also used to attract attention, often in a headline where the design complements the message. It may do this by being

Perpetua bold, 10/12 point, ranged left

Readability is the biggest single necessity for typography. Designers must always keep this as their chief priority. Copy which is meant to be read but is hard to read, no matter how clever or fashionable the layout might appear, is badly designed. Readability need not mean dullness. On the contrary, the more attractive, the more exciting, the more creative the feel for tone and space, the more readable that design will become. Although body copy usually occupies the largest area of space, it often

Perpetua roman

ABCDEFGHIJKLMNOPQRSTUVWXYZ

abcdefghijklmnopqrstuvwxyz

1234567890 1234567890 &!?().,:;""''£$¢f

Non-aligning figures are available.

Perpetua italic

ABCDEFGHIJKLMNOPQRSTUVWXYZ

abcdefghijklmnopqrstuvwxyz

1234567890 1234567890 &!?().,:;""''£$¢f

Non-aligning figures are available.

Perpetua bold

ABCDEFGHIJKLMNOPQRSTUVWXYZ

abcdefghijklmnopqrstuvwxyz

1234567890 &!?().,:;""''£$¢f

Non-aligning figures are available.

Perpetua bold italic

ABCDEFGHIJKLMNOPQRSTUVWXYZ

abcdefghijklmnopqrstuvwxyz

1234567890 &!?().,:;""''£$¢f

Non-aligning figures are available.

Also available
Perpetua Titling (capitals only)

Plantin

Monotype's Plantin, designed by works manager Frank Pierpoint in 1913, is a modern cutting of a 16th-century roman type by Robert Granjon. The face takes its name from Christopher Plantin, an Antwerp printer, for whom Granjon cut his type, although Plantin does not appear to have used it. Pierpoint had seen the type in an *Index Characterum* of the Plantin-Moretus Press in 1905 (the Moretus family had inherited Plantin's types in the 17th century). He deliberately thickened up the design, in order to compensate for printing on art and coated papers which had the effect of reducing the weight of the type. The large x-height makes the type both legible and economical. The roman and italic faces are available in light, regular and bold weights and the roman font comes in a bold condensed weight. Plantin's practical qualities have made it a highly favoured text face. It has one further claim to fame – it was the model for Times New Roman.

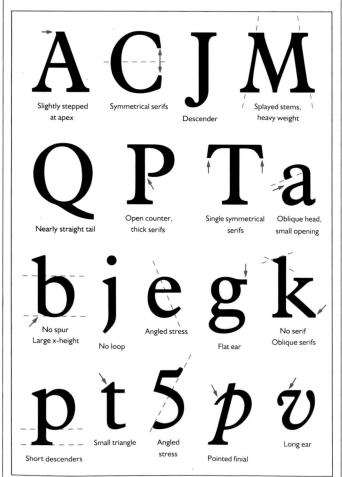

Plantin roman, 10/11 point, ranged left

Readability is the biggest single necessity for typography. Designers must always keep this as their chief priority. Copy which is meant to be read but is hard to read, no matter how clever or fashionable the layout might appear, is badly designed. Readability need not mean dullness. On the contrary, the more attractive, the more exciting, the more creative the feel for tone and space, the more readable that design will become. Although body copy usually occupies the largest area of space, it often requires the least amount of the designer's time. Type is also used to attract attention, often in a headline

Plantin roman, 10/12 point, ranged left

Readability is the biggest single necessity for typography. Designers must always keep this as their chief priority. Copy which is meant to be read but is hard to read, no matter how clever or fashionable the layout might appear, is badly designed. Readability need not mean dullness. On the contrary, the more attractive, the more exciting, the more creative the feel for tone and space, the more readable that design will become. Although body copy usually occupies the largest area of space, it often requires the least amount of the designer's time. Type is also used to attract attention, often in a headline

Plantin roman, 10/13 point, ranged left

Readability is the biggest single necessity for typography. Designers must always keep this as their chief priority. Copy which is meant to be read but is hard to read, no matter how clever or fashionable the layout might appear, is badly designed. Readability need not mean dullness. On the contrary, the more attractive, the more exciting, the more creative the feel for tone and space, the more readable that design will become. Although body copy usually occupies the largest area of space, it often requires the least amount of the designer's time. Type is also used to attract attention, often in a headline

Plantin roman, 10/12 point, justified

Readability is the biggest single necessity for typography. Designers must always keep this as their chief priority. Copy which is meant to be read but is hard to read, no matter how clever or fashionable the layout might appear, is badly designed. Readability need not mean dullness. On the contrary, the more attractive, the more exciting, the more creative the feel for tone and space, the more readable that design will become. Although body copy usually occupies the largest area of space, it often requires the least amount of the designer's time. Type is also used to attract attention, often in a headline

Plantin italic, 10/12 point, ranged left

Readability is the biggest single necessity for typography. Designers must always keep this as their chief priority. Copy which is meant to be read but is hard to read, no matter how clever or fashionable the layout might appear, is badly designed. Readability need not mean dullness. On the contrary, the more attractive, the more exciting, the more creative the feel for tone and space, the more readable that design will become. Although body copy usually occupies the largest area of space, it often requires the least amount of the designer's time. Type is also used

Plantin bold, 10/12 point, ranged left

Readability is the biggest single necessity for typography. Designers must always keep this as their chief priority. Copy which is meant to be read but is hard to read, no matter how clever or fashionable the layout might appear, is badly designed. Readability need not mean dullness. On the contrary, the more attractive, the more exciting, the more creative the feel for tone and space, the more readable that design will become. Although body copy usually occupies the largest area of space, it often

Plantin roman

ABCDEFGHIJKLMNOPQRSTUVWXYZ
abcdefghijklmnopqrstuvwxyz
1234567890 1234567890 &!?().,:;""'"£$¢f

Plantin italic

ABCDEFGHIJKLMNOPQRSTUVWXYZ
abcdefghijklmnopqrstuvwxyz
1234567890 1234567890 &!?().,:;""'"£$¢f

Plantin bold

ABCDEFGHIJKLMNOPQRSTUVWXYZ
abcdefghijklmnopqrstuvwxyz
1234567890 1234567890 &!?().,:;""'"£$¢f

Plantin bold italic

ABCDEFGHIJKLMNOPQRSTUVWXYZ abcdefghijklmnopqrstuvwxyz 1234567890

Plantin light

ABCDEFGHIJKLMNOPQRSTUVWXYZ abcdefghijklmnopqrstuvwxyz 1234567890

Plantin light italic

ABCDEFGHIJKLMNOPQRSTUVWXYZ abcdefghijklmnopqrstuvwxyz 1234567890

Times New Roman

This is the most commercially successful text typeface ever produced. Originally designed in 1932 by English typographer and type historian Stanley Morison (with help from Victor Lardent) for *The Times* newspaper in London, it was made available by Monotype for general distribution in the following year. Morison had taken Plantin as the model for his new typeface and then modernized it to produce a durable and legible roman with good weight, short ascenders and descenders, short and sharply cut bracketed serifs and a large x-height. It retained the Old Style qualities of an oblique stress and oblique serifs on the lower case letters and the type has no idiosyncracies – it is probably the most normal type ever manufactured. Times New Roman's practical qualities and numerous weights and widths, italics, special titling fonts and other variations make it the first choice for a text face.

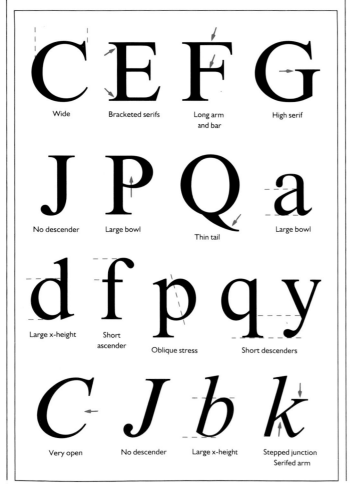

Wide Bracketed serifs Long arm and bar High serif

No descender Large bowl Thin tail Large bowl

Large x-height Short ascender Oblique stress Short descenders

Very open No descender Large x-height Stepped junction Serifed arm

Times New Roman, 10/11 point, ranged left

Readability is the biggest single necessity for typography. Designers must always keep this as their chief priority. Copy which is meant to be read but is hard to read, no matter how clever or fashionable the layout might appear, is badly designed. Readability need not mean dullness. On the contrary, the more attractive, the more exciting, the more creative the feel for tone and space, the more readable that design will become. Although body copy usually occupies the largest area of space, it often requires the least amount of the designer's time. Type is also used to attract attention,

Times New Roman, 10/12 point, ranged left

Readability is the biggest single necessity for typography. Designers must always keep this as their chief priority. Copy which is meant to be read but is hard to read, no matter how clever or fashionable the layout might appear, is badly designed. Readability need not mean dullness. On the contrary, the more attractive, the more exciting, the more creative the feel for tone and space, the more readable that design will become. Although body copy usually occupies the largest area of space, it often requires the least amount of the designer's time. Type is also used to attract attention,

Times New Roman, 10/13 point, ranged left

Readability is the biggest single necessity for typography. Designers must always keep this as their chief priority. Copy which is meant to be read but is hard to read, no matter how clever or fashionable the layout might appear, is badly designed. Readability need not mean dullness. On the contrary, the more attractive, the more exciting, the more creative the feel for tone and space, the more readable that design will become. Although body copy usually occupies the largest area of space, it often requires the least amount of the designer's time. Type is also used to attract attention,

Times New Roman, 10/12 point, justified

Readability is the biggest single necessity for typography. Designers must always keep this as their chief priority. Copy which is meant to be read but is hard to read, no matter how clever or fashionable the layout might appear, is badly designed. Readability need not mean dullness. On the contrary, the more attractive, the more exciting, the more creative the feel for tone and space, the more readable that design will become. Although body copy usually occupies the largest area of space, it often requires the least amount of the designer's time. Type is also used to attract attention, often in a

Times New Roman italic, 10/12 point, ranged left

Readability is the biggest single necessity for typography. Designers must always keep this as their chief priority. Copy which is meant to be read but is hard to read, no matter how clever or fashionable the layout might appear, is badly designed. Readability need not mean dullness. On the contrary, the more attractive, the more exciting, the more creative the feel for tone and space, the more readable that design will become. Although body copy usually occupies the largest area of space, it often requires the least

Times 421 semi-bold, 10/12 point, ranged left

Readability is the biggest single necessity for typography. Designers must always keep this as their chief priority. Copy which is meant to be read but is hard to read, no matter how clever or fashionable the layout might appear, is badly designed. Readability need not mean dullness. On the contrary, the more attractive, the more exciting, the more creative the feel for tone and space, the more readable that design will become. Although body copy usually occupies

Times New Roman 327

ABCDEFGHIJKLMNOPQRSTUVWXYZ
abcdefghijklmnopqrstuvwxyz
1234567890 1234567890 &!?().,:;"" £$¢

Times New Roman 327 italic

ABCDEFGHIJKLMNOPQRSTUVWXYZ
abcdefghijklmnopqrstuvwxyz
1234567890 1234567890 &!?().,:;"" £$¢

Times New Roman 421 semi-bold

ABCDEFGHIJKLMNOPQRSTUVWXYZ
abcdefghijklmnopqrstuvwxyz
1234567890 &!?().,:;"" £$¢

Times New Roman 421 semi-bold italic

ABCDEFGHIJKLMNOPQRSTUVWXYZ abcdefghijklmnopqrstuvwxyz 1234567890

Times New Roman medium

ABCDEFGHIJKLMNOPQRSTUVWXYZ abcdefghijklmnopqrstuvwxyz 1234567890

Times New Roman medium italic

ABCDEFGHIJKLMNOPQRSTUVWXYZ abcdefghijklmnopqrstuvwxyz 1234567890

Other versions
Times Roman (Linotype)

Albertina
1964

ABCDEFGHIJKLMNOPQRSTUVWXYZ &!?(),.:;" "

Aster
1958

ABCDEFGHIJKLMNOPQRSTUVWXYZ &!?(),.:;" "

ABCDEFGHIJKLMNOPQRSTUVWXYZ abcdefghijklmnopqrstuvwxyz 1234567890

Berling
1951-58

ABCDEFGHIJKLMNOPQRSTUVWXYZ &!?(),.:;" "

ABCDEFGHIJKLMNOPQRSTUVWXYZ abcdefghijklmnopqrstuvwxyz 1234567890

Breughel
1982

ABCDEFGHIJKLMNOPQRSTUVWXYZ &!?(),.:;""

ABCDEFGHIJKLMNOPQRSTUVWXYZ abcdefghijklmnopqrstuvwxyz 1234567890

Calisto
1988

ABCDEFGHIJKLMNOPQRSTUVWXYZ &!?(),.:;""

ABCDEFGHIJKLMNOPQRSTUVWXYZ abcdefghijklmnopqrstuvwxyz 1234567890

Cartier
1967

ABCDEFGHIJKLMNOPQRSTUVWXYZ &!?(),.:;" "

Adobe Caslon

ABCDEFGHIJKLMNOPQRSTUVWXYZ &!?(),.:;""

ABCDEFGHIJKLMNOPQRSTUVWXYZ abcdefghijklmnopqrstuvwxyz 1234567890

Caslon Buch

ABCDEFGHIJKLMNOPQRSTUVWXYZ &!?(),.:;""

ABCDEFGHIJKLMNOPQRSTUVWXYZ abcdefghijklmnopqrstuvwxyz 1234567890

**Caslon Old Face
No. 2** (Linotype)
1921

ABCDEFGHIJKLMNOPQRSTUVWXYZ &!?(),.:;" "

ABCDEFGHIJKLMNOPQRSTUVWXYZ abcdefghijklmnopqrstuvwxyz 1234567890

ITC Caslon

ABCDEFGHIJKLMNOPQRSTUVWXYZ &!?(),.:;" "

ABCDEFGHIJKLMNOPQRSTUVWXYZ abcdefghijklmnopqrstuvwxyz 1234567890

abcdefghijklmnopqrstuvwxyz 1234567890 £$

Albertina
1964

ABCDEFGHIJKLMNOPQRSTUVWXYZ *abcdefghijklmnopqrstuvwxyz 1234567890*

abcdefghijklmnopqrstuvwxyz 1234567890 £$¢*f*

Aster
1958

ABCDEFGHIJKLMNOPQRSTUVWXYZ *abcdefghijklmnopqrstuvwxyz 1234567890*

abcdefghijklmnopqrstuvwxyz 1234567890 £$¢*f*

Berling
1951-58

ABCDEFGHIJKLMNOPQRSTUVWXYZ *abcdefghijklmnopqrstuvwxyz 1234567890*

abcdefghijklmnopqrstuvwxyz 1234567890 £$¢*f*

Breughel
1982

ABCDEFGHIJKLMNOPQRSTUVWXYZ *abcdefghijklmnopqrstuvwxyz 1234567890*

abcdefghijklmnopqrstuvwxyz 1234567890 £$

Calisto
1988

ABCDEFGHIJKLMNOPQRSTUVWXYZ *abcdefghijklmnopqrstuvwxyz 1234567890*

abcdefghijklmnopqrstuvwxyz 1234567890 £$¢*f*

Cartier
1967

ABCDEFGHIJKLMNOPQRSTUVWXYZ *abcdefghijklmnopqrstuvwxyz 1234567890*

abcdefghijklmnopqrstuvwxyz 1234567890 *£$¢f*

Adobe Caslon

ABCDEFGHIJKLMNOPQRSTUVWXYZ *abcdefghijklmnopqrstuvwxyz 1234567890*

abcdefghijklmnopqrstuvwxyz 1234567890 *£$f*

Caslon Buch

ABCDEFGHIJKLMNOPQRSTUVWXYZ *abcdefghijklmnopqrstuvwxyz 1234567890*

abcdefghijklmnopqrstuvwxyz 1234567890 £$¢*f*

**Caslon Old Face
No. 2** (Linotype)
1921

ABCDEFGHIJKLMNOPQRSTUVWXYZ *abcdefghijklmnopqrstuvwxyz 1234567890*

abcdefghijklmnopqrstuvwxyz 1234567890 £$¢*f*

ITC Caslon

ABCDEFGHIJKLMNOPQRSTUVWXYZ *abcdefghijklmnopqrstuvwxyz 1234567890*

Caxton

ABCDEFGHIJKLMNOPQRSTUVWXYZ &!?(),.:;""

ABCDEFGHIJKLMNOPQRSTUVWXYZ abcdefghijklmnopqrstuvwxyz 1234567890

Concorde
1969

ABCDEFGHIJKLMNOPQRSTUVWXYZ &!?(),.:;""

ABCDEFGHIJKLMNOPQRSTUVWXYZ abcdefghijklmnopqrstuvwxyz 1234567890

Eldorado
1951

ABCDEFGHIJKLMNOPQRSTUVWXYZ &!?(),.:;""

ABCDEFGHIJKLMNOPQRSTUVWXYZ abcdefghijklmnopqrstuvwxyz 1234567890

Foundry Old Style

ABCDEFGHIJKLMNOPQRSTUVWXYZ &!?(),.:;" "

ABCDEFGHIJKLMNOPQRSTUVWXYZ abcdefghijklmnopqrstuvwxyz 1234567890

ITC Galliard
1978

ABCDEFGHIJKLMNOPQRSTUVWXYZ &!?(),.:;""

ABCDEFGHIJKLMNOPQRSTUVWXYZ abcdefghijklmnopqrstuvwxyz 1234567890

Garamond
(Berthold)

ABCDEFGHIJKLMNOPQRSTUVWXYZ &!?(),.:;""

ABCDEFGHIJKLMNOPQRSTUVWXYZ abcdefghijklmnopqrstuvwxyz 1234567890

ITC Garamond

ABCDEFGHIJKLMNOPQRSTUVWXYZ &!?(),.:;" "

ABCDEFGHIJKLMNOPQRSTUVWXYZ abcdefghijklmnopqrstuvwxyz 1234567890

Garamond no. 3
(Linotype)

ABCDEFGHIJKLMNOPQRSTUVWXYZ &!?(),.:;""

ABCDEFGHIJKLMNOPQRSTUVWXYZ abcdefghijklmnopqrstuvwxyz 1234567890

Garamond 156
(Monotype)
1922

ABCDEFGHIJKLMNOPQRSTUVWXYZ &!?(),.:;""

ABCDEFGHIJKLMNOPQRSTUVWXYZ abcdefghijklmnopqrstuvwxyz 1234567890

Garamond (Simoncini)
1961

ABCDEFGHIJKLMNOPQRSTUVWXYZ &!?(),.:;""

ABCDEFGHIJKLMNOPQRSTUVWXYZ abcdefghijklmnopqrstuvwxyz 1234567890

abcdefghijklmnopqrstuvwxyz 1234567890 £$¢ƒ

Caxton

ABCDEFGHIJKLMNOPQRSTUVWXYZ abcdefghijklmnopqrstuvwxyz 1234567890

abcdefghijklmnopqrstuvwxyz 1234567890 £$¢ƒ

Concorde
1969

ABCDEFGHIJKLMNOPQRSTUVWXYZ abcdefghijklmnopqrstuvwxyz 1234567890

abcdefghijklmnopqrstuvwxyz 1234567890 £$¢ƒ

Eldorado
1951

ABCDEFGHIJKLMNOPQRSTUVWXYZ abcdefghijklmnopqrstuvwxyz 1234567890

abcdefghijklmnopqrstuvwxyz 1234567890 £$¢ƒ

Foundry Old Style

ABCDEFGHIJKLMNOPQRSTUVWXYZ abcdefghijklmnopqrstuvwxyz 1234567890

abcdefghijklmnopqrstuvwxyz 1234567890 £$¢ƒ

ITC Galliard
1978

ABCDEFGHIJKLMNOPQRSTUVWXYZ abcdefghijklmnopqrstuvwxyz 1234567890

abcdefghijklmnopqrstuvwxyz 1234567890 £$¢ƒ

Garamond
(Berthold)

ABCDEFGHIJKLMNOPQRSTUVWXYZ abcdefghijklmnopqrstuvwxyz 1234567890

abcdefghijklmnopqrstuvwxyz 1234567890 £$¢ƒ

ITC Garamond

ABCDEFGHIJKLMNOPQRSTUVWXYZ abcdefghijklmnopqrstuvwxyz 1234567890

abcdefghijklmnopqrstuvwxyz 1234567890 £$¢ƒ

Garamond no. 3
(Linotype)

ABCDEFGHIJKLMNOPQRSTUVWXYZ abcdefghijklmnopqrstuvwxyz 1234567890

abcdefghijklmnopqrstuvwxyz 1234567890 £$¢

Garamond 156
(Monotype)
1922

ABCDEFGHIJKLMNOPQRSTUVWXYZ abcdefghijklmnopqrstuvwxyz 1234567890

abcdefghijklmnopqrstuvwxyz 1234567890 £$¢ƒ

Garamond (Simoncini)
1961

ABCDEFGHIJKLMNOPQRSTUVWXYZ abcdefghijklmnopqrstuvwxyz 1234567890

75

Garamont

ABCDEFGHIJKLMNOPQRSTUVWXYZ &!?(),.;""

ABCDEFGHIJKLMNOPQRSTUVWXYZ abcdefghijklmnopqrstuvwxyz 1234567890£$

Gazette

ABCDEFGHIJKLMNOPQRSTUVWXYZ &!?(),.;""

ABCDEFGHIJKLMNOPQRSTUVWXYZ abcdefghijklmnopqrstuvwxyz 1234567890

Goudy Catalogue
1921

ABCDEFGHIJKLMNOPQRSTUVWXYZ &!?(),.;" "

Goudy Old Style

ABCDEFGHIJKLMNOPQRSTUVWXYZ &!?(),.;" "

Granjon
(Linotype)
c1920

ABCDEFGHIJKLMNOPQRSTUVWXYZ &!?(),.;" "

ABCDEFGHIJKLMNOPQRSTUVWXYZ abcdefghijklmnopqrstuvwxyz 1234567890

Imprint
(Monotype)
1913

ABCDEFGHIJKLMNOPQRSTUVWXYZ &!?(),.;" "

ABCDEFGHIJKLMNOPQRSTUVWXYZ abcdefghijklmnopqrstuvwxyz 1234567890

Janson
(Linotype)
1937

ABCDEFGHIJKLMNOPQRSTUVWXYZ &!?(),.;" "

Lectura
1966

ABCDEFGHIJKLMNOPQRSTUVWXYZ &!?(),.;" "

ABCDEFGHIJKLMNOPQRSTUVWXYZ abcdefghijklmnopqrstuvwxyz 1234567890

Life
1965

ABCDEFGHIJKLMNOPQRSTUVWXYZ &!?(),.;" "

ABCDEFGHIJKLMNOPQRSTUVWXYZ abcdefghijklmnopqrstuvwxyz 1234567890

Minister
1929

ABCDEFGHIJKLMNOPQRSTUVWXYZ &!?(),.;" "

ABCDEFGHIJKLMNOPQRSTUVWXYZ abcdefghijklmnopqrstuvwxyz 1234567890

abcdefghijklmnopqrstuvwxyz 1234567890 £ $ **Garamont**

ABCDEFGHIJKLMNOPQRSTUVWXYZ *abcdefghijklmnopqrstuvwxyz 1234567890*

abcdefghijklmnopqrstuvwxyz 1234567890 £$¢*f* **Gazette**

ABCDEFGHIJKLMNOPQRSTUVWXYZ *abcdefghijklmnopqrstuvwxyz 1234567890*

abcdefghijklmnopqrstuvwxyz 1234567890 £$¢*f* **Goudy Catalogue**
1921

abcdefghijklmnopqrstuvwxyz 1234567890 £$ **Goudy Old Style**

ABCDEFGHIJKLMNOPQRSTUVWXYZ *abcdefghijklmnopqrstuvwxyz 1234567890*

abcdefghijklmnopqrstuvwxyz 1234567890 £$¢*f* **Granjon**
(Linotype)
c1920

ABCDEFGHIJKLMNOPQRSTUVWXYZ abcdefghijklmnopqrstuvwxyz 1234567890

abcdefghijklmnopqrstuvwxyz 1234567890 £$¢*f* **Imprint**
(Monotype)
1913

ABCDEFGHIJKLMNOPQRSTUVWXYZ abcdefghijklmnopqrstuvwxyz 1234567890

abcdefghijklmnopqrstuvwxyz 1234567890 £$¢*f* **Janson**
(Linotype)
1937

ABCDEFGHIJKLMNOPQRSTUVWXYZ abcdefghijklmnopqrstuvwxyz 1234567890

abcdefghijklmnopqrstuvwxyz 1234567890 £$¢*f* **Lectura**
1966

ABCDEFGHIJKLMNOPQRSTUVWXYZ abcdefghijklmnopqrstuvwxyz 1234567890

abcdefghijklmnopqrstuvwxyz 1234567890 £$¢*f* **Life**
1965

ABCDEFGHIJKLMNOPQRSTUVWXYZ abcdefghijklmnopqrstuvwxyz 1234567890

abcdefghijklmnopqrstuvwxyz 1234567890 £$¢ *f* **Minister**
1929

ABCDEFGHIJKLMNOPQRSTUVWXYZ abcdefghijklmnopqrstuvwxyz 1234567890

Palatino 1950

ABCDEFGHIJKLMNOPQRSTUVWXYZ &!?(),.:;" "

ABCDEFGHIJKLMNOPQRSTUVWXYZabcdefghijklmnopqrstuvwxyz 1234567890

Poliphilus
1937

ABCDEFGHIJKLMNOPQRSTUVWXYZ &!?(),.:;" "

Rotation

ABCDEFGHIJKLMNOPQRSTUVWXYZ &!?(),.:;" "

ABCDEFGHIJKLMNOPQRSTUVWXYZ abcdefghijklmnopqrstuvwxyz 1234567890

Sabon
1966

ABCDEFGHIJKLMNOPQRSTUVWXYZ &!?(),.:;" "

ABCDEFGHIJKLMNOPQRSTUVWXYZ abcdefghijklmnopqrstuvwxyz 1234567890

Spectrum
1955

ABCDEFGHIJKLMNOPQRSTUVWXYZ &!?(),.:;" "

Times
(Linotype)
1935

ABCDEFGHIJKLMNOPQRSTUVWXYZ &!?(),.:;" "

ABCDEFGHIJKLMNOPQRSTUVWXYZ abcdefghijklmnopqrstuvwxyz 1234567890

Trump Mediaeval
1954

ABCDEFGHIJKLMNOPQRSTUVWXYZ &!?(),.:;" "

ABCDEFGHIJKLMNOPQRSTUVWXYZ abcdefghijklmnopqrstuvwxyz 1234567890

Van Dijck
1935

ABCDEFGHIJKLMNOPQRSTUVWXYZ &!?(),.:;" "

Vendome
1952

ABCDEFGHIJKLMNOPQRSTUVWXYZ &!?(),.:;" "

ABCDEFGHIJKLMNOPQRSTUVWXYZ abcdefghijklmnopqrstuvwxyz 1234567890

Weiss
1924

ABCDEFGHIJKLMNOPQRSTUVWXYZ &!?(),.:;" "

ABCDEFGHIJKLMNOPQRSTUVWXYZ abcdefghijklmnopqrstuvwxyz 1234567890

abcdefghijklmnopqrstuvwxyz 1234567890 £$¢ **Palatino 1950**

ABCDEFGHIJKLMNOPQRSTUVWXYZ abcdefghijklmnopqrstuvwxyz 1234567890

abcdefghijklmnopqrstuvwxyz 1234567890 £$ **Poliphilus** 1937

abcdefghijklmnopqrstuvwxyz 1234567890 £$¢ƒ **Rotation**

ABCDEFGHJKLMNOPQRSTUVWXYZ abcdefghijklmnopqrstuvwxyz 1234567890

abcdefghijklmnopqrstuvwxyz 1234567890 £$¢ƒ **Sabon** 1966

ABCDEFGHIJKLMNOPQRSTUVWXYZ abcdefghijklmnopqrstuvwxyz 1234567890

abcdefghijklmnopqrstuvwxyz 1234567890 £$ **Spectrum** 1955

ABCDEFGHIJKLMNOPQRSTUVWXYZ abcdefghijklmnopqrstuvwxyz 1234567890

abcdefghijklmnopqrstuvwxyz 1234567890 £$¢ƒ **Times** (Linotype) 1954

ABCDEFGHIJKLMNOPQRSTUVWXYZ abcdefghijklmnopqrstuvwxyz 1234567890

abcdefghijklmnopqrstuvwxyz 1234567890 £$¢ƒ **Trump Mediaeval** 1954

ABCDEFGHIJKLMNOPQRSTUVWXYZ abcdefghijklmnopqrstuvwxyz 1234567890

abcdefghijklmnopqrstuvwxyz 1234567890 £$¢ƒ **Van Dijck** 1935

abcdefghijklmnopqrstuvwxyz 1234567890 £$¢ƒ **Vendome** 1952

ABCDEFGHIJKLMNOPQRSTUVWXYZ abcdefghijklmnopqrstuvwxyz 1234567890

abcdefghijklmnopqrstuvwxyz 1234567890 £$¢ƒ **Weiss** 1924

ABCDEFGHIJKLMNOPQRSTUVWXYZ abcdefghijklmnopqrstuvwxyz 1234567890

1 The photographically enlarged entry from a dictionary has been set in Times. The definition is the key to the design concept, so its importance is emphasized by the use of bright orange.

2 Berling has been chosen for this brochure. Its strong calligraphic qualities complement the literary quotation. The large raised initial letter draws the eye to the start of the quotation, and the generous margins help to focus attention on the words.

1

2

"That Europe's nothing on Earth but a great big auction, that's all it is."

TENNESSEE WILLIAMS

3 The choice of Sabon for this pharmaceutical packaging associates the product with familiarity and reliability to give the customer reassurance. The use of blue for the type reinforces the soothing qualities of the medicine, while the distinctive long stroke endings of the ampersand increase its noticeability to emphasize that the packet contains both a day and a night remedy.

4 In this advertisement, the overlapping of the two Plantin capital 'N's and the vertical alignment suggest movement and produce an appropriately sturdy logo for Runner fun board shoes.

3

4

Ques-
tion-
ing
Ed-
mond
Jabès

Warren F. Motte, Jr.

University of Nebraska Press

Lincoln & London

5

place markers, of reference. Di Chirico, Nosferatu the vampire, Huysmans, Hervey, Marx, Feuerbach, Freud, and other heroes people the pages, together with a running commentary on the 'marvelous' of everyday life, including the relation between the dreamed and the found in such places as gambling joints, like the Eden Casino, and Parisian streets, like the boulevard Magenta. § 'Human love must be rebuilt, like the rest: I mean that it can, that it must be reestablished upon its true bases.' This belief, like the relation between inner and outer lives, links the present volume closely to the author's *L'Amour fou* and *Arcane 17*, which are, in the main, books concerning love and the problem of its relation to the outside world. The three books communicate with each other, with the manifestos, and with *Nadja*, the great tale of the mad woman loved and abandoned.

Working through the Vessels

Among André Breton's works, *Les Vases communicants* is the most 'philosophical' and 'political,' in the strong senses of those terms. Upon its theories the whole edifice of Surrealism, as Breton conceived it, is based. Without its support his manifestos and critical essays, from the collection titled *La Clé des champs* on, would have lacked scope as well as central focus. § That it has taken so long for these communicating vessels to reach more than a limited number of readers is no great surprise: this work has neither the tragic density of *Nadja* nor the intense lyricism of *L'Amour fou*. It is not centered on the work of artists and writers familiar to a wider public. It is unique unto itself, with its dreams, its

high problematization of political comportment, its speculation as to the role of the writer and the artist, and its very deep melancholy. § What does this work desire, we might ask? What does an André Breton want?? The answer is, as he says of life, impossible. He wants the things he loves not to hide all the others from him; he wants the strawberries in the woods to be there for him alone and for all the others; he wants to take history into account and go beyond it; he wants, above all, to be persuasive, even as his style is progressively more difficult, his thought more unfamiliar. He wants Freud, Marx, Kant, alchemy, and the entire history of ideas to be summed up and available. He wants . . . § And yet indeed the whole history of Surrealism is here, in these pages. With its heartaches and quixotic endeavors, its pangs of conscience and its genuine wish to communicate, the desire itself aimed at such an image as that of communicating vessels is, without qualification, without reservation, enormously moving. What Breton seeks, or tries to have us undertake, is the replacement of the center at the center, the replacement of the person at 'the heart of the universe,' where, abstracted from those daily events that would decompose integrity into fragmentation, the human personality itself becomes, 'for every pain and every joy exterior to [it], an indefinitely perfectible place of resolution and resonance.' What endeavor more poetic? How to reconcile it with what we call a political reality? § The image of the communicating vessels was already present within the pages of *Le Surréalisme et la peinture* (Surrealism and painting) of 1928. It had to

1. The reference is, of course, to Freud's question, taken up at the end of this introduction.

xi

6

The mission of
The Seagram Company Ltd.
is to be the best-managed
beverage company in the world.
To accomplish this goal,
we will improve
our financial performance and
competitive position, build an
organization that encourages individuals
to contribute to our success,
and create an environment
in which all employees
are valued and motivated.

V.O.

8

7

5 Typographer Richard Eckersley's attractive, asymmetric title page for this University of Nebraska Press Publication exploits the crisp and powerful qualities of ITC Galliard, a 20th-century Old Style type based on Garamond. The word-breaking by syllables helps to emphasize the meaning of the title.

6 ITC Galliard is used again by Richard Eckersley for the text of this double-page spread from a book on literature entitled *Communicating Vessels*. It has been chosen for its good colour and close letter fit. Notice also the unusual method of indicating paragraph breaks with a double 'S' colophon – a typographical device commonly used for sentence breaks or footnotes in literary works.

7 & 8 Although it is a contemporary type design, ITC Galliard was chosen for the mission statement in this corporate annual report (left) because of its traditional look which complements the classical centred layout. On the double-page spread above, the text measure that has been selected is too long for optimum legibility, but no doubt it was chosen by the designers so that the shape of the text as a whole mimicked the proportions of a bottle label.

WILLIAM SHAKESPEARE

The Second Part of
the History of
Henry the Fourth

PENGUIN BOOKS

1

1 The title page of a Penguin
book on Shakespeare's *Henry IV*
is set in Bembo, an Old Style
typeface with a traditional feel
that is particularly suited to the
subject-matter.

2 The modified Garamond capi-
tal 'D', the natural 'o' shape of
the rose and the shape of the text
type on the facing page cleverly
reinforce the "Do it" call-to-
action message of the copy in this
brochure spread.

3 An example of descriptive type
in which the enlarged Bembo 'O'
represents the globe.

design & art-direction

We see design and art-direction as an
essential combination, beneficial to the
success of your business. Our total
involvement and hands-on approach
ensure the smooth running of each
project, creatively and financially,

Tim Garner has worked in-house for retailers Laura
Ashley, Polo Ralph Lauren, Hackett, and for Lamb &
Shirley as an art director. His background varies from
the design of shops, product ranges, packaging and
display through to creative and photographic direction.

Do it.

Stuart Russell has worked in almost all areas of design
and advertising since 1976, for a wide range of major
companies including Bass, Hedges & Butler, British
Aluminium, Guinness and Wedgwood. He ran his own
business from 1984 until the formation of Garner Russell.

therefore we can forsee any problems
or difficulties at the outset. In short,
contrary to common practice, we will
endeavour to produce a quotation,
with no extra charges billed to you
on the completion of your project.

071-287 0601

2

Envir**O**nment

3

4 The use of Bembo comple-
ments the style of architecture in
the photographs shown in this
marketing brochure. The spa-
cious leading gives a lightness to
the structure of the typography,
which mirrors the airiness and
back-formation of the classical
architecture on the facing page.

The Telephone Book

TECHNOLOGY, SCHIZOPHRENIA,
ELECTRIC SPEECH

Avital Ronell

5

4 JOHN CARPENTER STREET

LONDON EC4

4 John Carpenter Street is a new, highly
prominent, self-contained 63,130 sq ft office
development on ground and four upper floors,
completed to a highly advanced, full
developer's specification.
The elegant restored Italianate facades of the

former Guildhall School of Music and Drama
contrast with the new architecture to provide a
unique, distinctive headquarters office building,
situated on a commanding island site within the
heart of this well established professional and
financial region of the City of London.

5 For this book jacket, Richard
Eckersley selected Adobe
Garamond, which has elegant
flourishes to the top of the capital
'T' and 'B', to add a traditional
note to the design. The sombre
mood of the cover has been
intensified by reversing the type
out of a black background.

4

9 Plantin, a highly legible "workhorse" type with strong serifs and a large x-height, is chosen for this point-of-sale button-dispenser.

10 In Fernand Baudin's book cover design, the elegant, delicate and flowing forms of Garamont Italic are combined with an abruptly contrasting bold, static sans serif called Impact. The word "les" is high-lighted by the use of a lighter weight of sans serif type – an example of paradoxical emphasis.

6 A dramatic, minimal piece of typography in an advertisement for Marco Polo. The different sizes of Garamont Italic have been moulded photographically into organic shapes which com-plement the natural beauty of the photograph on the facing page.

7 ITC Garamond and other typographical elements move around the clock in this "typogram", or poem, about time. Such typographical poetry is easily produced on the Apple Macintosh.

8 Another example of descrip-tive type, in which the distorted Garamond gradually decreases in size to suggest a swirling movement towards the centre.

1 In this brochure, typographical elements alone give the feel that the PR company being promoted is well-established with a reputation for high quality. This is achieved through the use of Caslon 540, letterspaced running heads and generous leading. The contrasting style of the large but soft Commercial Script is used for decorative effect in place of illustrations.

2 A modern brochure design with a traditional feel, created by the use of Old Style, a symmetrical centred layout and a dropped initial capital letter at the beginning of the text.

3 A poster by Tony O'Hanlon predominantly features ITC Caslon and shows how changes in type size, weight, axis, colour and arrangement can be combined to create visual pauses which reflect the meaning of the words.

4 The development of letterforms from Phoenician scripts to digital typography is the subject of this poster design. Here Dürer's construction of an Old Style capital 'D' is an example of type used as an image.

5 A clever typographical pun for a New Year's greeting card, in which the non-aligning figures of Sabon are substituted for the Caslon punctuation marks.

MERVUE LEARNING CENTRE

He who

d..o..u..b..t..s.

nothing

KNOWS

N THING

A new year's wish for peace, happiness, and love.

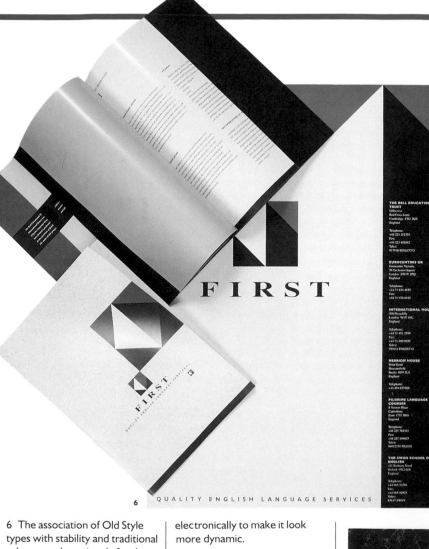

THE TIMES

8

9

8 The masthead of *The Times* is set in a new version of Times New Roman, designed specifically for computerized digital setting. The original version of the type was designed for the newspaper in 1932 by Stanley Morison.

9 The vertical type on these exhibition catalogue covers shows how interest can be created by an unusual change in type direction. It demonstrates also that the top half of lower case letters is the most important factor in letter recognition.

toi et moi pour toujours

elles sont de sortie

l a c

6 The association of Old Style types with stability and traditional values was the rationale for the choice of Monotype's Times New Roman for this identity. The type has been expanded electronically to make it look more dynamic.

7 The Times Bold used on the cover of this brochure about the Police National Computer is chosen for its authoritative and conservative feel. The dynamic vertical arrangement gives it a more modern feel in keeping with the computer-based technology being described.

10 The Panama & Pacific logo on this stylish, upmarket brochure is a good example of harmoniously mixing an Old Style type (Times) with a contrasting sans serif type (Futura). The use of italic and an elegant ampersand enriches the effect.

The
PANAMA & PACIFIC
LONDON

*London riverside apartments
of exceptional quality
with unrivalled amenities
in a new building of
unique architecture and style,
for completion in 1993.*

巴拿馬及太平

7

10

More than meets the Eye

Seeing Is Believing, But Can You Really Trust What You See? Maggie Scammell Enters The World Of Images & Illusions As She Meets The People Behind One Of Bt's Most Colourful Jobs.

GOOD OLD-FASHIONED CLICHES are the stock in trade of many an honest scribe. But spend some time with the "vision squad" at BT's Martlesham research laboratories and you are apt to think twice before ever repeating the line "seeing is believing".

The "vision squad" is a team of psychologists and engineers at BTRL who are investigating how to make the best use of colour on visual displays. Computers are required increasingly to show more and more complex information on screen and designers are looking to colour coding to simplify the message. Used correctly, colour is known to can make the user work twice as hard trying to untangle a multi-colour mess.

ILLUSIONS

To an innocent it might seem like a straightforward, commonsense job to identify the most digestible combinations of colours for text and graphical displays. But already the "vision squad" has made a research discovery which is a world breakthrough and shatters some comfortable illusions.

Contrary to conventional wisdom it is not the choice of colour which makes text readable on VDUs; it is the contrast in the brightness, or luminance, of the text and the background. In other words there is nothing intrinsically 'readable' about any colour in itself, it is the luminance. Hence previously accepted guidelines, such as the International Standards stricture to avoid displaying yellow text on a white background, miss the point.

Dr David Travis, team leader on the vision project which is part of the Graphical Interfaces and Control Rooms group, explains: 'The question of which colour combinations are bad and which are good is incredibly complicated. When we think of colour we tend to think of red, green, blue, yellow, violet and so on. And if it were that simple it would be easy to have an experiment with these colours

VISION SQUAD

JOHN FLETCHER DR DAVID TRAVIS ANNA GRETT HIGGINS

and use them on an interface and see which ones looked best.'

Colours on cathode ray tube screens are compounds made up of three component parts:
* **hue** – which is what we normally think of as colour, red, green, blue, for instance.
* **saturation** – white has zero saturation and as the colour becomes more intense so it becomes more saturated. Pink is a de-saturated red.
* **luminance** – some colours are dark and some are bright.

'We are trying to understand people's perception of colour by unpacking those three variables,' says David. 'We are examining each one separately. What we found in our experiments was that changes in luminance were much more important than changes in hue. The reason that white and black or yellow and blue are good combinations is that one is a very light colour and the other a dark one. So what the viewer gets out is a brightness difference.'

The vision squad proved this point with experiments involving a group of people with normal colour vision reading words on screens. In one of the tests people were asked to decipher the previously taboo combination of yellow on white. Altering the brightness contrast alone, and leaving colour unchanged, rendered completely illegible text easily readable.

But where does all this leave the software writer who is trying to design the ultimate user-friendly system? Says David: 'One way of interpreting our results would be to say that it doesn't matter which colours you use so long as there is an adequate brightness difference between foreground and background. The general rule for brightness contrast is a ratio of three to one.

Every general rule has its qualifications though and one rider is that saturated blue (that's a kind of bright royal blue to most of us) is hopeless for fine

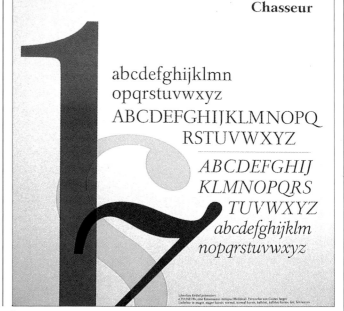

Chasseur

abcdefghijklmn
opqrstuvwxyz
ABCDEFGHIJKLMNOPQ
RSTUVWXYZ
ABCDEFGHIJ
KLMNOPQRS
TUVWXYZ
abcdefghijklm
nopqrstuvwxyz

NAPOLI

RAYMOND HUNTER
Age 24
Clyde Region Environment Workers

I'm from the East End of Glasgow - Ruchazie. It's classified as a severely depressed area.

I quite enjoyed school but I never really applied myself. Not until later on. I got a few qualifications: seven O grades, two Highers. After that I took evening classes and also went to college for a year and got my Ordinary National Certificate in biological sciences.

I was a very shy person. But I've changed a lot since then. I really just listened to what was going on. I was never outspoken in any way.

When I was younger my hobbies were bird watching and observing any form of wildlife. We weren't too far from the fringe of the city, near a loch. I got involved in egg collecting. Nobody ever told me it was wrong.

Clyde Region Environmental Workers - CREW started off in 1974 with four members. We go out every alternate Sunday. We improve areas for wildlife, as well as improve access for people. Tree planting. CREW relies heavily on the Scottish Conservation Project for transport, some tools, insurance.

I've been out with them for 5 years. Recently they asked me to take on the position of Publicity Officer. When I left school I didn't realise that I would ever want to work with people.

My first job as PR Officer was to produce a poster to put around in libraries. About 2 months later, I was up at a friend's house and came across a picture he had drawn that was really nice of a tree. I asked him if I could use it. We raised £150 to print 1,000 posters. Then I went to the main Glasgow

Library and asked them to help me to distribute it.

When I was younger I was quite depressed. At one time I had nothing to live for. But my attitude has changed for all sorts of reasons. And I've put a lot of hope. Still I feel like something deadly serious is on the horizon. The world has a lot of problems to overcome.

I'd like to see a lot more people getting involved in shaping society. Not necessarily conservation, but just getting involved.

I think we need to clean up our own backyards instead of just worrying about the rainforests.

I've a lot more confidence than I ever had before. I don't consider myself overconfident. I hope I will never appear boastful in any way.

These last few years I've been learning to lead people. Not telling them what to do, but putting suggestions before them and letting them choose what they want to do.

I'm going to America next week with 5 other Scots to meet a bunch of Americans and Canadians interested in the environment. It cost £350. I wrote off to a lot of organisations. It was quite a challenge for me to write off to people asking for money. And to try and show them that there were going to be benefits for the community.

Raymond Hunter
by
ALISTAIR WADDIE

11

1 In this British Telecom Journal, the traditional and familiar qualities of Sabon and Goudy Old Style are used to counteract the perceived coldness of the hi-tech communications industry. The combination of capital initial letters, small capitals and the alignment of the type on a central axis reinforces this traditional feel.

2 John McConnell of Pentagram made the apt choice of Perpetua, a type influenced by stone-carving, to suggest the crumbling architecture of Naples.

3 Perpetua is used to add an air of authority to this brochure for The Prince's Trust. Notice how the type's long ascenders and descenders demand generous leading.

4 The influence of stone-carved lettering on Eric Gill's Perpetua type makes it a natural choice once again for this call-for-entries logo for awards in the design of building product information and advertising. It is also a good example of how capital letters lend themselves to a stacked arrangement.

5 A poster to promote a new Berthold typeface, Chasseur, which clearly illustrates the Old Style characteristics of an oblique stress, oblique serifs and a medium contrast in letterstroke widths. It also shows the effect of overlapping coloured type and how type can be run around the contours of a shape.

6

from The Mouth of The Lour.

A KICK UP THE ARTS.

MODERN ART. A contradiction in terms, wouldn't you agree?

Picasso, for goodness' sake, was positively square compared with his postcursors, curse them all. Precious few of the blighters would pass muster as decent painters and decorators.

I, for one, would be the last to invite Jackson Pollock to wallop the walls *chez moi*.

And what pearls of wisdom or light of enlightenment have they bestowed upon the world?

Hockney tells us that there are a lot of swimming pools in California. O blinding flash of insight!

While, as for Bacon, a fitting *nomen familiae* if ever there was one, most of his scratchings (pork) resemble the interior of the local butcher's shop.

The latest thing, we hear, is crazy paving (the artist? sculptor? landscape gardener? should and will remain anonymous.) Yes, the careful arrangement of chunks of slate, large and small, into jolly little circles or squares. A talking point on the patio, maybe, but sitting in state in the Tate? (Where, one might add, one dare not so much as use a litter bin for fear of defiling some priceless exhibit, though one's crumpled copy of The Times, casually discarded on the foyer floor, has every chance of becoming one and will, like as not, soon find itself roped off in its own little temenus, the object of mass veneration.)

Aberlour Single Malt Whisky is, of course, an ancient art, inured in the time-honoured ways of our forefathers.

And if it is to claim commonalty with any of those dabblers in oil and water, it would be with Turner. Both being justly famous for the magnificent mellow glow they create. ●

ABERLOUR
10 YEARS OLD
SINGLE SPEYSIDE MALT

6 A typographical pastiche of Victorian typography using a typeface of Victorian origin (Mazarin), complete with "rivers" in the text and poor word and letterspacing. The advertisement is promoting the Victorian heritage of a brand of Scottish single malt whisky.

7

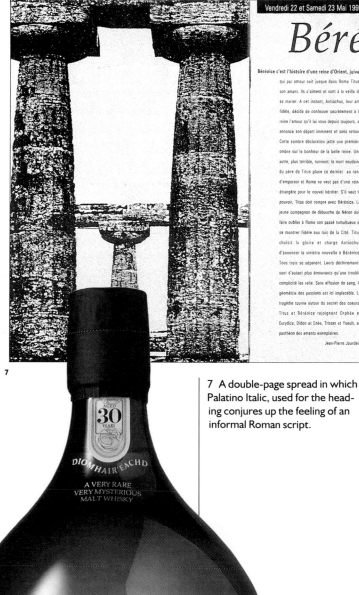

7 A double-page spread in which Palatino Italic, used for the heading conjures up the feeling of an informal Roman script.

A BOOK OF SCRIPTS

ABC
DEF
GHI
KLM

A KING PENGUIN

8

8 A well-known Jan Tschichold design for a *Book of Scripts* in the King Penguin series, which appropriately combines classical Old Style type with ornaments and embellishments.

9 The Palatino on this whisky bottle echoes the tradition associated with its contents.

Transitional

In 1692, the Roman du Roi, a new roman type cut by Phillipe Grandjean for the Imprimerie Nationale in Paris, initiated a departure from Old Style types which had prevailed for about 200 years. Grandjean's type, and those of Fournier in France and Baskerville in England which followed, are called Transitional faces because they possess characteristics of both the earlier Old Style and the Modern style types which appeared during the last quarter of the 18th century. Transitional faces are also known as Réales.

Some of the typefaces included in this section are revivals of 18th-century Transitional designs, but the majority are 20th-century romans which share some of the characteristics of the historical Transitional models. Equally, though, they may also have features of other type groups. The general appearance and weight of letterstroke of types in this section can vary enormously.

The style of 18th-century Transitional types reflect the greater precision allowed by the copperplate engraving tool and the availability of smoother paper which tolerated finer strokes and serifs. They also represent a move away from calligraphically influenced designs of the Humanist and Old Style faces. The early Transitional style of French punchcutter Philippe Grandjean's type, the Roman du Roi, was characterized by flat unbracketed serifs, a narrower set, high contrast between the thick and thin letterstrokes and a more vertical stress. Grandjean's italic font was the first designed to harmonize with the companion roman. In 1750, Frenchman Pierre Fournier designed a roman along very similar lines to the Roman du Roi which was revived by Stanley Morison at Monotype in 1924. It is available now as a digital face together with a rather whispy italic font which has peculiar oblique serifs.

The types of Englishman John Baskerville that followed in the 1750s are the most significant and influential of the Transitional style. Baskerville's first type appeared in 1757 and its lightness and degree of refinement was further testimony of the increasingly precise skills of the punchcutters. By the late 18th century, Baskerville's types had disappeared under the shadow of the emerging Modern-style types of Didot and Bodoni but were rediscovered in the early part of the 20th century

P. VIRGILII MARONIS

BUCOLICA

ECLOGA I. cui nomen *TITYRUS*.

MELIBŒUS, TITYRUS.

Tityre, tu patulæ recubans sub tegmine fagi,
Silvestrem tenui Musam meditaris avena:
Nos patriæ fines, et dulcia linquimus arva,
Nos patriam fugimus: tu Tityre lentus in umbra
Formosam resonare doces Amaryllida silvas.
T. O Melibœe, Deus nobis hæc otia fecit:
Namque erit ille mihi semper Deus; illius aram
Sæpe tener nostris ab ovilibus imbuet agnus:
Ille meas errare boves, ut cernis, et ipsum
Ludere quæ vellem, calamo permisit agresti.
M. Non equidem invideo; miror magis: undique totis
Usque adeo turbatur agris. en ipse capellas
Protenus æger ago: hanc etiam vix Tityre duco.
Hic inter densas corylos modo namque gemellos,
Spem gregis, ah! silice in nuda connixa reliquit.
Sæpe malum hoc nobis, si mens non læva fuisset,
De cœlo tactas memini prædicere quercus.
Sæpe sinistra cava prædixit ab ilice cornix.
Sed tamen, iste Deus qui sit, da, Tityre, nobis.
T. Urbem, quam dicunt Romam, Melibœe, putavi
Stultus ego huic nostræ similem, quo sæpe solemus
Pastores ovium teneros depellere fœtus.
Sic canibus catulos similes, sic matribus hædos
Noram; sic parvis componere magna solebam.

by many typefoundries including Deberny & Peignot, Monotype, Linotype and, more recently, ITC. Typefaces such as Bulmer, Bell and Caledonia, which can be regarded as Transitional-Modern "hybrids", are discussed in the following Modern section.

20th-century Transitional typefaces

The remainder of the typefaces included here are 20th-century romans, including the Linotype Legibility Group and other similar faces, which were all specifically designed for use as newspaper or magazine fonts. The

This page (left) from John Baskerville's *Virgil* (1754) has a lightness created through the use of wide margins, generous leading, letterspaced capitals, paragraph indents and unjustified setting. The openness of the type demands wide letterspacing and the companion italic is used for emphasis.

Quick selection guide
Availability: Generally good. Most typesetters hold the majority of these faces but not necessarily all of the more recent designs.

PostScript fonts for the Apple Macintosh: Baskerville, Century Schoolbook, ITC Cheltenham and other popular faces.

Some recent designs: Bitstream Charter, ITC Slimbaeh (1979), ITC Stone Serif (1988).

Faces by leading type designers: Joanna (1958) and Pilgrim by Eric Gill; Comenius, Melior, Orion (1974) and ITC Zapf International (1977) by Hermann Zapf: Apollo, Meridien and Versailles (1982) by Adrian Frutiger; Olympian by Matthew Carter; Electra (1935) by William Dwiggins.

Greek Fonts: Baskerville and Century Schoolbook.

common characteristics of these faces are open letters with robust serifs, a good weight, short ascenders and descenders and a good contrast between the thick and thin letters. They all have companion italic fonts. The Linotype Legibility Group types included here are Ionic (1922), Textype (1929), Corona (1949) and Excelsior (1951). Later "legibility faces" released by Linotype are Melior (1952) by Hermann Zapf and Olympian (1970) by Matthew Carter. Times Europa (1972) is a more sturdy version of Stanley Morison's Times New Roman.

Between 1900 and 1928, the Century family of types was produced by Morris Benton at American Typefounders from an original design by Theodore DeVinne for *The Century* Magazine in 1894. Probably the best-known members of this family are Century Old Style (1909), a slightly compressed type with strong, slightly bracketed serifs, and Century Schoolbook (1924), a wider design with heavy (almost slab-like) horizontal serifs. Impressum (1962) and Nimrod (1980) are in a similar mould. Other variations of Century, such as Century Expanded and ITC Century, which have a more abrupt contrast, can be found in the Modern section.

Selecting Transitional typefaces

There is no doubt that Baskerville is the most popular, legible and widely available text typeface in this section. However, its wide letters demand loose letterspacing and its medium-long descenders need plenty of leading – it is not the most economical of faces.

Most of the Transitional faces are legible text types, although there are a few exceptions such as Cochin (1922), which is too quaint, and Cheltenham (1896), too condensed and somewhat quirky. They nearly all come in families, too, but Binny Old Style (1908), Fournier (1924), Bookman (1936), Pilgrim (1953) and Orion (1974) have no bold face, while Century Old Style and Impressum have no bold italic.

Economical, somewhat narrow faces are Else (1982) by Robert Norton, Old Style 7 and Century Old Style. Demos (1978), by Dutch type designer Gerard Unger and Melior, Olympian or any of the other newspaper types are practical, workaday types with good weight and a large x-height. Adrian Frutiger's Meridien (1955), which has a wide set, and Apollo (1964), the first type specifically designed for phototypesetting (also by Adrian Frutiger), has long descenders, which require a lot of space. For optimum legibility, the many typefaces with a large x-height such as Comenius (1976) by Hermann Zapf or Nimrod by Robin Nicholas, are an excellent choice.

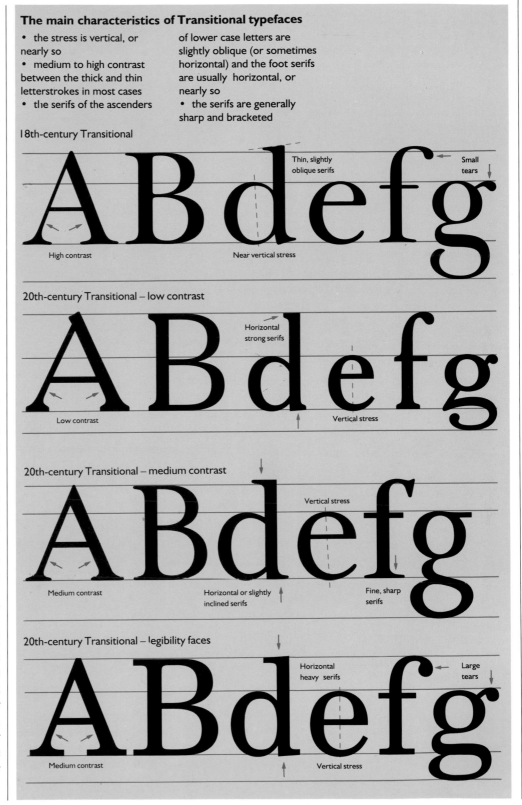

The main characteristics of Transitional typefaces

• the stress is vertical, or nearly so
• medium to high contrast between the thick and thin letterstrokes in most cases
• the serifs of the ascenders of lower case letters are slightly oblique (or sometimes horizontal) and the foot serifs are usually horizontal, or nearly so
• the serifs are generally sharp and bracketed

18th-century Transitional

Thin, slightly oblique serifs

Small tears

High contrast

Near vertical stress

20th-century Transitional – low contrast

Horizontal strong serifs

Low contrast

Vertical stress

20th-century Transitional – medium contrast

Vertical stress

Medium contrast

Horizontal or slightly inclined serifs

Fine, sharp serifs

20th-century Transitional – legibility faces

Horizontal heavy serifs

Large tears

Medium contrast

Vertical stress

Baskerville

The types designed by Englishman John Baskerville around 1754 are the epitome of the Transitional style. Baskerville's designs have a marked contrast between the thick and thin letterstrokes, the serifs of the lower case letters are nearly horizontal, the letters are rounded, the stress almost vertical and the serifs are slightly bracketed. Monotype's 1923 revival shown here is based on one of John Baskerville's original types of 1772 but it has been somewhat regularized in the re-cutting. The type has been converted into a digital form in regular, semi-bold and bold weights (together with matching italic fonts) and remains one of the most popular text faces. Baskerville's only disadvantage is that it needs wide letterspacing because of its rounded design and is therefore relatively uneconomical in the use of space. Linotype also released two revivals – Baskerville and Baskerville No. 2 – and, more recently, ITC has issued New Baskerville (1982).

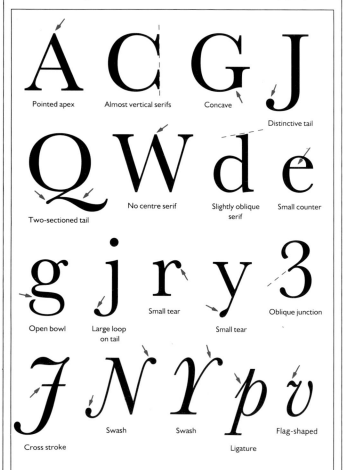

Pointed apex · Almost vertical serifs · Concave · Distinctive tail · Two-sectioned tail · No centre serif · Slightly oblique serif · Small counter · Open bowl · Large loop on tail · Small tear · Small tear · Oblique junction · Cross stroke · Swash · Swash · Ligature · Flag-shaped

Monotype Baskerville 169, 10/11 point, ranged left

Readability is the biggest single necessity for typography. Designers must always keep this as their chief priority. Copy which is meant to be read but is hard to read, no matter how clever or fashionable the layout might appear, is badly designed. Readability need not mean dullness. On the contrary, the more attractive, the more exciting, the more creative the feel for tone and space, the more readable that design will become. Although body copy usually occupies the largest area of space, it often requires the least amount of the designer's time. Type is also used to attract attention, often in a headline where the design

Monotype Baskerville 169, 10/12 point, ranged left

Readability is the biggest single necessity for typography. Designers must always keep this as their chief priority. Copy which is meant to be read but is hard to read, no matter how clever or fashionable the layout might appear, is badly designed. Readability need not mean dullness. On the contrary, the more attractive, the more exciting, the more creative the feel for tone and space, the more readable that design will become. Although body copy usually occupies the largest area of space, it often requires the least amount of the designer's time. Type is also used to attract attention, often in a headline where the design

Monotype Baskerville 169, 10/13 point, ranged left

Readability is the biggest single necessity for typography. Designers must always keep this as their chief priority. Copy which is meant to be read but is hard to read, no matter how clever or fashionable the layout might appear, is badly designed. Readability need not mean dullness. On the contrary, the more attractive, the more exciting, the more creative the feel for tone and space, the more readable that design will become. Although body copy usually occupies the largest area of space, it often requires the least amount of the designer's time. Type is also used to attract attention, often in a headline where the design

Monotype Baskerville 169, 10/12 point, justified

Readability is the biggest single necessity for typography. Designers must always keep this as their chief priority. Copy which is meant to be read but is hard to read, no matter how clever or fashionable the layout might appear, is badly designed. Readability need not mean dullness. On the contrary, the more attractive, the more exciting, the more creative the feel for tone and space, the more readable that design will become. Although body copy usually occupies the largest area of space, it often requires the least amount of the designer's time. Type is also used to attract attention, often in a headline where the design will need to arrest

Monotype Baskerville 169 italic, 10/12 point, ranged left

Readability is the biggest single necessity for typography. Designers must always keep this as their chief priority. Copy which is meant to be read but is hard to read, no matter how clever or fashionable the layout might appear, is badly designed. Readability need not mean dullness. On the contrary, the more attractive, the more exciting, the more creative the feel for tone and space, the more readable that design will become. Although body copy usually occupies the largest area of space, it often requires the least amount of the designer's time. Type is also used to attract attention, often in a headline where the design will need to arrest

Monotype Baskerville 312 bold, 10/12 point, ranged left

Readability is the biggest single necessity for typography. Designers must always keep this as their chief priority. Copy which is meant to be read but is hard to read, no matter how clever or fashionable the layout might appear, is badly designed. Readability need not mean dullness. On the contrary, the more attractive, the more exciting, the more creative the feel for tone and space, the more readable that design will become. Although body copy where

Monotype Baskerville 169

ABCDEFGHIJKLMNOPQRSTUVWXYZ
abcdefghijklmnopqrstuvwxyz
1234567890 1234567890 &!?().,:;""" £$¢

Monotype Baskerville 169 italic

ABCDEFGHIJKLMNOPQRSTUVWXYZ
abcdefghijklmnopqrstuvwxyz
1234567890 1234567890 &!?().,:;""" £$¢

Monotype Baskerville 312 bold

ABCDEFGHIJKLMNOPQRSTUVWXYZ
abcdefghijklmnopqrstuvwxyz
1234567890 1234567890 &!?().,:;""" £$¢

Monotype Baskerville 312 bold italic
ABCDEFGHIJKLMNOPQRSTUVWXYZ abcdefghijklmnopqrstuvwxyz 1234567890

Monotype Baskerville 313 semi-bold
ABCDEFGHIJKLMNOPQRSTUVWXYZ abcdefghijklmnopqrstuvwxyz 1234567890

Monotype Baskerville 313 semi-bold italic
ABCDEFGHIJKLMNOPQRSTUVWXYZ abcdefghijklmnopqrstuvwxyz 1234567890

Monotype Baskerville display bold
ABCDEFGHIJKLMNOPQRSTUVWXYZ abcdefghijklmnopqrstuvwxyz 1234567890

Other versions

Baskerville (Berthold)	Baskerville (Linotype)	Baskerville No 3	ITC New Baskerville
	Baskerville No 2	Fry's Baskerville	

Century Schoolbook

Century Schoolbook, designed in 1924, is the most popular member of the Century family of typefaces. It has a heavy colour, a vertical stress, a large x-height and strengthened (almost slab-like) serifs which are slightly bracketed. It is a legible, practical type which has found many applications in educational publishing as well as in the newspaper, magazine and book publishing industries. Century Schoolbook's original American Typefounders' version does not have bold italics, but Linotype have released New Century Schoolbook which has a full range of weights and companion italics including a black (extra bold). The version shown here is Monotype's recutting of the type which has a bold italic.

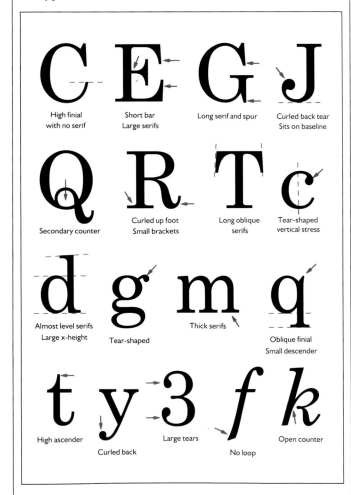

High finial with no serif · Short bar / Large serifs · Long serif and spur · Curled back tear / Sits on baseline · Secondary counter · Curled up foot / Small brackets · Long oblique serifs · Tear-shaped vertical stress · Almost level serifs / Large x-height · Tear-shaped · Thick serifs · Oblique finial / Small descender · High ascender · Curled back · Large tears · No loop · Open counter

Monotype Century Schoolbook roman, 10/11 point, ranged left

Readability is the biggest single necessity for typography. Designers must always keep this as their chief priority. Copy which is meant to be read but is hard to read, no matter how clever or fashionable the layout might appear, is badly designed. Readability need not mean dullness. On the contrary, the more attractive, the more exciting, the more creative the feel for tone and space, the more readable that design will become. Although body copy usually occupies the largest area of space, it often requires the least amount of the designer's

Monotype Century Schoolbook roman, 10/12 point, ranged left

Readability is the biggest single necessity for typography. Designers must always keep this as their chief priority. Copy which is meant to be read but is hard to read, no matter how clever or fashionable the layout might appear, is badly designed. Readability need not mean dullness. On the contrary, the more attractive, the more exciting, the more creative the feel for tone and space, the more readable that design will become. Although body copy usually occupies the largest area of space, it often requires the least amount of the designer's

Monotype Century Schoolbook roman, 10/13 point, ranged left

Readability is the biggest single necessity for typography. Designers must always keep this as their chief priority. Copy which is meant to be read but is hard to read, no matter how clever or fashionable the layout might appear, is badly designed. Readability need not mean dullness. On the contrary, the more attractive, the more exciting, the more creative the feel for tone and space, the more readable that design will become. Although body copy usually occupies the largest area of space, it often requires the least amount of the designer's

Monotype Century Schoolbook roman, 10/12 point, justified

Readability is the biggest single necessity for typography. Designers must always keep this as their chief priority. Copy which is meant to be read but is hard to read, no matter how clever or fashionable the layout might appear, is badly designed. Readability need not mean dullness. On the contrary, the more attractive, the more exciting, the more creative the feel for tone and space, the more readable that design will become. Although body copy usually occupies the largest area of space, it often requires the least amount of the designer's time.

Monotype Century Schoolbook italic, 10/12 point, ranged left

Readability is the biggest single necessity for typography. Designers must always keep this as their chief priority. Copy which is meant to be read but is hard to read, no matter how clever or fashionable the layout might appear, is badly designed. Readability need not mean dullness. On the contrary, the more attractive, the more exciting, the more creative the feel for tone and space, the more readable that design will become. Although body copy usually occupies the

Monotype Century Schoolbook bold, 10/12 point, ranged left

Readability is the biggest single necessity for typography. Designers must always keep this as their chief priority. Copy which is meant to be read but is hard to read, no matter how clever or fashionable the layout might appear, is badly designed. Readability need not mean dullness. On the contrary, the more attractive, the more exciting, the more creative the feel for tone and space, the more readable that design will become.

Monotype Century Schoolbook roman

ABCDEFGHIJKLMNOPQRSTUVWXYZ
abcdefghijklmnopqrstuvwxyz
1234567890 &!?().,:;""" £$¢

Monotype Century Schoolbook italic

ABCDEFGHIJKLMNOPQRSTUVWXYZ
abcdefghijklmnopqrstuvwxyz
1234567890 &!?().,:;""" £$¢

Monotype Century Schoolbook bold

ABCDEFGHIJKLMNOPQRSTUVWXYZ
abcdefghijklmnopqrstuvwxyz
1234567890 &!?().,:;""" £$¢

Monotype Century Schoolbook bold italic

ABCDEFGHIJKLMNOPQRSTUVWXYZ
abcdefghijklmnopqrstuvwxyz
1234567890 &!?().,:;""" £$¢

Other versions
Century Schoolbook (ATF)
New Century Schoolbook

Cheltenham

Originally designed in 1896 by American architect Bertram Goodhue, Cheltenham was developed into the first type family by Morris Benton, the resident type designer at American Typefounders (ATF). Since its release in 1902, its popularity has been largely concentrated in the United States where it found many admirers in the advertising world. Cheltenham is sturdy and has short, stubby serifs, a narrow set and long ascenders and short descenders. Its biggest asset is the enormous range of 18 or more different weights, widths and italics. In 1978, ITC released their own very substantial Cheltenham family complete with a large x-height and wider set. Other versions of Cheltenham are Winchester by Stephenson Blake and Gloucester by Monotype. The version shown here is that of ATF.

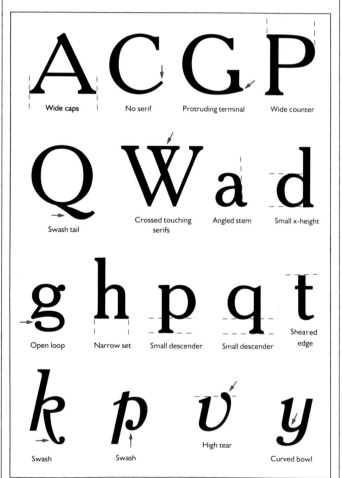

Wide caps No serif Protruding terminal Wide counter

Swash tail Crossed touching serifs Angled stem Small x-height

Open loop Narrow set Small descender Small descender Sheared edge

Swash Swash High tear Curved bowl

Cheltenham roman, 10/11 point, ranged left

Readability is the biggest single necessity for typography. Designers must always keep this as their chief priority. Copy which is meant to be read but is hard to read, no matter how clever or fashionable the layout might appear, is badly designed. Readability need not mean dullness. On the contrary, the more attractive, the more exciting, the more creative the feel for tone and space, the more readable that design will become. Although body copy usually occupies the largest area of space, it often requires the least amount of the designer's time. Type is also used to attract attention, often in a headline where the design complements the message. It may do this by being brash, crude

Cheltenham roman, 10/12 point, ranged left

Readability is the biggest single necessity for typography. Designers must always keep this as their chief priority. Copy which is meant to be read but is hard to read, no matter how clever or fashionable the layout might appear, is badly designed. Readability need not mean dullness. On the contrary, the more attractive, the more exciting, the more creative the feel for tone and space, the more readable that design will become. Although body copy usually occupies the largest area of space, it often requires the least amount of the designer's time. Type is also used to attract attention, often in a headline where the design complements the message. It may do this by being brash, crude

Cheltenham roman, 10/13 point, ranged left

Readability is the biggest single necessity for typography. Designers must always keep this as their chief priority. Copy which is meant to be read but is hard to read, no matter how clever or fashionable the layout might appear, is badly designed. Readability need not mean dullness. On the contrary, the more attractive, the more exciting, the more creative the feel for tone and space, the more readable that design will become. Although body copy usually occupies the largest area of space, it often requires the least amount of the designer's time. Type is also used to attract attention, often in a headline where the design complements the message. It may do this by being brash, crude

Cheltenham roman, 10/12 point, justified

Readability is the biggest single necessity for typography. Designers must always keep this as their chief priority. Copy which is meant to be read but is hard to read, no matter how clever or fashionable the layout might appear, is badly designed. Readability need not mean dullness. On the contrary, the more attractive, the more exciting, the more creative the feel for tone and space, the more readable that design will become. Although body copy usually occupies the largest area of space, it often requires the least amount of the designer's time. Type is also used to attract attention, often in a headline where the design complements the message. It may do this by being brash, crude

Cheltenham italic, 10/12 point, ranged left

Readability is the biggest single necessity for typography. Designers must always keep this as their chief priority. Copy which is meant to be read but is hard to read, no matter how clever or fashionable the layout might appear, is badly designed. Readability need not mean dullness. On the contrary, the more attractive, the more exciting, the more creative the feel for tone and space, the more readable that design will become. Although body copy usually occupies the largest area of space, it often requires the least amount of the designer's time. Type is also used to attract attention, often in a

Cheltenham bold, 10/12 point, ranged left

Readability is the biggest single necessity for typography. Designers must always keep this as their chief priority. Copy which is meant to be read but is hard to read, no matter how clever or fashionable the layout might appear, is badly designed. Readability need not mean dullness. On the contrary, the more attractive, the more exciting, the more creative the feel for tone and space, the more readable that design will become. Although body copy usually occupies the largest area of space,

Cheltenham roman

ABCDEFGHIJKLMNOPQRSTUVWXYZ
abcdefghijklmnopqrstuvwxyz
1234567890&!?().,:;""''£$¢ƒ

Cheltenham italic

ABCDEFGHIJKLMNOPQRSTUVWXYZ
abcdefghijklmnopqrstuvwxyz
1234567890&!?().,:;""''£$¢ƒ

Cheltenham bold

ABCDEFGHIJKLMNOPQRSTUVWXYZ
abcdefghijklmnopqrstuvwxyz
1234567890&!?().,:;""''£$¢ƒ

Cheltenham bold italic

ABCDEFGHIJKLMNOPQRSTUVWXYZ
abcdefghijklmnopqrstuvwxyz
1234567890&!?().,:;""''£$¢ƒ

Other versions
Cheltenham Nova
ITC Cheltenham
Gloucester Old Style (Monotype)

Apollo
1964

ABCDEFGHIJKLMNOPQRSTUVWXYZ &!?(),.:;""''

ABCDEFGHIJKLMNOPQRSTUVWXYZ abcdefghijklmnopqrstuvwxyz 1234567890

Auriga
1970

ABCDEFGHIJKLMNOPQRSTUVWXYZ &!?(),:;""

ABCDEFGHIJKLMNOPQRSTUVWXYZ abcdefghijklmnopqrstuvwxyz 1234567890

Baskerville
(Linotype)

ABCDEFGHIJKLMNOPQRSTUVWXYZ &!?(),:;"" ”

ABCDEFGHIJKLMNOPQRSTUVWXYZ abcdefghijklmnopqrstuvwxyz 1234567890

Baskerville No. 2

ABCDEFGHIJKLMNOPQRSTUVWXYZ &!?(),:;" ”

ABCDEFGHIJKLMNOPQRSTUVWXYZ abcdefghijklmnopqrstuvwxyz 1234567890

ITC New Baskerville

ABCDEFGHIJKLMNOPQRSTUVWXYZ &!?(),:;" ”

ABCDEFGHIJKLMNOPQRSTUVWXYZ abcdefghijklmnopqrstuvwxyz 1234567890

Binny Old Style
1908

ABCDEFGHIJKLMNOPQRSTUVWXY &!?(),:;" ”

ABCDEFGHIJKLMNOPQRSTUVWXYZ abcdefghijklmnopqrstuvwxyz 1234567890

Bitstream Charter

ABCDEFGHIJKLMNOPQRSTUVWXYZ &!?(),:;" ”

Bookman
(Linotype)
1936

ABCDEFGHIJKLMNOPQRSTUVWXYZ &!?(),:;" ”

ITC Bookman

ABCDEFGHIJKLMNOPQRSTUVWXYZ &!?(),:;"" ”

ABCDEFGHIJKLMNOPQRSTUVWXYZ abcdefghijklmnopqrstuvwxyz 1234567890

Candida
1936

ABCDEFGHIJKLMNOPQRSTUVWXYZ &!?(),:; " "

ABCDEFGHIJKLMNOPQRSTUVWXYZ abcdefghijklmnopqrstuvwxyz 1234567890

abcdefghijklmnopqrstuvwxyz 1234567890 £$¢*f*

Apollo
1964

abcdefghijklmnopqrstuvwxyz 1234567890 £$¢*f*

ABCDEFGHIJKLMNOPQRSTUVWXYZ abcdefghijklmnopqrstuvwxyz 1234567890

Auriga
1970

abcdefghijklmnopqrstuvwxyz 1234567890 £$¢*f*

ABCDEFGHIJKLMNOPQRSTUVWXYZ abcdefghijklmnopqrstuvwxyz 1234567890

Baskerville
(Linotype)

abcdefghijklmnopqrstuvwxyz 1234567890 £$¢*f*

ABCDEFGHIJKLMNOPQRSTUVWXYZ abcdefghijklmnopqrstuvwxyz 1234567890

Baskerville No. 2

abcdefghijklmnopqrstuvwxyz 1234567890 £$¢*f*

ABCDEFGHIJKLMNOPQRSTUVWXYZ abcdefghijklmnopqrstuvwxyz 1234567890

ITC New Baskerville

abcdefghijklmnopqrstuvwxyz 1234567890 £$¢*f*

ABCDEFGHIJKLMNOPQRSTUVWXYZ abcdefghijklmnopqrstuvwxyz 1234567890

Binny Old Style
1908

abcdefghijklmnopqrstuvwxyz 1234567890 £$

Bitstream Charter

abcdefghijklmnopqrstuvwxyz 1234567890 £$¢*f*

ABCDEFGHIJKLMNOPQRSTUVWXYZ abcdefghijklmnopqrstuvwxyz 1234567890

Bookman
(Linotype)
1936

abcdefghijklmnopqrstuvwxyz 1234567890 £$¢*f*

ABCDEFGHIJKLMNOPQRSTUVWXYZ abcdefghijklmnopqrstuvwxyz 1234567890

ITC Bookman

abcdefghijklmnopqrstuvwxyz 1234567890 £$¢*f*

ABCDEFGHIJKLMNOPQRSTUVWXYZ abcdefghijklmnopqrstuvwxyz 1234567890

Candida
1936

Century Old Style
1894

ABCDEFGHIJKLMNOPQRSTUVWXYZ &!?(),.:;""

ABCDEFGHIJKLMNOPQRSTUVWXYZ abcdefghijklmnopqrstuvwxyz 1234567890

ITC Cheltenham

ABCDEFGHIJKLMNOPQRSTUVWXYZ &!?(),.:;" "

ABCDEFGHIJKLMNOPQRSTUVWXYZ abcdefghijklmnopqrstuvwxyz 1234567890

Clarion

ABCDEFGHIJKLMNOPQRSTUVWXYZ&!?(),.:;" "

ABCDEFGHIJKLMNOPQRSTUVWXYZ abcdefghijklmnopqrstuvwxyz 1234567890

ITC Clearface

ABCDEFGHIJKLMNOPQRSTUVWXYZ &!?(),.:;" "

ABCDEFGHIJKLMNOPQRSTUVWXYZ abcdefghijklmnopqrstuvwxyz 1234567890

Cochin
1922

ABCDEFGHIJKLMNOPQRSTUVWXYZ &!?(),.:;""

ABCDEFGHIJKLMNOPQRSTUVWXYZ abcdefghijklmnopqrstuvwxyz 1234567890

Comenius
1976

ABCDEFGHIJKLMNOPQRSTUVWXYZ &!?(),.:;""

ABCDEFGHIJKLMNOPQRSTUVWXYZ abcdefghijklmnopqrstuvwxyz 1234567890

Corona
1949

ABCDEFGHIJKLMNOPQRSTUVWXYZ &!?(),.:;" "

Cremona

ABCDEFGHIJKLMNOPQRSTUVWXYZ &!?(),.:;" "

ABCDEFGHIJKLMNOPQRSTUVWXYZ abcdefghijklmnopqrstuvwxyz 1234567890

Electra
1935

ABCDEFGHIJKLMNOPQRSTUVWXYZ &!?(),.:;" "

ABCDEFGHIJKLMNOPQRSTUVWXYZ abcdefghijklmnopqrstuvwxyz 1234567890

Else NPL
1982

ABCDEFGHIJKLMNOPQRSTUVWXYZ &!?(),.:;""

ABCDEFGHIJKLMNOPQRSTUVWXYZ abcdefghijklmnopqrstuvwxyz 1234567890

abcdefghijklmnopqrstuvwxyz 1234567890 £$¢ƒ

Century Old Style
1894

ABCDEFGHIJKLMNOPQRSTUVWXYZ abcdefghijklmnopqrstuvwxyz 1234567890

abcdefghijklmnopqrstuvwxyz 1234567890 £$¢ƒ

ITC Cheltenham

ABCDEFGHIJKLMNOPQRSTUVWXYZ abcdefghijklmnopqrstuvwxyz 1234567890

abcdefghijklmnopqrstuvwxyz 1234567890 £$

Clarion

abcdefghijklmnopqrstuvwxyz 1234567890 £$¢ƒ

ITC Clearface

ABCDEFGHIJKLMNOPQRSTUVWXYZ abcdefghijklmnopqrstuvwxyz 1234567890

abcdefghijklmnopqrstuvwxyz 1234567890 £$¢ƒ

Cochin
1922

ABCDEFGHIJKLMNOPQRSTUVWXYZ abcdefghijklmnopqrstuvwxyz 1234567890

abcdefghijklmnopqrstuvwxyz 1234567890 £$

Comenius
1976

ABCDEFGHIJKLMNOPQRSTUVWXYZ abcdefghijklmnopqrstuvwxyz 1234567890

abcdefghijklmnopqrstuvwxyz 1234567890 £$¢ƒ

Corona
1949

ABCDEFGHIJKLMNOPQRSTUVWXYZ abcdefghijklmnopqrstuvwxyz 1234567890

abcdefghijklmnopqrstuvwxyz 1234567890 £$¢ƒ

Cremona

ABCDEFGHIJKLMNOPQRSTUVWXYZ abcdefghijklmnopqrstuvwxyz 1234567890

abcdefghijklmnopqrstuvwxyz 1234567890 £$¢ƒ

Electra
1935

ABCDEFGHIJKLMNOPQRSTUVWXYZ abcdefghijklmnopqrstuvwxyz 1234567890

abcdefghijklmnopqrstuvwxyz 1234567890 £$¢ƒ

Else NPL
1982

ABCDEFGHIJKLMNOPQRSTUVWXYZ abcdefghijklmnopqrstuvwxyz 1234567890

Excelsior
1951

ABCDEFGHIJKLMNOPQRSTUVWXYZ &!?(),:;""

ABCDEFGHIJKLMNOPQRSTUVWXYZ abcdefghijklmnopqrstuvwxyz 1234567890

Fournier
1924

ABCDEFGHIJKLMNOPQRSTUVWXYZ &!?(),:;""

Impressum
1962

ABCDEFGHIJKLMNOPQRSTUVWXYZ &!?(),:;""

ABCDEFGHIJKLMNOPQRSTUVWXYZ abcdefghijklmnopqrstuvwxyz 1234567890

Ionic 5
1922

ABCDEFGHIJKLMNOPQRSTUVWXYZ &!?(),:;""

ABCDEFGHIJKLMNOPQRSTUVWXYZ abcdefghijklmnopqrstuvwxyz 1234567890

Joanna
(cut 1928, issued 1958)

ABCDEFGHIJKLMNOPQRSTUVWXYZ &!?(),:;""

ABCDEFGHIJKLMNOPQRSTUVWXYZ abcdefghijklmnopqrstuvwxyz 1234567890

Melior
1952

ABCDEFGHIJKLMNOPQRSTUVWXYZ &!?(),:;""

ABCDEFGHIJKLMNOPQRSTUVWXYZ abcdefghijklmnopqrstuvwxyz 1234567890

Meridien
1955

ABCDEFGHIJKLMNOPQRSTUVWXYZ &!?(),:;""

ABCDEFGHIJKLMNOPQRSTUVWXYZ abcdefghijklmnopqrstuvwxyz 1234567890

Nimrod
1980

ABCDEFGHIJKLMNOPQRSTUVWXYZ &!?(),.:;""

ABCDEFGHIJKLMNOPQRSTUVWXYZ abcdefghijklmnopqrstuvwxyz 1234567890

Old Style 7

ABCDEFGHIJKLMNOPQRSTUVWXYZ &!?(),:;""

ABCDEFGHIJKLMNOPQRSTUVWXYZ abcdefghijklmnopqrstuvwxyz 1234567890

Olympian
1970

ABCDEFGHIJKLMNOPQRSTUVWXYZ &!?(),:;""

ABCDEFGHIJKLMNOPQRSTUVWXYZ abcdefghijklmnopqrstuvwxyz 1234567890

abcdefghijklmnopqrstuvwxyz 1234567890 £$¢ƒ

Excelsior
1951

ABCDEFGHIJKLMNOPQRSTUVWXYZ abcdefghijklmnopqrstuvwxyz 1234567890

abcdefghijklmnopqrstuvwxyz 1234567890 £$¢ƒ

Fournier
1924

ABCDEFGHIJKLMNOPQRSTUVWXYZ abcdefghijklmnopqrstuvwxyz 1234567890

abcdefghijklmnopqrstuvwxyz 1234567890 £$¢ƒ

Impressum
1962

ABCDEFGHIJKLMNOPQRSTUVWXYZ abcdefghijklmnopqrstuvwxyz 1234567890

abcdefghijklmnopqrstuvwxyz 1234567890 £$¢ƒ

Ionic 5
1922

ABCDEFGHIJKLMNOPQRSTUVWXYZ abcdefghijklmnopqrstuvwxyz 1234567890

abcdefghijklmnopqrstuvwxyz 1234567890 £$¢ƒ

Joanna
(cut 1928, issued 1958)

ABCDEFGHIJKLMNOPQRSTUVWXYZ abcdefghijklmnopqrstuvwxyz 1234567890

abcdefghijklmnopqrstuvwxyz 1234567890 £$¢ƒ

Melior
1952

ABCDEFGHIJKLMNOPQRSTUVWXYZ abcdefghijklmnopqrstuvwxyz 1234567890

abcdefghijklmnopqrstuvwxyz 1234567890 £$¢ƒ

Meridien
1955

ABCDEFGHIJKLMNOPQRSTUVWXYZ abcdefghijklmnopqrstuvwxyz 1234567890

abcdefghijklmnopqrstuvwxyz 1234567890 £$¢ƒ

Nimrod
1980

abcdefghijklmnopqrstuvwxyz 1234567890 £$¢ƒ

Old Style 7

ABCDEFGHIJKLMNOPQRSTUVWXYZ abcdefghijklmnopqrstuvwxyz 1234567890

abcdefghijklmnopqrstuvwxyz 1234567890 £$¢ƒ

Olympian
1970

ABCDEFGHIJKLMNOPQRSTUVWXYZ abcdefghijklmnopqrstuvwxyz 1234567890

Orion
1974

ABCDEFGHIJKLMNOPQRSTUVWXYZ &!?(),.:;""

Pilgrim
(Linotype)
1953

ABCDEFGHIJKLMNOPQRSTUVWXYZ &!?(),.:;""

Poppl Pontifex

ABCDEFGHIJKLMNOPQRSTUVWXYZ &!?(),.:;""

ABCDEFGHIJKLMNOPQRSTUVWXYZ abcdefghijklmnopqrstuvwxyz 1234567890

Quadriga Antiqua

ABCDEFGHIJKLMNOPQRSTUVWXYZ &!?(),.:;""

ABCDEFGHIJKLMNOPQRSTUVWXYZ abcdefghijklmnopqrstuvwxyz 1234567890

ITC Slimbach

ABCDEFGHIJKLMNOPQRSTUVWXYZ &!?(),.:;""

ABCDEFGHIJKLMNOPQRSTUVWXYZ abcdefghijklmnopqrstuvwxyz 1234567890

ITC Stone Serif

ABCDEFGHIJKLMNOPQRSTUVWXYZ &!?(),.:;""

ABCDEFGHIJKLMNOPQRSTUVWXYZ abcdefghijklmnopqrstuvwxyz 1234567890

Textype
1929

ABCDEFGHIJKLMNOPQRSTUVWXYZ &!?(),.:;" "

ABCDEFGHIJKLMNOPQRSTUVWXYZ abcdefghijklmnopqrstuvwxyz 1234567890

Times Europa
1972

ABCDEFGHIJKLMNOPQRSTUVWXYZ &!?(),.:;""

ABCDEFGHIJKLMNOPQRSTUVWXYZ abcdefghijklmnopqrstuvwxyz 1234567890

Versailles
1982

ABCDEFGHIJKLMNOPQRSTUVWXYZ &!?(),.:;""

ABCDEFGHIJKLMNOPQRSTUVWXYZ abcdefghijklmnopqrstuvwxyz 1234567890

ITC Zapf International
1977

ABCDEFGHIJKLMNOPQRSTUVWXYZ &!?(),.:;" "

ABCDEFGHIJKLMNOPQRSTUVWXYZ abcdefghijklmnopqrstuvwxyz 1234567890

abcdefghijklmnopqrstuvwxyz 1234567890 £$¢ƒ

Orion
1974

ABCDEFGHIJKLMNOPQRSTUVWXYZ abcdefghijklmnopqrstuvwxyz 1234567890

abcdefghijklmnopqrstuvwxyz 1234567890 £$¢ƒ

Pilgrim
(Linotype)
1953

ABCDEFGHIJKLMNOPQRSTUVWXYZ abcdefghijklmnopqrstuvwxyz 1234567890

abcdefghijklmnopqrstuvwxyz 1234567890 £$

Poppl Pontifex

ABCDEFGHIJKLMNOPQRSTUVWXYZ abcdefghijklmnopqrstuvwxyz 1234567890

abcdefghijklmnopqrstuvwxyz 1234567890 £$ƒ

Quadriga Antiqua

ABCDEFGHIJKLMNOPQRSTUVWXYZ abcdefghijklmnopqrstuvwxyz 1234567890

abcdefghijklmnopqrstuvwxyz 1234567890 £$¢ƒ

ITC Slimbach

ABCDEFGHIJKLMNOPQRSTUVWXYZ abcdefghijklmnopqrstuvwxyz 1234567890

abcdefghijklmnopqrstuvwxyz 1234567890 £$¢ƒ

ITC Stone Serif

ABCDEFGHIJKLMNOPQRSTUVWXYZ abcdefghijklmnopqrstuvwxyz 1234567890

abcdefghijklmnopqrstuvwxyz 1234567890 £$¢ƒ

Textype
1929

ABCDEFGHIJKLMNOPQRSTUVWXYZ abcdefghijklmnopqrstuvwxyz 1234567890

abcdefghijklmnopqrstuvwxyz 1234567890 £$¢ƒ

Times Europa
1972

ABCDEFGHIJKLMNOPQRSTUVWXYZ abcdefghijklmnopqrstuvwxyz 1234567890

abcdefghijklmnopqrstuvwxyz 1234567890 £$¢ƒ

Versailles
1982

ABCDEFGHIJKLMNOPQRSTUVWXYZ abcdefghijklmnopqrstuvwxyz 1234567890

abcdefghijklmnopqrstuvwxyz 1234567890 £$¢ƒ

ITC Zapf International
1977

ABCDEFGHIJKLMNOPQRSTUVWXYZ abcdefghijklmnopqrstuvwxyz 1234567890

1 In this Awards poster, the sharp wit of the copy and imagery is matched by the sharply cut serifs of Baskerville. The tight letterspacing has a modern feel, but it is too tight for optimum legibility because the wide set of the letters demands generous letterspacing.

2 The simple logo for a PR company illustrates how to mix successfully a Transitional type (Baskerville Bold) with a contrasting sans serif (Gill Bold). The contrast is accentuated by the change in axis.

3 In this poster for Amnesty International, the feeling of movement in a flickering flame is produced by the use of Baskerville Italic. Meanwhile, the contrasting condensed sans serif circumvents the Baskerville Roman candle (which has melted at the top).

4 The spacious and harmonious typographical layout matches the solitude and spaciousness of the photographs in this spread from a gardening book. The use of Baskerville Roman for the text and italic for the captions is a common but effective way of visually separating them.

5 The long serifs of Baskerville help the eye to travel along the wide type measure on this poster for Poems on the London Underground. The ample leading helps to maintain legibility and the decorated initial letter lends a literary touch.

6 The traditional qualities and English origins of Baskerville are an appropriate choice for a CD cover for a British Composer's Series of EMI Classics. For added visual interest, the word "fell" has been dropped into the bottom corner.

My beloved spake, and said unto me, Rise up, my Love, my fair one, and come away.

For lo, the winter is past, the rain is over, and gone.

The flowers appear on the earth, the time of the singing of birds is come, and the voice of the turtle is heard in our land.

The fig tree putteth forth her green figs, and the vines with the tender grape give a good smell.

Arise, my love, my fair one, and come away.

from THE SONG OF SOLOMON

The Poetry Society 071-373 3551 · The British Library (Zweig Programme) · The British Council · Queen Mary & Westfield College
Designed and produced by APT Photoset 071-701 6477 Printed by First Impression 071-733 1182

5

God caught them even before they fell.

EMI CLASSICS

BRITISH COMPOSERS
SIR ARTHUR BLISS
(1891-1975)
Morning Heroes

John Westbrook
Liverpool Philharmonic Choir
Royal Liverpool Philharmonic Orchestra
Sir Charles Groves

6

MAY 1987
CBA
RECORD

THE ADVOCATE

7

8

7 The ITC Cheltenham on this record magazine cover is an example of a 20th-century Transitional type with a low contrast in letterstrokes. The type in the masthead is unified by the horizontal rules, while the generous margins and understated typography allow the reader to focus on the image.

8 ATF Baskerville and Helvetica are used in this collage of typographical and cartographical elements, on a poster to chart the history of the Australian gold rush. The type size of the dates decreases as they move further into the past.

1 Eric Gill's Joanna is used to lighten the tone and give a contemporary feel to this traditional and understandably subdued brochure for the Ove Arup Memorial. An informal note is introduced by the asymmetrical arrangement of the headings at the top of the page.

2 The Century Bold Condensed Capitals used for the brand name on this packaging has a contemporary but established look which contrasts with the script. The colours reflect the dark, delicious chocolate inside.

3

4

3 A friendly brochure for small businesses in rural communities features Century Expanded which, despite its name, is a slightly condensed type suited to narrow measures. This is also a good example of how type can be run around the shape of an illustration.

4 A clever typographical "double-take" on a poster advertising an exhibition of the work of 22 female photographers. The elegant, graceful lower case italic 'f', and the sharp, modern '22', which are in a negative (reversed out) form, combine to make a simple but effective solution.

5 A jolly wine label from the 1930s, in which the rather hackneyed design centres around the letter 'J' which mirrors the handle of the umbrella below. The modified type has unusual curled stroke endings which terminate inside the bowls of the letters.

2

5

password

*Secure, recorded
communications at the
touch of a button*

6

7 The classic look of Century Old Style has been chosen to complement the shoes, and a modern feel is produced through the asymmetrical layout and use of white space.

7

GINA

Our most glamourous range, Gina shoes and accessories are for special occasions or whenever it is essential to look sensational. High elegant heels, fabulous colours and detailing make this a breath-takingly exquisite collection.

Styled for sheer extravagance and striking silhouette, Gina are the shoes for the unforgettable woman who never fails to make a dazzling entrance.

CLASSIC ELEGANCE,
SOPHISTICATED STYLE –
TWO RANGES FOR
EVERY OCCASION

6 Melior, a legible "straight" typeface with low contrast and a large x-height, helps to produce a business-like solution for this computer equipment brochure. The 'o' becomes a button – an example of Transitional type in action.

8 The traditional feel of the type on this label has associations with quality, homemade fare. By using capital letters, a larger type size is made possible in the limited space available.

8

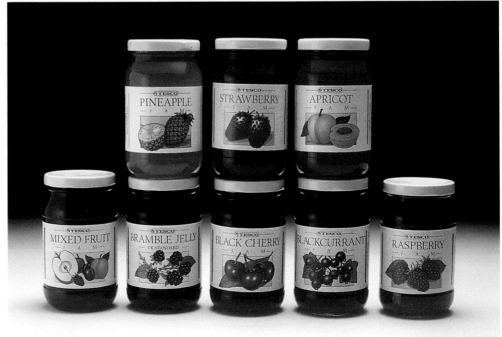

1 & 2 Two German LP covers utilizing the shape and texture of Baskerville and Baskerville Italic. In the example on the left, the step-and-repeat pattern of the type, creates an interesting layered effect. The heading is made up of cut-up letters to tie in with the surgery going on in the background photograph.

3 The elegant, distinctive 'Q' of New Baskerville Italic is enlarged from the masthead and cut in metal to become the central image on this cover of a quarterly journal.

4 The Habitat logo on this catalogue cover is set in Fry's Baskerville, a later stylish imitation of John Baskerville's types of the mid 18th century with fine bracketed serifs. The use of all lower case letters adds a functional, modernist feel.

5 On the cover of this financial services brochure for the Midland Bank, the Baskerville Roman capitals give the design a formal, business-like appeal, and the lower case italics add a touch of informality.

6 A Midland Bank folder for small businesses which mixes traditional, sophisticated colours with the modern, dynamic shapes of the panels. The logo, set in ITC Cheltenham Bold Condensed, has an appropriate sense of stability and strength.

7 Baskerville No. 3 is a suitable choice for this identity for a purveyor of traditional English food. The over-inked effect of the type, the natural colour and texture of the paper and the illustrations reinforce the traditional identity.

5

6

8 This brochure spread for the Society of Typographic Designers features Helicon, a 20th-century Transitional, and Univers. The sensitive typography reinforces the excellence professed in the copy, and the computer-generated effects suggest future directions for typography.

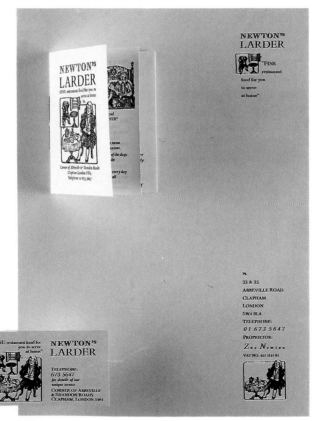

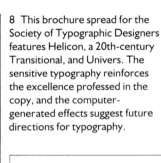

7

8

Modern

Frenchman Firmin Didot's roman of 1784 is regarded as the first type in the Modern style. Three years later, it was followed by a similar but superior face from Italian master-printer and type designer Giambattista Bodoni. Modern types remained unchallenged as the standard text style until the closing years of the 19th century. Modern is also referred to as Didone. Typefaces described in this section are either revivals of 18th- and 19th-century models or 20th-century romans which display similar features to the original Modern designs.

Due to further improvements in the printing process and paper and ink, the punchcutters of the Modern period were able to cut letterforms which previously would have been unthinkable. The types of Firmin Didot and Giambattista Bodoni are classic examples.

Didot's type of 1784 established all the hallmarks of the Modern style – an abrupt contrast in the thick and thin letterstrokes, a vertical stress and hairline, horizontal serifs. But Bodoni's roman, which was cut shortly afterwards, was superior in many details and, in particular, his hairline

A double-page spread (below) from *Divina Comedia* (1796), set in Giambattista Bodoni's type. The typography and the use of space is controlled and authoritative, and the high-contrast type sparkles on the page. The leading of the justified setting is wide in order to compensate for the strong vertical stress of the type.

Vieni dunque, o SIGNOR, vieni, e l'affetto
E il desiderio universal consola;
E a raddoppiar la nostra gioja teco
Venga, degna di te, l'augusta Sposa,
Nuovo ornamento a questi lidi, e nuovo
Felice innesto, onde la chiara in terra,
E protetta dal ciel, Borbonia pianta
Più bella ognor su questo suol verdeggi,
E nuovi rami germogliando stenda
Le amiche braccia, e in sue radici eterna
Di placid' ombra e preziosi frutti
Protegga e nutra le Parmensi rive.

A' STUDIOSI

DEL DIVINO POETA

GIO: JACOPO MARCH. DIONISI

CANONICO DI VERONA.

I

Dalla letterata Firenze, dall'intimo seno delle sue Biblioteche ho tratta, Signori, con un po' di destrezza e un po' più di pazienza nell'anno 1789 la divina Commedia di straniere brutture purgata, e di natie bellezze riadorna, la quale or esce felicemente alla luce. Io la serbava, come cosa cara, per me, avendo fisso nell'animo di pubblicarla, non senza le dovute sue illustrazioni, unitamente alla Vita Nuova, alle Rime, al Convito, e all'

serifs were bracketed and concave where Didot's had been flat and unbracketed. However, despite the extensive use of Bodoni's types as text faces during the 19th century, they are not ideal for continuous reading because they are too condensed and the strong vertical stress interrupts the natural horizontal flow of the eye along the line. Bodoni's grand and striking design is more suited to display or limited text applications. Many typefounders have revived Bodoni's types, including Baeur, Linotype and Monotype. Didot's types are available from Monotype as a digital typeface called Neo Didot (1904).

There have been many copies of Bodoni's design (mostly bad) but that of German Justus Walbaum of about 1800 is a highly creditable cutting which has become a popular type in its own right. The German typefoundry Berthold's version (1800) has hairline unbracketed serifs, a large x-height and is available in regular and bold weights with companion italics. Monotype's rendition (1921) has a wider set and less contrast between the width of the letterstrokes, a smaller x-height and bracketed serifs. Basilia Haas (1982) and Torino (1908) are also based on Bodoni's design.

In England, Bulmer and Bell, which have a mixture of Transitional, Old Style and Modern features, appeared at about the same time as the types of Didot and Bodoni. Bulmer, a Transitional-Modern hybrid, was narrow, had sharply cut serifs and a high but not abrupt contrast. It has been revived in the 20th century by a number of typefounders. Bell was originally designed in about 1790 and this elegant type was revived by Monotype in 1931.

In 1809 Richard Austin produced a new roman for Miller & Company of Edinburgh. Called Scotch Roman, it was revived in the early part of the 20th century by Linotype and Monotype. Over the years, the face has been used extensively for the setting of literature but its heavy capitals do not harmonize particularly well with the lighter lower case letters.

The majority of the other faces included in this section are 20th-century romans, many of which have been inspired either by Bodoni's types or other 18th- and early 19th-century models.

Selecting Modern typefaces

Many of the Modern-style types are not the most legible typefaces for continuous text, especially those which have a very abrupt contrast in the letterstrokes such as Bodoni, Neo Didot and Walbaum. These demand plenty of leading to compensate for the strong vertical stress. Scotch Roman and similar designs are more appropriate for continuous text but many of these faces have no bold italic or,

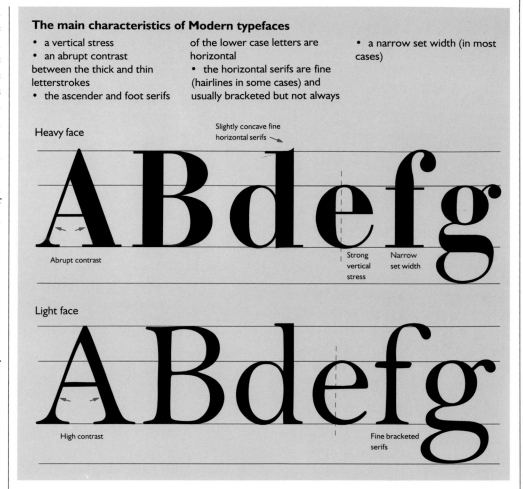

The main characteristics of Modern typefaces

- a vertical stress
- an abrupt contrast between the thick and thin letterstrokes
- the ascender and foot serifs

of the lower case letters are horizontal
- the horizontal serifs are fine (hairlines in some cases) and usually bracketed but not always

- a narrow set width (in most cases)

Heavy face

Slightly concave fine horizontal serifs

Abrupt contrast

Strong vertical stress

Narrow set width

Light face

High contrast

Fine bracketed serifs

in some cases, no bold fonts at all. The Century-based types – Linotype Centennial (1978), Century Expanded (1900), ITC Century (1975) and others – are some of the most legible faces and have a fuller range of weights and italics. Caledonia (1931) is a durable text face. Monotype's Bell, which has regular, semi-bold and bold variations but only a regular italic font, is elegant but rather delicate.

A small number of other Modern faces such as ITC Fenice (1980) and Fairfield (1939) have peculiar characteristics which preclude their use as serious text types. The lower case 'v' and 'w' of Neo Didot are probably the quirkiest features to be found in this section. Typefaces with a large x-height are in abundance here – ITC Modern (1982), Linotype Centennial, ITC Century, Walbaum (Berthold) are but a few. Narrow faces, which are economical in the use of space, are Caledonia and Madison (1909), but Iridium (1975) and Bulmer (1928), whose long ascenders and descenders need leading, and ITC Modern and ITC Zapf Book (1976).

Quick selection guide

Availability: Average to good.

PostScript fonts for the Apple Macintosh: Bauer Bodoni, Bell, ITC Century and others.

Recent designs: Ellington (1990), Linotype Centennial (1978).

Faces by leading type designers: Augustea (1951) and ITC Fenice (1980) by Aldo Novarese, Linotype Centennial by Matthew Carter, Iridium by Adrian Frutiger, Caledonia by William Dwiggins and ITC Zapf Book by Hermann Zapf.

Greek fonts: Caledonia.

Bell

In 1788, John Bell, an English publisher and bookseller, established Bell's British Letter Foundry and, in the same year, he employed punchcutter John Handy to cut a new roman type. Bell had progressive ideas on type design and his new roman embodied characteristics of both the emerging Modern-style types of Didot and Bodoni and of the types of the earlier Old Style and Transitional periods (it could equally be classified as a Transitional face). Bell's design had a narrow set, sharply cut serifs, a strong contrast between the thick and thin letterstrokes, and a vertical stress. Stanley Morison rediscovered Bell's type in the 1920s which resulted in its re-cutting by Monotype for hot metal composition in 1931. The regular weight is now available from Monotype as a digital typeface (shown here) in both roman and italic fonts and the roman also has semi-bold and bold weights. Bell is a handsome type but its delicate design restricts its use.

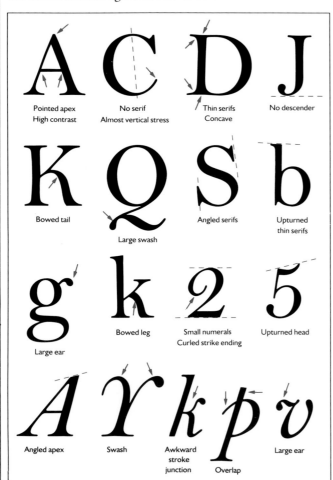

Monotype Bell, 10/11 point, ranged left

Readability is the biggest single necessity for typography. Designers must always keep this as their chief priority. Copy which is meant to be read but is hard to read, no matter how clever or fashionable the layout might appear, is badly designed. Readability need not mean dullness. On the contrary, the more attractive, the more exciting, the more creative the feel for tone and space, the more readable that design will become. Although body copy usually occupies the largest area of space, it often requires the least amount of the designer's time. Type is also used to attract attention, often in a headline where the

Monotype Bell, 10/12 point, ranged left

Readability is the biggest single necessity for typography. Designers must always keep this as their chief priority. Copy which is meant to be read but is hard to read, no matter how clever or fashionable the layout might appear, is badly designed. Readability need not mean dullness. On the contrary, the more attractive, the more exciting, the more creative the feel for tone and space, the more readable that design will become. Although body copy usually occupies the largest area of space, it often requires the least amount of the designer's time. Type is also used to attract attention, often in a headline where the

Monotype Bell, 10/13 point, ranged left

Readability is the biggest single necessity for typography. Designers must always keep this as their chief priority. Copy which is meant to be read but is hard to read, no matter how clever or fashionable the layout might appear, is badly designed. Readability need not mean dullness. On the contrary, the more attractive, the more exciting, the more creative the feel for tone and space, the more readable that design will become. Although body copy usually occupies the largest area of space, it often requires the least amount of the designer's time. Type is also used to attract attention, often in a headline where the

Monotype Bell, 10/12 point, justified

Readability is the biggest single necessity for typography. Designers must always keep this as their chief priority. Copy which is meant to be read but is hard to read, no matter how clever or fashionable the layout might appear, is badly designed. Readability need not mean dullness. On the contrary, the more attractive, the more exciting, the more creative the feel for tone and space, the more readable that design will become. Although body copy usually occupies the largest area of space, it often requires the least amount of the designer's time. Type is also used to attract attention, often in a headline where the design will need to arrest

Monotype Bell italic, 10/12 point, ranged left

Readability is the biggest single necessity for typography. Designers must always keep this as their chief priority. Copy which is meant to be read but is hard to read, no matter how clever or fashionable the layout might appear, is badly designed. Readability need not mean dullness. On the contrary, the more attractive, the more exciting, the more creative the feel for tone and space, the more readable that design will become. Although body copy usually occupies the largest area of space, it often requires the least amount of the designer's time. Type is also used to attract

Monotype Bell bold, 10/12 point, ranged left

Readability is the biggest single necessity for typography. Designers must always keep this as their chief priority. Copy which is meant to be read but is hard to read, no matter how clever or fashionable the layout might appear, is badly designed. Readability need not mean dullness. On the contrary, the more attractive, the more exciting, the more creative the feel for tone and space, the more readable that design will become. Although body copy will

Monotype Bell

ABCDEFGHIJKLMNOPQRSTUVWXYZ
abcdefghijklmnopqrstuvwxyz
1234567890 &!?()..,:;"" £$¢

Monotype Bell italic

ABCDEFGHIJKLMNOPQRSTUVWXYZ
abcdefghijklmnopqrstuvwxyz
1234567890 &!?()..,:;"" £$¢

Monotype Bell bold

ABCDEFGHIJKLMNOPQRSTUVWXYZ
abcdefghijklmnopqrstuvwxyz
1234567890 &!?()..,:;"" £$¢

Monotype Bell bold italic

ABCDEFGHIJKLMNOPQRSTUVWXYZ
abcdefghijklmnopqrstuvwxyz
1234567890 &!?()..,:;"" £$¢

Bodoni

The radical Modern-style types of Giambattista Bodoni arrived on the typographic scene in Europe in about 1787. Bodoni was determined to produce letterforms of great beauty. His type had a strong vertical stress, an abrupt contrast between the thick and thin letterstrokes and slightly concave hairline, bracketed serifs. Bodoni has been revived by many typefounders during the 20th century, including Linotype (1914–16) and Monotype (1921). The Bauer version shown here was chosen because it is regarded as being close to the original 18th-century design and is widely available in a range of widths, weights and italics. The strong vertical stress of the type demands generous leading. The display types called Poster Bodoni and Ultra Bodoni are not directly related to the original Bodoni design.

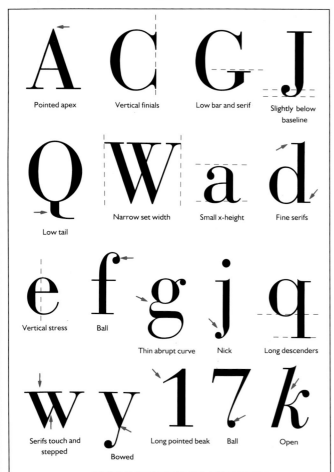

Pointed apex · Vertical finials · Low bar and serif · Slightly below baseline

Low tail · Narrow set width · Small x-height · Fine serifs

Vertical stress · Ball · Thin abrupt curve · Nick · Long descenders

Serifs touch and stepped · Bowed · Long pointed beak · Ball · Open

Bauer Bodoni roman, 10/11 point, ranged left

Readability is the biggest single necessity for typography. Designers must always keep this as their chief priority. Copy which is meant to be read but is hard to read, no matter how clever or fashionable the layout might appear, is badly designed. Readability need not mean dullness. On the contrary, the more attractive, the more exciting, the more creative the feel for tone and space, the more readable that design will become. Although body copy usually occupies the largest area of space, it often requires the least amount of the designer's time. Type is also used to attract attention,

Bauer Bodoni roman, 10/12 point, ranged left

Readability is the biggest single necessity for typography. Designers must always keep this as their chief priority. Copy which is meant to be read but is hard to read, no matter how clever or fashionable the layout might appear, is badly designed. Readability need not mean dullness. On the contrary, the more attractive, the more exciting, the more creative the feel for tone and space, the more readable that design will become. Although body copy usually occupies the largest area of space, it often requires the least amount of the designer's time. Type is also used to attract attention, often in a headline where

Bauer Bodoni roman, 10/13 point, ranged left

Readability is the biggest single necessity for typography. Designers must always keep this as their chief priority. Copy which is meant to be read but is hard to read, no matter how clever or fashionable the layout might appear, is badly designed. Readability need not mean dullness. On the contrary, the more attractive, the more exciting, the more creative the feel for tone and space, the more readable that design will become. Although body copy usually occupies the largest area of space, it often requires the least amount of the designer's time. Type is also used to attract attention, often in a headline where

Bauer Bodoni roman, 10/12 point, justified

Readability is the biggest single necessity for typography. Designers must always keep this as their chief priority. Copy which is meant to be read but is hard to read, no matter how clever or fashionable the layout might appear, is badly designed. Readability need not mean dullness. On the contrary, the more attractive, the more exciting, the more creative the feel for tone and space, the more readable that design will become. Although body copy usually occupies the largest area of space, it often requires the least amount of the designer's time. Type is also used to attract attention, often in a headline where

Bauer Bodoni italic, 10/12 point, ranged left

Readability is the biggest single necessity for typography. Designers must always keep this as their chief priority. Copy which is meant to be read but is hard to read, no matter how clever or fashionable the layout might appear, is badly designed. Readability need not mean dullness. On the contrary, the more attractive, the more exciting, the more creative the feel for tone and space, the more readable that design will become. Although body copy usually occupies the largest area of space, it often

Bauer Bodoni bold, 10/12 point, ranged left

Readability is the biggest single necessity for typography. Designers must always keep this as their chief priority. Copy which is meant to be read but is hard to read, no matter how clever or fashionable the layout might appear, is badly designed. Readability need not mean dullness. On the contrary, the more attractive, the more exciting, the more creative the feel for tone and space, the more readable that design will become. Although body copy usually occupies the

Bauer Bodoni roman

ABCDEFGHIJKLMNOPQRSTUVWXYZ
abcdefghijklmnopqrstuvwxyz
1234567890 &!?().,:;""£$¢ƒ

Non-aligning figures are available.

Bauer Bodoni italic

ABCDEFGHIJKLMNOPQRSTUVWXYZ
abcdefghijklmnopqrstuvwxyz
1234567890 &!?().,:;""£$¢ƒ

Non-aligning figures are available.

Bauer Bodoni bold

ABCDEFGHIJKLMNOPQRSTUVWXYZ
abcdefghijklmnopqrstuvwxyz
1234567890 &!?().,:;""£$¢ƒ

Non-aligning figures are available.

Bauer Bodoni bold italic

ABCDEFGHIJKLMNOPQRSTUVWXYZ abcdefghijklmnopqrstuvwxyz 1234567890

Bauer Bodoni black

ABCDEFGHIJKLMNOPQRSTUVWXYZ abcdefghijklmnopqrstuvwxyz 1234567890

Bauer Bodoni black italic

ABCDEFGHIJKLMNOPQRSTUVWXYZ abcdefghijklmnopqrstuvwxyz 1234567890

Other versions
Bodoni (Linotype)
Monotype Bodoni 135

Caledonia

This popular and legible text type (also called Cornelia) was designed in 1931 for Linotype by American type and book designer William Dwiggins. It was produced as a modernized version of Scotch Roman but in style it is a cross between Scotch Roman and Bulmer. Caledonia is a regularized face, with a large x-height, a vertical stress, a good contrast between the thick and thin letterstrokes, horizontal serifs, and capitals that are shorter than the ascenders of the lower case letters. Available in regular, bold and italic forms, its durability and legibility has led to its extensive use as a text type for paperbacks. Linotype have issued a modernized version called New Caledonia which has a wider range of weights including semi-bold and black variations.

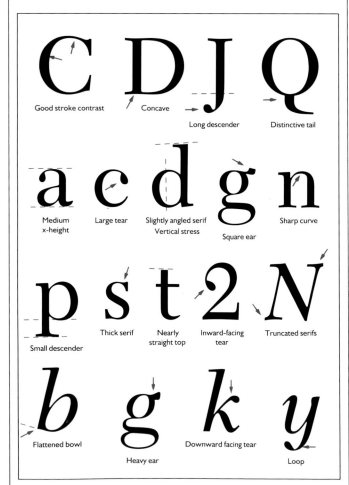

Good stroke contrast / Concave / Long descender / Distinctive tail

Medium x-height / Large tear / Slightly angled serif / Vertical stress / Square ear / Sharp curve

Small descender / Thick serif / Nearly straight top / Inward-facing tear / Truncated serifs

Flattened bowl / Heavy ear / Downward facing tear / Loop

Caledonia roman, 10/11 point, ranged left

Readability is the biggest single necessity for typography. Designers must always keep this as their chief priority. Copy which is meant to be read but is hard to read, no matter how clever or fashionable the layout might appear, is badly designed. Readability need not mean dullness. On the contrary, the more attractive, the more exciting, the more creative the feel for tone and space, the more readable that design will become. Although body copy usually occupies the largest area of space, it often requires the least amount of the designer's time. Type is also used to attract attention, often in a headline where the

Caledonia roman, 10/12 point, ranged left

Readability is the biggest single necessity for typography. Designers must always keep this as their chief priority. Copy which is meant to be read but is hard to read, no matter how clever or fashionable the layout might appear, is badly designed. Readability need not mean dullness. On the contrary, the more attractive, the more exciting, the more creative the feel for tone and space, the more readable that design will become. Although body copy usually occupies the largest area of space, it often requires the least amount of the designer's time. Type is also used to attract attention, often in a headline where the

Caledonia roman, 10/13 point, ranged left

Readability is the biggest single necessity for typography. Designers must always keep this as their chief priority. Copy which is meant to be read but is hard to read, no matter how clever or fashionable the layout might appear, is badly designed. Readability need not mean dullness. On the contrary, the more attractive, the more exciting, the more creative the feel for tone and space, the more readable that design will become. Although body copy usually occupies the largest area of space, it often requires the least amount of the designer's time. Type is also used to attract attention, often in a headline where the

Caledonia roman, 10/12 point, justified

Readability is the biggest single necessity for typography. Designers must always keep this as their chief priority. Copy which is meant to be read but is hard to read, no matter how clever or fashionable the layout might appear, is badly designed. Readability need not mean dullness. On the contrary, the more attractive, the more exciting, the more creative the feel for tone and space, the more readable that design will become. Although body copy usually occupies the largest area of space, it often requires the least amount of the designer's time. Type is also used to attract attention, often in a headline where the

Caledonia italic, 10/12 point, ranged left

Readability is the biggest single necessity for typography. Designers must always keep this as their chief priority. Copy which is meant to be read but is hard to read, no matter how clever or fashionable the layout might appear, is badly designed. Readability need not mean dullness. On the contrary, the more attractive, the more exciting, the more creative the feel for tone and space, the more readable that design will become. Although body copy usually occupies the largest area of space, it often

Caledonia bold, 10/12 point, ranged left

Readability is the biggest single necessity for typography. Designers must always keep this as their chief priority. Copy which is meant to be read but is hard to read, no matter how clever or fashionable the layout might appear, is badly designed. Readability need not mean dullness. On the contrary, the more attractive, the more exciting, the more creative the feel for tone and space, the more readable that design will become. Although body copy usually occupies the largest area of space, it often

Caledonia roman

ABCDEFGHIJKLMNOPQRSTUVWXYZ
abcdefghijklmnopqrstuvwxyz
1234567890 &!?().,:;""£$¢ƒ

Caledonia italic

ABCDEFGHIJKLMNOPQRSTUVWXYZ
abcdefghijklmnopqrstuvwxyz
1234567890 &!?().,:;""£$¢ƒ

Caledonia bold

ABCDEFGHIJKLMNOPQRSTUVWXYZ
abcdefghijklmnopqrstuvwxyz
1234567890 &!?().,:;""£$¢ƒ

Caledonia bold italic

ABCDEFGHIJKLMNOPQRSTUVWXYZ
abcdefghijklmnopqrstuvwxyz
1234567890 &!?().,:;""£$¢ƒ

Other versions
New Caledonia

Augustea
1951

ABCDEFGHIJKLMNOPQRSTUVWXYZ &!?(),.:;""

ABCDEFGHIJKLMNOPQRSTUVWXYZ abcdefghijklmnopqrstuvwxyz 1234567890

Haas Basilia
1982

ABCDEFGHIJKLMNOPQRSTUVWXYZ &!?(),.:;""

ABCDEFGHIJKLMNOPQRSTUVWXYZ abcdefghijklmnopqrstuvwxyz 1234567890

Bodoni
(Linotype)
1914

ABCDEFGHIJKLMNOPQRSTUVWXYZ &!?(),.:;""

ABCDEFGHIJKLMNOPQRSTUVWXYZ abcdefghijklmnopqrstuvwxyz 1234567890

Bodoni
(Monotype)
1921

ABCDEFGHIJKLMNOPQRSTUVWXYZ &!?(),.:;""

ABCDEFGHIJKLMNOPQRSTUVWXYZ abcdefghijklmnopqrstuvwxyz 1234567890

Bruce Old Style
1909

ABCDEFGHIJKLMNOPQRSTUVWXYZ &!?(),.:;""

Bulmer
1928

ABCDEFGHIJKLMNOPQRSTUVWXYZ &!?(),.:;""

**Linotype
Centennial**

ABCDEFGHIJKLMNOPQRSTUVWXYZ &!?(),.:;""

ABCDEFGHIJKLMNOPQRSTUVWXYZ abcdefghijklmnopqrstuvwxyz 1234567890

ITC Century

ABCDEFGHIJKLMNOPQRSTUVWXYZ &!?(),.:;""

ABCDEFGHIJKLMNOPQRSTUVWXYZ abcdefghijklmnopqrstuvwxyz 1234567890

Century expanded
1900

ABCDEFGHIJKLMNOPQRSTUVWXYZ &!?(),.:;""

Century Nova
1966

ABCDEFGHIJKLMNOPQRSTUVWXYZ &!?(),.:;""

abcdefghijklmnopqrstuvwxyz 1234567890 £$¢ƒ

Augustea
1951

abcdefghijklmnopqrstuvwxyz 1234567890 £$¢ƒ

ABCDEFGHIJKLMNOPQRSTUVWXYZ abcdefghijklmnopqrstuvwxyz 1234567890

Haas Basilia
1982

abcdefghijklmnopqrstuvwxyz 1234567890 £$¢ƒ

ABCDEFGHIJKLMNOPQRSTUVWXYZ abcdefghijklmnopqrstuvwxyz 1234567890

Bodoni
(Linotype)
1914

abcdefghijklmnopqrstuvwxyz 1234567890 £$¢

ABCDEFGHIJKLMNOPQRSTUVWXYZ abcdefghijklmnopqrstuvwxyz 1234567890

Bodoni
(Monotype)
1921

abcdefghijklmnopqrstuvwxyz 1234567890 £$¢ƒ

ABCDEFGHIJKLMNOPQRSTUVWXYZ abcdefghijklmnopqrstuvwxyz 1234567890

Bruce Old Style
1909

abcdefghijklmnopqrstuvwxyz 1234567890 £$¢ƒ

ABCDEFGHIJKLMNOPQRSTUVWXYZ abcdefghijklmnopqrstuvwxyz 1234567890

Bulmer
1928

abcdefghijklmnopqrstuvwxyz 1234567890 £$¢ƒ

ABCDEFGHIJKLMNOPQRSTUVWXYZ abcdefghijklmnopqrstuvwxyz 1234567890

Linotype Centennial

abcdefghijklmnopqrstuvwxyz 1234567890 £$¢ƒ

ABCDEFGHIJKLMNOPQRSTUVWXYZ abcdefghijklmnopqrstuvwxyz 1234567890

ITC Century

abcdefghijklmnopqrstuvwxyz 1234567890 £$¢ƒ

ABCDEFGHIJKLMNOPQRSTUVWXYZ abcdefghijklmnopqrstuvwxyz 1234567890

Century expanded
1900

abcdefghijklmnopqrstuvwxyz 1234567890 £$¢ƒ

ABCDEFGHIJKLMNOPQRSTUVWXYZ abcdefghijklmnopqrstuvwxyz 1234567890

Century Nova
1966

Corvinus
1929

ABCDEFGHIJKLMNOPQRSTUVWXYZ &!?,:;""

ABCDEFGHIJKLMNOPQRSTUVWXYZ abcdefghijklmnopqrstuvwxyz 1234567890

De Vinne
1894

ABCDEFGHIJKLMNOPQRSTUVWXYZ &!?(),.:;""

Ellington

ABCDEFGHIJKLMNOPQRSTUVWXYZ &!?(),.:;" "

ABCDEFGHIJKLMNOPQRSTUVWXYZ abcdefghijklmnopqrstuvwxyz 1234567890

Fairfield
1939

ABCDEFGHIJKLMNOPQRSTUVWXYZ &!?(),.:;" "

ITC Fenice
1980

ABCDEFGHIJKLMNOPQRSTUVWXYZ &!?(),.:;" "

ABCDEFGHIJKLMNOPQRSTUVWXYZ abcdefghijklmnopqrstuvwxyz 1234567890

French Round Face
1906

ABCDEFGHIJKLMNOPQRSTUVWXYZ &!?(),.:;" "

Iridium
1975

ABCDEFGHIJKLMNOPQRSTUVWXYZ &!?(),.:;" "

ABCDEFGHIJKLMNOPQRSTUVWXYZ abcdefghijklmnopqrstuvwxyz 1234567890

Madison
1909

ABCDEFGHIJKLMNOPQRSTUVWXYZ &!?(),.:;" "

ABCDEFGHIJKLMNOPQRSTUVWXYZ abcdefghijklmnopqrstuvwxyz 1234567890

Monotype Modern 7

ABCDEFGHIJKLMNOPQRSTUVWXYZ &!?(),.:;" "

ITC Modern 216

ABCDEFGHIJKLMNOPQRSTUVWXYZ &!?(),.:;" "

ABCDEFGHIJKLMNOPQRSTUVWXYZ abcdefghijklmnopqrstuvwxyz 1234567890

abcdefghijklmnopqrstuvwxyz **1234567890 £$¢**

Corvinus
1929

AABCDEFGGHIJKKLMMNNOPQRSTUVWXYZ abcdefghijklmnopqrstuvwwxyz 1234567890

abcdefghijklmnopqrstuvwxyz 1234567890 £$¢*f*

De Vinne
1894

ABCDEFGHIJKLMNOPQRSTUVWXYZ abcdefghijklmnopqrstuvwxyz 1234567890

abcdefghijklmnopqrstuvwxyz 1234567890 £$¢

Ellington

abcdefghijklmnopqrstuvwxyz 1234567890 £$¢*f*

Fairfield
1939

ABCDEFGHIJKLMNOPQRSTUVWXYZ abcdefghijklmnopqrstuvwxyz 1234567890

abcdefghijklmnopqrstuvwxyz 1234567890 £$ ¢*f*

ITC Fenice
1980

ABCDEFGHIJKLMNOPQRSTUVWXYZ abcdefghijklmnopqrstuvwxyz 1234567890

abcdefghijklmnopqrstuvwxyz 1234567890 £$

French Round Face
1906

ABCDEFGHIJKLMNOPQRSTUVWXYZ abcdefghijklmnopqrstuvwxyz 1234567890

abcdefghijklmnopqrstuvwxyz 1234567890 £$¢*f*

Iridium
1975

ABCDEFGHIJKLMNOPQRSTUVWXYZ abcdefghijklmnopqrstuvwxyz 1234567890

abcdefghijklmnopqrstuvwxyz 1234567890 £$¢*f*

Madison
1909

ABCDEFGHIJKLMNOPQRSTUVWXYZ abcdefghijklmnopqrstuvwxyz 1234567890

abcdefghijklmnopqrstuvwxyz **1234567890 £$**

**Monotype
Modern 7**

ABCDEFGHIJKLMNOPQRSTUVWXYZ abcdefghijklmnopqrstuvwxyz 1234567890

abcdefghijklmnopqrstuvwxyz 1234567890 £$¢*f*

ITC Modern 216

ABCDEFGHIJKLMNOPQRSTUVWXYZ abcdefghijklmnopqrstuvwxyz 1234567890

Neo Didot
1904

ABCDEFGHIJKLMNOPQRSTUVWXYZ &!?(),.:;""''

Photina

ABCDEFGHIJKLMNOPQRSTUVWXYZ &!?(),.:;""''

ABCDEFGHIJKLMNOPQRSTUVWXYZ abcdefghijklmnopqrstuvwxyz 1234567890

Primer
1951

ABCDEFGHIJKLMNOPQRSTUVWXYZ &!?(),.:;""''

ABCDEFGHIJKLMNOPQRSTUVWXYZ abcdefghijklmnopqrstuvwxyz 1234567890

Scotch Roman
(Monotype)
1907

ABCDEFGHIJKLMNOPQRSTUVWXYZ &!?(),.:;""''

Scotch 2
(Linotype)

ABCDEFGHIJKLMNOPQRSTUVWXYZ &!?(),.:;""''

Tiemann
1923

ABCDEFGHIJKLMNOPQRSTUVWXYZ &!?(),.:;""''

Torino
1908

ABCDEFGHIJKLMNOPQRSTUVWXYZ &!?(),.:;""''

Walbaum
(Monotype)
1937

ABCDEFGHIJKLMNOPQRSTUVWXYZ &!?(),.:;""''

ABCDEFGHIJKLMNOPQRSTUVWXYZ abcdefghijklmnopqrstuvwxyz 1234567890

ITC Zapf Book
1976

ABCDEFGHIJKLMNOPQRSTUVWXYZ &!?(),.:;""''

ABCDEFGHIJKLMNOPQRSTUVWXYZ abcdefghijklmnopqrstuvwxyz 1234567890

abcdefghijklmnopqrstuvwxyz 1234567890 £$

Neo Didot
1904

ABCDEFGHIJKLMNOPQRSTUVWXYZ abcdefghijklmnopqrstuvwxyz 1234567890

abcdefghijklmnopqrstuvwxyz 1234567890 £$¢f

Photina

ABCDEFGHIJKLMNOPQRSTUVWXYZ abcdefghijklmnopqrstuvwxyz 1234567890

abcdefghijklmnopqrstuvwxyz 1234567890 £$¢f

Primer
1951

ABCDEFGHIJKLMNOPQRSTUVWXYZ abcdefghijklmnopqrstuvwxyz 1234567890

abcdefghijklmnopqrstuvwxyz **1234567890 £$**

Scotch Roman
(Monotype)
1907

ABCDEFGHIJKLMNOPQRSTUVWXYZ abcdefghijklmnopqrstuvwxyz 1234567890

abcdefghijklmnopqrstuvwxyz 1234567890 £$

Scotch 2
(Linotype)

ABCDEFGHIJKLMNOPQRSTUVWXYZ abcdefghijklmnopqrstuvwxyz 1234567890

abcdefghijklmnopqrstuvwxyz 1234567890 £$¢f

Tiemann
1923

abcdefghijklmnopqrstuvwxyz 1234567890 £$¢f

Torino
1908

ABCDEFGHIJKLMNOPQRSTUVWXYZ abcdefghijklmnopqrstuvwxyz 1234567890

abcdefghijklmnopqrstuvwxyz 1234567890 £$¢f

Walbaum
(Monotype)
1937

ABCDEFGHIJKLMNOPQRSTUVWXYZ abcdefghijklmnopqrstuvwxyz 1234567890

abcdefghijklmnopqrstuvwxyz 1234567890 £$¢f

ITC Zapf Book
1976

ABCDEFGHIJKLMNOPQRSTUVWXYZ abcdefghijklmnopqrstuvwxyz 1234567890

WEST COAST SHOW

26

The 26th Annual West Coast Show sponsored by the Western Art Directors Club

1

SMALL STOCKINGS

ALMOND

bhs

BARELY-THERE

SOPHISTICATED SHEER STOCKINGS
WITH A SUPERB FIT

7

DENIER
APPEARANCE

2

1 A simple but bold typographical solution for a poster which demonstrates the strong visual emphasis and striking effect of Bauer Bodoni. A dynamic shape is created by the inverted pyramid made by the arrangement of the type.

2 The elegance of the slightly condensed Bauer Bodoni on this packaging reflects the upmarket brand of ladies' stockings inside.

3 The contrast between the negative and the positive Bodoni type, and the use of all lower case letters gives individuality to this simple but elegant identity on this label.

Royal Shakespeare Company

Othello

RSC
Royal Shakespeare Company

Sponsored by
Royal Insurance

The Other Place
Stratford-upon-Avon
The Young Vic
London

4

alistair blair

3

4 Here Bodoni Italic has been distorted purely for effect, to produce an attention-grabbing, legible image on the cover of this leaflet for the Royal Shakespeare Company.

5

6

5 & 6 Walbaum, an imitation of Bodoni originally cut by Justus Walbaum in about 1800, is used exclusively for this private-press-style typography. Note the generous leading required in the text to compensate for the strong vertical emphasis of the type.

7 Bodoni has been chosen here to echo the classical architecture illustrated on the facing page. However, the uneven texture created by the multitude of capital letters in the text interrupts its horizontal flow.

8 The high contrast of Modern types is exploited through distortion in this appropriate solution for the opening sequence of a television programme entitled *Opinions*.

8

Bühnentechnischer Plan, 1908

Die Einführung der Baueingabe im 19. Jahrhundert (Bauerlaubnis nach Prüfung der Pläne durch eine Baubehörde) sowie die zunehmende Spezialisierung für Teilbereiche bei größeren Projekten – z. B. Eisenbetonpläne, Installationspläne usw. – machte die Vervielfältigung des Originals notwendig. Hierfür wurden eigene Pausverfahren (vgl. Einleitung) entwickelt. Dieses Blatt entstammt einer Planserie für die Bühnenmaschinerie des Basler Stadttheaters. Es wurde nach einem Brand 1904 von Fritz Stehlin wieder aufgebaut. Der Plan will nicht nur die technische Seite des Hochbaus zeigen, sondern auch die graphische Wirkung der um 1900 üblichen Blaupause. Die Pause veränderte den graphischen Charakter des Originals. Für eine Baupolizei- oder Werkzeichnung genügte die gute Lesbarkeit. Daneben begrüßte man aber auch ein gefälliges Aussehen der Pause. Dies galt sogar für Ingenieurzeichnungen. Das technische Büro A. Rosenberg aus Köln, welches für die Bühnentechnik verantwortlich war, verwendete nicht nur einen Jugendstilstempel, sondern zeichnete auch Zierränder, womit sich die Pläne einheitlich und gut repräsentierten.
Das Blatt 99 × 62 cm trägt die Aufschrift: «Stadttheater Basel, Blatt 3, Längenschnitt seitlich der Bühnenmitte, M. 1:50.» (Ausschnitt 29 × 40 cm auf 24 × 33 cm verkleinert, einen Teil des Bühnenbodens mit Hebe- und Senkvorrichtungen zeigend). Blaupause.

94

7

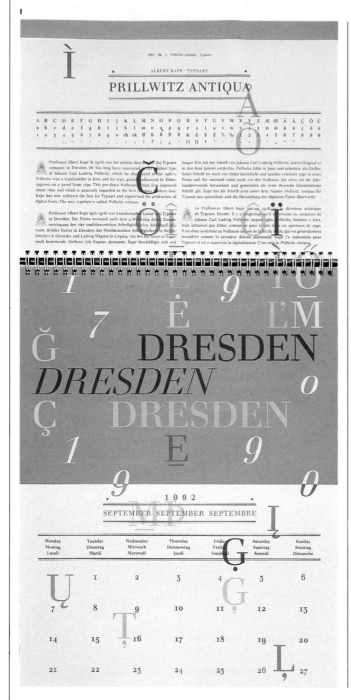

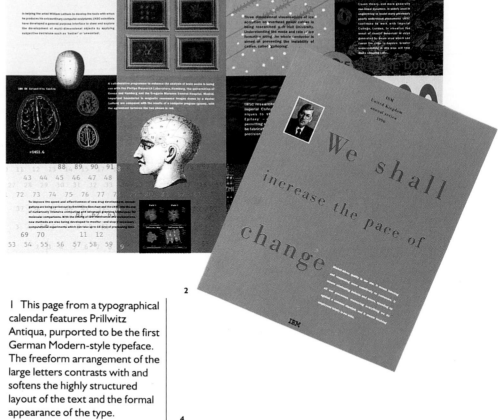

1 This page from a typographical calendar features Prillwitz Antiqua, purported to be the first German Modern-style typeface. The freeform arrangement of the large letters contrasts with and softens the highly structured layout of the text and the formal appearance of the type.

2 The heavy contrast in stroke widths of Bodoni enables the use of subtle colours with a low contrast, while maintaining good legibility on this cover for an IBM annual report.

4 The stylish qualities of Bodoni are displayed in this creative typographical composition from a brochure for a communications company. Notice how interest is created through variations in type size, colour and arrangement.

3 The wide letterspacing and fine unbracketed serifs of this Modern type produces an airiness in keeping with the floating Cumulus cloud – the name and image of the company.

5

5 & 6 Linotype Centennial, a contemporary Modern type, is used for a bold, colourful image in this stationery design for Lucerne School of Art. The enlarged vertical type, which highlights the concave sans serifs on the lower case letters, contrasts with the horizontal direction of the text rules.

6

7

7 The characteristic features of Modern types – an abrupt contrast in letterstroke widths, fine serifs and a strong vertical stress – are clearly demonstrated in the large, bold type (representing the initials of the speakers) used in this brochure for the Monotype Conference. The fine serifs and detail of Bodoni have been selected to demonstrate the quality of type available for desktop publishing systems – the subject of the conference.

8 The brilliance, precision and diagonal arrangement of the Modern type contrasts with the loose, brush-formed Japanese character in this minimal design for a Japanese beer can.

8

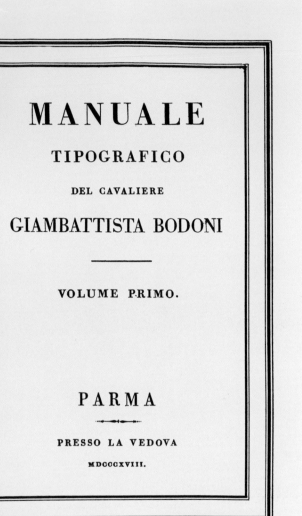

3 The type on this postage stamp highlights how the wide letterstrokes of Modern type are an important factor where the registration of small, coloured type is central.

1 Giambattista Bodoni's *Manuale Tipografico* (1818) is one of the finest type-specimen books ever produced. The title page shown here demonstrates the striking and grand design of Bodoni's type.

2 The abrupt contrast in the letterstrokes, a characteristic feature of Modern types, can be seen in the brand cigarette name of this packet. The 'l' and 'b' have been extended to exploit the vertical stress.

4 In this brochure, the small blocks of Bodoni are generously leaded to counterbalance the extreme vertical stress of the typeface. Although the type here works well, Bodoni is tiring to read when used for large amounts of continuous text.

5 The reversed-out logotype for Laurence Simons shows both the fine unbracketed serifs of Bodoni and its impact as a display face.

8 A technical brochure which shows how Modern types can be mixed successfully with contrasting sans serif types.

9 Elongated Roman, a stylish condensed Modern type, is used for the wine variety names on these bottle labels. This type style was popular in the 19th century.

6 On this poster, Bodoni is used in a descriptive way to represent the vocal sounds of Shelley Hirsch.

7 The Linotype Centennial Italic, used for the main headings in this holiday brochure, adds an air of informality and an upmarket feel. The large x-height of the type is typical of contemporary Modern typeface designs and is an important factor for good legibility.

Slab serif

Slab serifs are also referred to as square serifs, Egyptians or Mécanes and, in the early 19th century when they first appeared, as Antiques. The early slab serif types which appeared in England from 1817 onwards were display faces specifically designed for advertising and other jobbing work. Their heavy monoline and mechanical structure and unbracketed square serifs gave them more impact than the fat faces ("beefed-up" Modern types) and they were a great success. Initially, these fonts were produced in capitals only but lower case forms soon followed and slab serifs remained popular until the last quarter of the 19th century.

In the 1920s and 30s, a crop of new geometric-style slab serifs were released as a spin-off from the Geometric sans serifs such as Futura. This string of new Geometric designs included Memphis (1929), Beton (1931), Stymie (1931) and Rockwell (1934) – these types often have been referred to as Futura with serifs. The faces were tame compared to their fat and aggressive 19th-century models, and were more suitable for text setting, albeit on a limited scale. City (1937), a rather ugly square design with poor legibility, was also released at this time.

In 1938, Schadow Antiqua by Georg Trump appeared. This was a slab serif with lighter unbracketed serifs.

It had some contrast in the width of the letters and a narrower set width. The type is now available as Stempel Schadow (1983) and has a full range of weights and italics. Egyptian 505 and Egyptienne (1960), which have slightly bracketed concave serifs, are in the same mould. There has also been a steady flow of new geometric slab serif designs in recent times. Adrian Frutiger's Serifa (1967) and Glypha (1979), ITC Lubalin Graph (1974) by Herb Lubalin and Calvert (1980) by Margaret Calvert are some typical examples.

In the mid-1800s, a sub-group of slab serifs, called Clarendons, appeared. The first Clarendon was designed by Robert Besley in 1845 as a bold text face to accompany a Modern style roman type, the popular text face of the day. Clarendons remained popular for most of the 19th century but went out of favour early in the 20th century.

In the 1950s, an outbreak of expanded (wide) sans serifs sparked-off a complementary wave of new wide slab serif faces. The revival of interest centred around the Clarendon style. Among the expanded Clarendons appearing at this time were Fortune (1955), which is also known at Volta, and New Clarendon (1960), by Monotype. A small sub-group of this category – mock-typewriter faces – are also included in this section.

The heavy, mechanical look of this 19th-century Egyptian (below) is a product of the Industrial Revolution. The boldness of slab serifs made these faces one of the most popular forms of display type. The square slab serifs are the same thickness as the stem and there is little contrast in the letterstrokes. The decoration is a typical example of the desire for ornamentation in the Victorian age.

EIGHT LINES PICA EGYPTIAN ORNAMENTED, No. 2.

Selecting slab serif typefaces

The modern Clarendons are undoubtedly the most suitable designs for text setting because of their large x-height and the fluent horizontal flow created by their strong serifs. Available in a limited range of weights and widths (but no italics), Clarendon's robust design is particularly suitable for newspaper setting because it reproduces successfully on low quality newsprint.

The regularized geometric sans serifs such as Rockwell, Glypha and Serifa, which all have a good range of weights, italics and large x-heights, are best suited to limited text applications such as for brochures and other jobbing work. ITC Lubalin Graph with its huge x-height and slight quirkiness, and the condensed Beton, with its long ascenders and peculiar lower case 'y', are less applicable for text setting, as is Stempel Schadow, which has a number of idiosyncratic features. Egyptian 505 is more regularized but has no italic, while Egyptienne, somewhat unusually, has a flowing italic (most other slab serifs have a slanted roman style of italic).

A narrow, economical design is ITC Officina Serif (1991). Conversely, New Clarendon, with its long descenders and wide set, is uneconomical on space – it also has no italics.

The main characteristics of slab serif typefaces

- little or no contrast in the thickness of the letterstrokes
- the set is generally wide
- the serifs are usually of the same thickness as the stem
- most have unbracketed square serifs with the exception of Clarendons
- the lower case 'g' is often single storey
- a large x-height is common

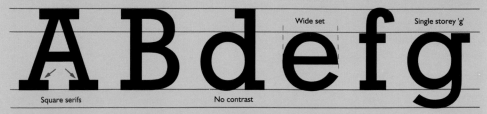

Square serifs

Square serifs / No contrast / Wide set / Single storey 'g'

Bracketed serifs

Slightly bracketed serifs / Some contrast with letterstrokes / Double storey 'g'

Round serif – typewriter faces

This 20th-century slab serif (left) used for the signposting on the Tyne and Wear Metro shows how the slab serif design has been refined and become more legible. The letters are monoline and the type has a large x-height. The type shown was later adapted for digital typesetting as a text and display type, called Calvert.

Quick selection guide

Availability: Average. Most typesetters will hold only a limited range.

PostScript fonts for the Apple Macintosh: Clarendon, Serifa, Stymie and others.

Recent designs: ITC Officina Serif, Helserif.

Faces by leading type designers: ITC Lubalin Graph by Herb Lubalin, Egyptienne, Glypha and Serifa by Adrian Frutiger.

Display fonts related to faces in this section: ITC L&C Stymie Hairline (Stymie) (1970).

Greek font: Rockwell.

Clarendon

The first Clarendon type was issued by the English Fann Street Foundry in 1845 as a bold square serif face to accompany a regular weight Modern roman. Clarendon became the term for a sub-group of slab or square serif typefaces with some differentiation of contrast of letter-strokes, a large x-height and bracketed serifs. Clarendon, which is suitable for both text and display setting, is a durable face that is a particularly good choice when printing on poor quality papers such as newsprint. Most type manufacturers have a Clarendon in their range.

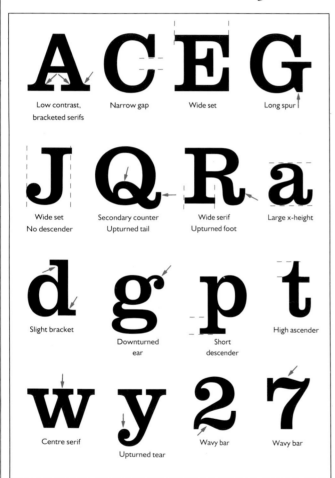

Low contrast, bracketed serifs | Narrow gap | Wide set | Long spur

Wide set No descender | Secondary counter Upturned tail | Wide serif Upturned foot | Large x-height

Slight bracket | Downturned ear | Short descender | High ascender

Centre serif | Upturned tear | Wavy bar | Wavy bar

Clarendon roman, 10/11 point, ranged left

Readability is the biggest single necessity for typography. Designers must always keep this as their chief priority. Copy which is meant to be read but is hard to read, no matter how clever or fashionable the layout might appear, is badly designed. Readability need not mean dullness. On the contrary, the more attractive, the more exciting, the more creative the feel for tone and space, the more readable that design will become. Although body copy usually occupies the largest area of space, it often requires the least amount

Clarendon roman, 10/12 point, ranged left

Readability is the biggest single necessity for typography. Designers must always keep this as their chief priority. Copy which is meant to be read but is hard to read, no matter how clever or fashionable the layout might appear, is badly designed. Readability need not mean dullness. On the contrary, the more attractive, the more exciting, the more creative the feel for tone and space, the more readable that design will become. Although body copy usually occupies the largest area of space, it often requires the least amount

Clarendon roman, 10/13 point, ranged left

Readability is the biggest single necessity for typography. Designers must always keep this as their chief priority. Copy which is meant to be read but is hard to read, no matter how clever or fashionable the layout might appear, is badly designed. Readability need not mean dullness. On the contrary, the more attractive, the more exciting, the more creative the feel for tone and space, the more readable that design will become. Although body copy usually occupies the largest area of space, it often requires the least amount

Clarendon roman, 10/12 point, justified

Readability is the biggest single necessity for typography. Designers must always keep this as their chief priority. Copy which is meant to be read but is hard to read, no matter how clever or fashionable the layout might appear, is badly designed. Readability need not mean dullness. On the contrary, the more attractive, the more exciting, the more creative the feel for tone and space, the more readable that design will become. Although body copy usually occupies the largest area of space, it often requires the least amount

Clarendon bold, 10/12 point, ranged left

Readability is the biggest single necessity for typography. Designers must always keep this as their chief priority. Copy which is meant to be read but is hard to read, no matter how clever or fashionable the layout might appear, is badly designed. Readability need not mean dullness. On the contrary, the more attractive, the more exciting, the more creative the feel for tone and space, the more readable that design will become.

Clarendon light

ABCDEFGHIJKLMNOPQRSTUVWXYZ
abcdefghijklmnopqrstuvwxyz
1234567890&!?().,:;""'"£$¢ƒ

Clarendon roman

ABCDEFGHIJKLMNOPQRSTUVWXYZ
abcdefghijklmnopqrstuvwxyz
1234567890&!?().,:;""'"£$¢ƒ

Clarendon bold

ABCDEFGHIJKLMNOPQRSTUVWXYZ
abcdefghijklmnopqrstuvwxyz
1234567890&!?().,:;""'"£$¢ƒ

Clarendon heavy

ABCDEFGHIJKLMNOPQRSTUVWXYZ abcdefghijklmnopqrstuvwxyz 1234567890

Clarendon black

ABCDEFGHIJKLMNOPQRSTUVWXYZ abcdefghijklmnopqrstuvwxyz 1234567890

Other versions
Haas Clarendon
Monotype Clarendon

Rockwell

Rockwell was issued by Monotype in 1934, a time when slab serifs were enjoying a revival. The type, which is popular as a text type for brochures and other jobbing work, has many admirers, especially in England. It is geometric and monoline in design but slightly narrow, the x-height is large and it has few eccentricities, except perhaps the half serifs on the centre strokes of the lower case 'm' in the medium, bold and extra bold weights. Rockwell has four weights – light, medium, bold and extra bold, all with matching italic fonts. Condensed and bold condensed variations (without italic) are also available.

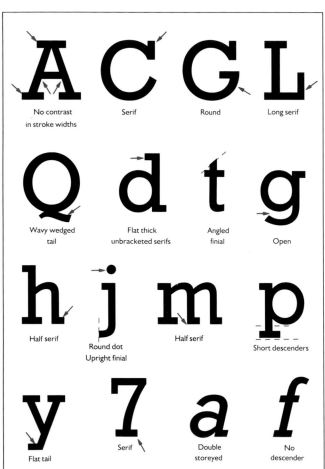

No contrast in stroke widths · Serif · Round · Long serif

Wavy wedged tail · Flat thick unbracketed serifs · Angled finial · Open

Half serif · Round dot Upright finial · Half serif · Short descenders

Flat tail · Serif · Double storeyed · No descender

Rockwell roman, 10/11 point, ranged left

Readability is the biggest single necessity for typography. Designers must always keep this as their chief priority. Copy which is meant to be read but is hard to read, no matter how clever or fashionable the layout might appear, is badly designed. Readability need not mean dullness. On the contrary, the more attractive, the more exciting, the more creative the feel for tone and space, the more readable that design will become. Although body copy usually occupies the largest area of space, it often requires the least amount of the designer's time. Type is also used to attract attention,

Rockwell roman, 10/12 point, ranged left

Readability is the biggest single necessity for typography. Designers must always keep this as their chief priority. Copy which is meant to be read but is hard to read, no matter how clever or fashionable the layout might appear, is badly designed. Readability need not mean dullness. On the contrary, the more attractive, the more exciting, the more creative the feel for tone and space, the more readable that design will become. Although body copy usually occupies the largest area of space, it often requires the least amount of the designer's time. Type is also used to attract attention,

Rockwell roman, 10/13 point, ranged left

Readability is the biggest single necessity for typography. Designers must always keep this as their chief priority. Copy which is meant to be read but is hard to read, no matter how clever or fashionable the layout might appear, is badly designed. Readability need not mean dullness. On the contrary, the more attractive, the more exciting, the more creative the feel for tone and space, the more readable that design will become. Although body copy usually occupies the largest area of space, it often requires the least amount of the designer's time. Type is also used to attract attention,

Rockwell roman, 10/12 point, justified

Readability is the biggest single necessity for typography. Designers must always keep this as their chief priority. Copy which is meant to be read but is hard to read, no matter how clever or fashionable the layout might appear, is badly designed. Readability need not mean dullness. On the contrary, the more attractive, the more exciting, the more creative the feel for tone and space, the more readable that design will become. Although body copy usually occupies the largest area of space, it often requires the least amount of the designer's time. Type is also used to attract attention,

Rockwell italic 10/12 point, ranged left

Readability is the biggest single necessity for typography. Designers must always keep this as their chief priority. Copy which is meant to be read but is hard to read, no matter how clever or fashionable the layout might appear, is badly designed. Readability need not mean dullness. On the contrary, the more attractive, the more exciting, the more creative the feel for tone and space, the more readable that design will become. Although body copy usually occupies the

Rockwell bold, 10/12 point, ranged left

Readability is the biggest single necessity for typography. Designers must always keep this as their chief priority. Copy which is meant to be read but is hard to read, no matter how clever or fashionable the layout might appear, is badly designed. Readability need not mean dullness. On the contrary, the more attractive, the more exciting, the more creative the feel for tone and space, the more readable that design will become. Although body copy usually occupies

Rockwell roman

ABCDEFGHIJKLMNOPQRSTUVWXYZ
abcdefghijklmnopqrstuvwxyz
1234567890 &!?().,:;""£$¢f

Rockwell italic

ABCDEFGHIJKLMNOPQRSTUVWXYZ
abcdefghijklmnopqrstuvwxyz
1234567890 &!?().,:;""£$¢f

Rockwell bold

ABCDEFGHIJKLMNOPQRSTUVWXYZ
abcdefghijklmnopqrstuvwxyz
1234567890 &!?().,:;""£$¢f

Rockwell light

ABCDEFGHIJKLMNOPQRSTUVWXYZ abcdefghijklmnopqrstuvwxyz 1234567890

Rockwell light italic

ABCDEFGHIJKLMNOPQRSTUVWXYZ abcdefghijklmnopqrstuvwxyz 1234567890

Rockwell bold italic

ABCDEFGHIJKLMNOPQRSTUVWXYZ abcdefghijklmnopqrstuvwxyz 1234567890

Rockwell extra bold

ABCDEFGHIJKLMNOPQRSTUVWXYZ abcdefghijklmnopqrstuvwxyz 1234567890

A & S Gallatin

ABCDEFGHIJKLMNOPQRSTUVWXYZ &!?(),.:;""''

ABCDEFGHIJKLMNOPQRSTUVWXYZ abcdefghijklmnopqrstuvwxyz 1234567890

Aachen
1969

ABCDEFGHIJKLMNOPQRSTUVWXYZ &!?(),.:;" "

**ITC American
Typewriter**
1974

ABCDEFGHIJKLMNOPQRSTUVWXYZ &!?(),.:;" "

ABCDEFGHIJKLMNOPQRSTUVWXYZ abcdefghijklmnopqrstuvwxyz 1234567890

Beton
1931

ABCDEFGHIJKLMNOPQRSTUVWXYZ &!?(),.:;""

ABCDEFGHIJKLMNOPQRSTUVWXYZ abcdefghijklmnopqrstuvwxyz 1234567890

Calvert
1980

ABCDEFGHIJKLMNOPQRSTUVWXYZ &!?(),.:;" "

City
1937

ABCDEFGHIJKLMNOPQRSTUVWXYZ &!?(),.:;""

ABCDEFGHIJKLMNOPQRSTUVWXYZ abcdefghijklmnopqrstuvwxyz 1234567890

New Clarendon
(Monotype)
1960

ABCDEFGHIJKLMNOPQRSTUVWXYZ &!?().,:;" "

ABCDEFGHIJKLMNOPQRSTUVWXYZ abcdefghijklmnopqrstuvwxyz 1234567890

Courier Typewriter

ABCDEFGHIJKLMNOPQRSTUVWXYZ &!?(),.:;" "

Egyptian 505

ABCDEFGHIJKLMNOPQRSTUVWXYZ &!?(),.:;""

ABCDEFGHIJKLMNOPQRSTUVWXYZ abcdefghijklmnopqrstuvwxyz 1234567890

Egyptienne
1960

ABCDEFGHIJKLMNOPQRSTUVWXYZ &!?(),.:;""

ABCDEFGHIJKLMNOPQRSTUVWXYZ abcdefghijklmnopqrstuvwxyz 1234567890

abcdefghijklmnopqrstuvwxyz 1234567890 £$¢ƒ

A & S Gallatin

abcdefghijklmnopqrstuvwxyz 1234567890 £$¢ƒ

Aachen
1969

abcdefghijklmnopqrstuvwxyz 1234567890 £$¢ƒ

ITC American Typewriter
1974

abcdefghijklmnopqrstuvwxyz 1234567890 £$¢ƒ

Beton
1931

abcdefghijklmnopqrstuvwxyz 1234567890 £$¢ƒ

Calvert
1980

abcdefghijklmnopqrstuvwxyz 1234567890 £$¢ƒ

City
1937

abcdefghijklmnopqrstuvwxyz 1234567890 £$¢

New Clarendon
(Monotype)
1960

abcdefghijklmnopqrstuvwxyz 1234567890 £$¢ƒ

Courier Typewriter

abcdefghijklmnopqrstuvwxyz 1234567890 £$¢ƒ

Egyptian 505

abcdefghijklmnopqrstuvwxyz 1234567890 £$¢ƒ

ABCDEFGHIJKLMNOPQRSTUVWXYZ abcdefghijklmnopqrstuvwxyz 1234567890

Egyptienne
1960

Glypha
1979

ABCDEFGHIJKLMNOPQRSTUVWXYZ &!?(),:;""

ABCDEFGHIJKLMNOPQRSTUVWXYZ abcdefghijklmnopqrstuvwxyz 1234567890

Helserif

ABCDEFGHIJKLMNOPQRSTUVWXYZ &!?(),:;""

ABCDEFGHIJKLMNOPQRSTUVWXYZ abcdefghijklmnopqrstuvwxyz 1234567890

Linotype Typewriter

ABCDEFGHIJKLMNOPQRSTUVWXYZ &!?(),:;""

ITC Lubalin Graph
1974

ABCDEFGHIJKLMNOPQRSTUVWXYZ &!?(),:;""

ABCDEFGHIJKLMNOPQRSTUVWXYZ abcdefghijklmnopqrstuvwxyz 1234567890

Memphis
1929.

ABCDEFGHIJKLMNOPQRSTUVWXYZ &!?(),:;""

ABCDEFGHIJKLMNOPQRSTUVWXYZ abcdefghijklmnopqrstuvwxyz 1234567890

ITC Officina Serif

ABCDEFGHIJKLMNOPQRSTUVWXYZ &!?(),:;""

ABCDEFGHIJKLMNOPQRSTUVWXYZ abcdefghijklmnopqrstuvwxyz 1234567890

Stempel Schadow
1983

ABCDEFGHIJKLMNOPQRSTUVWXYZ &!?(),:;""

ABCDEFGHIJKLMNOPQRSTUVWXYZ abcdefghijklmnopqrstuvwxyz 1234567890

Serifa
1967

ABCDEFGHIJKLMNOPQRSTUVWXYZ &!?(),:;""

ABCDEFGHIJKLMNOPQRSTUVWXYZ abcdefghijklmnopqrstuvwxyz 1234567890

Stymie
(Linotype)

ABCDEFGHIJKLMNOPQRSTUVWXYZ &!?(),:;""

ABCDEFGHIJKLMNOPQRSTUVWXYZ abcdefghijklmnopqrstuvwxyz 1234567890

Volta (or Fortune)
1955

ABCDEFGHIJKLMNOPQRSTUVWXYZ &!?()""

ABCDEFGHIJKLMNOPQRSTUVWXYZ abcdefghijklmnopqrstuvwxyz 1234567890

abcdefghijklmnopqrstuvwxyz 1234567890 £$¢ƒ

Glypha
1979

ABCDEFGHIJKLMNOPQRSTUVWXYZ abcdefghijklmnopqrstuvwxyz 1234567890

abcdefghijklmnopqrstuvwxyz 1234567890 £$¢ƒ

Helserif

ABCDEFGHIJKLMNOPQRSTUVWXYZ abcdefghijklmnopqrstuvwxyz 1234567890

abcdefghijklmnopqrstuvwxyz 1234567890 £$¢ƒ

**Linotype
Typewriter**

abcdefghijklmnopqrstuvwxyz 1234567890 £$¢ƒ

ITC Lubalin Graph
1974

ABCDEFGHIJKLMNOPQRSTUVWXYZ abcdefghijklmnopqrstuvwxyz 1234567890

abcdefghijklmnopqrstuvwxyz 1234567890 £$¢ƒ

Memphis
1929

ABCDEFGHIJKLMNOPQRSTUVWXYZ abcdefghijklmnopqrstuvwxyz 1234567890

abcdefghijklmnopqrstuvwxyz 1234567890 £$¢ƒ

ITC Officina Serif

ABCDEFGHIJKLMNOPQRSTUVWXYZ abcdefghijklmnopqrstuvwxyz 1234567890

abcdefghijklmnopqrstuvwxyz 1234567890 £$¢ƒ

Stempel Schadow
1983

ABCDEFGHIJKLMNOPQRSTUVWXYZ abcdefghijklmnopqrstuvwxyz 1234567890

abcdefghijklmnopqrstuvwxyz 1234567890 £$¢ƒ

Serifa
1967

ABCDEFGHIJKLMNOPQRSTUVWXYZ abcdefghijklmnopqrstuvwxyz 1234567890

abcdefghijklmnopqrstuvwxyz 1234567890 £$¢ƒ

Stymie
(Linotype)

abcdefghijklmnopqrstuvwxyz 1234567890 £$¢

Volta (or Fortune)
1955

ABCDEFGHIJKLMNOPQRSTUVWXYZ abcdefghijklmnopqrstuvwxyz 1234567890

1 An influential book on layout from the 1930s, a time when Geometric slab serifs were enjoying a revival – a by-product of the popularity of Geometric sans serifs such as Futura.

2 In these broadsheets, which summarize the wool fabric forecast for menswear, the large x-height (which is typical of many Geometric sans serifs) can be seen in the Rockwell used. The mechanical layout and simplicity of the type does not detract from the rich variety of fabric shown in the photograph. The use of all lower case adds style.

3 A concert poster influenced by the modern art movements of the 1920s in which the Rockwell Condensed gradually becomes larger until the type in the foreground appears to come forward to confront the reader.

4 On this label designed in the 1950s by Milner Gray, the word "Gilbeys" is set in an expanded Clarendon-style slab serif, which became popular at this time as a result of the introduction of a wave of extended sans serifs.

5 Fortune (or Volta), an extended Clarendon which was popular in the late 1950s, is the type used for a Gulf Oil poster from 1957. The understated typography and the asymmetric layout are typical of a movement in advertising at this time towards simplicity in design and a happy marriage between copy, type and image.

6 In this poster for an International Design Exhibition, the title is set in ITC Cheltenham, modified into a slab serif. The overlapping letters of the title mirror the interlocking figure image which itself resembles a Japanese character.

7 A 1970s poster for Bally Shoes in which the uniform, stream-lined letterstrokes of a modified slab serif (based on Glypha) provides a simple but stylish look in harmony with the sleak French shoes.

8 Pentagram's typographic poster to enliven the head-quarters of IBM in Paris, uses a combination of roman, blackletter and a mechanical-looking Clarendon capital 'T' as a pedestal to produce a descriptive image.

Brooklyn Ac' cents

A Celebration of Brooklyn Literature

Wednesday December 2, 1987

St. Francis College
180 Remsen Street
Brooklyn Heights, New York
(718) 522-2300

1 In this contrived 1950s design for an orange drink label, a decorative and modified slab serif is adorned by the use of a drop shadow and outline to give a hint of Victorian typography.

2 Bulletin Typewriter, a round slab serif, suggests a dictionary entry, lending an appropriate literary tone to a poster advertising "A Celebration of Brooklyn Literature".

3 The immediacy of the typewritten word is used to conjure up a suitable logo for a brand of cigarettes called "Reporter". The red underscore provides an additional journalistic reference.

4

7

5

6

4 A promotional calendar set in Helserif, a modern Geometric slab serif that complements the hi-tech imagery. The interconnecting structured typography mirrors the maze of computer circuitry in the background photograph. The style and weight of the type makes it a practical choice that is legible when reversed out.

5 A typographic solution for a poster for the Early Learning Centre that successfully combines Stymie Extra Bold with a sans serif. A contrast in colour and axis produces a strong design which highlights the key words to emphasize the meaning of the quotation.

6 A promotional type specimen sheet for Letraset's Belwe Mono by David Quay. The arrangement of the small type around the 'O' emphasizes the geometric style of the type's design and is an example of the impact that can be achieved by placing type in an unusual configuration.

7 The clean, mechanical look of Rockwell makes a strong and appropriate companion for the hi-tech chimney system in the photograph on the cover of a technical brochure.

Sans serif

Sans serif types are also known as Gothics in the United States and Grotesks or Lineales in Europe. The types can be broadly divided into three categories – Grotesques, Geometrics and Humanists.

Grotesques

All sans serif types produced in the 19th century are known as Grotesques. The first one, confusingly called an Egyptian, appeared in capital form only in the type specimen catalogue of the Caslon Foundry in England in 1816. Subsequent early Grotesques were display faces only and were heavy and the capital letters were of an equal width. But in 1832, William Thorowgood issued a heavy Grotesque with a clumsy and crude lower case. Different widths and lighter weights soon followed.

Grotesque designs that had a lower case were perfected much earlier in Germany than in England. The German typefounders also produced capital letters of varying widths and with a slight thinning of the letterstrokes at the junctions. An example of this style is Akzidenz Grotesk (or Standard), designed in 1898. The flexibility and plastic quality of the sans serif design was later exploited by Morris Benton at American Typefounders in 1908 when he designed the News Gothic family of type – Trade Gothic (1948) is similar. Franklin Gothic (1905), a heavy display type, was developed into another family of Grotesque types by Morris Benton. In 1980, ITC brought out their version of Franklin, which has many additional lighter weights and matching italics, so making the type more suitable for text setting.

The 1950s was a great revival period for Grotesque types. In 1957, Adrian Frutiger designed the successful Univers family which had a total of 21 variations. The following year, Max Miedinger designed Helvetica, one of the most well used faces of all time – the design for which he based on Akzidenz Grotesk. Folio (1957), Neue Helvetica, Haas Unica (1980) and others are all in the same mould.

Geometrics

In the 1920s, as a direct result of the typography of the modern art movements in Europe and the Bauhaus in Germany, an austere, functional style of sans serif emerged called Geometric. These monoline types, which were simply constructed from straight lines, the circle and the rectangle, stormed on to the typographical scene in the late 1920s. Perhaps the most popular type in this category is Paul Renner's Futura (1928). Rudolf Koch's Kabel (1928), Metro (1929-30) by William Dwiggins, Spartan and Tempo (1930) are but a few of the Futura look-alikes which appeared in quick succession. Eurostile (1962) by Aldo Novarese, a square and ugly type, also belongs to this sans serif category.

Humanists

Calligrapher Edward Johnston's sans serif type for the London Underground in 1916 broke new ground in type design – it was based on classical Roman letterforms. Then, in 1929, Eric Gill, who had been a pupil and admirer of Johnston's, designed Gill Sans for Monotype which was influenced by the London Underground type. Gill's type has a distinctive lower case 'e' and 'g' plus a flowing cursive-style italic. In 1958, Hermann Zapf produced an original and influential Humanist sans serif called Optima which had a pronounced contrast in the width of the letterstrokes and a thickening of the terminals of the strokes.

During the last 20 years or more, type designers have looked to these early Humanist models in search of more expressive and less mechanical forms of sans serif types. Syntax (1968) by Hans Meier, Frutiger (1988) by Adrian Frutiger, Praxis (1979) by Gerard Unger and, more recently, ITC Stone Sans (1988) by Sumner Stone and ITC Quay Sans (1990) by David Quay, are part of a tidal wave of recent Humanist designs.

Selecting sans serif typefaces

Research into the legibility of sans serif faces in comparison to their serif counterparts has not produced a definitive answer. However, there is a view that the more distinctive and uniquely individual letter shapes of serif types and the additional reading flow produced by the serifs themselves tips the balance in favour of serif faces – at least as far as continuous text reading, such as for novels, is concerned. Having said that, many sans serif typefaces are highly legible – the Humanist and

The crudeness of the first sans serif types in the early 19th century is illustrated above in this capital 'S' from an 1830 specimen. The curves and proportions of the letters are poor and the open counters are too small. This causes them to fill in if over-inked.

This 'S' (above) is from a recent PostScript font for the Macintosh, called Template Gothic Bold. Its simplicity and open counters have been designed specifically for use on low-resolution laser printers as a text and display type.

Grotesque designs perhaps more so than the Geometric. As many sans serifs come in large families, of different weights and widths with companion italics, they are more flexible than serif types for use as both text and display faces.

Gill Sans is an old favourite that has plenty of character. The disadvantage of Gill is the length of the descenders which means that extra leading needs to be specified. Univers and Helvetica are equally legible, but perhaps rather more mechanical. They have the advantage of being available in a multitude of weights, widths, italics and other special fonts and are stock typefaces of just about every typesetter in the world. The simplified forms of Futura and the other Geometric sans serifs have made them popular for setting children's books. However, their open and similar letter shapes make them tiring to read in any quantity.

Some narrow sans serifs that save on space include News Gothic, Trade Gothic, ITC Officina Sans (1991), ITC Goudy Sans (1986), and Bell Centennial (1978) by Matthew Carter, a customized and narrow design for setting telephone directories in the United States (it replaced Bell Gothic). Types with a wide set are Eurostyle and Heldustry, and Erbar (1926) and Kabel (1927) have a small x-height and long ascenders – all these faces extend the length of copy.

Most of the sans serifs included in this section have few eccentricities and are therefore suitable for continuous text setting. Exceptions include Eurostile, Erbar, ITC Avant Garde (1970), ITC Kabel (1976), the sloping ITC Eras (1976), Heldustry, Antique Olive (1963), Clearface Gothic, OCR-A and OCR-B. If a typeface with a large x-height is required, use Helvetica, ITC Franklin Gothic (1980) or Frutiger. Lucida Sans and Praxis are practical types of good colour and with a large x-height which are particularly suitable for low-resolution output from desktop publishing systems.

Quick selection guide

Availability: Generally excellent.

PostScript fonts for the Apple Macintosh: Helvetica, Univers, Gill, Futura, ITC Franklin Gothic and many others.

Recent designs: ITC Stone Serif, ITC Quay Sans, ITC Goudy Sans, Meta, Abadi and ITC Officina Sans.

Faces by leading type designers: Bell Centennial (1978) by Matthew Carter, Univers and Frutiger by Adrian Frutiger, Metro by William Dwiggins, ITC Avant Garde Gothic (1970) by Herb Lubalin, Optima by Hermann Zapf, Gill Sans by Eric Gill.

Display fonts related to faces in this section: Helvetica Bold Outline, Gill Cameo and many others.

Greek font: Helvetica, Optima, Antique Olive (1962-6).

The main characteristics of Grotesque sans serifs

- some contrast in the thickness of the letterstrokes
- a slight squareness to the curves
- the capital 'R' usually has a curled leg
- the lower case 'g' is often, but not always, open-tailed
- the capital 'G' usually has a spur

Very large x-height

Thinning strokes at junctions

The main characteristics of Geometric sans serifs

- constructed from simple geometric shapes such as the circle and rectangle
- usually monoline
- usually have a single storey lower case 'a'

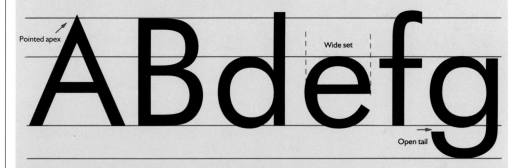

Pointed apex

Wide set

Open tail

The main characteristics of Humanist sans serifs

- based on the proportions of Roman inscriptional capitals and the lower case design of 15th- and 16th-century roman types
- some contrast in the thickness of the letterstrokes
- the lower case 'a' and 'g' are usually double-storey

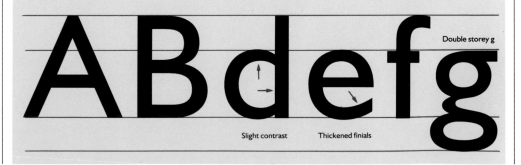

Double storey g

Slight contrast Thickened finials

Franklin Gothic

The original Franklin Gothic was designed by Morris Benton, the in-house designer at American Typefounders (ATF), and it was first released in 1905. A condensed version followed in the same year and an extra condensed the year after. Franklin Gothic is an extra bold sans serif which closely resembles the first Grotesques of the early 19th century and was influenced by Akzidenz Grotesk, issued by the Berthold Foundry of Berlin in 1898. Franklin Gothic is a monoline design of medium width which has some slight thinning at the junction of the vertical and curved strokes and also a small contrast in the width of the letterstrokes. The ITC version shown here was designed by Victor Caruso in 1980. Book and medium weights were added which made the face suitable for continuous text setting. It has a slightly larger x-height than ATF's original version and a full range of matching italic fonts.

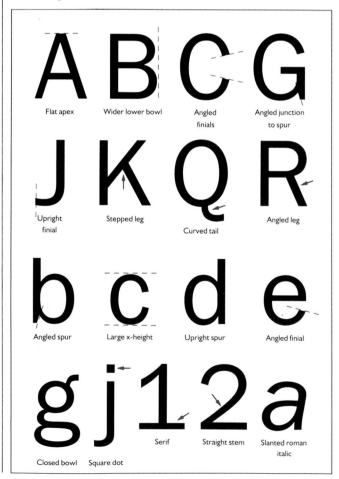

Flat apex · Wider lower bowl · Angled finials · Angled junction to spur · Upright finial · Stepped leg · Curved tail · Angled leg · Angled spur · Large x-height · Upright spur · Angled finial · Serif · Straight stem · Slanted roman italic · Closed bowl · Square dot

ITC Franklin Gothic book, 10/11 point, ranged left

Readability is the biggest single necessity for typography. Designers must always keep this as their chief priority. Copy which is meant to be read but is hard to read, no matter how clever or fashionable the layout might appear, is badly designed. Readability need not mean dullness. On the contrary, the more attractive, the more exciting, the more creative the feel for tone and space, the more readable that design will become. Although body copy usually occupies the largest area of space, it often requires the least amount of the designer's time. Type is also used

ITC Franklin Gothic book, 10/12 point, ranged left

Readability is the biggest single necessity for typography. Designers must always keep this as their chief priority. Copy which is meant to be read but is hard to read, no matter how clever or fashionable the layout might appear, is badly designed. Readability need not mean dullness. On the contrary, the more attractive, the more exciting, the more creative the feel for tone and space, the more readable that design will become. Although body copy usually occupies the largest area of space, it often requires the least amount of the designer's time. Type is also used

ITC Franklin Gothic book, 10/13 point, ranged left

Readability is the biggest single necessity for typography. Designers must always keep this as their chief priority. Copy which is meant to be read but is hard to read, no matter how clever or fashionable the layout might appear, is badly designed. Readability need not mean dullness. On the contrary, the more attractive, the more exciting, the more creative the feel for tone and space, the more readable that design will become. Although body copy usually occupies the largest area of space, it often requires the least amount of the designer's time. Type is also used

ITC Franklin Gothic book, 10/12 point, justified

Readability is the biggest single necessity for typography. Designers must always keep this as their chief priority. Copy which is meant to be read but is hard to read, no matter how clever or fashionable the layout might appear, is badly designed. Readability need not mean dullness. On the contrary, the more attractive, the more exciting, the more creative the feel for tone and space, the more readable that design will become. Although body copy usually occupies the largest area of space, it often requires the least amount of the designer's time. Type is also used

ITC Franklin Gothic book italic, 10/12 point, ranged left

Readability is the biggest single necessity for typography. Designers must always keep this as their chief priority. Copy which is meant to be read but is hard to read, no matter how clever or fashionable the layout might appear, is badly designed. Readability need not mean dullness. On the contrary, the more attractive, the more exciting, the more creative the feel for tone and space, the more readable that design will become. Although body copy usually occupies the largest area of space,

ITC Franklin Gothic demi, 10/12 point, ranged left

Readability is the biggest single necessity for typography. Designers must always keep this as their chief priority. Copy which is meant to be read but is hard to read, no matter how clever or fashionable the layout might appear, is badly designed. Readability need not mean dullness. On the contrary, the more attractive, the more exciting, the more creative the feel for tone and space, the more readable that design will become. Although body copy usually occupies the largest area of

ITC Franklin Gothic book

ABCDEFGHIJKLMNOPQRSTUVWXYZ
abcdefghijklmnopqrstuvwxyz
1234567890&!?().,:;""'"£$¢ƒ

ITC Franklin Gothic book italic

ABCDEFGHIJKLMNOPQRSTUVWXYZ
abcdefghijklmnopqrstuvwxyz
1234567890&!?().,:;""'"£$¢ƒ

ITC Franklin Gothic demi

ABCDEFGHIJKLMNOPQRSTUVWXYZ
abcdefghijklmnopqrstuvwxyz
1234567890&!?().,:;""'"£$¢ƒ

ITC Franklin Gothic demi italic

ABCDEFGHIJKLMNOPQRSTUVWXYZ abcdefghijklmnopqrstuvwxyz 1234567890

ITC Franklin Gothic medium

ABCDEFGHIJKLMNOPQRSTUVWXYZ abcdefghijklmnopqrstuvwxyz 1234567890

ITC Franklin Gothic medium italic

ABCDEFGHIJKLMNOPQRSTUVWXYZ abcdefghijklmnopqrstuvwxyz 1234567890

ITC Franklin Gothic heavy

ABCDEFGHIJKLMNOPQRSTUVWXYZ abcdefghijklmnopqrstuvwxyz 1234567890

ITC Franklin Gothic heavy italic

ABCDEFGHIJKLMNOPQRSTUVWXYZ abcdefghijklmnopqrstuvwxyz 1234567890

Other versions
Franklin Gothic (ATF)
Franklin Gothic No 2

147

Frutiger

Originally designed by leading type designer Adrian Frutiger as an alphabet for the signposting scheme at Charles de Gaulle Airport in Paris, Frutiger was later adapted by Linotype as a text face and issued in 1976. It is a Humanist sans serif in the tradition of Edward Johnston's type for the London Underground. Frutiger's type is rounded, has a definite thinning at stroke junctions, a slight stress and some contrast in the width of the letterstrokes. Adrian Frutiger has produced a wide range of numerically coded weights and italics.

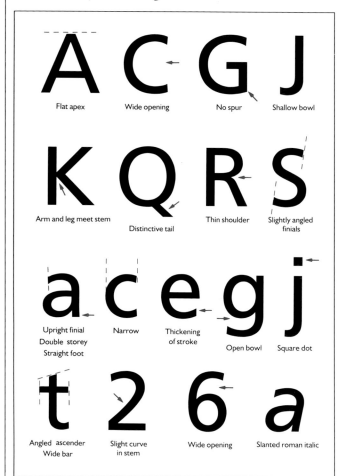

Flat apex | Wide opening | No spur | Shallow bowl

Arm and leg meet stem | Distinctive tail | Thin shoulder | Slightly angled finials

Upright finial Double storey Straight foot | Narrow | Thickening of stroke | Open bowl | Square dot

Angled ascender Wide bar | Slight curve in stem | Wide opening | Slanted roman italic

Frutiger roman, 10/11 point, ranged left

Readability is the biggest single necessity for typography. Designers must always keep this as their chief priority. Copy which is meant to be read but is hard to read, no matter how clever or fashionable the layout might appear, is badly designed. Readability need not mean dullness. On the contrary, the more attractive, the more exciting, the more creative the feel for tone and space, the more readable that design will become. Although body copy usually occupies the largest area of space, it often requires the least amount of the designer's

Frutiger roman, 10/12 point, ranged left

Readability is the biggest single necessity for typography. Designers must always keep this as their chief priority. Copy which is meant to be read but is hard to read, no matter how clever or fashionable the layout might appear, is badly designed. Readability need not mean dullness. On the contrary, the more attractive, the more exciting, the more creative the feel for tone and space, the more readable that design will become. Although body copy usually occupies the largest area of space, it often requires the least amount of the designer's

Frutiger roman, 10/13 point, ranged left

Readability is the biggest single necessity for typography. Designers must always keep this as their chief priority. Copy which is meant to be read but is hard to read, no matter how clever or fashionable the layout might appear, is badly designed. Readability need not mean dullness. On the contrary, the more attractive, the more exciting, the more creative the feel for tone and space, the more readable that design will become. Although body copy usually occupies the largest area of space, it often requires the least amount of the designer's

Frutiger roman, 10/12 point, justified

Readability is the biggest single necessity for typography. Designers must always keep this as their chief priority. Copy which is meant to be read but is hard to read, no matter how clever or fashionable the layout might appear, is badly designed. Readability need not mean dullness. On the contrary, the more attractive, the more exciting, the more creative the feel for tone and space, the more readable that design will become. Although body copy usually occupies the largest area of space, it often requires the least amount of the designer's

Frutiger italic, 10/12 point, ranged left

Readability is the biggest single necessity for typography. Designers must always keep this as their chief priority. Copy which is meant to be read but is hard to read, no matter how clever or fashionable the layout might appear, is badly designed. Readability need not mean dullness. On the contrary, the more attractive, the more exciting, the more creative the feel for tone and space, the more readable that design will become. Although body copy usually occupies

Frutiger bold, 10/12 point, ranged left

Readability is the biggest single necessity for typography. Designers must always keep this as their chief priority. Copy which is meant to be read but is hard to read, no matter how clever or fashionable the layout might appear, is badly designed. Readability need not mean dullness. On the contrary, the more attractive, the more exciting, the more creative the feel for tone and space, the more readable that design will become. Although body copy usually occupies

Frutiger roman

ABCDEFGHIJKLMNOPQRSTUVWXYZ
abcdefghijklmnopqrstuvwxyz
1234567890 &!?().,:;""£$¢ƒ

Frutiger italic

ABCDEFGHIJKLMNOPQRSTUVWXYZ
abcdefghijklmnopqrstuvwxyz
1234567890 &!?().,:;""£$¢ƒ

Frutiger bold

ABCDEFGHIJKLMNOPQRSTUVWXYZ
abcdefghijklmnopqrstuvwxyz
1234567890 &!?().,:;""£$¢ƒ

Frutiger bold italic
ABCDEFGHIJKLMNOPQRSTUVWXYZ abcdefghijklmnopqrstuvwxyz 1234567890

Frutiger light
ABCDEFGHIJKLMNOPQRSTUVWXYZ abcdefghijklmnopqrstuvwxyz 1234567890

Frutiger light italic
ABCDEFGHIJKLMNOPQRSTUVWXYZ abcdefghijklmnopqrstuvwxyz 1234567890

Frutiger black
ABCDEFGHIJKLMNOPQRSTUVWXYZ abcdefghijklmnopqrstuvwxyz 1234567890

Frutiger ultra black
ABCDEFGHIJKLMNOPQRSTUVWXYZ abcdefghijklmnopqrstuvwxyz 12345

Other weights
Frutiger Black Italic

149

Futura

Designed by German book and type designer Paul Renner in 1928 and originally manufactured by the Bauer Type Foundry of Frankfurt, Futura is the most famous and popular of the Geometric style of the sans serif types. The monotone letters are constructed of simple geometric shapes (such as the circle) which result in the 'C', 'G', 'O' and 'Q' looking too wide and open. The ascenders are also long and the lower case 'j' is difficult to differentiate from the lower case 'i'. It is not a particularly appropriate face for continuous text setting and it is best used in small amounts. However, Futura comes in an enormous range of weights, widths and italics and has been particularly popular in educational and children's publishing. The type was responsible for a renaissance of sans serif types and an avalanche of Futura lookalikes such as Spartan, Tempo and 20th Century.

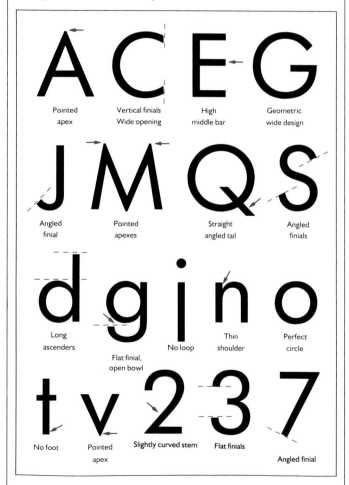

Futura book, 10/11 point, ranged left

Readability is the biggest single necessity for typography. Designers must always keep this as their chief priority. Copy which is meant to be read but is hard to read, no matter how clever or fashionable the layout might appear, is badly designed. Readability need not mean dullness. On the contrary, the more attractive, the more exciting, the more creative the feel for tone and space, the more readable that design will become. Although body copy usually occupies the largest area of space, it often requires the least amount of the designer's time. Type is also used

Futura book, 10/12 point, ranged left

Readability is the biggest single necessity for typography. Designers must always keep this as their chief priority. Copy which is meant to be read but is hard to read, no matter how clever or fashionable the layout might appear, is badly designed. Readability need not mean dullness. On the contrary, the more attractive, the more exciting, the more creative the feel for tone and space, the more readable that design will become. Although body copy usually occupies the largest area of space, it often requires the least amount of the designer's time. Type is also used

Futura book, 10/13 point, ranged left

Readability is the biggest single necessity for typography. Designers must always keep this as their chief priority. Copy which is meant to be read but is hard to read, no matter how clever or fashionable the layout might appear, is badly designed. Readability need not mean dullness. On the contrary, the more attractive, the more exciting, the more creative the feel for tone and space, the more readable that design will become. Although body copy usually occupies the largest area of space, it often requires the least amount of the designer's time. Type is also used

Futura book, 10/12 point, justified

Readability is the biggest single necessity for typography. Designers must always keep this as their chief priority. Copy which is meant to be read but is hard to read, no matter how clever or fashionable the layout might appear, is badly designed. Readability need not mean dullness. On the contrary, the more attractive, the more exciting, the more creative the feel for tone and space, the more readable that design will become. Although body copy usually occupies the largest area of space, it often requires the least amount of the designer's time. Type is also used

Futura book italic, 10/12 point, ranged left

Readability is the biggest single necessity for typography. Designers must always keep this as their chief priority. Copy which is meant to be read but is hard to read, no matter how clever or fashionable the layout might appear, is badly designed. Readability need not mean dullness. On the contrary, the more attractive, the more exciting, the more creative the feel for tone and space, the more readable that design will become. Although body copy usually occupies the largest area of

Futura heavy, 10/12 point, ranged left

Readability is the biggest single necessity for typography. Designers must always keep this as their chief priority. Copy which is meant to be read but is hard to read, no matter how clever or fashionable the layout might appear, is badly designed. Readability need not mean dullness. On the contrary, the more attractive, the more exciting, the more creative the feel for tone and space, the more readable that design will become. Although body copy usually occupies

Futura book

ABCDEFGHIJKLMNOPQRSTUVWXYZ
abcdefghijklmnopqrstuvwxyz
1234567890&!?().,:;""£$¢ƒ

Futura book italic

ABCDEFGHIJKLMNOPQRSTUVWXYZ
abcdefghijklmnopqrstuvwxyz
1234567890&!?().,:;""£$¢ƒ

Futura heavy

ABCDEFGHIJKLMNOPQRSTUVWXYZ
abcdefghijklmnopqrstuvwxyz
1234567890&!?().,:;""£$¢ƒ

Futura heavy italic

ABCDEFGHIJKLMNOPQRSTUVWXYZ abcdefghijklmnopqrstuvwxyz 1234567890

Futura light

ABCDEFGHIJKLMNOPQRSTUVWXYZ abcdefghijklmnopqrstuvwxyz 1234567890

Futura medium

ABCDEFGHIJKLMNOPQRSTUVWXYZ abcdefghijklmnopqrstuvwxyz 1234567890

Futura bold

ABCDEFGHIJKLMNOPQRSTUVWXYZ abcdefghijklmnopqrstuvwxyz

Futura extra black

ABCDEFGHIJKLMNOPQRSTUVWXYZ abcdefghijklmnopqrstuvwxyz

Other weights
Light italic
Medium italic
Quarter-bold
Quarter-bold italic
Semi-bold
Semi-bold italic
Bold italic

151

Gill Sans

Eric Gill's elegant and influential type, one of the most outstanding sans-serif designs of the 20th century, was issued by Monotype in England for mechanical composition in 1929. Gill Sans was inspired by Edward Johnston's type for the London Underground in 1916 and started life as a lettering style for the sign on the front of the bookshop of a friend of Gill's. Stanley Morison at Monotype was instrumental in persuading Gill to develop this lettering into a text type face. A Humanist san serif, it follows the style of classical Roman letterforms, such as the double story of the lower-case g and the scale and proportions of the capital letters.

If Gill Sans has a weakness as a text face, it lies in its various weights – the light is too light for continuous text, and the regular is too heavy. A full selection of weights and italics are available, plus Gill Cameo (a reversed-out form), Gill Shadow Titling (1930), and others.

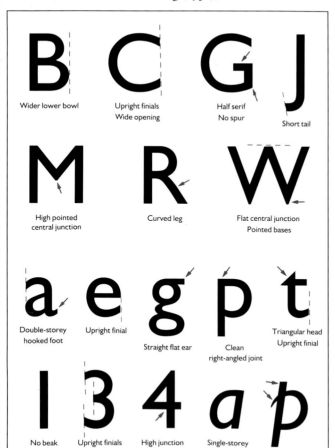

Gill Sans roman, 10/11 point, ranged left

Readability is the biggest single necessity for typography. Designers must always keep this as their chief priority. Copy which is meant to be read but is hard to read, no matter how clever or fashionable the layout might appear, is badly designed. Readability need not mean dullness. On the contrary, the more attractive, the more exciting, the more creative the feel for tone and space, the more readable that design will become. Although body copy usually occupies the largest area of space, it often requires the least amount of the designer's time. Type is also used to attract attention, often in a headline where the design

Gill Sans roman, 10/12 point, ranged left

Readability is the biggest single necessity for typography. Designers must always keep this as their chief priority. Copy which is meant to be read but is hard to read, no matter how clever or fashionable the layout might appear, is badly designed. Readability need not mean dullness. On the contrary, the more attractive, the more exciting, the more creative the feel for tone and space, the more readable that design will become. Although body copy usually occupies the largest area of space, it often requires the least amount of the designer's time. Type is also used to attract attention, often in a headline where the design

Gill Sans roman, 10/13 point, ranged left

Readability is the biggest single necessity for typography. Designers must always keep this as their chief priority. Copy which is meant to be read but is hard to read, no matter how clever or fashionable the layout might appear, is badly designed. Readability need not mean dullness. On the contrary, the more attractive, the more exciting, the more creative the feel for tone and space, the more readable that design will become. Although body copy usually occupies the largest area of space, it often requires the least amount of the designer's time. Type is also used to attract attention, often in a headline where the design

Gill Sans roman, 10/12 point, justified

Readability is the biggest single necessity for typography. Designers must always keep this as their chief priority. Copy which is meant to be read but is hard to read, no matter how clever or fashionable the layout might appear, is badly designed. Readability need not mean dullness. On the contrary, the more attractive, the more exciting, the more creative the feel for tone and space, the more readable that design will become. Although body copy usually occupies the largest area of space, it often requires the least amount of the designer's time. Type is also used to attract attention, often in a headline where the design

Gill Sans italic, 10/12 point, ranged left

Readability is the biggest single necessity for typography. Designers must always keep this as their chief priority. Copy which is meant to be read but is hard to read, no matter how clever or fashionable the layout might appear, is badly designed. Readability need not mean dullness. On the contrary, the more attractive, the more exciting, the more creative the feel for tone and space, the more readable that design will become. Although body copy usually occupies the largest area of space, it often requires the least amount of the designer's time. Type is also

Gill Sans bold, 10/12 point, ranged left

Readability is the biggest single necessity for typography. Designers must always keep this as their chief priority. Copy which is meant to be read but is hard to read, no matter how clever or fashionable the layout might appear, is badly designed. Readability need not mean dullness. On the contrary, the more attractive, the more exciting, the more creative the feel for tone and space, the more readable that design will become. Although body copy usually occupies

Gill Sans roman

ABCDEFGHIJKLMNOPQRSTUVWXYZ
abcdefghijklmnopqrstuvwxyz
1234567890&!?().,:;""£$¢ƒ

Gill Sans italic

ABCDEFGHIJKLMNOPQRSTUVWXYZ
abcdefghijklmnopqrstuvwxyz
1234567890&!?().,:;""£$¢ƒ

Gill Sans bold

ABCDEFGHIJKLMNOPQRSTUVWXYZ
abcdefghijklmnopqrstuvwxyz
1234567890&!?().,:;""£$¢ƒ

Gill Sans bold italic

ABCDEFGHIJKLMNOPQRSTUVWXYZ abcdefghijklmnopqrstuvwxyz 1234567890

Gill Sans light

ABCDEFGHIJKLMNOPQRSTUVWXYZ abcdefghijklmnopqrstuvwxyz 1234567890

Gill Sans light italic

ABCDEFGHIJKLMNOPQRSTUVWXYZ abcdefghijklmnopqrstuvwxyz 1234567890

Gill Sans extra bold

ABCDEFGHIJKLMNOPQRSTUVWXYZ abcdefghijklmnopqrstuvwxyz 123456789

Gill Sans bold condensed

ABCDEFGHIJKLMNOPQRSTUVWXYZ abcdefghijklmnopqrstuvwxyz 1234567890

Grotesque

In England, Monotype were responsible for producing a wide range of Grotesques including Grotesque 215 and 216, which are regular and bold weight faces with matching italic fonts. Other weights and widths are also available such as Grotesque 126, a light face.

All these types follow the traditional Grotesque design which was firmly established in the 19th century. This medium width monoline face is characterized by some thinning at the junctions of letterstrokes and a slight contrast between the width of the strokes. The flexibility of the sans serif design can be seen in the extensive range of widths and weights of the Grotesque types which have been produced. Traditional Grotesques such as Grotesque 215 and 216 were eclipsed by the arrival of Univers, Helvetica and others in the 1950s and they no longer enjoy such widespread popularity.

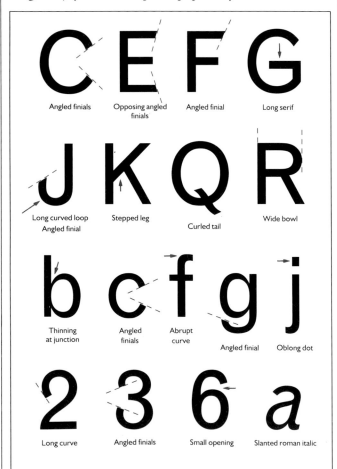

Angled finials	Opposing angled finials	Angled finial	Long serif
Long curved loop Angled finial	Stepped leg	Curled tail	Wide bowl
Thinning at junction	Angled finials	Abrupt curve / Angled finial	Oblong dot
Long curve	Angled finials	Small opening	Slanted roman italic

Grotesque 215 roman, 10/11 point, ranged left

Readability is the biggest single necessity for typography. Designers must always keep this as their chief priority. Copy which is meant to be read but is hard to read, no matter how clever or fashionable the layout might appear, is badly designed. Readability need not mean dullness. On the contrary, the more attractive, the more exciting, the more creative the feel for tone and space, the more readable that design will become. Although body copy usually occupies the largest area of space, it often requires the least amount of the designer's time. Type is also used

Grotesque 215 roman, 10/12 point, ranged left

Readability is the biggest single necessity for typography. Designers must always keep this as their chief priority. Copy which is meant to be read but is hard to read, no matter how clever or fashionable the layout might appear, is badly designed. Readability need not mean dullness. On the contrary, the more attractive, the more exciting, the more creative the feel for tone and space, the more readable that design will become. Although body copy usually occupies the largest area of space, it often requires the least amount of the designer's time. Type is also used

Grotesque 215 roman, 10/13 point, ranged left

Readability is the biggest single necessity for typography. Designers must always keep this as their chief priority. Copy which is meant to be read but is hard to read, no matter how clever or fashionable the layout might appear, is badly designed. Readability need not mean dullness. On the contrary, the more attractive, the more exciting, the more creative the feel for tone and space, the more readable that design will become. Although body copy usually occupies the largest area of space, it often requires the least amount of the designer's time. Type is also used

Grotesque 215 roman, 10/12 point, justified

Readability is the biggest single necessity for typography. Designers must always keep this as their chief priority. Copy which is meant to be read but is hard to read, no matter how clever or fashionable the layout might appear, is badly designed. Readability need not mean dullness. On the contrary, the more attractive, the more exciting, the more creative the feel for tone and space, the more readable that design will become. Although body copy usually occupies the largest area of space, it often requires the least amount of the designer's time. Type is also used

Grotesque 215 italic, 10/12 point, ranged left

Readability is the biggest single necessity for typography. Designers must always keep this as their chief priority. Copy which is meant to be read but is hard to read, no matter how clever or fashionable the layout might appear, is badly designed. Readability need not mean dullness. On the contrary, the more attractive, the more exciting, the more creative the feel for tone and space, the more readable that design will become. Although body copy usually occupies the largest area of space, it often

Grotesque 216 bold, 10/12 point, ranged left

Readability is the biggest single necessity for typography. Designers must always keep this as their chief priority. Copy which is meant to be read but is hard to read, no matter how clever or fashionable the layout might appear, is badly designed. Readability need not mean dullness. On the contrary, the more attractive, the more exciting, the more creative the feel for tone and space, the more readable that design will become. Although body copy

Grotesque 215 roman

ABCDEFGHIJKLMNOPQRSTUVWXYZ
abcdefghijklmnopqrstuvwxyz
1234567890&!?().,:;""£$¢ƒ

Grotesque 215 italic

ABCDEFGHIJKLMNOPQRSTUVWXYZ
abcdefghijklmnopqrstuvwxyz
1234567890&!?().,:;""£$¢ƒ

Grotesque 216 bold

ABCDEFGHIJKLMNOPQRSTUVWXYZ
abcdefghijklmnopqrstuvwxyz
1234567890&!?().,:;""£$¢ƒ

Grotesque 216 bold italic

ABCDEFGHIJKLMNOPQRSTUVWXYZ abcdefghijklmnopqrstuvwxyz 1234567890

Grotesque 126 light

ABCDEFGHIJKLMNOPQRSTUVWXYZ abcdefghijklmnopqrstuvwxyz 1234567890

Grotesque 126 light italic

ABCDEFGHIJKLMNOPQRSTUVWXYZ abcdefghijklmnopqrstuvwxyz 1234567890

Helvetica

Designed in 1957 by Max Miedinger and formerly called Neue Haas Grotesk, Helvetica has been one of the most commercially successful designs of the 20th century. During the 1960s and 1970s, it was the only typeface used by the Swiss typographic movement. This movement was very influential throughout the world at this time and, as a result, the type became very popular. Helvetica is a legible Grotesque-style sans serif which is rounded, has a large x-height, short ascenders and descenders and no eccentricities. Indeed, some people might say it is characterless. It has become acceptable as a text typeface and is widely used in book publishing and advertising. Like all modern sans serifs, Helvetica has a large family of weights, widths and italics as well as outline, Greek and Cryllic fonts. Linotype have subsequently introduced Neue Helvetica, a modernized version, which has a full repertoire of variations including shaded and ultra thin fonts.

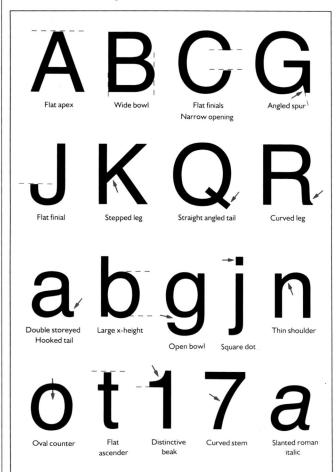

Flat apex Wide bowl Flat finials Angled spur
Narrow opening

Flat finial Stepped leg Straight angled tail Curved leg

Double storeyed Large x-height Thin shoulder
Hooked tail
Open bowl Square dot

Oval counter Flat ascender Distinctive beak Curved stem Slanted roman italic

Helvetica roman, 10/11 point, ranged left

Readability is the biggest single necessity for typography. Designers must always keep this as their chief priority. Copy which is meant to be read but is hard to read, no matter how clever or fashionable the layout might appear, is badly designed. Readability need not mean dullness. On the contrary, the more attractive, the more exciting, the more creative the feel for tone and space, the more readable that design will become. Although body copy usually occupies the largest area of space, it often requires the least amount of the designer's time. Type is also used to attract attention

Helvetica roman, 10/12 point, ranged left

Readability is the biggest single necessity for typography. Designers must always keep this as their chief priority. Copy which is meant to be read but is hard to read, no matter how clever or fashionable the layout might appear, is badly designed. Readability need not mean dullness. On the contrary, the more attractive, the more exciting, the more creative the feel for tone and space, the more readable that design will become. Although body copy usually occupies the largest area of space, it often requires the least amount of the designer's time. Type is also used to attract attention

Helvetica roman, 10/13 point, ranged left

Readability is the biggest single necessity for typography. Designers must always keep this as their chief priority. Copy which is meant to be read but is hard to read, no matter how clever or fashionable the layout might appear, is badly designed. Readability need not mean dullness. On the contrary, the more attractive, the more exciting, the more creative the feel for tone and space, the more readable that design will become. Although body copy usually occupies the largest area of space, it often requires the least amount of the designer's time. Type is also used to attract attention

Helvetica roman, 10/12 point, justified

Readability is the biggest single necessity for typography. Designers must always keep this as their chief priority. Copy which is meant to be read but is hard to read, no matter how clever or fashionable the layout might appear, is badly designed. Read ability need not mean dullness. On the contrary, the more attractive, the more exciting, the more creative the feel for tone and space, the more readable that design will become. Although body copy usually occupies the largest area of space, it often requires the least amount of the designer's time. Type is also used to attract attention,

Helvetica italic, 10/12 point, ranged left

Readability is the biggest single necessity for typography. Designers must always keep this as their chief priority. Copy which is meant to be read but is hard to read, no matter how clever or fashionable the layout might appear, is badly designed. Readability need not mean dullness. On the contrary, the more attractive, the more exciting, the more creative the feel for tone and space, the more readable that design will become. Although body copy usually occupies the largest area of

Helvetica bold, 10/12 point, ranged left

Readability is the biggest single necessity for typography. Designers must always keep this as their chief priority. Copy which is meant to be read but is hard to read, no matter how clever or fashionable the layout might appear, is badly designed. Readability need not mean dullness. On the contrary, the more attractive, the more exciting, the more creative the feel for tone and space, the more readable that design will become. Although body copy usually occupies

Helvetica roman

ABCDEFGHIJKLMNOPQRSTUVWXYZ
abcdefghijklmnopqrstuvwxyz
1234567890 &!?().,:;""£$¢ƒ

Helvetica italic

ABCDEFGHIJKLMNOPQRSTUVWXYZ
abcdefghijklmnopqrstuvwxyz
1234567890 &!?().,:;""£$¢ƒ

Helvetica bold

ABCDEFGHIJKLMNOPQRSTUVWXYZ
abcdefghijklmnopqrstuvwxyz
1234567890 &!?().,:;""£$¢ƒ

Helvetica bold italic

ABCDEFGHIJKLMNOPQRSTUVWXYZ abcdefghijklmnopqrstuvwxyz 1234567890

Helvetica thin

ABCDEFGHIJKLMNOPQRSTUVWXYZ abcdefghijklmnopqrstuvwxyz 1234567890

Helvetica light

ABCDEFGHIJKLMNOPQRSTUVWXYZ abcdefghijklmnopqrstuvwxyz 1234567890

Helvetica heavy

ABCDEFGHIJKLMNOPQRSTUVWXYZ abcdefghijklmnopqrstuvwxyz 1234567890

Helvetica black

ABCDEFGHIJKLMNOPQRSTUVWXYZ abcdefghijklmnopqrstuvwxyz 1234567

Other weights
Ultra light
Ultra light italic
Thin italic
Light italic
Heavy italic
Black italic
Black No 2

Other versions
Helvetica Catalogue
Neue Helvetica

Optima

Optima.is a highly original Humanist sans serif by the leading German type designer Hermann Zapf and originally issued by the Stempel Foundry in Frankfurt in 1958. Optima broke new ground in commercial type design – it successfully combined characteristics of both serif and sans serif letterforms (Zapf called it "a serifless roman"). It is a rounded sans serif with some of the stress of a serif and flared terminals to the letterstrokes. The italic is a slanted roman, and regular, demi-bold, bold, black and extra black weights of the roman and italic are available. It is a popular text face which benefits from loose letter-spacing.

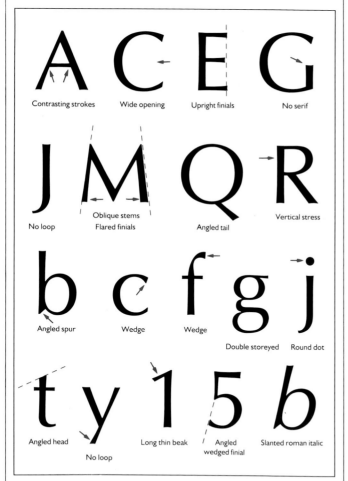

Contrasting strokes · Wide opening · Upright finials · No serif

No loop · Oblique stems / Flared finials · Angled tail · Vertical stress

Angled spur · Wedge · Wedge · Double storeyed · Round dot

Angled head · No loop · Long thin beak · Angled wedged finial · Slanted roman italic

Optima roman, 10/11 point, ranged left

Readability is the biggest single necessity for typography. Designers must always keep this as their chief priority. Copy which is meant to be read but is hard to read, no matter how clever or fashionable the layout might appear, is badly designed. Readability need not mean dullness. On the contrary, the more attractive, the more exciting, the more creative the feel for tone and space, the more readable that design will become. Although body copy usually occupies the largest area of space, it often requires the least amount of the designer's time. Type is also used to attract

Optima roman, 10/12 point, ranged left

Readability is the biggest single necessity for typography. Designers must always keep this as their chief priority. Copy which is meant to be read but is hard to read, no matter how clever or fashionable the layout might appear, is badly designed. Readability need not mean dullness. On the contrary, the more attractive, the more exciting, the more creative the feel for tone and space, the more readable that design will become. Although body copy usually occupies the largest area of space, it often requires the least amount of the designer's time. Type is also used to attract

Optima roman, 10/13 point, ranged left

Readability is the biggest single necessity for typography. Designers must always keep this as their chief priority. Copy which is meant to be read but is hard to read, no matter how clever or fashionable the layout might appear, is badly designed. Readability need not mean dullness. On the contrary, the more attractive, the more exciting, the more creative the feel for tone and space, the more readable that design will become. Although body copy usually occupies the largest area of space, it often requires the least amount of the designer's time. Type is also used to attract

Optima roman, 10/12 point, justified

Readability is the biggest single necessity for typography. Designers must always keep this as their chief priority. Copy which is meant to be read but is hard to read, no matter how clever or fashionable the layout might appear, is badly designed. Readability need not mean dullness. On the contrary, the more attractive, the more exciting, the more creative the feel for tone and space, the more readable that design will become. Although body copy usually occupies the largest area of space, it often requires the least amount of designer's time. Type is also used to attract attention,

Optima italic, 10/12 point, ranged left

Readability is the biggest single necessity for typography. Designers must always keep this as their chief priority. Copy which is meant to be read but is hard to read, no matter how clever or fashionable the layout might appear, is badly designed. Readability need not mean dullness. On the contrary, the more attractive, the more exciting, the more creative the feel for tone and space, the more readable that design will become. Although body copy usually occupies the largest area of space, it often requires the

Optima bold, 10/12 point, ranged left

Readability is the biggest single necessity for typography. Designers must always keep this as their chief priority. Copy which is meant to be read but is hard to read, no matter how clever or fashionable the layout might appear, is badly designed. Readability need not mean dullness. On the contrary, the more attractive, the more exciting, the more creative the feel for tone and space, the more readable that design will become. Although body copy usually occupies the largest area of space, it often

Optima roman

ABCDEFGHIJKLMNOPQRSTUVWXYZ
abcdefghijklmnopqrstuvwxyz
1234567890&!?().,:;""£$¢f

Optima italic

ABCDEFGHIJKLMNOPQRSTUVWXYZ
abcdefghijklmnopqrstuvwxyz
1234567890&!?().,:;""£$¢f

Optima bold

ABCDEFGHIJKLMNOPQRSTUVWXYZ
abcdefghijklmnopqrstuvwxyz
1234567890&!?().,:;""£$¢f

Optima bold italic
ABCDEFGHIJKLMNOPQRSTUVWXYZ abcdefghijklmnopqrstuvwxyz 1234567890

Optima medium
ABCDEFGHIJKLMNOPQRSTUVWXYZ abcdefghijklmnopqrstuvwxyz 1234567890

Optima demi bold
ABCDEFGHIJKLMNOPQRSTUVWXYZ abcdefghijklmnopqrstuvwxyz 1234567890

Optima black
ABCDEFGHIJKLMNOPQRSTUVWXYZ abcdefghijklmnopqrstuvwxyz 1234567890

Optima extra black
ABCDEFGHIJKLMNOPQRSTUVWXYZ abcdefghijklmnopqrstuvwxyz 12345678

Other weights
Medium italic
Demi-bold italic
Black italic
Extra black italic

159

Univers

The Univers family of sans serif types established its designer, Adrian Frutiger, at the forefront in the development of type design. Univers, designed in 1957, is sympathetic in its detail and Frutiger has designed out all the more quirky features of traditional Grotesque faces in order to create a legible and harmonious text face. The family has a total of 21 members, ranging from ultra light condensed to extra black extended and everything else in between. Most weights and widths have companion italic fonts. The type is characterized by a slight contrast in the width of letterstrokes, short ascenders and descenders and, when compared to the rounded shape of Helvetica, a more compressed (almost square) appearance. A minor criticism of its design is the closeness of the end of the tail of the lower case 'g' to its bowl. Univers has found its way on to the type specimen lists of typesetters throughout the world.

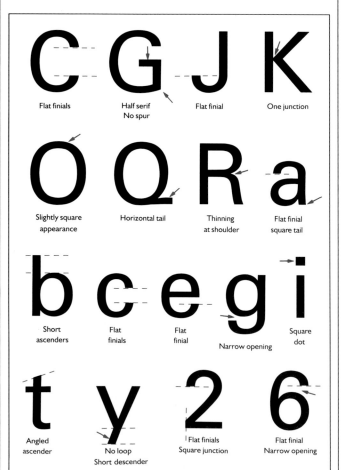

Flat finials Half serif No spur Flat finial One junction

Slightly square appearance Horizontal tail Thinning at shoulder Flat finial square tail

Short ascenders Flat finials Flat finial Narrow opening Square dot

Angled ascender No loop Short descender Flat finials Square junction Flat finial Narrow opening

Univers roman, 10/11 point, ranged left

Readability is the biggest single necessity for typography. Designers must always keep this as their chief priority. Copy which is meant to be read but is hard to read, no matter how clever or fashionable the layout might appear, is badly designed. Readability need not mean dullness. On the contrary, the more attractive, the more exciting, the more creative the feel for tone and space, the more readable that design will become. Although body copy usually occupies the largest area of space, it often requires the least amount

Univers roman, 10/12 point, ranged left

Readability is the biggest single necessity for typography. Designers must always keep this as their chief priority. Copy which is meant to be read but is hard to read, no matter how clever or fashionable the layout might appear, is badly designed. Readability need not mean dullness. On the contrary, the more attractive, the more exciting, the more creative the feel for tone and space, the more readable that design will become. Although body copy usually occupies the largest area of space, it often requires the least amount

Univers roman, 10/13 point, ranged left

Readability is the biggest single necessity for typography. Designers must always keep this as their chief priority. Copy which is meant to be read but is hard to read, no matter how clever or fashionable the layout might appear, is badly designed. Readability need not mean dullness. On the contrary, the more attractive, the more exciting, the more creative the feel for tone and space, the more readable that design will become. Although body copy usually occupies the largest area of space, it often requires the least amount

Univers roman, 10/12 point, justified

Readability is the biggest single necessity for typography. Designers must always keep this as their chief priority. Copy which is meant to be read but is hard to read, no matter how clever or fashionable the layout might appear, is badly designed. Readability need not mean dullness. On the contrary, the more attractive, the more exciting, the more creative the feel for tone and space, the more readable that design will become. Although body copy usually occupies the largest area of space, it often requires the least amount

Univers italic, 10/12 point, ranged left

Readability is the biggest single necessity for typography. Designers must always keep this as their chief priority. Copy which is meant to be read but is hard to read, no matter how clever or fashionable the layout might appear, is badly designed. Readability need not mean dullness. On the contrary, the more attractive, the more exciting, the more creative the feel for tone and space, the more readable that design will become. Although body copy usually occupies

Univers bold, 10/12 point, ranged left

Readability is the biggest single necessity for typography. Designers must always keep this as their chief priority. Copy which is meant to be read but is hard to read, no matter how clever or fashionable the layout might appear, is badly designed. Readability need not mean dullness. On the contrary, the more attractive, the more exciting, the more creative the feel for tone and space, the more readable that design will become. Although body copy usually occupies

Univers roman 55

ABCDEFGHIJKLMNOPQRSTUVWXYZ
abcdefghijklmnopqrstuvwxyz
1234567890 &!?().,:;""£$¢ƒ

Univers italic 56

ABCDEFGHIJKLMNOPQRSTUVWXYZ
abcdefghijklmnopqrstuvwxyz
1234567890 &!?().,:;""£$¢ƒ

Univers bold 65

ABCDEFGHIJKLMNOPQRSTUVWXYZ
abcdefghijklmnopqrstuvwxyz
1234567890 &!?().,:;""£$¢ƒ

Univers bold italic 66
ABCDEFGHIJKLMNOPQRSTUVWXYZ abcdefghijklmnopqrstuvwxyz 1234567890

Univers light 45
ABCDEFGHIJKLMNOPQRSTUVWXYZ abcdefghijklmnopqrstuvwxyz 1234567890

Univers light italic 46
ABCDEFGHIJKLMNOPQRSTUVWXYZ abcdefghijklmnopqrstuvwxyz 1234567890

Univers black 75
ABCDEFGHIJKLMNOPQRSTUVWXYZ abcdefghijklmnopqrstuvwxyz 1234567

Univers extra black 85
ABCDEFGHIJKLMNOPQRSTUVWXYZ abcdefghijklmnopqrstuvwxyz 123456

Other weights
Black italic 76

Abadi

ABCDEFGHIJKLMNOPQRSTUVWXYZ &!?(),:;" "

ABCDEFGHIJKLMNOPQRSTUVWXYZ abcdefghijklmnopqrstuvwxyz 1234567890

Akzidenz Grotesk
1902

ABCDEFGHIJKLMNOPQRSTUVWXYZ &!?(),:;""

ABCDEFGHIJKLMNOPQRSTUVWXYZ abcdefghijklmnopqrstuvwxyz 1234567890

Antique Olive
1962-66

ABCDEFGHIJKLMNOPQRSTUVWXYZ &!?(),:;""

ABCDEFGHIJKLMNOPQRSTUVWXYZ abcdefghijklmnopqrstuvwxyz 1234567890

Arial

ABCDEFGHIJKLMNOPQRSTUVWXYZ &!?(),:;" "

ABCDEFGHIJKLMNOPQRSTUVWXYZ abcdefghijklmnopqrstuvwxyz 1234567890

ITC Avant Garde Gothic
1970

ABCDEFGHIJKLMNOPQRSTUVWXYZ &!?(),:;""

ABCDEFGHIJKLMNOPQRSTUVWXYZ abcdefghijklmnopqrstuvwxyz 1234567890

Avenir

ABCDEFGHIJKLMNOPQRSTUVWXYZ &!?(),:;""

ABCDEFGHIJKLMNOPQRSTUVWXYZ abcdefghijklmnopqrstuvwxyz 1234567890

Bell Centennial
1978

ABCDEFGHIJKLMNOPQRSTUVWXYZ &!?(),:;" "

Bell Gothic
1938

ABCDEFGHIJKLMNOPQRSTUVWXYZ &!?(),:;\"//

ABCDEFGHIJKLMNOPQRSTUVWXYZ abcdefghijklmnopqrstuvwxyz 1234567890

Bernhard Gothic
1930

ABCDEFGHIJKLMNOPQRSTUVWXYZ &!?(),:;""

ABCDEFGHIJKLMNOPQRSTUVWXYZ abcdefghijklmnopqrstuvwxyz 1234567890

Clearface Gothic

ABCDEFGHIJKLMNOPQRSTUVWXYZ &!?(),:;" "

ABCDEFGHIJKLMNOPQRSTUVWXYZ abcdefghijklmnopqrstuvwxyz 1234567890

162

abcdefghijklmnopqrstuvwxyz 1234567890 £$

Abadi

ABCDEFGHIJKLMNOPQRSTUVWXYZ abcdefghijklmnopqrstuvwxyz 1234567890

abcdefghijklmnopqrstuvwxyz 1234567890 £$¢*f*

Akzidenz Grotesk
1902

ABCDEFGHIJKLMNOPQRSTUVWXYZ abcdefghijklmnopqrstuvwxyz 1234567890

abcdefghijklmnopqrstuvwxyz 1234567890 £$¢*f*

Antique Olive
1962-66

ABCDEFGHIJKLMNOPQRSTUVWXYZ abcdefghijklmnopqrstuvwxyz 1234567890

abcdefghijklmnopqrstuvwxyz 1234567890 £$

Arial

ABCDEFGHIJKLMNOPQRSTUVWXYZ abcdefghijklmnopqrstuvwxyz 1234567890

abcdefghijklmnopqrstuvwxyz 1234567890 £$¢*f*

ITC Avant Garde Gothic
1970

ABCDEFGHIJKLMNOPQRSTUVWXYZ abcdefghijklmnopqrstuvwxyz 1234567890

abcdefghijklmnopqrstuvwxyz 1234567890 £$¢*f*

Avenir

abcdefghijklmnopqrstuvwxyz 1234567890 $¢

Bell Centennial
1978

abcdefghijklmnopqrstuvwxyz 1234567890 £$¢*f*

Bell Gothic
1938

abcdefghijklmnopqrstuvwxyz 1234567890 £

Bernhard Gothic
1930

abcdefghijklmnopqrstuvwxyz 1234567890 £$¢*f*

Clearface Gothic

ITC Eras
1976

ABCDEFGHIJKLMNOPQRSTUVWXYZ &!?(),.;""

ABCDEFGHIJKLMNOPQRSTUVWXYZ abcdefghijklmnopqrstuvwxyz 1234567890

Erbar
1922-30

ABCDEFGHIJKLMNOPQRSTUVWXYZ &!?(),.;""

Eurostile
1962

ABCDEFGHIJKLMNOPQRSTUVWXYZ &!?(),.;""

ABCDEFGHIJKLMNOPQRSTUVWXYZ abcdefghijklmnopqrstuvwxyz 1234567890

Folio
1957

ABCDEFGHIJKLMNOPQRSTUVWXYZ &!?(),.;" "

ABCDEFGHIJKLMNOPQRSTUVWXYZ abcdefghijklmnopqrstuvwxyz 1234567890

Foundry Sans

ABCDEFGHIJKLMNOPQRSTUVWXYZ &!?(),.;""

ABCDEFGHIJKLMNOPQRSTUVWXYZ abcdefghijklmnopqrstuvwxyz 1234567890

Franklin Gothic
(ATF)
1905

ABCDEFGHIJKLMNOPQRSTUVWXYZ &!?(),.;""

ABCDEFGHIJKLMNOPQRSTUVWXYZ abcdefghijklmnopqrstuvwxyz 1234567890

ITC Goudy Sans

ABCDEFGHIJKLMNOPQRSTUVWXYZ &!?(),.;""

ABCDEFGHIJKLMNOPQRSTUVWXYZ abcdefghijklmnopqrstuvwxyz 1234567890

Heldustry

ABCDEFGHIJKLMNOPQRSTUVWXYZ &!?(),.;""

ABCDEFGHIJKLMNOPQRSTUVWXYZ abcdefghijklmnopqrstuvwxyz 1234567890

Neue Helvetica

ABCDEFGHIJKLMNOPQRSTUVWXYZ &!?(),.;""

ABCDEFGHIJKLMNOPQRSTUVWXYZ abcdefghijklmnopqrstuvwxyz 1234567890

Imago

ABCDEFGHIJKLMNOPQRSTUVWXYZ &!?(),.;""

ABCDEFGHIJKLMNOPQRSTUVWXYZ abcdefghijklmnopqrstuvwxyz 1234567890

abcdefghijklmnopqrstuvwxyz 1234567890 £$¢ƒ

ITC Eras
1976

abcdefghijklmnopqrstuvwxyz 1234567890 £$¢ƒ

Erbar
1922-30

abcdefghijklmnopqrstuvwxyz 1234567890 £$¢ƒ

Eurostile
1962

abcdefghijklmnopqrstuvwxyz 1234567890 £$¢ƒ
ABCDEFGHIJKLMNOPQRSTUVWXYZ abcdefghijklmnopqrstuvwxyz 1234567890

Folio
1957

abcdefghijklmnopqrstuvwxyz 1234567890 £$¢ƒ
ABCDEFGHIJKLMNOPQRSTUVWXYZ abcdefghijklmnopqrstuvwxyz 1234567890

Foundry Sans

abcdefghijklmnopqrstuvwxyz 1234567890 £$¢ƒ
ABCDEFGHIJKLMNOPQRSTUVWXYZ abcdefghijklmnopqrstuvwxyz 1234567890

Franklin Gothic
(ATF)
1905

abcdefghijklmnopqrstuvwxyz 1234567890 £$¢ƒ
ABCDEFGHIJKLMNOPQRSTUVWXYZ abcdefghijklmnopqrstuvwxyz 1234567890

ITC Goudy Sans

abcdefghijklmnopqrstuvwxyz 1234567890 £$¢ƒ
ABCDEFGHIJKLMNOPQRSTUVWXYZ abcdefghijklmnopqrstuvwxyz 1234567890

Heldustry

abcdefghijklmnopqrstuvwxyz 1234567890 £$¢ƒ
ABCDEFGHIJKLMNOPQRSTUVWXYZ abcdefghijklmnopqrstuvwxyz 1234567890

Neue Helvetica

abcdefghijklmnopqrstuvwxyz 1234567890 £$
ABCDEFGHIJKLMNOPQRSTUVWXYZ abcdefghijklmnopqrstuvwxyz 1234567890

Imago

Kabel
1927

ABCDEFGHIJKLMNOPQRSTUVWXYZ &!?(),.:;""

ABCDEFGHIJKLMNOPQRSTUVWXYZ abcdefghijklmnopqrstuvwxyz 1234567890

ITC Kabel
1976

ABCDEFGHIJKLMNOPQRSTUVWXYZ &!?(),.:;""

ABCDEFGHIJKLMNOPQRSTUVWXYZ abcdefghijklmnopqrstuvwxyz 1234567890

Lucida Sans

ABCDEFGHIJKLMNOPQRSTUVWXYZ &!?(),.:;""

ABCDEFGHIJKLMNOPQRSTUVWXYZ abcdefghijklmnopqrstuvwxyz 1234567890

FF Meta

ABCDEFGHIJKLMNOPQRSTUVWXYZ&!?(),.:;""

ABCDEFGHIJKLMNOPQRSTUVWXYZ abcdefghijklmnopqrstuvwxyz 1234567890

Metrolite
1929-30

ABCDEFGHIJKLMNOPQRSTUVWXYZ &!?(),.:;""

ABCDEFGHIJKLMNOPQRSTUVWXYZ abcdefghijklmnopqrstuvwxyz 1234567890

ITC Mixage

ABCDEFGHIJKLMNOPQRSTUVWXYZ &!?(),.:;""

ABCDEFGHIJKLMNOPQRSTUVWXYZ abcdefghijklmnopqrstuvwxyz 1234567890

Neuzeit Grotesk
1928

ABCDEFGHIJKLMNOPQRSTUVWXYZ &!?(),.:;""

ABCDEFGHIJKLMNOPQRSTUVWXYZ abcdefghijklmnopqrstuvwxyz 1234567890

News Gothic
1908

ABCDEFGHIJKLMNOPQRSTUVWXYZ &!?(),.:;" "

ABCDEFGHIJKLMNOPQRSTUVWXYZ abcdefghijklmnopqrstuvwxyz 1234567890

OCR-A

ABCDEFGHIJKLMNOPQRSTUVWXYZ &!?()⌐.:⌐

ABCDEFGHIJKLMNOPQRSTUVWXYZ abcdefghijklmnopqrstuvwxyz 1234567890

OCR-B

ABCDEFGHIJKLMNOPQRSTUVWXYZ&!?(),.:;""

ABCDEFGHIJKLMNOPQRSTUVWXYZ abcdefghijklmnopqrstuvwxyz 1234567890

abcdefghijklmnopqrstuvwxyz 1234567890 £$¢ƒ **Kabel** 1927

abcdefghijklmnopqrstuvwxyz 1234567890 £$¢ ƒ **ITC Kabel** 1976

abcdefghijklmnopqrstuvwxyz 1234567890 £ $ ¢ ƒ **Lucida Sans**

ABCDEFGHIJKLMNOPQRSTUVWXYZ abcdefghijklmnopqrstuvwxyz 1234567890

abcdefghijklmnopqrstuvwxyz 1234567890 £$¢ƒ **FF Meta**

abcdefghijklmnopqrstuvwxyz 1234567890 £$¢ƒ **Metrolite**

ABCDEFGHIJKLMNOPQRSTUVWXYZ abcdefghijklmnopqrstuvwxyz 1234567890

abcdefghijklmnopqrstuvwxyz 1234567890 £$¢ƒ **ITC Mixage**

ABCDEFGHIJKLMNOPQRSTUVWXYZ abcdefghijklmnopqrstuvwyz 1234567890

abcdefghijklmnopqrstuvwxyz 1234567890 £$¢ƒ **Neuzeit Grotesk** 1928

abcdefghijklmnopqrstuvwxyz 1234567890 £ $¢ƒ **News Gothic** 1908

abcdefghijklmnopqrstuvwxyz1234567890£$ **OCR-A**

abcdefghijklmnopqrstuvwxyz1234567890£$ **OCR-B**

ITC Officina Sans

ABCDEFGHIJKLMNOPQRSTUVWXYZ&!?(),.:;""

ABCDEFGHIJKLMNOPQRSTUVWXYZ abcdefghijklmnopqrstuvwxyz 1234567890

20th Century
(Monotype)

ABCDEFGHIJKLMNOPQRSTUVWXYZ &!?(),.:;" "

ABCDEFGHIJKLMNOPQRSTUVWXYZ abcdefghijklmnopqrstuvwxyz 1234567890

ITC Quay Sans

ABCDEFGHIJKLMNOPQRSTUVWXYZ&!?(),.:;""

ABCDEFGHIJKLMNOPQRSTUVWXYZ abcdefghijklmnopqrstuvwxyz 1234567890

Spartan
(Linotype)
1951-54

ABCDEFGHIJKLMNOPQRSTUVWXYZ &!?(),.:;""

ABCDEFGHIJKLMNOPQRSTUVWXYZ abcdefghijklmnopqrstuvwxyz 1234567890

ITC Stone Sans

ABCDEFGHIJKLMNOPQRSTUVWXYZ &!?(),.:;""

ABCDEFGHIJKLMNOPQRSTUVWXYZ abcdefghijklmnopqrstuvwxyz 1234567890

Syntax
1968

ABCDEFGHIJKLMNOPQRSTUVWXYZ &!?(),.:;" "

ABCDEFGHIJKLMNOPQRSTUVWXYZ abcdefghijklmnopqrstuvwxyz 1234567890

Trade Gothic
1948

ABCDEFGHIJKLMNOPQRSTUVWXYZ &!?(),.:;" "

ABCDEFGHIJKLMNOPQRSTUVWXYZ abcdefghijklmnopqrstuvwxyz 1234567890

Haas Unica
1980

ABCDEFGHIJKLMNOPQRSTUVWXYZ &!?(),.:;" "

ABCDEFGHIJKLMNOPQRSTUVWXYZ abcdefghijklmnopqrstuvwxyz 1234567890

Venus
1907

ABCDEFGHIJKLMNOPQRSTUVWXYZ &!?(),.:;" "

ABCDEFGHIJKLMNOPQRSTUVWXYZ abcdefghijklmnopqrstuvwxyz 1234567890

Video
1977

ABCDEFGHIJKLMNOPQRSTUVWXYZ &!?(),.:;""

ABCDEFGHIJKLMNOPQRSTUVWXYZ abcdefghijklmnopqrstuvwxyz 1234567890

abcdefghijklmnopqrstuvwxyz1234567890 £$¢ƒ

ITC Officina Sans

ABCDEFGHIJKLMNOPQRSTUVWXYZ abcdefghijklmnopqrstuvwxyz 1234567890

abcdefghijklmnopqrstuvwxyz 1234567890 £$

20th Century
(Monotype)

ABCDEFGHIJKLMNOPQRSTUVWXYZ abcdefghijklmnopqrstuvwxyz 1234567890

abcdefghijklmnopqrstuvwxyz 1234567890 £$¢

ITC Quay Sans

ABCDEFGHIJKLMNOPQRSTUVWXYZabcdefghijklmnopqrstuvwxyz1234567890

abcdefghijklmnopqrstuvwxyz 1234567890 £$¢ ƒ

Spartan
(Linotype)
1951-54

ABCDEFGHIJKLMNOPQRSTUVWXYZ abcdefghijklmnopqrstuvwxyz 1234567890

abcdefghijklmnopqrstuvwxyz 1234567890 £$¢ƒ

ITC Stone Sans

ABCDEFGHIJKLMNOPQRSTUVWXYZ abcdefghijklmnopqrstuvwxyz 1234567890

abcdefghijklmnopqrstuvwxyz 1234567890 £$¢ƒ

Syntax
1968

ABCDEFGHIJKLMNOPQRSTUVWXYZ abcdefghijklmnopqrstuvwxyz 1234567890

abcdefghijklmnopqrstuvwxyz 1234567890 £$¢ ƒ

Trade Gothic
1948

ABCDEFGHIJKLMNOPQRSTUVWXYZ abcdefghijklmnopqrstuvwxyz 1234567890

abcdefghijklmnopqrstuvwxyz 1234567890 £$¢ƒ

Haas Unica
1980

ABCDEFGHIJKLMNOPQRSTUVWXYZ abcdefghijklmnopqrstuvwxyz 1234567890

abcdefghijklmnopqrstuvwxyz 1234567890 £$¢ƒ

Venus
1907

abcdefghijklmnopqrstuvwxyz 1234567890 £$¢ƒ

Video
1977

169

1 *Ariel* was the first of more than 500 Penguin books redesigned by Jan Tschichold during the 1940s. The covers feature Gill Sans, probably the most widely used Humanist sans serif face.

2 The elegance and traditional feel of Gill Sans is derived from the classical roman letterform on which its creator, Eric Gill, based the design. These qualities have been exploited and further enhanced by the classical centred layout on these labels for Cockburn port.

3 Johnston, an alphabet originally designed by Edward Johnston for the London Underground in 1916, was redrawn and extra weights were added in the early 1980s. The updated version, New Johnston, is illustrated on this page from a special international calendar for type buffs.

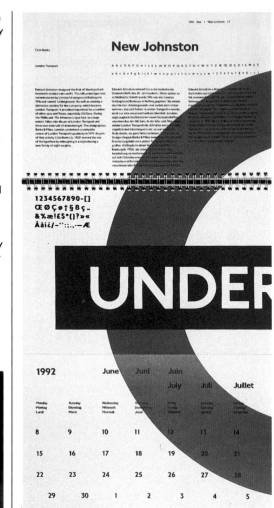

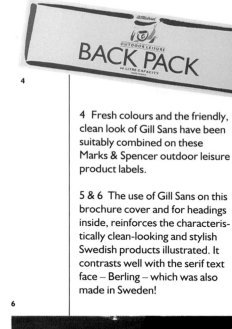

4 Fresh colours and the friendly, clean look of Gill Sans have been suitably combined on these Marks & Spencer outdoor leisure product labels.

5 & 6 The use of Gill Sans on this brochure cover and for headings inside, reinforces the characteristically clean-looking and stylish Swedish products illustrated. It contrasts well with the serif text face – Berling – which was also made in Sweden!

170

7 ITC Officina Sans, one of a new wave of Humanist sans serifs, reinforces the modern and sporty look of *Time Magazine*'s Olympic Challenge. Notice the use of italic type to suggest movement.

8 Optima, a Humanist sans serif with the proportions of classical letterforms, is chosen to accompany the images from a classical play *Les Atrides*, on this theatre poster. The wide letterspacing and generous leading of the type reflects the lightness and gracefulness of the performance.

9 A poster design by David Quay which exclusively features his own Humanist sans serif, Foundry Sans. This is a good example of how the hierarchy of the information content is made visually apparent by variations in type size, weight and arrangement.

10 In this annual report, ITC Goudy Sans provides a background texture to the page and a contrast to the colourful images. The large x-height and short descenders are reminiscent of its namesake, Goudy Old Style.

5

2

1 Geometric sans serif faces are constructed of simple shapes, such as circles and straight lines, which can be appreciated by studying the brand name on this yoghurt carton.

2 The dramatic effect produced by an extreme change of type size is shown on this exhibition poster. The simplicity of the Futura capital 'A' echoes the modern art on show at the exhibition.

3 This page of a Sports Council manual, designed by the Perfect Design Company, uses the bold, geometric letter shapes of Futura to harmonize with the simple line illustrations.

4 The letterspaced Futura produces a simple but stylish logo. The type style and the use of all lower case letters gives it more than a hint of modernism.

6

3

4

5 The overprinted layers of computer-originated Futura are a typographical parody of Quin's repetitive music.

6 The dancing lines of Futura represent the sounds produced by wind instruments.

7 The impact of Geometric sans serif types during the 1920s and 1930s is shown on this hotel luggage label from this period.

8 The clean, clinical look of the white Futura type on this packaging is chosen to reflect the dental product inside. The clinical effect is enhanced by the use of fresh colours.

9 The impact of the heavier weights of Geometric sans serifs can be appreciated from the vertical Futura type below. Notice also that the ascenders of the 't' and the 'k' have been cut off as a subtle visual reference to the Russian alphabet.

10 An airy and understated use of Futura for an identity and brochure for the Espree Health and Fitness Club. The controlled typography complements the photographic images on the facing page.

ICA documents 8
novostroika
new structures
culture in the
soviet union today

Martin Walker	Vladimir Sorokin
Andrew Wilson	Igor Pomerantsev
Victoria Ivleva	Andrei Sinyavsky
John Berger	Jamey Gambrell
Zinovy Zinik	Erik Bulatov
Frank Williams	Ilya Kabakov
Mikhail Epshtein	Komar & Melamid
Sally Laird	Igor Kopistiansky
Almanakh	Ilona Medvedeva
Dmitri Prigov	Simon Faibisovich
Mikhail Eisenberg	Ian Christie
Lev Rubinshtein	Alla Latinina

1 This spread from the New Europe *Impact* magazine is set in Helvetica, the archetypical Euro-typeface of the 1960s and 1970s, to give the design the appropriate mood.

2 A page from a proposed inter-national calendar for Linotype which uses figures only. The large number 12 (representing December) illustrates how the softer curves and lines of Helvetica are more sympathetic than the brutal, squarish shapes of the early 20th-century Grotesque sans serifs.

3 A deconstructivist-style poster design for an art exhibition held "in the sticks", which shows how the flexible sans serif design (represented here by Helvetica) lends itself to a multiplicity of different variations and effects.

4 This design for Polygram's annual report shows how the mood and emphasis of even large bold type can be changed com-pletely when it is printed in soft or sophisticated colours such as the turquoise used here.

GLAS**GOW**

CITY FOR TODAY

5

6

*The*Guardian

7

ICL　　　　　　*fᵢ***IT**

The Transworld Competition
La concurrence sans frontières
Competición mundial
Weltweiter Wettbewerb
page 3-5

Focus on France
Gros plan sur le secteur
bancaire français
Enfocando a Francia
Schwerpunkt Frankreich
page 7-8

3
ISSUE NUMBER

The FINANCIAL INSTITUTIONS' IT *Company*

8

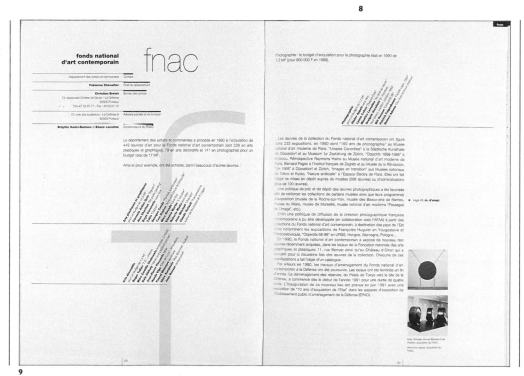

9

5 A simple but clever logotype for the city of Glasgow, with a double meaning. By emboldening "go", the positive, dynamic aspects of the city have been emphasized, and the choice of Helvetica promotes a modern, clean image.

6 The vertical Helvetica type has been distorted in a considered (and successful) way in order to make it more compatible with the narrow portrait format of the Lauré Directory. However, be wary of indiscriminate distortion and modification of type; the results are often visually poor.

7 The masthead of *The Guardian* newspaper, redesigned in 1988, demonstrates the effect of mixing a Grotesque sans serif type (Helvetica Black) with a serif face (Garamond Italic).

8 Although the designer of this cover for ICL's international in-house magazine was restricted to the exclusive use of their corporate typeface Helvetica, the design demonstrates how some interesting and lively effects can still be achieved solely through variations in type size, weight, colour and distortion.

9 The use of all lower case letters for headings and the small Helvetica type harks back to the Swiss typographic style that was prevalent in the 1960s. The design shows how sufficient tonal and textural differences can be produced through the use of the different weights available within a type family such as Helvetica, rules and tints when only one-colour printing is available.

1 In the Brand Development Business logo, a capital 'D' and a question mark are cleverly combined to form the capital 'B'. The sans serif face Adsans gives a contemporary feel, while the asymmetrical centred layout suggests reliability and creativity.

3 This folder is a good example of how interesting effects can be created by mixing two different sans serif types, provided they are (as here) sufficiently different in either style, weight, width or a combination of these factors. Equally, these effects can be achieved by using variations within the same type family.

4 & 5 Two posters in which the simple letter structure of Univers and its positioning on a grey panel make it easily legible against the lively background imagery.

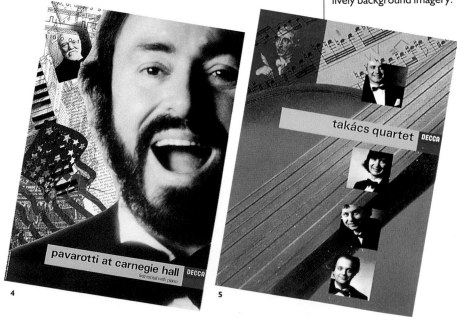

2 Descriptive sans serif type. In the top poster, the wavy line of Univers represents the Seville-Madrid high speed train. Below, the different coloured words represent the train's carriages and the decreasing size of the rows of type suggest their movement away into the distance. The modern, clean lines of Univers complement the hi-tech engineering of the train.

6

7

9

9 In this report and accounts, News Gothic, a Grotesque sans serif, echoes the modern style of the architecture. The unity of the design is helped by letterspacing the heading onto the photograph.

10 The large Franklin Gothic type used here clearly identifies the title and provides continuity through changes in the background colour of each leaflet.

10

6 The punchy, modified sans serif type and its diagonal alignment were chosen to catch the eye. The ascenders of the 'k', 't' and 'h' have been shortened to produce a unique brand identity.

7 On this vodka label, an extra bold customized sans serif type has been drawn, and the letters generously letterspaced to give a strong, clean look.

8 This book jacket design shows the effect of mixing a sans serif type (Impact) with a serif face (Garamond), and how the contrasts can be multiplied through changes in weight and axis.

8

Display

This section only scratches the surface of the enormous range of display types that are available today such as fat face, thin face, decorative, ornamental, inline, outline, shaded, 3-D, brush script, pen script, expanded, condensed, and many others. Some typefaces included here may also be suitable for limited amounts of text setting for advertisements, brochures and for other forms of jobbing and typographic work. But the primary role of these types is for display purposes – they have been designed to be noticed. Display types can convey a gamut of messages and emotions. They can be aggressive or quiet, modern or traditional, happy or sad, high tech or low tech, hard or soft, young or old and so on.

For typographers, the choice and quality of the display types available has never been better. The relatively low cost of producing new fonts or reviving old ones for headline phototypesetting machines, digital typesetters, desktop publishing systems or for dry transfer lettering has led to an explosion of display types.

This section has been divided into five categories. The first category includes types which imitate styles of handwriting – blackletter (or gothic minuscule), uncial, pen and brush script and cursive handwriting (on which italic types are based). The other four categories are serif and slab serif, sans serif, hybrid serif and, finally, decorative and ornamental. All these typefaces have been designed for use in the many forms of commercial jobbing and typographic work that have mushroomed since the Industrial Revolution – packaging, brochures, posters, leaflets, advertisements and such like.

Types based on handwriting

The first movable types of Gutenberg of the mid-15th century were based on the blackletter style of handwriting that was popular in Germany at the time. Blackletter type remained in general use in Germany until the early 1940s when the Nazis banned its use. Apart from being a popular choice for newspaper mastheads, formal certificates and so on, blackletter types are rarely used today.

Rudolf Koch, the German type designer, produced many blackletter types and his Wilhelm Klingspor Schrift (1924–26), a pointed and compressed design, was one of his finest. Cloister Black (1904), sometimes called Old English, was cut by Morris Benton at American Typefounders and is a revival of a style of black letter used in England during the 16th century.

Uncials and half uncials were in widespread use as book scripts (especially in Ireland) between the 4th and 9th centuries. Victor Hammer, a German type designer and calligrapher, was responsible for a revival of these letterforms in the first half of the 20th century. American Uncial (1945), his most well-known type, was issued by Stempel in 1952. Uncials are hardly ever seen nowadays except perhaps as nostalgia faces to advertise Irish crafts, for example.

Most italic types derive from the early 16th-century chancery cursive style of handwriting. Ludovico Arrighi's italic of 1523 (based on this style) was the model for three influential italic fonts produced to accompany roman types – Arrighi Italic (1929), designed by Frederic Warde for Centaur, Blado Italic (1923) for Poliphilus, and Cancelleresca Bastarda (1934), designed by Jan Van Krimpen for Romulus.

From the mid-17th century, new commercial writing styles emerged which clearly showed the influence of pen-crafted calligraphy (rather than the popular style of handwriting). One such style, called Ronde, was upright and light, an example of which is Matthew Carter's Gando Ronde (1974). Carter also designed Snell Roundhand (1966), a flowing script in the English Roundhand or copperplate style of about 1600. Shelley Allegro Script is another type in this mould which has particularly extravagant flourishes. Brush Script (1942) and Roger Excoffon's Mistral (1953) are early brush scripts which imitate the ordinary flowing handwriting of today.

A wide variety of scripts is important for a typographer's display type palette. A traditional pen-formed flowing script may be suitable for a wedding invitation, while a modern brush style may be appropriate for sale cards in shops.

Serif and slab serif

This category contains a small selection of serif and slab serif types, some of which were designed for display use only, while others are also suitable for limited amounts of

The first group of display types, which appeared in the early 19th century, were fattened-up Modern types called fat faces. In this capital 'D' (above), the stems have been considerably thickened but the thin strokes and serifs have not. The strong vertical stress and the reduction in the size of the counter makes it almost illegible.

The Art Nouveau movement of the turn of the 20th century influenced typographical design, as shown in this decorative capital 'D' (above). The sweeping curves and elaborate floral ornament are characteristic features of the style.

Black letter

Uncials

Special italics

Scripts

Serif and slab serif

Sans serif

Hybrid serif

Decorative

Ornamental

text setting. Goudy Handtooled (1923), an inline type by Morris Benton, and Fry's Baskerville (1910) are special variations of well-known roman types. Such faces make elegant titling fonts. Koch Antiqua (1922), by Rudolf Koch, and Bernhard Modern (1937) by Lucien Bernhard, are stylish and highly individual faces which make good period or nostalgia types, as does Windsor (1905), a product of the Art Nouveau style. Pabst Extra Bold (1902), designed by Frederic Goudy, is an example of a fat face while ITC L&C Stymie Hairline (1970) is a thin face.

Sans serif

The typefaces in this category demonstrate the flexibility and impact of sans serifs as display types. Gill Sans, unrecognizable in its "pumped-up" ultra bold version, Gill Kayo (1928–30), Bank Gothic (1930), a square sans serif, and Compacta Bold (1963) by Fred Lambert, are all letterforms which show the dramatic typographic effects and textures that can be achieved through the use of extreme variations in the width and weight of sans serif types. ITC Benguiat Gothic (1979), ITC Bauhaus (1975) and ITC Ronda also illustrate the plastic, maleable qualities of the sans serif design.

Hybrid serif

These typefaces either have glyphic serifs (stone-cut), wedge-shaped serifs or flared terminals to the letterstrokes. They look neither serif nor sans serif in origin but have some characteristics of each, and are known as hybrid serif faces. Albertus (1937), designed by Berthold Wolpe, and Octavian (1961), by David Kindersley and Will Carter, are elegant display types which have an authoritative, stone-carved quality. Icone (1980) by Adrian Frutiger, and ITC Novarese (1980), by Aldo Novarese, are examples of the recent wave of typefaces with small wedge-shaped serifs.

Decorative and ornamental

The working life of a decorative type is normally short. However, this is not always true. The typefaces included here are all classics that have found their own markets – Playbill (1938) has become synonymous with spaghetti westerns and "wanted" posters, Broadway (1929) represents theatreland and the 1920s in general, and Sapphire (1952) is an archetypal floriated type that has graced numerous book covers. Although many decorative and ornamental types do not aspire to the highest typographical design standards, their novelty alone can create atmosphere and attract attention. They are an important weapon in the typographic armoury.

During the late 1980s, the Apple Macintosh has been responsible for a flood of distorted letterforms with poor legibility. This highly condensed 'D' (above), which has a hint of the 1930s Art Moderne style about it, is a good example of this type genre.

American Uncial 1945	abcdefghijklmnopqrstuvwxyz &!?(),:;'
Arrighi italics c1925	ABCDEFGHIJKLMNOPQRSTUVWXYZ&!?(),.:;""
Blado italics 1923	ABCDEFGHIJKLMNOPQRSTUVWXYZ &!?(),:;""
Brush Script 1942	ABCDEFGHIJKLMNOPQRSTUVWXYZ &!?(),:;""
Cancelleresca Bastarda 1931	ABCDEFGHIJKLMNOPQRSTUVWXYZ & !?(),:;""
Cloister black 1904	ABCDEFGHIJKLMNOPQRSTUVWXYZ &!?[],:;""
Gando Ronde 1974	ABCDEFGHIJKLMNOPQRSTUVWXYZ &!?(),:;""
Goudy Text 1928	ABCDEFGHIJKLMNOPQRSTUVWXYZ &!?(),:;""
Klang 1955	ABCDEFGHIJKLMNOPQRSTUVWXYZ &!?(),:;""
Libra 1938	abcdefghijklmnopqrstuvwxyz &!?(),:;""
Mistral 1953	ABCDEFGHIJKLMNOPQRSTUVWXYZ &!?(),:;""
Shelley Allegro Script	ABCDEFGHIJKLMNOPQRSTUVWXYZ &!?(),.:;""
Snell Roundhand Script 1966	ABCDEFGHIJKLMNOPQRSTUVWXYZ &!?(),.:;""
Wilhelm Klingspor Gotisch 1924-26	ABCDEFGHIJKLMNOPQRSTUVWXYZ &!?(),:;""
ITC Zapf Chancery 1974	ABCDEFGHIJKLMNOPQRSTUVWXYZ &!?(),:;""

1234567890 £$

abcdefghijklmnopqrstuvwxyz1234567890 £$¢ f

abcdefghijklmnopqrstuvwxyz 1234567890 £$

abcdefghijklmnopqrstuvwxyz 1234567890 £$¢f

abcdefghijklmnopqrstuvwxyz 1234567890 $

abcdefghijklmnopqrstuvwxyz 1234567890 £$¢ f

abcdefghijklmnopqrstuvwxyz 1234567890 £$¢f

abcdefghijklmnopqrstuvwxyz 1234567890

abcdefghijklmnopqrstuvwxyz 1234567890 £ $

1234567890 £$¢f

abcdefghijklmnopqrstuvwxyz 1234567890 £$¢f

abcdefghijklmnopqrstuvwxyz 1234567890 £$¢f

abcdefghijklmnopqrstuvwxyz 1234567890 £$¢ f

abcdefghijklmnopqrstuvwxyz 1234567890 £$¢f

abcdefghijklmnopqrstuvwxyz 1234567890 £$¢f

Belwe 1913	ABCDEFGHIJKLMNOPQRSTUVWXYZ &!?(),.:;""
Bernhard Modern 1937	ABCDEFGHIJKLMNOPQRSTUVWXYZ &!?(),.:;""
Caslon Antique c1890	ABCDEFGHIJKLMNOPQRSTUVWXYZ &!?(),.:;""
Fry's Baskerville 1910	ABCDEFGHIJKLMNOPQRSTUVWXYZ &!?(),.:;""
Goudy Handtooled 1923	ABCDEFGHIJKLMNOPQRSTUVWXYZ &!?(),.:;""
Karnak Black 1931	**ABCDEFGHIJKLMNOPQRSTUVWXYZ &!?(),.:;""**
Koch Antiqua 1922	ABCDEFGHIJKLMNOPQRSTUVWXYZ &!?(),.:;""
Nicholas Cochin 1929	ABCDEFGHIJKLMNOPQRSTUVWXYZ &!?(),.:;""
Pabst Extra Bold (or Cooper Black) 1902	**ABCDEFGHIJKLMNOPQRSTUVWXYZ &!?(),.:;""**
Poster Bodoni Black 1929	**ABCDEFGHIJKLMNOPQRSTUVWXYZ &!?(),.:;"**
Promotor 1960	ABCDEFGHIJKLMNOPQRSTUVWXYZ &!?(),.
ITC Souvenir	ABCDEFGHIJKLMNOPQRSTUVWXYZ &!?(),.:;""
ITC Stymie Hairline	ABCDEFGHIJKLMNOPQRSTUVWXYZ &!?(),.:;""
ITC Tiffany	ABCDEFGHIJKLMNOPQRSTUVWXYZ &!?(),.:;""
Windsor 1960	**ABCDEFGHIJKLMNOPQRSTUVWXYZ &!?(),.:;""**

abcdefghijklmnopqrstuvwxyz 1234567890 £$¢ƒ

Belwe
1913

abcdefghijklmnopqrstuvwxyz 1234567890 £$¢ƒ

Bernhard Modern
1937

abcdefghijklmnopqrstuvwxyz 1234567890 £$¢ƒ

Caslon Antique
c1890

abcdefghijklmnopqrstuvwxyz 1234567890 £$¢ƒ

Fry's Baskerville
1910

abcdefghijklmnopqrstuvwxyz 1234567890 £$¢ƒ

Goudy Handtooled
1923

abcdefghijklmnopqrstuvwxyz 1234567890 £$¢ƒ

Karnak Black
1931

abcdefghijklmnopqrstuvwxyz 1234567890 £$¢ƒ

Koch Antiqua
1922

abcdefghijklmnopqrstuvwxyz 1234567890 £$¢ƒ

Nicholas Cochin
1929

abcdefghijklmnopqrstuvwxyz 1234567890 £$¢ƒ

Pabst Extra Bold
(or Cooper Black) 1902

abcdefghijklmnopqrstuvwxyz1234567890£$¢ƒ

Poster Bodoni Black
1929

abcdefghijklmnopqrstuvwxyz 1234567890 £$¢ƒ

Promotor
1960

abcdefghijklmnopqrstuvwxyz 1234567890 £$¢ƒ

ITC Souvenir

abcdefghijklmnopqrstuvwxyz 1234567890 £$¢ƒ

ITC Stymie Hairline

abcdefghijklmnopqrstuvwxyz 1234567890 £$¢ƒ

ITC Tiffany

abcdefghijklmnopqrstuvwxyz 1234567890 £$¢ƒ

Windsor
1960

Bank Gothic
1930

ABCDEFGHIJKLMNOPQRSTUVWXYZ &!?(),:;" "

ITC Bauhaus

ABCDEFGHIJKLMNOPQRSTUVWXYZ &!?(),:;""

ITC Benguiat Gothic

ABCDEFGHIJKLMNOPQRSTUVWXYZ &!?(),:;" "

Compacta Bold
1963

ABCDEFGHIJKLMNOPQRSTUVWXYZ &!?[],:;" "

Compacta Bold Outline 1965

ABCDEFGHIJKLMNOPQRSTUVWXYZ &!?(),:;" "

Folio Extra Bold
1960

ABCDEFGHIJKLMNOPQRSTUVWXYZ &!?[],:;" "

Gill Kayo
c1928-30

ABCDEFGHIJKLMNOPQRSTUVWXYZ &!?(),:;" "

ITC Ronda

ABCDEFGHIJKLMNOPQRSTUVWXYZ &!?(),:;" "

Souvenir Gothic

ABCDEFGHIJKLMNOPQRSTUVWXYZ &!?(),:;""

Tempo Heavy Condensed 1930

ABCDEFGHIJKLMNOPQRSTUVWXYZ &!?(),:;""

Albertus
1937

ABCDEFGHIJKLMNOPQRSTUVWXYZ &!?(),.:;""

Americana
1965

ABCDEFGHIJKLMNOPQRSTUVWXYZ &!?(),.:;" "

ITC Benguiat

ABCDEFGHIJKLMNOPQRSTUVWXYZ &!?(),:;" "

Copperplate Gothic
(31-BC) 1901

ABCDEFGHIJKLMNOPQRSTUVWXYZ &!?(),:;" "

ITC Friz Quadrata

ABCDEFGHIJKLMNOPQRSTUVWXYZ &!?(),.:;" "

ABCDEFGHIJKLMNOPQRSTUVWXYZ 1234567890 £$¢ƒ

Bank Gothic
1930

abcdefghijklmnopqrstuvwxyz 1234567890 £$¢ƒ

ITC Bauhaus

abcdefghijklmnopqrstuvwxyz 1234567890 £$¢ƒ

ITC Benguiat Gothic

abcdefghijklmnopqrstuvwxyz 1234567890 £$¢ƒ

Compacta Bold
1963

1234567890 £$

Compacta Bold
Outline 1965

abcdefghijklmnopqrstuvwxyz 1234567890 £$¢ƒ

Folio Extra Bold
1960

abcdefghijklmnopqrstuvwxyz 1234567890 £$¢ƒ

Gill Kayo
c1928-30

abcdefghijklmnopqrstuvwxyz 1234567890 £$¢ƒ

ITC Ronda

abcdefghijklmnopqrstuvwxyz 1234567890

Souvenir Gothic

abcdefghijklmnopqrstuvwxyz 1234567890 £$¢ƒ

Tempo Heavy
Condensed 1930

abcdefghijklmnopqrstuvwxyz 1234567890 £$¢ƒ

Albertus
1937

abcdefghijklmnopqrstuvwxyz 1234567890 £$¢ƒ

Americana
1965

abcdefghijklmnopqrstuvwxyz 1234567890 £$¢ƒ

ITC Benguiat

ABCDEFGHIJKLMNOPQRSTUVWXYZ 1234567890 £$¢ƒ

Copperplate Gothic
(31-BC) 1901

abcdefghijklmnopqrstuvwxyz 1234567890 £$¢ƒ

ITC Friz Quadrata

Icone
1980
ABCDEFGHIJKLMNOPQRSTUVWXYZ &!?(),.:;""''

ITC Newtext
ABCDEFGHIJKLMNOPQRSTUVWXYZ &!?(),.:;" "

ITC Novarese
1980
ABCDEFGHIJKLMNOPQRSTUVWXYZ &!?(),.:;""''

Octavian
(Monotype) 1961
ABCDEFGHIJKLMNOPQRSTUVWXYZ &!?(),.:;"" ''

Spartan
(Size 1) (Monotype) c1923
ABCDEFGHIJKLMNOPQRSTUVWXYZ &!?(),.:;" "

Broadway
1929
ABCDEFGHIJKLMNOPQRSTUVWXYZ &!?(),.:;"" ""

Calypso
1958
ABCDEFGHIJKLMNOPQRSTUVWXYZ &!?(),.:;" "

Futura Black
1929
ABCDEFGHIJKLMNOPQRSTUVWXYZ &!?(),.:;"" ""

Gill Cameo
ABCDEFGHIJKLMNOPQRSTUVWXYZ &!?()::!:""""

Mole Foliate
1960
ABCDEFGHIJKLMNOPQRSTUVWXYZ& ,.;!?'-

Neon
1935
ABCDEFGHIJKLMNOPQRSTUVWXYZ &!?(),.;;" "

Neuland
1923
ABCDEFGHIJKLMNOPQRSTUVWXYZ &!?(),.:;""

Playbill
1938
ABCDEFGHIJKLMNOPQRSTUVWXYZ &!?(),.:;" "

Prisma
1931
ABCDEFGHIJKLMNOPQRSTUVWXYZ &!?(),.:;"" ""

Sapphire
1952
ABCDEFGHIJKLMNOPQRSTUVXYZ &!?[],.:;""

abcdefghijklmnopqrstuvwxyz 1234567890 £$¢*f*

Icone
1980

abcdefghijklmnopqrstuvwxyz 1234567890 £$¢*f*

ITC Newtext

abcdefghijklmnopqrstuvwxyz 1234567890 £$¢*f*

ITC Novarese
1980

abcdefghijklmnopqrstuvwxyz 1234567890 £$

Octavian
(Monotype) 1961

1234567890 £$

Spartan
(Size 1) (Monotype) c1923

abcdefghijklmnopqrstuvwxyz1234567890 £$¢*f*

Broadway
1929

1234567890 £$¢

Calypso
1958

abcdefghijklmnopqrstuvwxyz 1234567890 £$¢*f*

Futura Black
1929

1234567890 £$

Gill Cameo

1234567890

Mole Foliate
1960

1234567890 £$¢

Neon
1935

1234567890 £$'

Neuland
1923

abcdefghijklmnopqrstuvwxyz 1234567890 £$¢*f*

Playbill
1938

1234567890 £$¢

Prisma
1931

1234567890 £$

Sapphire
1952

1 The choice of a blackletter 'C' on this catalogue cover reflects the style of the collection on show at the museum. The sheer weight and pronounced vertical stress of blackletter can be appreciated here.

2 On this packaging for condensed milk, the blackletter is used to give an established, quality feel to the brand name.

3 The elegant calligraphic script, complete with flourishes, provides a personal, bookish theme that complements the literary passages quoted in the text of this corporate brochure. A modern feel is injected through the choice of colours for the type.

1

2

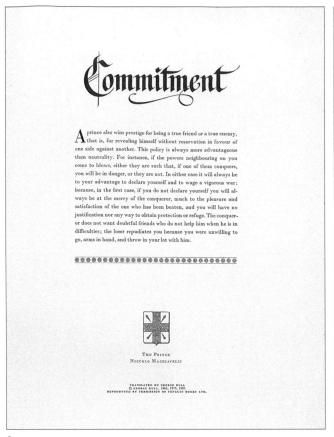

3

4

4 On this plaque, cut by Lida Lopes Cardozo, the beauty and delicacy of calligraphic letterforms is skilfully recreated in slate. Notice the sharp, clean stroke endings and bevel made by the chisel.

5 The elegance and grandeur of a calligraphic script gives an appropriate upmarket look to this prestigious sales brochure. The effect is enriched by the classical centred layout of the title page, the initial letter and the decorative border.

5

6

Penguin Books

6 A traditional note is evoked by the use of Yale Script, in the style of a flowing roundhand pen script that was popular in England around 1600, for this literature for the Canary Wharf Chelsea Flower Show. The asymmetric layout of the folder gives a contemporary feel to the design.

7 The combination of a calligraphic and roman italic font provides an appropriate tone to this colophon on the title page of *A Book of Scripts*, designed by Jan Tschichold.

8 A compressed calligraphic script has been chosen to high-

light the name of this classical musician. The use of Bodoni to accompany it adds an Italian flavour.

9 The flowing modern pen script used on this poster for a retrospective of the work of Bernard Villiers brings a French feel. The

contrasting sans serif (Syntax) suggests modernity.

10 The contrast in the width of the letterstrokes of Poster Bodoni, a fat face from the 1920s, contrasts with the ITC Galliard on the title page of a book by André Breton.

COMMUNICATING

Veßels

ANDRÉ BRETON

1 In this book jacket design by Richard Eckersley, "Glas" is set in Glaser Stencil, which has a broken line effect that is mirrored in the style of the illustration.

2 A striking, colourful design for a publishing company, Visitor Publications Limited, where the large lower case 'v' of ITC Esprit Black Italic has been chosen deliberately for its abstract, decorative qualities. The Gill Extra Bold 'v' draws the eye to the range of services offered.

3 The handrawn quality of the condensed sans serif type on a poster promoting a fund raising event has an appropriate 1960s feel. The strong vertical emphasis of the type produces a striking, powerful image.

1

2

3

4

4 This poster celebrates a breakthrough in heart medicine. The brush illustration of the heart, which represents the restoration of good health, matches the type of the distorted wedge serif type.

5 Albertus, an elegant Monotype face designed by Berthold Wolpe in the 1930s was used for this logo for the Countryside Commission.

7 Caslon Old Face, a classic roman titling typeface, and the centred layout are suitably combined with the roman figures in the illustration on this brochure cover. The dynamic use of white space gives a modern feel.

5

6 Lloyd Northover's use of ITC Veljovic, a serif face with distinctive, pointed wedge-shaped serifs, brings a sense of movement to this identity for a transport services company.

8 Chevalier, a serif display face, brings a restrained, formal tone to this identity for a financial services company. The laid paper and natural colours build an established, stable image.

9 The ornate typography on this label is typically Victorian. The type has been modified through the addition of an outline, drop-shadow and wavy pattern.

10 A 1940s label for Southern Comfort uses a number of types – a decorative serif, a copper-plate script and a sans serif. The combination of typography, flourishes and illustration produces a rich, traditional effect.

11 The fussiness of this design suggests the style of the Victorian era. The typography and colours have a charm that is in keeping with the product.

191

Type

Typ

Measuring type

Type

Structuring type

Wo

with

Type

Specifying type

Type

Enlivening text

e

Type

rking

type

Desktop typography

Type

Type

Representing type

Tpye

Display typography

Type and colour

Type

Working with type

Before a musical tune can be played, it is necessary to learn the notes. Typography is no different. The basic typographical components, rules and conventions must first be understood before they can be put into effective practice. But neither the ability to produce a successful piece of typographic design nor the writing of a symphony can be accomplished in a day – it requires plenty of "hands-on" experience and dedication.

The first part of this section is an introduction to the basic terminology and components of type. There then follows a guide to structuring type, copyfitting, choosing text typefaces, legibility, specifying type and marking up proofs, enlivening text, display typography and colour. It concludes with a brief overview of desktop typography.

Although it is not within the scope of this book to include an appraisal of typesetting systems, print production, printing processes and paper, it is important to gain knowledge of all these aspects because they can be influential in the selection of a typeface and contribute to the success or failure of a design. It is also essential to learn how to be proficient with the basic typographical "tool kit" – type scale, depth scale, copyfitting tables, calculator, type specimen books and so on.

The language of type

Many typographical terms have their origins in the days when type was a three-dimensional rectangular piece of metal of a uniform height of 0.918 of an inch. The letter was cut in relief on the top of the metal body which was inked and impressed on to a piece of paper by means of a platen or impression cylinder. Today, type is produced photographically or electronically but much of the traditional metal type terminology remains.

Typographical language is particularly colourful. Ear, tail, bowl, ascender, descender, eye, fillet, beak, x-height, cap height, serif and spine are some of the names of parts of a letter. All these terms, together with the parts of a font (the name for one size of a type style which comprises a set of capitals, small capitals, lower case letters, figures, fractions and punctuation) and the different variations in weight, width and italic of the same type style (collectively called a type family) are illustrated below.

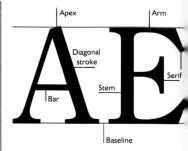

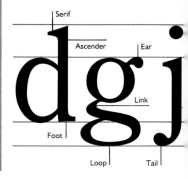

Capitals | Lower case

ABCDEFGHIJKLMNOPQRSTUVWXYZ& abcdefg

hijklmnopqrstuvwxyz

Small caps | Ampersand

ABCDEFGHIJKLMNOPQRSTUVWXYZ&

Aligning figures
1234567890

Non-aligning figures
1234567890

Superior figures (superscript)
1234567890

Inferior figures (subscript)
1234567890

Fractions
⅓ ¼ ½ ⅔ ¾

Dipthongs
Æ Œ æ œ

Ligatures
ffl ffi ff fl fi

Mathematical signs
+ − ÷ × = % °

Punctuation
. : , ; ! ? - – — " " ' () [] /

Accented and international characters
Å Á À Â Ä Ñ Ç å á à â ä ñ ç ø ß « » ¡ ¿ →

Reference marks
SM TM ℗ ® ©

Monetary symbols
□ ■ • ★ † ‡ § $ ¢ £

Measuring type

For more than 250 years after the invention of movable type by Gutenberg, each typefoundry produced type to its own specifications and sizes which meant that type was not interchangeable between one foundry and another. But in response to this chaotic situation, a French type-cutter called Pierre Simon Fournier, formulated the point system in 1737. This was the first standardized method of typographic measurement. Although the system was modified in about 1785 by another Frenchman, Firmin Didot, it remains the method of measuring type in mainland Europe. It is now referred to as the European Didot point system.

Another slightly different point system is also used today which was adopted by Britain and the United States in around 1870. This system still uses the point as its basic unit of measurement, but it is fractionally smaller – 0.0138 of an inch compared to the European Didot point which measures 0.0148 of an inch. The increasing use of the metric system in many parts of the world as the standard system of measurement has resulted in some typographic measurements, such as the depth of a column of type, often being expressed in millimetres while type sizes and other dimensions are generally specified in points. Although two measurement systems used side-by-side may be seen to be complex, in practice they work well together. There can be little doubt, however, that the point system will eventually be swept away by the relentless tide of metrication.

Points and picas

Two of the basic increments of typographic measurement are the point and the pica (which is 12 points). A third measurement, called a unit, which relates to the width of each letter, is discussed later. There are approximately 72 points, or six picas, to one inch. In the European Didot system, 12 points are called a cicero in France and Germany, a riga tipografica (or riga) in Italy, and an augustijn (or aug) in the Netherlands. As a guideline, there are about 14 European Didot points to 15 Anglo-American points. The pica is often used as a "shorthand" measurement to express larger measurements such as the length of a line of type which is called the measure. For example, a typical measure is specified as 18 picas and not 216 points. It is essential to quickly be able to gauge visually the basic typographical measurements. Try drawing freehand the width of a point, a pica or six picas without the use of a type scale or ruler.

Type size

The depth of type is also measured in points and is called the type or point size (in metal type this also is referred to as the body size). Hence, type is specified, for example, as 8 point or 10 point respectively. Before the introduction

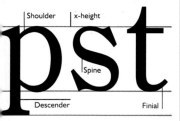

Left: The font
A font is a set of characters of one size of a typeface usually comprising capitals, lower case, small capitals, figures, fractions, ligatures, mathematical signs, punctuation and reference marks.

Right: The type family
The range of weights, italic and widths (and sometimes swash characters) available in one typeface is known as a type family.

Light
Light italic
Roman
Italic
Bold
Bold italic

Black
Black italic
Extra Black
Condensed
Ultra Condensed
Extended

Measurement comparisons

Anglo-American points	Didot points	mm
1	0.935	0.351
5	4.675	1.755
6	5.61	2.106
7	6.545	2.457
8	7.48	2.808
9	8.415	3.159
10	9.35	3.51
11	10.285	3.861
12	11.22	4.212

of the point system, each type size had an individual name – for example, 8 point was called Brevier and 10 point was Long Primer.

It is important to understand from the outset that the type size cannot be determined by measuring the depth of the typeset or printed letter. By necessity, the depth of each letter is less than the specified type size so that the descenders of one line do not touch the ascenders of the line below. The only method of determining the correct type size is to measure the distance in points between the baseline of one line of type (this is the horizontal line on which the base of the capitals and lower case letters sit) and that of the next line by using a depth scale. Provided that no extra vertical space (called leading) has been inserted between the lines this measurement will confirm the type size.

Type is usually available in 1½ point increments. As a general rule, type sizes below 12 point are suitable for text setting (although for continuous text, when optimum legibility is essential, choose sizes between 8 and 11 point), and use 12 point and above for headings and other display purposes. Text typesetting systems can normally generate type up to 96 points but sometimes up to 300 points or more. Larger sizes of type can also be set on a phototypesetter called a headline machine. Some systems specify type size in terms of the height in millimetres of the capital letters. Measurement by "cap height" is more usual for headline or display setting. A further system of specifying type sizes, now rarely used, is by key sizes, which (units larger than points) also relate to the height of the capital letters.

Leading

If no additional vertical space is inserted between lines of type, the setting is said to be set solid. Interline spacing is called leading and the term derives from the strips of lead which were placed between the lines of metal type. Line feed is an alternative term for leading and is sometimes specified in millimetres. As with type sizes, leading can be increased or decreased in 1½ point increments.

The amount of leading required depends upon the type size, the x-height of the typeface, the line length (measure) and the length of the ascenders and descenders. Too little or too much leading impairs legibility (see page 204). In situations where legibility is not of paramount importance, generous leading can create interesting textural effects. The normal way to express a type size and its leading is, for example, 8/9pt – in other words, 8 point type with 1 point leading.

Using typescales

To measure the amount of vertical typographical space occupied by typeset copy, or to work out the number of lines of type that will fit into a particular depth, use a depth scale (B) which usually has calibrations (that should be lined up with the baseline of the type) for type sizes ranging from 6 to 14 points. A type scale (C) is best for measuring horizontal space, and has calibrations for 8, 10 and 12 points (picas) as well as a millimetre or inch scale. A clear plastic template (A) is useful for overlaying onto type to check the type size or cap height.

Measure

The measure is the line length and it is normally specified in picas, but sometimes in millimetres. To decide the correct measure, it is essential to take account of the type size and the amount of leading between the lines. This is a critical tri-partite relationship which, if out of balance, greatly affects legibility. For continuous text sizes (8 to 11 point), a measure containing between 60 and 65 characters is required for optimum legibility.

Type measure

A typesetter's composing "stick" is used for handsetting metal type. The distance to which the stick is set is the type measure, and the strips of lead inserted between the lines is known as the leading.

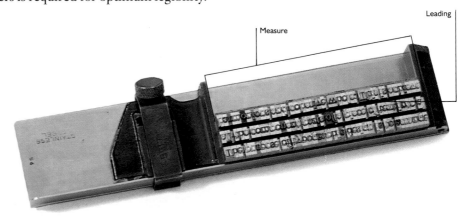

Set, units and ems

The width of type is called the set width (or set) and the set of each letter is measured in units which are tiny, equal, vertical measurements. The number of units per letter varies, according to the letter's overall width. Furthermore, the size of a unit is governed by the em which is the square of the type size. For example, the em of 10-point type is 10 points. The maximum number of units to the em varies between typesetting systems – 18, 32, 34, 64 or 96 units to the em are common configurations. On a basic 18-unit system, a capital 'M' (the widest letter and the derivation of the term "em") has 18 units, lower case 'o', 10 units and a lower case 'i' 4 units. Similarly, the unit value fluctuates from one typeface to another. For example, a letter in a condensed typeface has a smaller number of units than the corresponding letter in an expanded typeface.

The term "em" is sometimes mistakenly used to specify a measurement of 12 points but this should be called a 12-point em or pica em. Paragraph indents are often specified in ems.

Wordspacing and letterspacing

Typesetting systems that have the highest number of units to the em offer the greatest degree of control over word and letterspacing. On many phototypesetting and digital typesetting systems, the number of units of space between words is infinitely variable and these are usually specified in plus or minus units of space or in more general terms such as normal, loose or tight. The smallest possible increment of space is a ½ unit. As a rule, the optimum amount of wordspacing is equivalent to about the width of a lower case 'r'.

The space between letters can be adjusted and specified in the same way. The unit value of a letter includes a built-in space on either side of it for inter-letter, or inter-character, spacing. Differences in letterspacing can affect the texture and colour of text and display type may need to be spaced on a letter-by-letter basis in order to achieve good, even visual spacing.

Wordspacing, letterspacing and leading are inextricably linked and unless their visual relationship is correct, a piece of text setting does not have maximum legibility. If wordspacing is visually wider than the spaces between the lines, the setting becomes fragmented and legibility impaired. Similarly, if wordspacing is too close, the words may appear to merge. Typefaces which have wide and open letterforms require more wordspacing than typefaces of a narrower design, and small type sizes need proportionally more space than larger sizes. (Other legibility factors are discussed in more detail on pages 203–205). There is no ready-made formula for determining the correct spatial relationships between words and letters – a feel for this is developed through the practical experience of working with type.

In hot metal typesetting, metal blocks or spacers, called quads, were inserted between the words. One of these quads is the em, which has already been discussed, but others are the en (half the width of an em), and thick, middle, thin and hair spaces.

Kerning

In metal typesetting, some letter combinations, such as 'Ti', 'Yi' or 'fi', have ugly wide spaces between them. In order to close up the spaces between them, these letter combinations were cast as a single piece of type, called a ligature. Alternatively, in the larger sizes of type, notches were cut in these letters so that they could interlock and fit closer together. This is called kerning (or sometimes morticed type).

However, with the arrival of the first phototypesetters in the 1950s the problems and difficulties of kerning disappeared overnight because the new machines could set letters in such a way that awkward spaces were removed. The ability to control kerning is particularly important when setting display type because it avoids having to adjust letterspacing by hand in order to achieve even visual spacing. Today, phototypesetting and digital typesetting systems are programmed to compensate automatically for these spacing problems.

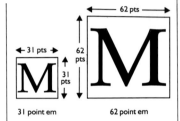

The em
The em is the square of the type size which in turn is based on the space occupied by the capital M (hence the name).

The set width
The width of type, called the set width, is measured in vertical slices called units, but the number of units in the set em varies from one typesetting system to another (an 18-unit system is shown). Other letters have a proportionate number of units to the set em depending on their width.

WATER
Un-kerned

WATER
Kerned

To To
Un-kerned Kerned

Kerning
Kerning is the overlapping of one letter into the horizontal space of an adjoining letter in order to avoid ugly wide spaces, such as between 'WA' and 'To'.

Letterspacing
On today's digital typesetting systems, letterspacing can be finely controlled. Optimum letterspacing depends on the design of each typeface – very wide, open letters require wider letterspacing.

tight word and letterspacing

normal word and letterspacing

loose word and letterspacing

Structuring type

The purpose of typographic design is to arrange the component parts of a design into a harmonious and cohesive whole. This is achieved either through the unity of similar design elements or by a more dynamic composition of contrasting values. Before making any decisions, however, consider the answers to some questions fundamental to every typographic design project. Who is it for? What is its purpose? What is the message to be communicated? The answers should be resolved during the briefing.

The approach to structuring the copy (the words) is dictated by its nature and complexity. For example, the manuscript for a book usually has a complex structure comprising main text, different levels of headings, captions and so on, each of which need to be specified typographically. By comparison, the small amount of copy for a poster or an advertisement is relatively easy to organize. The tone and style of the copy also affects the structure – for example, is the copy promotional or informational? After the content and purpose of the copy is understood, a hierarchy of its component parts can be formulated. This should start from the most important part and descend to the least. An appropriate typographic structure can then be designed to reflect each part of the copy.

Type alignment

Described below are the basic conventional typographic structures that are commonly used.

Justified setting – In the medieval era, scribes produced manuscripts in which the handwriting on facing pages was perfectly symmetrical, and both the right and left-hand edges of the text were aligned. With the introduction of movable metal type in the 15th century, the early printers copied this custom, filling out the lines of text to the full measure by inserting even metal spaces between the words. These lines were said to be justified.

Justified setting remains popular today. It is sometimes referred to as ranged left and ranged right, or flush left and flush right setting. It is the most familiar and traditional style for setting continuous text because of its quiet, rhythmic and regular appearance. The predictability of justified setting allows the reader to focus on other design elements, such as illustrations and photographs, while the justified columns of text define and reinforce the typographic structure from page to page.

One of the disadvantages of justified setting is the wide wordspaces which can occur as part of the justifica-

Justified

The purpose of typographic design is to arrange all the component parts of a piece of text into a harmonious and cohesive whole. This is achieved either through the unity of similar design elements or by a more dynamic com-

Ranged left

The purpose of typographic design is to arrange all the component parts of a piece of text into a harmonious and cohesive whole. This is achieved either through the unity of similar design elements or by a

Ranged right

The purpose of typographic design is to arrange all the component parts of a piece of text into a harmonious and cohesive whole. This is achieved either through the unity of similar design elements or by a

Centred

The purpose of typographic design is to arrange all the component parts of a piece of text into a harmonious and cohesive whole. This is achieved either through the unity of similar design elements or by

Asymmetric

The purpose of typographic design is to arrange all the component parts of a piece of text into a harmonious and cohesive whole.

tion process. When a series of wordspaces align vertically they are said to create "rivers" of space through the text. By breaking the last word of the line with hyphenation, this spacing problem can be reduced. Justified setting is not suitable for short measures, such as for captions, because the small number of words in a line reduces the ability to control the rivers and bad spacing in general.

Unjustified setting – Until the end of the 19th century, the traditional justified and symmetrical (centred) styles of setting prevailed. But in the 1920s, the "modern" typography of the emerging European art movements and that of the Bauhaus in Germany, reflected the dynamism of the 20th-century machine age. A characteristic feature of this modern typography was a new functional method of continuous text setting, called unjustified setting, which employed a fixed wordspace and avoided the rivers prevalent in justified setting.

There are two variations of unjustified setting: ranged (or flush) left and ragged right, and ranged (or flush) right and ragged left. The former has become a standard style of text setting while the latter is limited mostly to headings and for small amounts of copy – for example, in advertising or captions. Ranged left and ragged right setting (often called unjustified for short) is commonly used for brochures, reports and many other forms of jobbing work. Its even wordspacing, texture and irregular line lengths are visually more interesting and legible, and

In this deconstructivist poster design (above), the surface is fragmented into many layers and different sections through changes in colour, panel shapes, leading, type size and rules, but still the message is legible. It is also a good example of different methods of type alignment. The main blocks of text are ranged left and ragged right except in the bottom right of the yellow area, where the type is ranged right and ragged left. In some cases, the first line of each block of text is indented, whereas the author's name and date headings are placed in an asymmetric arrangement. In the bottom left the type follows, or runs around, the shapes of the figures.

it has more impact than justified setting. However, the degree of irregularity of the line lengths needs to be carefully controlled (usually by specifying a minimum and maximum length of line) in order to avoid the ragged edge becoming an ugly shape. To help keep the lines inside the specified parameters, words can be broken with hyphenation where necessary. Unjustified is a suitable style of setting than justified for short measures and for display copy.

Centred – This static, symmetrical style pivots on a central axis and both the left- and right-hand edges are ragged and the word spacing is even. Centred typography is associated with traditional values and is popular for display work such as book covers and packaging. By alternating short and long lines, the type retains an interesting shape and, by breaking the lines in accordance with the sense of the copy, the correct emphasis is communicated.

Asymmetric setting – This term applies to an informal style of setting in which the lines of type are placed intuitively or in an unstructured fashion to create unusual and dramatic effects. The Futurist movement used this style extensively. Normally, it has even word spacing and is suitable only for display work. Generous leading is often required to help the reader locate the start of the next line. Asymmetric layout, which has a wider meaning, is discussed later.

Dividing the text

Continuous text copy should be divided logically into paragraphs which must be clearly separated from each other. The creation of paragraphs within the text is the job of the author or editor. In books, the most common and economical method of separating paragraphs is by indenting the first line of the paragraph – usually by 1 or 2 ems, although it can be more. Generally speaking, the shorter the measure, the less indentation is needed. The first line of a new section or chapter should not be indented because this spoils the strong squared-up shape made by the column of type. Indentations should also be avoided on the first line of a paragraph which occurs immediately after a cross- or paragraph heading.

Paragraphs can also be separated by inserting a line space between them. The inter-paragraph space can vary, but a half line or full line space is common. For example, if the type is 10/12pt, the inter-paragraph space would be 6 points for a half line space or 12 points for a full line space. Although this form of separation is popular for annual reports and brochures, it can make the copy look

1 em paragraph indent

The purpose of typographic design is to arrange all the component parts of a piece of text into a harmonious whole.

 This is achieved either through the unity of similar design elements or by a more dynamic composition of contrasting

Half line paragraph space

The purpose of typographic design is to arrange all the component parts of a piece of text into a harmonious whole.

This is achieved either through the unity of similar design elements or by a more dynamic composition of contrasting

1 em hanging paragraph indent

The purpose of typographic design is to arrange all the component parts of a piece of text into a harmonious whole.
This is achieved either through the unity of similar design elements or by a more dynamic composition of contrasting

fragmented when there are a large number of short paragraphs. Obviously, it is also less economical in the use of space than the indentation method. Furthermore, if a half line space is specified and there are an uneven number of paragraph spaces in a column of type, the lines of type in that column may not align horizontally with those of the adjacent column.

Another style of indentation, called a hanging indent, in which the second and subsequent lines of a paragraph are indented under the first line, is used to emphasize blocks of copy within the main text, such as tables and quotations. This typographical technique is usually reserved for reports, and should be employed sparingly.

Introductory copy – The importance of the scene-setting copy at the beginning of a chapter or at the start of a brochure can be emphasized through the use of a larger type size which should be set to a wider measure such as a double column width. Newspapers and magazines use this technique for the opening paragraphs of their lead stories.

Captions – Ideally, captions should be set in a smaller type size and to a narrower measure than the main text, and positioned next to the illustrations or diagrams to which they refer. When the captions cannot be placed in this way, group them together elsewhere on the page and add positional instructions in the caption copy, such as "top left" or "bottom right". Alternatively, allocate a number to each illustration which is then cross-referenced to the caption copy. It is important for captions to be in a sufficiently contrasting typographic style to the main text. For example, the combination of a serif text face and a sans

A double-page spread from a University of Nebraska Press book designed by Richard Eckersley entitled *Communicating Vessels* (above) in which the text is divided into "paragraphs" by means of a double 'S' colophon or symbol. This is a very subtle way of separating paragraphs, and a familiar typographical device used in literary works.

serif for captions is common. Italics or bold type are also widely used but the choice of typeface should relate to the relative importance of the caption.

Headings – The treatment of headings within a typographic design should reflect their relative importance and the degree of emphasis required. In more complex typographical projects, there will be a wide range of headings, but the relationships of brand names, sales slogans and logos or in advertisement copy may be more simple.

Type layout

It is instinctive to attempt to bring a sense of order to our lives, but if the order is too rigid we find it too inhuman and mechanical. When arranging type in a space – laying it out – the same visual judgements come in to play. Layout is influenced by the size of the "frame" – it may be an A4 page, a food label, a poster for a hoarding, and so on. The way that information is organized in a space reflects the importance of each element. The reader's eye should be attracted to each component in the correct sequential order. These relationships are the foundations of good typographical design.

Margins – The margins are the spaces around the type which help the reader to focus on the information. There are many theories concerning the construction and proportion of margins to image areas but these cannot be individually discussed in the limited space available here. However, there are some basic considerations on the specification of margins which have an effect on layout.

Margins not only provide a frame or border for the type, but they have other practical functions. The foredge margins (the outer side margins) are used for handling a book or brochure and for turning over the pages and, therefore, it is important that they should be sufficiently wide for this purpose. A traditional formula for calculating the width of margins is that the foredge and top margins should be equal, but the bottom margin must be deeper in order to avoid the type or image area looking bottom heavy. This illusion occurs because the eye tends to centre the type or image optically above the actual centre point. Classically, the gutter margins (those next to the spine) are narrower than those of the foredges.

The more unconventional margins of asymmetric layouts, discussed below, are popular for brochures and many other forms of jobbing work. In these layouts, the margins do not follow the traditional proportions and are often deliberately narrow to create a tension or dramatic effect. In loose leaf binding work, gutter margins are unusually wide so that the type areas avoids the hole

punching and binding mechanism. In newspaper design, the narrow margins give the illusion of reading faster, which emphasizes the urgency of the information.

Symmetrical layout – In this traditional and rather static style of layout, the type is arranged around a central axis giving the impression of harmony, stability, authority and permanence. The typographic space is regarded as three-dimensional with the type as the foreground and the background space as a receding surface. It is a quiet style, extensively used in book design, to which it is most suited.

Asymmetric layout – This more dynamic style developed in the 1920s as part of the new typographic manifesto of the Bauhaus and the modern art movements. Its rationale is to create tensions and movement for dramatic effect. Contrasting typographic elements are aligned on an off-centre axis) and counterbalanced by type or other images positioned elsewhere in the space. Type or rules are often placed close to the edge or even "bleed" (run) off the image area to increase the tension. The unity of asymmetric compositions is maintained by this harmonious marriage of typographical opposites.

Grids – Order and clarity in a typographic design is enhanced by the use of a grid, which is an invisible frame-

In the technical brochure above, an "invisible" grid (shown in light blue for the purpose of this explanation) is used for the arrangement of the type and illustrations in an organized and consistent way, which helps the reader to take in the information with ease. The visual hierarchy of main, sub- and paragraph headings is clear, and the position of the image area, margins, type measures, folios and inter-column spaces are consistent in conforming to the grid.

1 Head margin
2 Foredge margin
3 Foot margin
4 Spine or back edge margin
5 Column
6 Gutter
7 Line guides
8 Running heading
9 Heading
10 Sub- or cross-heading
11 Folio

work. Grids can vary in complexity. The most simple kind of grid is, say, one used for the design of a press advertisement while a highly complex one is required for a reference book. The basic concept of a grid is modular: its mathematical proportions and divisions of space have a distinct and recognizable visual relationship with one another. Grids help to unify a design but should not inhibit typographic freedom and variety. They are not intended to be a strait-jacket and can be broken out of for dramatic effect when there is a good reason for doing so.

The advantages of a grid are manifold. First and foremost it is an aid to the legibility and clarity of a design, but it is also a practical aid for achieving consistency in the production of typesetting, artwork, scaling photographs and checking printing proofs.

It is sensible to draw up a grid at an early stage and plot all the major grid lines which relate to the page size, image area, margins, type columns, widths, headings, inter-column margins, folios (page numbers), running headings, bleed area and so on. The depth of the type areas is normally dictated by a set number of lines of text in a column. It is useful to produce or print the grid both as a film overlay for checking proofs and on board for pasting-up.

Copyfitting

Copyfitting, casting off, is the mathematical conversion of typewritten copy into type. It is a relatively simple technique at which all typographers must be proficient.

The character count

Place an inch ruler on the typed manuscript to determine if there are 10 (pica) or 12 (elite) typewriter characters to the inch. Then make a mark, say five inches along the length of the line, and draw a vertical rule down the sheet of manuscript (if your typewriter has 12 characters to the inch there will be 60 characters of manuscript up to the vertical line). Count the number of full lines of 60 characters in each paragraph and add this number to the number of the characters in the lines which run short of the vertical line and the number of characters in the full lines which fall beyond it. This will give the total number of characters per paragraph. By continuing through the manuscript in this way, produce a character count for each paragraph and page in order to arrive at a grand total for the manuscript. If copyfitting tables are not available, use the following method, which works for any type size. Multiply the intended measure by 29 (this figure is an industry standard relating to the 26 letters of the lower case alphabet plus a compensating adjustment equivalent to 3 characters) and then divide it by the length of the lower case alphabet as shown on the type specimen sheet (in points and picas). The resulting figure is the number of characters per typeset line. The number of lines of setting that each paragraph of the manuscript will occupy can now be calculated by dividing the number of characters in one line of type.

When the calculations are completed it may be necessary to juggle with the type size, leading or measure in order to make the copy fit the design or the space available. If the copyfitting process results in a major overrun of space, consult with the client or editor to decide how the copy can be cut.

Copyfitting tables

If the type measure is fixed, the number of characters in a given type size that will fit it can be estimated by consulting the type manufacturer's copyfitting tables (below). These tables give the number of characters in a pica for each text type size of each typeface available, or they give the number of characters for each text size in a range of different measures. To become familiar with these simple methods of copyfitting, practise using copyfitting tables and a calculator to simplify and speed up the process. However, remember that copyfitting is not an exact science and a margin of error of between five and ten per cent should be allowed.

```
Display Types                                   60 characters

This section only scratches the surface of the enormous range of display +10
types that are available today such as fat face, thin face, decorative, +9
ornamental, inline, outline, shaded, 3-D, brush script, pen script, +5       60
expanded, condensed, and many others.  Some typefaces included here may +9   x 10
also be suitable for limited amounts of text setting for advertisements, +10  ___
brochures and for other forms of jobbing and typographic work.  But the +9   600
primary role of these types is for display purposes - they have been +6       + 85
designed to be noticed.  Display types can convey a gamut of messages and +11  ___
emotions.  They can be aggressive or quiet, modern or traditional, happy or +13 685
sad, high tech or low tech, hard or soft, young or old and so on.  +3

For typographers, the choice and quality of the display types available has +13
never been better.   The relatively low cost of producing new fonts or +8    60
reviving old ones for headline phototypesetting machines, digital  +3        x 4
typesetters, desktop publishing systems or for dry transfer lettering has +11 ___
led to an explosion of display types.      + 37                               240
                                                                              + 72
                                                                              ___
                                                                              312
This section has been divided into five categories.  The first category +9
includes types which imitate styles of handwriting - blackletter (or gothic +13
minuscule), uncial, pen and brush script and cursive handwriting (on which +12
italic types are based).  The other four categories are serif and slab +7     60
serif, sans serif, hybrid serif and, finally, decorative and ornamental.+10   x 8
All these typefaces have been designed for use in the many forms of +5        ___
commercial jobbing and typographic work that h                                480
Industrial Revolution - packaging, brochures,
advertisements and such like.
```

Characters per line (mm)										
mm	1.00	40	50	60	70	80	90	100	110	120
50	1.60	64	80	96	112	128	144	160	176	192
52	1.54	62	77	92	108	123	138	154	169	185
54	1.48	59	74	89	104	119	133	148	163	178
56	1.43	57	71	86	100	114	129	143	157	171
58	1.38	55	69	83	97	110	124	138	152	166
60	1.33	53	67	80	93	107	120	133	147	160
62	1.29	52	65	77	90	103	116	129	142	155
64	1.25	50	63	75	88	100	113	125	138	150
66	1.21	48	61	73	85	97	109	121	133	145
68	1.18	47	59	71	82	94	106	118	129	141
70	1.14	46	57	69	80	91	103	114	126	137
72	1.11	44	56	67	78	89	100	111	122	133
74	1.08	43	54	65	76	86	97	108	119	130

(alphabet length ref. no. at 10 pt)

Choosing text typefaces

The choice, quality and ease of access to type has never been better. Today, type specimen books present an Aladdin's cave of styles which have varying degrees of typographical merit and practicality. A cross-section of typefaces are included in the Directory of Typefaces in this book which gives an overview of the universe of type. When selecting a text typeface, remember that this should not simply be a matter of personal preference, it should be a careful and considered decision based on its appropriateness to the content and to the purpose of the job for which it is being used. Is the audience young or old, consumer or business orientated? Is the nature of the copy educational, informational, promotional or just fun? Is there a need to portray a traditional or modern look? Will the type be used on a poster or packaging or in a book? All these questions must be answered. The choice of typeface may be dictated also by the need for special typographical characters such as non-aligning figures (sometimes called old style figures), small capitals or mathematical formulae. In addition, the general design concept, budget restrictions, the amount of space available and the extent of the copy and images to be included should be known.

Of course, the choice of typefaces available may be limited to the range of styles of the local typesetter, or perhaps to those available as PostScript fonts for the Apple Macintosh. The budget constraints of reproduction process, the image generation system, or the paper on which a job is being printed are also factors that may influence the choice of typeface. When designing a book, which is typographically complex, the choice of typeface is limited to those that have the necessary family of weights, widths, italics and small capitals or perhaps ones that are economical on the use of space.

Before setting the bulk of the text it is common practice to ask the typesetter for sample settings so that the correct type size, letterspacing, wordspacing, measure and leading can be accurately judged and the legibility assessed. Sample settings are important for another reason. The design of a typeface can vary from one type manufacturer to another and from one typesetting system to another. Typefaces that have been pirated and issued by other manufacturers under another name have often been tinkered with and are not necessarily as good as the original.

The personality of a typeface

Typefaces can express mood, emotion or associations with particular industries, products, lifestyles or historical periods. Typographers can exploit these qualities when choosing the most appropriate typefaces. Serif typefaces look dignified and graceful; slab serifs suggest mechanization and robustness; scripts are delicate and elegant, and Geometric-style sans serifs, such as Futura, are associated with simplicity and modernism. Other faces may be chosen for the graphic appeal of their shapes, or the abstract qualities of their letters. They may be compressed, expanded, angular, round, and so on. Alternatively, a typeface may be chosen because of its aesthetic harmony with the form and style of the images that accompany it. Mood and texture can also be enhanced by the way in which type style is used. It is, for example, possible to create a modern style using a traditional typeface. Some of these considerations also particularly influence the choice of display types (see pages 210–13).

Mixing typefaces

By mixing typefaces, a rich typographic canvas can be produced. However, it is essential to choose typefaces that have a strong contrast in styles – the combination of a serif and sans serif is the most obvious example. While it is common practice to mix one style of display type with a different style of text face, using more than two different styles in one project can be visually too confusing for the reader. If further typographic variations are required, they can be easily produced through changes in type size, case, weight, widths, italics, spacing and colour.

These guidelines provide only an introduction into the pitfalls and factors governing the choice of type style for text setting, and they do not represent a quick for-

The text from a play (above left) in which the lines spoken by each character are allocated a unique weight or width of roman type or italics of Univers, demonstrates the variety of typographical effects that can be achieved from the use of only one text type. The ICL brochure entitled *Forum* (above) shows the use of two contrasting serif typefaces – Caslon Open Face and Perpetua – with italics to emphasize the key words, "open discussion".

This "typogram" by Denis Ichiyama (above) is a simple typographical exercise which shows the emotional properties of type. The cold, monotone shapes of Helvetica are a stark contrast to the flickering warmth and softness generated by Garamond italic and Venetian bold.

mula. It is often the intuitive, unexpected mix and use of typefaces that brings about a new and dynamic typographic solution.

Legibility

The key consideration when choosing a text typeface is its legibility. By legibility, we mean the ease by which the words can be read with comfort at normal reading speed, and there are many factors that can affect it.

Typeface design – When searching for potential text typefaces, it is important to check that the shapes of the letters are sufficiently open and clear and that there are no unusual or quirky characteristics which could distract the reader. Look at the classic roman typefaces, such as Garamond, Bembo, Plantin and Baskerville, and note their clear, regular and well-proportioned features and medium weight. These are the qualities that make them so legible. However, the legibility of even these typefaces can be impaired by bad spacing or leading.

Serif vs sans serif – A great deal of typographic research has focussed on the comparative legibility of serif and sans serif types for continuous text setting. Although the "legibility gap" between them is quite small there is a case for saying that the more individual letter shapes of serif typefaces lead to less reader confusion than the more ambiguous and monotonous letter shapes of sans serifs. Serifs also aid the horizontal flow of the eye along the line. Certainly, there is a strong preference for serif typefaces for the continuous text setting of novels, newspapers and magazines. However, in some other areas where legibility is also paramount but where fewer words are needed – for example, signposting – sans serif types are preferred.

Lower case vs capitals – Word shape is an important factor in legibility. The more individual shapes of lower case letters are considerably more legible than capital letters. Capitals have a uniform horizontal alignment that is difficult to read comfortably and, therefore, they are less memorable to the reader. Capital letters should be used sparingly for key words and headings.

Letterspacing and wordspacing – The amount of spacing between the letters and words has a critical effect on legibility and reading comfort. It is essential that the letters fit together tightly but they should not visually merge. Conversely, if letterspacing and wordspacing are too loose, the words become fragmented and lose their unique integral shape. Text setting that has optimum

A regularized type design is more legible than a decorative one.

legibility · legibility

Serif type is more legible than monotone sans serif.

legibility · legibility

The lower case letterforms are more legible than capitals.

legibility · LEGIBILITY

If letterspacing or word spacing is too tight or too loose, it will impair legibility. The correct amount of letterspacing depends upon the characteristics of the type face being used.

The key consideration when choo
The key consideration when
T h e k e y c o n s

Very small or very large type tires the reader and reduces legibility.

legibility · legibility · legibility

When a type measure is too narrow the reader tires through having to change lines too frequently, and if it is too wide, it is difficult to find the start of the next line.

The key consideration when choosing a typeface for

The key consideration when choosing a typeface for continuous text is legibility. By legibility, we mean the ease by which the words can be read with comfort at normal reading speed, and there are many factors that can affect it.

The key consideration when choosing a typeface for continuous text is legibility. By legibility, we mean the ease by which the words can be read with comfort at normal reading speed, and there are many

Leading that is too narrow or too wide may reduce legibility.

The key consideration when choosing a typeface for continuous text is

The key consideration when choosing a typeface for continuous text is

The key consideration when choosing a typeface for

A medium weight type is more legible than a light or bold face.

legibility · legibility · **legibility**

The even wordspacing of unjustified type is more legible than the variable spacing of justified type.

The key consideration when choosing a typeface for continuous text is legibility. By legibility, we mean the ease

The key consideration when choosing a typeface for continuous text is legibility. By legibility, we mean the ease by

Textured, rough surfaces break up type and reduce legibility.

legibility · legibility

Black on white is more legible than any other colour combination.

legibility · legibility

203

legibility is achieved by the harmonious and rhythmic pattern in which words and lines are clearly separated.

Type size – Legible, flowing text is achieved by establishing the correct visual relationship between type size, measure and leading. A change in the specification of any one of these three factors normally requires corresponding adjustments in the other two.

Continuous text type which is either too large or too small tires the reader very quickly. If type is too large, the reader needs to scan it in several "sweeps" (called fixation pauses) instead of a single eye movement, and if type is too small the counters (internal shapes) of the letters appear to fill in. In both situations, legibility is reduced. Type sizes of between 8 and 11 point have optimum legibility although typefaces with a proportionally large x-height to the ascenders and descenders have a positive and significant effect on legibility. When deciding upon the appropriate type size, carefully consider the intended audience. Very young children and older people with weak eyesight, for example, may need a larger type size than would normally be specified.

Measure – The length of the measure for continuous text setting depends upon the type size. There is no absolute formula for finding the perfect line length but a rule of thumb is to choose a measure that holds about 60 to 65 characters – this often equates to about twice the type size in picas (for example, a 10-point type should be set to about 20 picas). If the measure is too long, the reader becomes easily fatigued and has difficulty finding the beginning of the next line. Alternatively, if a line is very short, the reader has to change lines too frequently and again tires in the process.

The length of the measure is also influenced by the amount of leading or line feed. If the type is set solid or has insufficient leading the optimum line length is effectively reduced. However, there are situations where the ideal typographic specifications are overriden. For example, the measures used in newspapers and magazines are often shorter than the optimum specifications but the relatively small amounts of copy involved, together with the transient nature of the content and the general production requirements, make such short measures acceptable. This example clearly illustrates that standards of legibility vary in accordance with the purpose and importance of the copy.

Leading – Leading is inserted to ensure a clear horizontal separation of the lines. If lines are too close together, the reader is distracted by the lines immediately above or below and, subsequently, legibility is affected. Legibility research has also shown that readers find it difficult to locate the next line if continuous text is set solid.

To maintain optimum legibility, text sizes of between 8 and 11 point require leading of up to 4 points. Also those faces with a strong vertical stress, such as Bodoni, need generous leading to maintain a clear separation of the lines. A key factor that has an adverse effect on leading is the size of the x-height. Typefaces with a large x-height, such as ITC Garamond, require comparatively more leading, as do types with exceptionally long ascenders and descenders which close up the interline spacing. One such face is Perpetua.

Weight – If type used for continuous text is either too heavy or too light its legibility is adversely affected. A light typeface loses its contrast with the background,

In signposting schemes, such as those above designed by Kinneir Calvert, the optimum legibility of type is critical. The simple, uniform and open letter shapes of the sans serif type and generous type,size, letterspacing and leading as well as contrasting colours are carefully selected to maximize the clarity of the words.

A frame promoting an Anglia TV programme (above), in which the optimum legibility of type and colour is deliberately sacrificed in order to exploit their expressive qualities. Notice how the light scatter effect on the type tends to fatten it up.

Colour and texture of text
The choice of typeface, type size, leading, letterspacing and wordspacing affects the texture and "colour" (tonal value) of text setting. In the examples on the right, the weight and style of Clarendon and Bodoni produce a heavy effect by comparison with the lightness of Baskerville. The abrupt contrast in the letterstrokes and the strong vertical stress of Bodoni produces a much richer texture than the monotone look of Helvetica. Notice also the changes in colour and texture achieved by increasing the leading or by using italic type.

9pt solid Helvetica

The purpose of typographic design is to arrange all the component parts of a piece of text into a harmonious and cohesive whole. This can be achieved either through the unity of similar design elements or by a more dynamic

9/14pt Helvetica

The purpose of typographic design is to arrange all the component parts of a piece of text into a harmonious and cohesive whole. This can be achieved either through the unity of similar design elements or by a more dynamic

9/11½pt Bauer Bodoni

The purpose of typographic design is to arrange all the component parts of a piece of text into a harmonious and cohesive whole. This can be achieved either through the unity of similar design elements or by a more dynamic

9/11½pt Clarendon light

The purpose of typographic design is to arrange all the component parts of a piece of text into a harmonious and cohesive whole. This can be achieved either through the unity of similar design elements

9/11½pt Baskerville roman

The purpose of typographic design is to arrange all the component parts of a piece of text into a harmonious and cohesive whole. This can be achieved either through the unity of similar design elements or by a more dynamic

9/11½pt Baskerville italic

The purpose of typographic design is to arrange all the component parts of a piece of text into a harmonious and cohesive whole. This can be achieved either through the unity of similar design elements or by a more dynamic

while the counter of the letters of a heavy typeface is reduced by the filling-in effect. For maximum legibility, use a typeface with a medium weight, such as Garamond and many of the classic Old Style typefaces. Each of these faces has the optimum amount of contrast against the background and clear and open internal letter shapes. Use italics sparingly. They are an effective means of giving emphasis for key words or small amounts of text, such as captions, but their compressed and sloping forms are tiring to read in any quantity.

Width – Legibility is also reduced if a typeface is too condensed (narrow) or too expanded (wide). The amount of openness of a letterform is critical to its legibility as a text type. However, the use of condensed and expanded faces for small blocks of text, such as for captions and headings, is perfectly acceptable.

Justified vs unjustified setting – Research has found that unjustified setting when ranged left and ragged right is the most legible form of typesetting. The variable line lengths make it easy for the reader to move from the end of one line to the beginning of the next (providing it is correctly leaded), and its even wordspacing avoids awkward spaces and rivers. However, it is important that the unjustified lines do not fluctuate in length too much as this causes an ugly silhouette to the ragged edge which distracts the reader.

Image degeneration – The quality of reproduction has a direct effect on legibility. Weak printing or rough-textured papers can break up type which reduces its weight, resulting in a reduction of legibility. Alternatively, type that is over-inked fills in and suffers another kind of degeneration. A robust typeface with a good weight is a sensible choice if the problem of image degeneration seems likely to occur. Type used for television is equally affected by this phenomenon through "light scatter" or "light spread" which tends to fatten the letterforms.

Colour – A high contrast in colour between the type and its background is essential for good legibility. Black type on a white background is by far the best combination. The reverse – white type on a black background – can dazzle the reader and, therefore, should be limited to display applications where impact is the most important criterion. All other colour combinations diminish the legibility of type to a certain degree, but this may be an acceptable sacrifice when a more subtle contrast may be desired for reasons of atmosphere or tone.

I leaped into the darkness,

In this double-page spread from a book designed by Richard Eckersley, the importance of a strong contrast between the type and the background colour is evident. While the large Gill Sans at the top of the page is legible, the block of small, justified serif type is beginning to fill in, reducing its legibility.

Representing type

Text

Tramlines For representing text type, use a rapidograph and a parallel motion to draw "tramlines" for the top of the x-height and the baseline. The thickness of line should visually match the weight of the typeset copy.

Rendering When it is important to show the copy content and the typeface being used, hand render the type with a rapidograph. Draw guidelines for the cap height, x-height, baseline and descender line to maintain an even type size and proportions.

Using sample setting If sample settings of the actual text are available, photocopy them and paste them down in position or, alternatively, use sample Latin text. This gives an accurate guide as to what the finished job will look like.

Display

Tracing For larger sizes of type, such as headings, trace the type from a specimen sheet using a rapidograph. Ensure that the letterspacing, wordspacing and shape of the display type is visually correct and even.

Transfer lettering If a high-quality finish is required, use dry transfer lettering. Each sheet contains a spacing guide, and the quantity of each character supplied relates to its frequency of use in the English language.

Adding colour Coloured type can be rendered with a fine brush and gouache or ink over white dry transfer lettering.

Specifying type

Marking up copy for setting is a task that should be carried out with great care and accuracy because any mistakes in the instructions are likely to be expensive to correct later.

Copy preparation and marking-up

Wherever possible, copy should be typed in double line spacing and preferably with wide margins in which the necessary instructions to the typesetter can be written. Copyfitting is also made easier if the copy is typed to a measure that corresponds with the number of characters in a line when typeset. Using a coloured pen (preferably red), clearly and neatly mark the typographic specification on the typewritten copy. It is important that any typographical symbols or instructions used conform to the standard list of editors' and proofreaders' marks. Remember, your instructions should be complete and explicit so that the typesetter does not need to make any typographic judgements.

If the copy runs to many sheets and the typographical specification is repetitive, it is sufficient to write the instructions on the first sheet only and make it clear that the same instructions apply to subsequent pages. For more complex publishing work, some organizations use a separate typographical style specification sheet on which all the principal details are given. The typographical specification must include information on the type manufacturer (if relevant), typeface, font (roman, bold, italic, etc.), type size, case, leading, letterspacing, wordspacing, type alignment (justified, unjustified, centred, etc.) and measure. When there are many different heading levels or captions, include a style code sheet for them to which the typesetter can refer. All other detailed specifications for bold, italic, capitals, paragraph indents, run-on and so forth should be marked neatly in the margin of the copy. If copy is to be set with the line breaks as typed, write the words "line for line" against the relevant part of the copy.

Complicated tables or charts should be accompanied by a layout otherwise misunderstandings can easily creep in. It is wise to ask the typesetter for a sample setting for each style of table to ensure that the instructions have been interpreted correctly. Typeset rules, which can be specified in either 1¼ point or 0.1 millimetre increments, are of a superior quality to the handrawn variety. You will also need to specify for bullet points, ticks and boxes to be set. Copy that is supplied to the typesetter (or to a bureau) in the form of a disk for DTP must be accompanied by a complete marked-up set of hard copy and any instructions about its formatting.

Running head: 14pt Helvetica small caps, roman
Main heading: 16pt Helvetica bold upper and lower case
General text: 9½/13pt Helvetica Roman ranged left on 110mm measure

Running head →

Directory of Typefaces: Display types

Display Types ⎤ — main heading

10pt #

7pt #

This section only scratches the surface of the enormous range of display types that are available today such as fat face, thin face, decorative, ornamental, inline, outline, shaded, 3-D, brush script, pen script, expanded, condensed, and many others. Some typefaces included here may also be suitable for limited amounts of text setting for advertisements, brochures and for other forms of jobbing and typographic work. But the primary role of these types is for display purposes – they have been designed to be noticed. Display types can convey a gamut of messages and emotions. They can be aggressive or quiet, modern or traditional, happy or sad, high tech or low tech, hard or soft, young or old and so on.

For typographers, the choice and quality of the display types available has never been better. The relatively low cost of producing new fonts or reviving old ones for headline phototypesetting machines, digital typesetters, desktop publishing systems or for dry transfer lettering has led to an explosion of display types.

This section has been divided into five categories. The first category includes types which imitate styles of handwriting - blackletter (or gothic minuscule), uncial, pen and brush script and cursive handwriting (on which italic types are based). The other four categories are serif and slab serif, sans serif, hybrid serif and, finally, decorative and ornamental. All these typefaces have been designed for use in the many forms of commercial jobbing and typographic work that have mushroomed since the Industrial Revolution – advertisements and such

It is essential to provide a thorough and clear type specification for the typesetter. Ambiguous instructions or errors can be expensive to put right. General type specifications should be written on the first page or on a cover sheet, and the details and other instructions written in the margins of the copy. The typeset version of the marked-up copy is shown on the right.

DIRECTORY OF TYPEFACES: DISPLAY TYPES

Display Types

This section only scratche s the surface of the enormous range of display types that are available today such as fat face, thin face, decorative, ornamental, inline, outline, shaded, 3-D, brush script, pen script, expanded, condensed, and many others. Some typefaces included here may also be suitable for limited amounts of text setting for advertisements, brochures and for other forms o jobbing and typographic work. But the primary role of these types is for display purposes – they have been designed to be noticed. Display types can convey a gamut of messages and emotions. they can be aggressive or quiet, modern or traditional, happy orsad, high tech or low tech, hard or soft, young or old and so on.

For typographers, the choice and quality of the display types availablehas never been better. The relatively low cost of producing new fonts or reviving old ones for headline phototypesetting machines, digital typesetters, desktop publishing systems or for dry transfer lettering has led to an explosion of display types.

This section has been divided into five categories. The first category includes types which imitate styles of handwriting – blackletter (or gothic minuscule), uncial, pen and brush script and cursive handwriting (on which italic types are based). The other four categories are serif and slab

Marking-up the proofs and fine-tuning type

The first proofs received back from the typesetter are called galley proofs. These normally show the type in columns and should be checked carefully by an editor or copywriter (and by the client, if applicable) for literals, hyphens, the same word appearing in the same position on consecutive lines, widows (single, lonely words on the last line of a paragraph), and orphans (a single word at the end of a paragraph which has been run over to the top of the following column). The typographer must also be aware of these problems and work with the editor or copywriter to find ways of eradicating them and also to shorten the text if it is running too long.

The typographer is responsible for checking the galley setting for bad wordspacing and rivers (which generally occur only in justified setting), and for broken or "battered" type. The font, type size, measure, leading, letterspacing and wordspacing must be checked too. If the typesetter has already produced a piece of sample setting, there should be few corrections and less adjusting of the specification at this stage – although complex typographical tables often need several revisions before they are visually satisfactory. Look carefully at display type to see if any changes in the line breaks are required or if any kerning or adjustments to the letterspacing are necessary. Other fine detailed adjustments such as type alignment should be checked thoroughly. All corrections must be clearly marked on the galley proofs using the standard proofreaders' marks. It is imperative that galley proof-checking is carried out thoroughly and carefully as it will be the last opportunity to get things right. Later corrections will be more costly.

If the corrections are heavy, ask the typesetter for a revised set of galleys, but if corrections are light, it should be possible to go straight to page make-up (if the typesetter is performing this task). If appropriate, prepare a rough paste-up of the galleys to check for fit, or to act as a guide for the typesetter for "run-arounds" (type that follows around the shape of photographs and illustrations). On DTP systems, designers can easily adjust the text on the screen at page make-up stage. Although page make-up can be expensive, when compared with the cost of the time spent pasting-up page proofs in the studio, it may work out as being more cost efficient. If paste-up is decided on, ask for bromides of the type to be returned from the typesetters for making-up as pages in the studio. DTP users will be able to make all the corrections on the screen, run out revised page proofs and then final bromides as artwork (the latter stage may be done via a bureau or typesetter if good commercial quality setting is not available in-house).

Marking up type to fit into specific irregular shapes, such as the figure in the example on the right, or to run around other design elements, needs careful planning and detailed instructions on measure and indents for the typesetter. Below left is the type mark-up for the typesetting shown in the example below, where the copy runs around the large fat-face 'D'. Run arounds can be expensive to set because they are time-consuming.

Proof correction marks

	Text mark	Margin mark
Insert new material	the end	very/
Insert period	the end	⊙
Delete	the end	℘
Close up	the end	⌒
Transpose	the end	trs.
Insert space	the end	#
Move up	the end	⊔
Indent	the end	⌐
Indent 1 em	the end	□
Cancel indent	the end	⌐
Take over	the end	[
Take back	the end]
Run on	the end	⌒
Set in caps	the end	caps
Set in lower case	The end	l.c.
Set in italic	the end	ital
Set in roman	the end	rom
Set in bold	the end	bold
Set in small caps	The end	sc
Disregard marks	The end	stet

DIRECTORY OF TYPEFACES: DISPLAY TYPES

Display Types

This section only scratches the surface of the enormous range of display types that are available today such as fat face, thin face, decorative, ornamental, inline, outline, shaded, 3-D, brush script, pen script, expanded, condensed, and many others. Some typefaces included here may also be suitable for limited amounts of text setting for advertisements, brochures and for other forms of jobbing and typographic work. But the primary role of these types is for display purposes – they have been designed to be noticed. Display types can convey a gamut of messages and emotions. they can be aggressive or quiet, modern or traditional, happy or sad, high tech or low tech, hard or soft, young or old and so on. For typographers, the choice and quality of the display types available has never been better. The relatively low cost of producing new fonts or reviving old ones for headline phototypesetting machines, digital typesetters, desktop publishing systems or for dry transfer lettering has led to an explosion of display types. This section has been divided into five categories. The first category includes types which imitate styles of handwriting – blackletter (or gothic minuscule), uncial, pen and brush script and cursive handwriting (on

DIRECTORY OF TYPEFACES: DISPLAY TYPES

Display Types

This section only scratches the surface of the enormous range of display types that are available today such as fat face, thin face, decorative, ornamental, inline, outline, shaded, 3-D, brush script, pen script, expanded, condensed, and many others. Some typefaces included here may also be suitable for limited amounts of text setting for advertisements, brochures and for other forms of jobbing and typographic work. But the primary role of these types is for display purposes – they have been designed to be noticed. Display types can convey a gamut of messages and emotions. They can be aggressive or quiet, modern or traditional, happy or sad, high tech or low tech, hard or soft, young or old and so on. For typographers, the choice and quality of the display types available has never been better. The relatively low cost of producing new fonts or reviving old ones for headline phototypesetting machines, digital typesetters, desktop publishing systems or for dry transfer lettering has led to an explosion of display types. This section has been divided into five categories. The first category includes types which imitate styles of handwriting – blackletter (or gothic

Enlivening text

Page after page of uninterrupted continuous text has a quiet, regular rhythm suitable for a novel but not for most other commercial applications, such as brochures, leaflets and advertisements, where visual breaks in the text are needed to maintain interest, create impact and avoid monotony. There are many typographic techniques that can help to enliven text setting, but the skill of the typographer is knowing when and how much to use them. It is easy to make the cardinal error of typographic overkill which spoils the design as a whole and reduces legibility.

Creating emphasis

Natural breaks in the text are created by main headings, sub-headings, paragraph headings and paragraph indentations or spaces. However, these factors alone may not weave a sufficiently rich typographic tapestry to keep the reader's attention, or to communicate the message effectively. Giving emphasis to key words or phrases in the text provides further interest, but the style of typographic treatment depends upon the degree of stress that is appropriate to the key words. A conventional way of stressing a particularly important word or phrase is by the use of italics. Small capitals, often used for the setting of the first few words of a chapter or section in a book, are another restrained and formal way of creating emphasis. A greater impact is created by capitalizing special words or phrases but this needs to be handled with care because a run of words in capital letters can look ungainly and over-powering.

The simplest and most dramatic way of creating emphasis is to use bold type, providing that the weight of type is appropriate to the degree of stress required. Mixing typefaces with contrasting styles (such as a serif and a sans serif) is also an effective means of highlighting proper names in the text or perhaps for paragraph head-

In this typographic poster for the Kilkenny Design Awards (above), the shapes of the small blocks of text (set in Helvetica) follow the outline of selected parts of the letters 'ny'. The unusual shapes and their positioning in the space draw the reader's eye.

A deconstructivist design for a wallchart (left), in which the type and images are combined to form a collage. The different levels of headings are either reversed out of panels or set in a larger size of type for emphasis, while a bold weight of Univers is used for the text so that it is legible against the background imagery.

A composition from a student workbook (above) where only one typeface weight and the italics are used. Emphasis is created through colour and type size.

ings that are turning in to the beginning of the first line of a paragraph. But, in these situations, it is important to ensure that the x-heights and cap heights of the two typefaces align, because these can vary between one typeface and another, even if the type size is the same.

A mixture of different measures also helps to ring the changes, but the choice of copy for each measure should relate to its content. For example, it is appropriate to set important introductory copy to a wider measure (and in a larger type size) while caption copy is best suited to a narrower measure than the main text. Allowing the columns of type to fall to uneven drops adds yet more interest.

Quotations and feature boxes – A more dramatic form of emphasis can be achieved by extracting a key phrase or quotation from the text, setting it in a larger and bolder type, and positioning it centrally in the measure perhaps with separation rules above and below it. Alternatively, the quotation can be positioned on a squared-up tint panel or even reversed out of black or a second colour (if available) – this is a treatment that is particularly popular in magazines and newspapers. Feature boxes (sometimes called "nuggets"), which provide an in-depth focus on a particular editorial theme, provide a useful foil or relief.

Initial letters

In book publishing, a traditional typographic convention is the use of a large initial letter at the beginning of a chapter. These letters can be either a capital letter in a large size of the text face or a highly decorative, contrasting style of typeface – perhaps in a second colour.

Illustrations, photographs and colour

Of course, illustrations and photographs are major points of visual interest in themselves and care must be taken to ensure that typographic emphasis does not conflict or detract from them in any way. Colour is a powerful tool for enriching a piece of typography but it should be used sparingly and consistently – perhaps for headings and initial letters only. However, if the text is to be translated into a foreign language it is imperative that it is printed in black so that production costs and plate changes are kept to a minimum.

A whole armoury of other typographic techniques and embellishments are available from typesetters – rules, symbols (often called dingbats), underscoring, bullet points, boxes and so on. The potential firepower is enormous. But remember, the key is knowing when and where it is appropriate to use these devices.

A double-page spread from a book (left), where key extracts from the text are highlighted by a change in typeface, weight and diagonal direction.

David Quay's promotional poster for a new Letraset typeface called Academy Engraved (below), utilizes changes in measure, weight, colour and leading to differentiate between each block of foreign language text.

An annual report (above); set exclusively in one typeface (Frutiger). The unusual text shapes, indentations and the use of bold type and a second colour give the design visual interest.

An appropriate mood is injected into this page from an annual report (right), through the use of a brightly coloured comic-strip style initial letter 'S' to complement the illustration of a cartoon character. Paragraphs are separated subtly by means of symbols.

Display typography

Display typography has relatively few rules and those that exist can usually be broken if the right opportunity arises. There are areas of typographic design in which display type plays a particularly significant role – packaging, book covers, advertisements, record album sleeves, exhibitions, posters, TV graphics and others – and the persuasive qualities of type compete for our attention wherever we go – in the street, in our homes, offices, shops, public buildings and on public transport. Today, typographers have an enormous choice of display faces and they can be used to great effect either on their own or in combination with text faces and other images such as photographs and illustrations. However, if there is a golden rule about display type, it is to use it in a sensitive and purposeful way while maximizing its effect.

From the outset, it is essential to recognize the importance of a happy marriage between the sense of display copy and the typographic presentation of it. Many a good piece of copywriting has been ruined by the typographical emphasis inadvertently being placed on the wrong words. Punctuation within display copy should be used sparingly and rarely at the end of a line where the line break itself represents a natural pause.

Making emphasis work

The degree of emphasis given to the constituent parts of a piece of display typography depends upon their relationship to each other. It also depends on the nature and purpose of the job and the style and importance of the accompanying text typography and images, such as photographs and illustrations.

It is particularly true of display faces that each type has its own personality which evokes a mood or emotion, or identifies itself with a historical period or lifestyle (see also page 202).

A successful piece of design shows sufficient contrast between the typographic treatment of each part so that the whole works efficiently.

Choosing between capitals and lower case, and roman and italic – The use of capital letters for key words and phrases or for a small block of copy provides a subtle change of emphasis from the regular rhythm of text set in upper and lower case roman type. Capital letters are more formal than their lower case counterparts, but they often need more letterspacing which consumes greater horizontal space. However, lines of capital letters can be set closer together than lower case letters, which have the problem of descenders and ascenders "clashing" into one another. Small capitals, which are formal and discreet, provide an even more subtle change of emphasis.

Italics add informality and movement to a design and are effective for highlighting key phrases or lines of copy. However, they look small and, therefore, a larger type size is often required to maintain an equal strength with their roman counterparts.

Contrasting size, weight and width – An increase in type size is a strong form of emphasis, but it fills more typographical space. When used to emphasize an important line of display copy it provides a focal point which attracts the reader's attention.

The introduction of a different weight is a powerful weapon in the typographical armoury. Its limited use enriches a design through the addition of a dark tonal value that contrasts with the greyness of regular weight text type. A smaller size of bold type provides more impact than a larger size of regular weight type. However, the blackness of bold type requires proportionally more white space around it as a counterbalance. Large quantities of bold type are best avoided as the effect can easily become overpowering.

Today, there are extreme variations of width within a single family of type – condensed (narrow) fonts and expanded (wide) fonts are common. The contrast of the vertical stress of a condensed type against the strong horizontal stress of an expanded type can be an effective form of emphasis. But the disadvantages are that condensed type needs more leading between the lines and, of course, expanded typefaces drive out the length of the copy.

The use of a heavy weight of display sans serif type and large initial letter (left), creates a dramatic contrast to the light text type.

This title page (top) features a clever juxtaposition of two different weights of Helvetica capitals, which contrast abruptly with the smaller ITC Galliard Italic.

Impact is achieved on this theatre poster (above) by the tightly spaced large capital letters and the deliberate mistake of reversing them.

Mixing typefaces – When mixing typefaces, two kinds of contrast can be achieved – a contrast of structure and a contrast of form. Structural contrast is achieved by combining monoline designs, such as sans serif and slab serif types, with those faces that have a contrast in the width of the thick and thin strokes, such as serif types and scripts. The cover of Jan Tschichold's *Typographische Gestaltung* uses this structural contrast very clearly. A contrast of form is achieved by combining different styles of letters, such as that between an expanded sans serif and a condensed roman italic.

A greater impact is achieved by a doubling or tripling of contrasts, such as combining a light italic serif face with an extra bold roman slab serif.

Changing texture – The play of one texture against another is a useful device in typography. Texture is provided by the shapes of a typeface, whether it is light or bold, upright or sloping, and these features can be exploited. Endless effective permutations can be produced through repetition or enlargement to make a pattern or texture, which may be hard or soft, dark or light and so on, and by changes in letterspacing, wordspacing and leading.

Shape and arrangement – Display copy must be divided into logical blocks according to meaning, and the arrangement of the blocks and the spaces between them must reflect their relationship to each other and to the design as a whole. It is important for blocks of display type to have an aesthetically pleasing shape. Avoid consecutive lines of equal length, or lines that vary too greatly in length. Alternate long and short lines and keep the optical centre of the shape slightly above half way in order to prevent if from looking bottom heavy. Often a change in type size or case will overcome disparate line lengths and maintain the balance.

Dynamic designs can be produced through a contrast or mix of type arrangements, such as the combination of a centred heading with justified text, or a word or groups of words set in a different direction – perhaps vertically, diagonally or even upside down. Such ideas produce a dramatic contrast.

Rules – Rules should only be used to separate blocks of text when other means of division are not possible or sufficient. The weight (thickness) of the rules should match the tonal value of the type to which they relate.

Jan Tschichold:

Typographische Gestaltung

Benno Schwabe & Co . Basel 1935

The title page of Jan Tschichold's *Typographische Gestaltung* (left), shows the visual interest created by the contrast in the widths of the letterstrokes of the script against the monoline slab serif.

The design of this page from a promotional brochure (below) is given impact by a contrast of colour, type size and typeface.

The contrasts are multiplied by changes in typeface, size, weight, width and direction on this poster for an art exhibition (above).

A playful typographic solution for a poster (right), which exploits the abstract qualities of letter shapes, and differences in weight, size and colour.

211

Special effects

The development of phototypesetting machines and photographic type fonts during the 1960s and 1970s was directly responsible for the original outbreak of modified and distorted type. In the mid-1980s, the arrival of desktop publishing systems, such as the Apple Macintosh, meant that many of these effects could be produced by even the most inexperienced typographer at the press of a button. While many typographers and type designers consider such special effects to be a kind of typographical "butchery", because the original design features and properties of a typeface have been brutalized by photographic distortion, a judicious and sparing use of these possibilities can produce striking designs.

Today, most phototypesetting, digital typesetting machines and DTP systems can condense, expand, italicize and backslant type, but, frequently the results are visually poor. When distorted type is compared to typefaces that were originally designed to be condensed, italicized and so on, it is clear that the horizontal and vertical letter-stroke widths have become disproportionate to each other, thereby producing ugly letter shapes.

With the wide availability of text type "families" which have a full range of widths and italics, it is unnecessary to distort type for continuous text reading. However, minor modifications to display faces can be acceptable, provided great care and sensitivity is taken in their execution. Italicized roman fonts through distortion tend to look particularly awkward since many letters, such as the lower case 'g' and 'y', have characteristic features that are unique to italic type.

Graphics modifier – A whole range of additional effects can be created on a machine called a graphics modifier, which can produce almost any typestyle in outline, inline, triline or even set it in a circle or in perspective.

One area of design that has made extensive use of the modification and distortion of type is television graphics. In the medium of television, typographical effects are often combined with animation to produce dramatic "living" compositions.

For this logotype for Raleigh Bicycles (below), the sans serif type has been modified and the letters overlapped to give it a sense of movement. The type is given a 3-D quality by the addition of a drop shadow.

A simple but clever logotype by Pentagram for a new photographer's gallery (below centre), which is a good example of descriptive type – the out-of-focus typographic image visually describes the word's meaning.

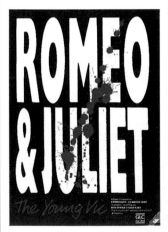

On the cover of this journal (above), the distorted type, produced on the Macintosh, gives the effect of being projected onto the surface of the coloured shapes and objects in the background.

A design for a book jacket (left), in which the type is distorted by means of photographic projection on to the 3-D sculpture. This makes the type look as if it is floating in water.

The type on this theatre poster for the Young Vic (above), has been electronically condensed and enlarged on the Macintosh computer. Notice how the vertical strokes of the normally monoline letters have become thinner, while the horizontal strokes are thicker.

Type as image

The use of type as an image in its own right and vice versa is not a new idea but it has become increasingly popular. The exploitation of the abstract qualities of letterforms, either by repetition, collage, overlapping or interlocking, to produce patterns and textures is now a common feature in typographic design. In the creation of logos, designers frequently select particular letterforms for their abstract qualities in order to produce unique and memorable typographical effects.

Type can also represent objects – for example, a lower case 'j' resembles a hook, or two capital 'O's can represent the wheels on a car. Conversely, images can become type – a pair of compasses can form a capital 'A', or performing acrobats make an acceptable capital 'D'. Indeed, books full of photographic, illustrative or painted alphabets depicting objects of all kinds have appeared in ever-increasing numbers in bookshops during recent years.

Descriptive type – In the early 20th century, the Dadaists and Futurists created "freeform" typographical compositions (sometimes called concrete poetry) as a dramatic and aggressive visual expression of their revolutionary messages. This style involves the selection and arrangement of type that specifically enhances or mirrors the meaning of the words – for example, "a loud cry" would be set in a emphatic extra bold type.

Another form of descriptive type is produced by the visual shaping or degeneration of type to express its verbal meaning. One of the most obvious examples of this style is a Letraset typeface called Shatter, in which the letters have been treated as though they have been shattered and broken into pieces. Most typographers at one time or another have produced their own forms of descriptive type, such as the deliberate breaking up of type to produce the effect of a rubber stamp, or making a treadmark pattern over type to give the effect of its being walked on.

Handwritten letterforms – Handwritten calligraphy or hand-drawn lettering can produce some of the most informal and individual examples of descriptive "type". Whether a broad-nibbed pen, brush, wax crayon or finger is the tool and ink, paint or mud the medium, cleverly executed handwritten letterforms can provide graphic and spontaneous design solutions.

An identity for a leading London Orchestra (above), in which the calligraphic brush script has a spontaneity and flair intended to reflect their approach to the 20th century music that they play.

This flowing calligraphic pen script (below), and its considered layout has an appropriate and personal quality in keeping with the poem.

Sowing the seeds of change

An example of an image as type (above), where the knight becomes the capital 'S' in "Chess".

In the image above right 3-D photographic type has been made up from architectural elements and modelled in to the shape of a building complex.

In Grundy & Northedge's design for the cover of the IPPF Annual Report (right), the initial letters representing the organization's name are made up from illustrative figures.

KIKAKU

Type and colour

The extent to which colour is used on a typographic design largely depends on the budget and the nature of the job. But whatever the budget or other constraints may be, it is essential always to make the most effective use of the colour possibilities that are available, and in order to do this it is important for the typographer to be familiar with the technicalities of colour printing – an aspect of graphic design that is beyond the remit of this book.

The impact of colour

An understanding of the properties of each colour in the spectrum and their relationship to each other is fundamental to working with coloured type.

The colour spectrum can be divided into two halves – warm and cold colours. Warm colours are those at the red-yellow end of the spectrum. These are the most striking colours and appear to jump out from the background. Cold colours – the blue-greens – appear to recede. The high noticeability of red is the reason why it is used for danger or mandatory road signs.

Colour is a powerful means of conveying mood, emotion, atmosphere and for enhancing the visual interest and effectiveness of a design. Designers can draw on their readers' inbuilt response to colour. For example, red is identified with heat and danger, blue with cold and water, green with peace and quiet and white with purity.

Packaging designers rely on colour associations to persuade the consumer of the merits and qualities of a product. For instance, bright blue or white is often used on the packaging of soap powders in order to suggest cleanliness and freshness, while browns are the dominant colours on packets of bran or cereal in order to identify the product with a natural and healthy lifestyle. A further set of colour associations can be related to specific target groups such as young or old people, boys or girls, men or women and consumers or business people. The widespread use of bright primary colours for young children's toys and books is an example. Designers working on logos and corporate identity projects draw heavily on the psychology of colour. In this context, colour reflects a company's field of activity, their products and services and their culture and experience.

If for budgetry reasons a job is limited to one-colour printing, this does not mean that all the type has to be black – as long as you stick to one colour, you can choose from tints of grey, brown, blue, or virtually any other colour that will bring individuality and visual interest to

Pentagram's proposed design for a poster to promote the conservation of the City of Naples' cultural heritage (below), uses Neapolitan tutti frutti colours splattered with ink as a protest against pollution. Note the differences in contrast of the various colours against the white background.

A poster design by Pentagram (above) where the colours of the type represent the national flags of European countries.

The metallic colours used on the packaging of a range of men's toiletries (far left, top), have been chosen to give a masculine feel.

A well-known packaging design for a leading brand of French cigarettes (far left, bottom). Here blue is used predominantly to evoke a soothing quality.

In this Moto Sportswear brochure (left), the bright, translucent colours produce a sporty, trendy image.

The sophisticated, subtle colours on this Mayfair property brochure (below) have an upmarket, elegant look. The strong contrast of the white type against the dark background highlights the address of the property.

The strength of the colours for the type on this magazine cover (above) are chosen to emphasize the relative importance of each part of the copy. Notice how the texture in the diagram breaks up the surface of the type and reduces legibility.

the job. Further tonal contrasts can be introduced through the use of tints and textures or by printing on a coloured or textured paper.

Of course, in the limited space available here, it is impossible to include a detailed technical appraisal of colour, but some of the basic considerations for its effective use in typographical design are discussed below.

Legibility of coloured type

It has been noted that black type on a white background is the most legible "colour" combination because it has the maximum amount of tonal contrast. All other colour combinations have a reduced level of tonal contrast which impairs legibility. The use of bright colours such as a orange or red also has an effect on legibility because type in these colours is tiring to read in any quantity.

Reversing out – White type reversed out of a black background has considerable impact, but compared with black type on a white background, it is tiring to read. Legibility of reversed-out type is also affected by the choice of typeface. A robust type of uniform thickness, such as Gill Sans, is more legible when reversed out than the equivalent type size of a more delicate typeface, such as Bodoni, because fine serifs can disappear or "break up" during the printing process.

Coloured type reversed out of a background suffers a loss of tonal contrast that reduces legibility, but the reduction can be counteracted to some extent by setting the type in a larger size or in a bolder weight. Coloured type that is printed by the four-colour process, can be subject to poor colour registration which diminishes legibility further. For this reason, it is wise to avoid reversing out small type from a four-colour photograph or a solid background made up of tints of the process colours.

The use of colour for emphasis

The selective and consistent use of colour for emphasis and for the identification of important elements or themes is a useful alternative to increasing type size when space is limited. A small amount of a bright colour is more noticeable than a larger area of soft or pastel tones. But if a more subtle form of differentiation is required, pastel or receding colours will work. A simple and effective use of two-colour printing is to use the darkest colour predominantly for the text and the second colour in a more selective way – for example, for the headings. If the second colour is bright, it will immediately attract the reader's attention and thereby increase the effectiveness of the message. Avoid using the two colours in equal amounts.

Specifying colour

Any errors in colour work are expensive to correct, therefore it is important to make an accurate specification from the outset for which you need to obtain the correct colour reference charts and swatch books. A colour swatch book of the range of colours available in the Pantone ® Colour Matching System (which is virtually an industry standard) is essential for the specification of special colours, as is reference for the numerous permutations of tints which can be created from the four-colour process colours of cyan, magenta, yellow and black.

Owing to the adverse effect of poor registration on legibility, when printing in four-colour process do not specify colour for type smaller than say 12 point, but if smaller coloured type is required, then use a special colour or use a solid process colour.

Paper quality can also affect colour. Whenever possible, try to find examples of work that has been printed on the paper being specified. Varnishing and lamination can also subtly change colours, often giving them a slightly yellow cast.

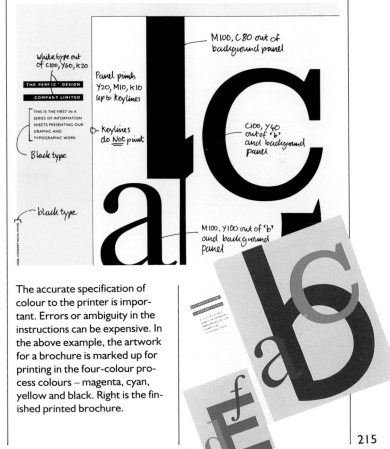

The accurate specification of colour to the printer is important. Errors or ambiguity in the instructions can be expensive. In the above example, the artwork for a brochure is marked up for printing in the four-colour process colours – magenta, cyan, yellow and black. Right is the finished printed brochure.

Desktop typography

The typographical revolution brought about by the desktop publishing (DTP) boom of the late 1980s irrevocably changed the working procedures of designers and typographers. The affordability and cost effectiveness of the new computer-driven technology meant that studios and publishing houses around the world purchased desktop systems that gave them the ability to produce typesetting, page make-up, artwork and, in some cases, film separations in-house.

In addition, desktop systems provided designers with a rapid visualizing tool which replaced many time-consuming, laborious studio methods. The user-friendly qualities of the Apple Macintosh (or Mac, for short), the brand leader, and other systems allowed inexperienced typographers to operate them with relatively little training.

The pace of technological advance in desktop systems has brought with it advantages and disadvantages. Bringing typesetting and page make-up work in-house consumes more of the designer's time, and many have had to go back to "school" in order to transfer their skills to DTP. However, at the end of the day, the desktop computer has had a positive effect for designers because it has given them much more control at all stages of production.

A detailed appraisal of DTP systems and how they work is beyond the remit of this book, but the main aspects which specifically relate to desktop typography are discussed below.

The tools and how they work

Before discussing desktop typography, it is necessary to understand the basic component parts of a DTP system and how they function.

The industry standard is the Apple Macintosh which comprises a personal computer, a screen, disk drive, keyboard and a mouse (a sort of movable selection button). Other elements are a laser printer and sometimes a scanning machine for inputting photographs, illustrations or logotypes. An extensive range of computer applications are available, including page make-up programs such as Pagemaker® and QuarkXPress® and drawing applications such as FreeHand® and Illustrator®.

The copy, which can be either typed directly into the DTP system or imported via a floppy disk from an alternative compatible system, is converted into type by selecting typographical specifications from menus which can then be manipulated and merged with any photographs or illustrations into a page layout. Corrections can be made easily, and the final artwork can be run out on a laser printer or an imagesetter.

Type fonts

There are two kinds of DTP fonts, and these have separate functions. Screen fonts are for display on the monitor and printer fonts are for the output of the type onto paper or film.

Screen fonts are made up of tiny squares called pixels and are referred to as "bitmap fonts". For a screen font to accurately resemble its printed appearance, it has to be

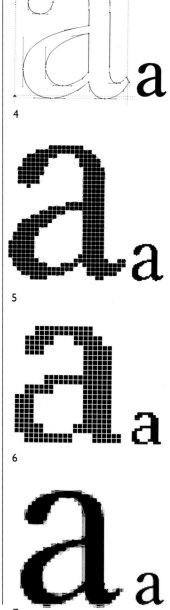

4, 5, 6 & 7 The same character generated using different facilities. (4) Outline Font. (5) Screen font, from a font installed at the same size. This is superior to (6), a screen font created from the nearest available size. (7) The same character as the last, improved using an anti-aliasing facility.

1 A simple design by Malcolm Garrett executed on the Macintosh, which shows how interesting effects can be produced using type and colour.

2 & 3 In 2, the lower case 'n' is from a screen (bitmap) font, without hinting (a facility to improve the quality of type at low resolutions). Notice the uneven thickness of the stems and the crudeness of letter shape when compared to the 'n' in 3, which has the benefit of hinting.

Creating a typeface

1 Points are plotted on a master outline drawing of each letter, then fed into the computer by means of a digitizer and digitizing pad.

2 The outline of the plotted letter is shown at the same size on the computer screen.

3 The outline can be manipulated further using a mouse as shown here, or by keying in coordinates for each point.

4 Once the outline is finalized, the data is held in a file which allows the information to be called up and used with the other characters in the font.

5 The file acts as a device to harmoniously integrate all characters in the font by adding side bearings to them in order to determine the letter spacing.

installed on the system in a range of different sizes. Alternatively, the computer will automatically display the nearest available size to that which is required. However, when this occurs, the edges of the type look "jagged" – an effect referred to as "aliasing".

With the arrival of the Adobe Type Manager (ATM), Apple's TrueType font format, and applications such as FontStudio®, there is no longer a need to have a range of bitmap font sizes because these three facilities can generate a wide selection of bitmap screen fonts from an outline printer font. With FontStudio, bitmap fonts can be amended using special "editing tools" which can delete or even embolden the type. FontStudio also has an anti-aliasing facility which smoothes out the jagged edges of the type by adding "grayscale pixels" to produce a crisper reproduction on the screen.

Outline fonts

These are the fonts used to output the type. Each character outline comprises a series of points which are connected by lines, curves and segments. Software applications allow the designer to change the position of the points in order to modify the shape of the type.

Designing and editing an outline font

New digital outline fonts are created either by drawing the letters on a graphics computer and scanning them into the system or by importing digital data describing the typeface design from another source. Alternatively, if original artwork already exists this can be scanned in, and an outline template produced either by the automatic tracing facility of the application or by hand.

For designing a new typeface, applications, such as Fontographer®, Ikarus® or FontStudio, have editing tools which allow the designer to store a library of letter shapes (such as serifs) which can be called up and used repeatedly to help maintain consistency in design from one letter to another. Existing or new typeface designs can then also be fine-tuned using editing tools as required. FontStudio has an auto-hinting facility which can be applied to individual characters or to a complete font to improve the quality of output of small sizes of type on low resolution (coarse quality) output printers and for more accurate presentation of the fonts in bitmap form on the screen.

Type formats

There are two kinds of type formats – PostScript and TrueType. PostScript was invented by Adobe Systems in the USA in the late 1980s. It is a page description language (PDL) which encodes the descriptive information about the typeface, size, layout and so on. For the first time, it enabled type to be output in existing commercial typeface designs. This was the spark that set off the desktop publishing boom.

With the arrival of PostScript, Adobe soon began to build up a library of PostScript typefaces which included many popular serif and sans serif faces, as well as new designs produced specifically for DTP systems. Originally, Adobe manufactured two type fonts – Type 1 and Type 3 – but Type 1 fonts were exclusively for original Adobe font designs and, additionally, they had a hinting facility.

Later, Adobe made Type 1 fonts readily available for general use (which made the Type 3 font format increas-

ABCD EFGH IJKL MNOP QRST UVWX YZ[?]

8

8 A customized typeface for *The Face* magazine designed on the Mac by Neville Brody. The letter shapes are simplified and the number of curves reduced to make it suitable for low resolution work and to produce a distinctive design.

ABCDEFGHIJKLMN
OPQRSTUVWXYZ
ÆŒ&æœ fi fl ff ffi ffl

1234567890

¼ ½ ¾ ⅛ ⅜ ⅝ ⅞

$\frac{1}{4}$ $\frac{1}{2}$ $\frac{3}{4}$ $\frac{1}{8}$ $\frac{3}{8}$ $\frac{5}{8}$ $\frac{7}{8}$ $\frac{1}{3}$ $\frac{2}{3}$

For many of the popular text typefaces, an "expert set" (above) is available which includes small caps, ligatures, non-aligning figures and fractions.

(Below) A high degree of control over letter- and wordspacing is possible on the Macintosh. For justified setting, minimum, maximum and optimum spacing parameters can be set up, which help to achieve even word-spacing and avoid rivers. When setting unjustified type, spacing is controlled by plus or minus increments in the tracking.

Word spacing:
Minimum: 100%
Optimum: 100%
Maximum: 150%
Character spacing:
Minimum: 0%
Optimum: 0%
Maximum: 15%

9pt Helvetica

The key consideration when choosing a typeface for continuous text is legibility. By legibility, we mean the ease by which the words can be read with comfort at normal reading speed, and there

9pt Century Schoolbook

The key consideration when choosing a typeface for continuous text is legibility. By legibility, we mean the ease by which the words can be read with comfort at normal reading

Word spacing:
Minimum: 80%
Optimum: 90%
Maximum: 100%
Character spacing:
Minimum: -10%
Optimum: -5%
Maximum: 0%

9pt Helvetica

The key consideration when choosing a typeface for continuous text is legibility. By legibility, we mean the ease by which the words can be read with comfort at normal reading speed, and there are many

9pt Century Schoolbook

The key consideration when choosing a typeface for continuous text is legibility. By legibility, we mean the ease by which the words can be read with comfort at normal reading speed, and there are

9pt Helvetica, 0 tracking

The key consideration when choosing a typeface for continuous text is legibility. By legibility, we mean the ease by which the words can be read with

9pt Helvetica, +0.025 em tracking

The key consideration when choosing a typeface for continuous text is legibility. By legibility, we mean the ease by which the words can be read with comfort at normal

9pt Helvetica, +0.05 em tracking

The key consideration when choosing a typeface for continuous text is legibility. By legibility, we mean the ease by which the words can be read with comfort

ingly obsolete). To maintain a competitive edge, they introduced the Adobe Type Manager (ATM) which improved the screen font image by utilizing the information in the outline font file, thereby virtually eliminating the need for separate bitmap screen fonts.

TrueType
This is a more recent competitive font format manufactured by Apple. Its main advantages are that the screen and printer fonts are created from one master outline font and TrueType can be output on any make of printer, not just PostScript machines. The number of TrueType fonts is steadily growing, but the range is not so extensive as PostScript at this time. This is of little consequence, however, since TrueType and PostScript fonts can be used side by side.

Special character sets
The many special characters, such as small capitals, which historically have been readily available in fonts held by trade typesetters, are not normally supplied with the basic PostScript or TrueType fonts. However, they can be obtained as a separate package called an expert set. Fractions and non-aligning numerals are also available in this form.

Type quality
The quality of the type manufactured by digital type foundries, whether PostScript or TrueType, is generally reasonably good, but it can vary and there are a number of important points to consider before choosing a typeface for use on a DTP system. Is it a good reproduction of the original design? Is the alignment and fit of the letters satisfactory and when set, is the "colour" even? Is the font suitable and is the type quality acceptable at the resolution of the output device to be used? (Resolution is the number of pixels or dots per inch – referred to as "dpi"). High resolution is from 1,270 to 2,540 dpi, and low resolution from below 1,270 dpi down to 300 dpi. The higher the resolution, the better the type quality. The jagged edges of digital type are not visible above 600 dpi.

Some typefaces suffer badly when output on low resolution printers – in particular, types with subtle stroke variations (such as Optima) and type with very fine serifs (for example, Bodoni). However, in recent years many typefaces have been designed specifically for low resolution devices. Lucida and ITC Stone Informal are two such types, and many other faces are supplied with hinting in order to compensate for the effects of low resolution output.

Type compatibility
A further consideration when choosing type fonts is their compatibility with the graphics applications to be used. It is important to check that the font can be manipulated and changed within the application as required. A good working principle is to use only one type format and, if possible, purchase fonts from a single foundry and then work with the same application. Fewer compatibility problems will be experienced this way.

Type measurement
Type sizes and leading on DTP systems are normally specified in points, but the PostScript point is actually slightly larger at 0.013 889 inch than the Anglo-American point of 0.013 837 inch. The former is exactly $\frac{1}{72}$ inch and this is why the resolution of the screen of a Macintosh computer is 72 dpi. Type measures and margins are normally specified in millimetres.

Letterspacing, wordspacing, tracking and kerning
Both letterspacing and wordspacing, called tracking on the Macintosh, are specified in fractions of an em so that the correct visual spacing can be achieved. However, the actual size of an em for the same type size of the same face can vary slightly from one application to another.

The possibilities for typographical effects and modifications on the Macintosh are considerable. As shown above, type can be condensed, expanded or backslanted to any degree or angle. Alternatively, type can be produced in perspective, in a circle, or to follow irregular shapes, overlapped, a shadow or outline added. Many other modifications are also possible. Distorted and modified type has become the trademark of the Macintosh.

Some type fonts are supplied with a full set of kerning pairs which avoid ugly, wide spaces occurring between certain letter combinations such as 'To' and 'WA'. Most applications can distinguish these kerning pairs, which makes life easier for the designer because spacing adjustments can be made simply by altering the tracking. But avoid using kerning pairs if the tracking specified is very tight because uneven spacing can occur.

Type alignment

When setting justified text on the Macintosh, a facility is available to set up maximum and minimum parameters as well as optimum levels of tracking. An auto-hyphenation device can also be activated to help avoid ugly spaces or rivers in the text. Centering and running type around specific shapes is relatively simple on the Macintosh.

Special effects

The Macintosh offers a huge range of special effects. Type can be slanted, backslanted, condensed, expanded, rotated or reversed out. Alternatively, drop shadow, outline, inline, patterned or tinted versions can be produced.

Many drawing applications available for DTP systems can electronically distort type by a process called horizontal scaling. However, it should be used with restraint because the end results do not favourably compare with type designed originally as a condensed or expanded face.

Advantages and disadvantages of desktop typography

There is no doubt that the advantages of desktop typography for the designer are manifold, but the most significant are the savings in time and cost, and the high degree of control which it gives over design and production. Admittedly, in order to enjoy these benefits, designers are faced with a learning process which is continuous because of the need to be familiar with the new or modified applications which come on to the market at regular intervals. In order to cope with this problem, and to assist with non-creative activities on the Macintosh, many design companies employ a Mac operator who may specialize in one or more applications.

It is easy for designers to become too Mac-orientated in their approach to design solutions. At the beginning of each job it is essential to decide if it is suitable for the Mac or not. When a particular typeface is not available in PostScript or TrueType and the setting has to be bought in from a trade typesetter, it may be quicker to do that particular job conventionally. Above all, do not allow the limitations of the computer to restrict the creative potential of the job.

In future, the rapid technological advancement in hardware, software and font quality is set to continue and this applies most especially in the development of low cost, high resolution printers and cheap colour monitors and printers that even small design companies can afford.

Keyboard panel

(Right) The layout of the standard Macintosh keyboard. Each key has four options, selected by depressing the key itself or a combination of that key and one or two others. The options available using the 'Q' key are shown below.

Q	Œ
Shift + character keys	Option + Shift + character keys
Character key only	Option + character keys
q	œ

Index

Page numbers in italic refer
to the illustrations and captions

Further reading

Aldrich-Ruenzell, Nancy & Fennell, John, Designer's Guide to Typography. Phaidon Press, London (1991); Watson Guptill, New York (1991).

Anderson, Donald, The Art of Written Forms: the theory and practice of calligraphy. Holt, Rinehart & Winston, New York & London (1969).

ATypI (Association Typographique Internationale), Index of Typefaces, (1975).

ATypI "The Computer and the Hand in Type Designs" in Visible Language Vol. XIX No. 1, Winter 1985, Cleveland, Ohio.

Bain, Erik K, Display Typography. Focal Press, London (1970).

Barlow, Geoff, Typesetting and Composition, (Publisher's Guide Series). Blueprint, London (1987).

Bigelow, Charles, Haydon Duensing, Paul & Gentry, Linnea (Eds), Fine Print on Type. Lund Humphries, London (1989).

Campbell, Alastair, The Designer's Handbook. Macdonald, London (1983).

Campbell, Alastair, The Mac Designer's Handbook. Harper Collins, London (1992); Running Press, Philadelphia (1992).

Carter, Rob, American Typography Today, Van Nostrand Reinhold, New York (1989).

Carter, Rob, Day, Ben & Meggs, Philip, B., Typographic Design: Form & Communication, Van Nostrand Reinhold, New York (1989).

Carter, Sebastian, Twentieth Century Type Designers, Trefoil Publications, London (1987); Taplinger, New York (1987).

Craig, James, Production for the Graphic Designer. (Ed. Margit Malmstrom),Pitman, London (1974). Watson Guptill, New York (1974).

Craig, James, Designing with Type. Watson Guptill, New York (1971).

Craig, James, Phototypesetting: a design manual. (Ed. Margit Malmstrom) Pitman, London (1978). Watson Guptill, New York (1978).

Dair, Carl, Design with Type. University of Toronto Press, Toronto (1967).

Garland, Ken, Illustrated Graphics Glossary. Barrie & Jenkins, London (1980).

Jaspert, W. Pincus, The Encyclopedia of Typefaces. Blandford Press, London (1970).

Lawson, Alexander, Anatomy of a Typeface. Hamish Hamilton, London (1990). David R. Godine, Boston (1990).

McLean, Ruari, Jan Tschichold, Typographer. Lund Humphries, London (1975); David R. Godine, Boston (1975).

McLean, Ruari, The Thames & Hudson Manual of Typography. Thames & Hudson, London & New York (1980).

McQuiston, Liz & Kitts, Barry, Graphic Design Source Book. Macdonald Orbis, London (1987).

March, Marion, Creative Typography. Phaidon, Oxford (1988); North Light Books, Cincinnati (1988).

Morison, Stanley & Day, Kenneth, The Typographic Book, 1450-1935. Benn, London (1963); University of Chicago Press, Chicago & New York (1964).

Perfect, Christopher & Rookledge, Gordon, Rookledge's International Type-finder. Sarema, London (1983); Moyer Bell Limited, New York (1991).

Rowland, Anna, Bauhaus Source Book. Phaidon, Oxford (1990); Van Nostrand Reinhold, New York (1990).

Spencer, Herbert (Ed.), The Liberated Page. Lund Humphries, London (1987); Chronicle Books, San Francisco (1988).

Spencer, Herbert, Pioneers of Modern Typography. Lund Humphries, London (1969, 1982); M.I.T. Press, Cambridge, (Mass.) (1983).

Sutton, James & Bartram, Alan, An Atlas of Typeforms. Wordsworth Editions, Hertfordshire (1988).

Sutton, James & Bartram, Alan, Typefaces for Books. New Amsterdam Books, New York (1990).

Swann, Cal, Techniques of Typography. Lund Humphries, London (1969, 1980); Watson Guptill, New York (1969).

Wallis, L.W., A Concise Chronology of Typesetting Developments 1886-1986. Lund Humphries in association with the Wynkyn de Worde Society, London (1988).

Zapf, Hermann, About Alphabets. M.I.T. Press, Cambridge (Mass.) & London (1960, 1970).

Credits

10-11 1, 2, 3, 4 Quarto Publishing, 5 C M Dixon, 6 The Board of Trinity College, Dublin. **12-13** 1 by courtesy of the Board of Trustees of The V & A Museum, 2 C M Dixon, 3, 4 St Bride's Printing Library, 5 The British Library. **14-15** 1 by courtesy of the Board of Trustees of The V & A Museum, 2, 3, 4, 5, St Bride's Printing Library. **16-17** 1, 2, 3, 4 St Bride's Printing Library. **18-19** 1, 2, 3, 4 St Bride's Printing Library. **20-21** 1, 2, 3, 4 St Bride's Printing Library. **22-23** Inset, 1, 2, 3, 4 St Bride's Printing Library. **24-25** 1 and inset St Bride's Printing Library, 2 E Tarchive, 3 by courtesy of the Board of Trustees of The V & A Museum, 4 *Lacerba*, 5 David King. **26-27** 1, 2 Bauhaus-Archiv, Museum fur Gestaltung, 4, 5 Robert Opie Collection. **28-29** 1, 2, 4, 6 St Bride's Printing Library, 3, 5 The Times Newspapers. **30-31** 1 Penguin Books, 2, 3 Adrian Frutiger. **32-33** 1, 2 Doyle Dane Bernbach Ltd, 3 Brownjohn Chermayeff and Geismar. **34-35** 1 Virgin Records, 3 Studio Dubar, 4 Neville Brody, 5 Emigré. **38-39** tr St Bride's Printing Library. **48-49** 1 St Bride's Printing Library, 2 Gustav Jaeger, 3 APT, 4, 5 Alan Swann. **50-51** 1 Bruce Rogers, 2, 4 The Chase Creative Consultants, 3 Treacyfaces, 5 Mullen, 7 Gustav Jaeger, 8 Paul Shaw. **52** St Bride's Printing Library. **80-81** 1 Intégral Concept, 2 Davies Baron, 3 Carter Wong, 4 Carlos Rolando, 5, 6, Richard Eckersley, 7, 8 Michael Peters Ltd. **82-83** 1 Penguin Books, 2 Wings Design Consultants, 3 Garner Russell Ltd, 4 Satpaul Bhamra, 5 Richard Eckersley, 6 David Wakefield, 7 Dennis Ichiyama, 8 Fernand Baudin, 9 John Nash & Friends, 10 Visuel Design. **84-85** 1 The Partners, 2 Jo Kaupe, Starling Corporate Design, 3 Tony O'Hanlon, 4 Jill Yelland, 5 Paul Shaw, 6 Appleby Case Ltd, 7 The Team, 8 The Times Newspapers, 9, 10 Intégral Concept, 11 John Nash & Friends. **86-87** 1 Carole Theobald and William Redfern, The Four Hundred, 2 John McConnell, Pentagram, 3 Michael Peters Ltd, 4 John Nash & Friends, 5 Gustav Jaeger, 6 David Wakefield, 7 Tatoo, 8 Blackburn's, 9 Jan Tschichold, Penguin Books. **88** St Bride's Printing Library. **104-5** 1 Bob Conge, 2 The Perfect Design Company, 3 The Chase Creative Consultants, 4 Nancy Williams, Laura Head, 5 APT, 6 Sampson Tyrrell Ltd, London, 7 Bob Conge, 8 Jill Yelland. **106-107** 1 Phoa Kia Boon, Paul Rollo, 2 Robert Opie Collections, 3 The Perfect Design Company, 4 The Partners, 5 Sampson Tyrrell Ltd, London, 6 Sally Geeve, Baker Hill Ltd, 7 Robert Opie Collection, 8 Tatham Pearce. **108-109** 1, 2 Vaughan Oliver, 3 Louise Stocking, 4 Habitat Ltd, 5, 6 The Perfect Design Company, 7 The Team, 8 David Quay. **110** St Bride's Printing Library. **124-125** 1 Russell Leong, 2 Davies Baron, 3 Jeremy Leslie, 4 Tatham Pearce, 5, 6 Peter Bartl, 7 Albert Gomm, 8 English Markell Pockett. **126-127** 1 Hans Dieter Reichert, Banks & Miles, London, 2, 3 The Partners, 4 Rudi Meyer, Paris, 5, 6, Hans Peter Dubacher and Jurg Meyer, 7 Michael Peters Ltd, 8 Robert Opie Collection. **128-129** 1 St Bride's Printing Library, 2 Robert Opie Collection, 3 Post Office, 4 Turning Point Design, 5 Thumb Design Partnership, 6 Hans Arnolds and Tom Homburg, 7 The Perfect Design Company, 8 John Nash & Friends, 9 Nucleus Design Ltd. **130-131** St Bride's Printing Library. **140-141** 1 Pat Schleger, 2 John Nash & Friends, 3 Tom Homburg and Kees Wagenaars, 4 Robert Opie Collection, 7 Bernard Villemot, 8 Pentagram. **142-3** 1 Robert Opie Collection, 2 Paul Shaw, 3 Robert Opie Collection, 4 Roundel, 5 Tony O'Hanlon, 6 David Quay, 7 John Nash & Friends. **144** t St Bride's Printing Library, b Emigré. **170-171** 1 Penguin Books, 2 Blackburn's, 3 Hans Dieter Reichert, Banks & Miles, London, 4 Tatham Pearce, 5, 6 Orjan Nordling, Literature Grafisk Formgivning AB, 7 The Perfect Design Company, 8 Giant, 9 Tatoo, 10 Michael Peters Ltd, 11 David Quay. **172-173** 1 Robert Opie Collection, 2 Intégral Concept, 3 The Perfect Design Company, 4 Thumb Design Partnership, 5, 6 Kees Wagenaars, 7 Robert Opie Collection, 8 John Nash & Friends, 9 Jeremy Leslie, 10 The Team. **174-175** 1 Jeremy Leslie, 2 Leonard Currie, 3 Tony O'Hanlon, 4 CGI London, 5 David Hillman and Leigh Brownsword, Pentagram, 6 The Team, 7 Satpaul Bhamra, 8 Carole Theobald and William Redfern, The Four Hundred, 9 Intégral Concept. **176-177** 1 Fir Tree Design Company, 2 Debbie Martindale and Adam Throup, 3 Grundy & Northedge, 4, 5 The Partners, 6, 7 Robert Opie Collection, 8 Fernand Baudin, 9 Laura Starling, Starling Corporate Design, 10 The Team. **178** t & b St Bride's Printing Library. **179** Neville Brody. **188-189** 1 Intégral Concept, 2 Robert Opie Collection, 3 Stocks Austin Sice, 4 Lida Lopes Cardozo, 5 The Team, 6 Nancy Williams & Laura Head, 7 Jan Tschichold, 8 Kees Wagenaars, 9 Tom Homburg & Kees Wagenaars, 10 Richard Eckersley. **190-191** 1 The Perfect Design Company, 2 Richard Eckersley, 3 Paul Shaw, 4 Tim Girvin, 5, 6 Lloyd Northover Ltd, London, 7 Carole Theobald, The Four Hundred. **198** Giant. **199** Richard Eckersley. **200** Wings Design Consultants. **202** 1 Kees Wagenaars, 2 Carole Theobald, The Four Hundred, 3 Dennis Ichiyama. **204** t Kinneir Calvery, b English Markell Pockett. **207** Pentagram. **208** bl, br April Greiman Inc, tr Tony O'Hanlon. **209** tl Richard Eckersley, bl Rudi Meyer, Paris, tr David Quay, br Michael Peters Ltd. **210** t Richard Eckersley, b Jeremy Leslie. **211** tl Jan Tschichold, tr, br Intégral Concept, bl Paul Shaw. **212** t Carole Theobald and William Redfern, The Four Hundred, bl Leonard Currie and David Quay, tr Tatham Pearce, mr Peter Saville, Pentagram, br Jeremy Leslie. **213** l Tatham Pearce, bl Grundy & Northedge, m Takenobu Igarashi, tr Nucleus Design Ltd, br John Stevens. **214** tl, bl Robert Opie Collection, m David James, tr Alan Fletcher, Pentagram, br Pentagram. **215** tl Thumb Design Partnership, bl Hard Werken, r The Perfect Design Company.

While every effort has been made to trace and acknowledge all copyright holders, Quarto would like to apologize if any omissions have been made.